The Art of
Terrestrial Diagrams
in Early China

The Art of
Terrestrial Diagrams
in Early China

MICHELLE H. WANG

The University of Chicago Press
Chicago and London

The University of Chicago Press, Chicago 60637
The University of Chicago Press, Ltd., London
© 2023 by The University of Chicago
Published 2023
Printed in China

32 31 30 29 28 27 26 25 24 23 1 2 3 4 5

ISBN-13: 978-0-226-82746-9 (cloth)
ISBN-13: 978-0-226-82747-6 (e-book)
DOI: https://doi.org/10.7208/chicago/9780226827476.001.0001

Library of Congress Cataloging-in-Publication Data

Names: Wang, Michelle H., author.
Title: The art of terrestrial diagrams in early China / Michelle H. Wang.
Description: Chicago : The University of Chicago Press, 2023. | Includes bibliographical
 references and index.
Identifiers: LCCN 2022051896 | ISBN 9780226827469 (cloth) | ISBN 9780226827476 (ebook)
Subjects: LCSH: Cartography—China—History. | Early maps—China—History. |
 Cartography—China—Methodology—History. | Tombs—China. | China—Antiquities.
Classification: LCC GA1123.1.A1 W36 2023 | DDC 526.0931—dc23/eng20230119
LC record available at https://lccn.loc.gov/2022051896

∞ This paper meets the requirements of ANSI/NISO Z39.48-1992 (Permanence of Paper).

Contents

The Work of Diagrams

The Chinese term *ditu*, commonly translated as "map" in English, consists of two characters: *di*, "terrestrial," and *tu*, "diagram." A more literal translation of *ditu*, then, is "terrestrial diagram" rather than "map." In the Chinese language, a map is a diagram of terrestrial space.[1] This book starts from this understanding and argues that the seemingly banal assertion that *ditu* are *tu*—that maps are diagrams—produces important analytical consequences for understanding the production of renderings of space and expectations about their functions within the cultures of preimperial and early imperial China. Recategorizing terrestrial diagrams as diagrams rather than maps necessitates a reexamination of the extant artifacts and a reevaluation of their functions. Departing from the rational, mathematical standards associated with the study of normative cartography, this book aims to recast these early terrestrial diagrams, in all their diversity, as pictures that did not simply *represent* the world—a long-standing criterion for the efficacy of maps— but rather *made and remade* worlds. In each of the book's four chapters, I reconstruct the physical making of the diagrams to show how these early graphic renderings could generate alternative spaces for the living and, upon their burial in the tombs from which they were excavated, make auspicious worlds in the afterlife for the dead.

All extant early Chinese terrestrial diagrams that date from the fourth to the second centuries BCE were excavated from three tomb sites. They were buried with the dead, and upon being installed in their final resting place, were expected to never be seen or used by the living. In early China, terrestrial diagrams were certainly not made exclusively for burial purposes, but their findspots in tombs must condition our interpretations of China's early history of rendering space. Rather than a straightforward representation of

topography, these excavated terrestrial diagrams instead were designed with graphic strategies that retained the structural relations embedded within the ritual, administrative, and military worlds of the living that subsequently were expected to make homeomorphic worlds in the afterlife. Not limited by the constraints of accurate, mimetic representation, these diagrams left considerable latitude for postmortem contingencies. The chapters that follow trace the making of a ritual space that retains kingly power and ensures visitors in perpetuity (chap. 1); an administrative procedure that guarantees that the deceased will always be treated fairly, if not in life, then certainly in death (chap. 2); and an auspicious landscape organized according to an art of war that will eternally situate the deceased in the most advantageous position (chaps. 3 and 4).

In this introduction, I lay out the theoretical and methodological foundation that informs each chapter. After an initial section discussing problems with a cartographic understanding of early Chinese terrestrial diagrams, I outline the analytical consequences of returning terrestrial diagrams to the category of diagrams before concluding with a section that defines the terminology appearing throughout the book.

Maps and Mapping

Before 1973 the earliest known Chinese maps were carved on opposite sides of stone steles, the earliest appearing in 1136 CE during the early Southern Song dynasty (1127–1279 CE). Both of that stele's engravings meet certain cartographic expectations: a highly visible grid structures the placement of administrative units; textual labels name individual prefectures, mountains, and rivers; a map scale appears on one and cardinal directions on the other.[2] In both maps, neatly carved lines, almost mechanical in their appearance, obscure a production process that was dependent on human labor from the initial step of brushing the maps on stone to their engraving. The Southern Song stele paints a picture of a mapmaking tradition focused on the mimetic representation of terrestrial space.

In 1973 three silk renderings of terrestrial space that look strikingly different emerged from excavations at Mawangdui tomb 3 (ca. 168 BCE), located in modern-day Changsha, Hunan Province. For comparison, we can turn to one example titled the *Diagram of the Residence and Burial Ground* (*jūzang tu*) by some modern scholars and *Diagram of the Auspicious Domain* (*zhaoyu tu*) by others (fig. I.1).[3] While the drawing may not look like a normative map, it is undoubtedly a terrestrial diagram. The silk manuscript, measuring a near perfect square of 52 by 52.5 centimeters, does not contain a legend or a consistent map scale, and each of its lines retains the traces of the hand(s) that made them. It is also drawn according to two systems of projection. At the top, an amoebic form, filled with cross hatchings,

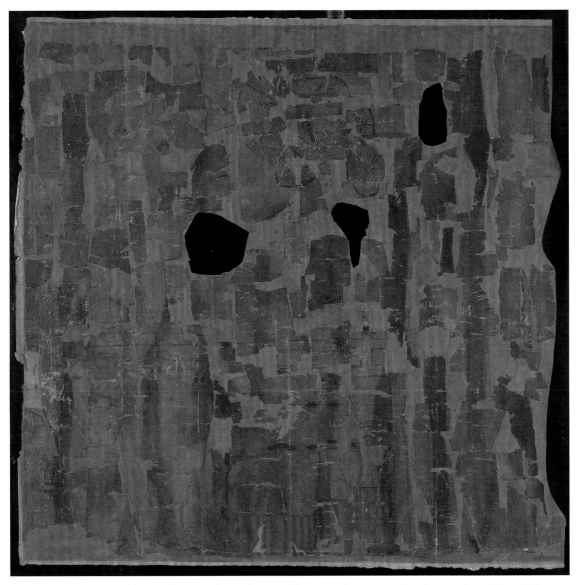

FIGURE I.1 *Diagram of the Residence and Burial Ground* (Jüzang tu), Western Han dynasty (206 BCE–9 CE), excavated from Mawangdui tomb 3. Ink on silk, 52 × 52.5 cm. Reproduced by permission from the Hunan Museum.

contains within it a blank space shaped like the Chinese character *jia*. The brush-written characters "xian mao shi zhang er chi" appear in a smaller rectangle that protrudes from one side of the blank space and provide the dimensions for a burial chamber.[4] Together these geometric shapes and the inscription indicate to their viewers that this image-text combination is a plan view of a burial site made up of a burial chamber dug beneath a burial mound. At the bottom of the silk manuscript, we see a different composition rendered in both elevation and plan views. Three red rectangles dominate this bottom portion, with one side of two rectangles marking the boundary

of the entire drawing along with a black seam that hems the bottom edge. Surrounding the red rectangles, a series of gates (rendered in elevation) are linked together by black lines (drawn from an aerial perspective) that build up a loose grid, but a grid that looks more like rectangles unevenly stacked one on top of the next than a measured application of perpendicular lines.

I further explore this diagram in the coda, but I introduce it here to make two points in this section, one (short) that defines the scope of the book and another (much longer) that problematizes the placement of these early artifacts squarely in the history of cartography. First, the graphic variations in this drawing are mostly present in all early Chinese terrestrial diagrams that have since come to light. These other excavated examples push back the date of the earliest extant terrestrial diagram to the fourth century BCE. They include a bronze plaque with a mausoleum diagram cast on one side (ca. 313 BCE), seven brush-and-ink drawings on four wooden boards (ca. third century BCE), a hemp paper fragment that contains a snippet of what scholars have identified as a topographic drawing (ca. second century BCE), and two other silk manuscripts excavated from Mawangdui (ca. 168 BCE). This book focuses on this group of early renderings of terrestrial space, "early" being a modern designation for the time period between the prehistory and the end of the Eastern Han dynasty (25–220 CE) of the area now known as China. For the purposes of this project, "early" also serves as a temporal marker for the period that precedes the millennium between the production of the Mawangdui terrestrial diagrams and the Southern Song engravings, wherein artefactual evidence of *ditu* making in China is currently absent.[5]

Second, in a standard history of cartography, the Mawangdui diagram would be considered a less accurate map than the Song dynasty examples. Pei Xiu (224–271 CE), famous in his own right as an influential figure in the history of Chinese cartography, disparaged the inaccuracies of Han dynasty terrestrial diagrams because they "do not designate proportional measure; moreover, [they] do not establish a regulated view, and do not carefully record the known mountains and major rivers. Although they have general forms, [they are] all not carefully investigated and cannot be relied on."[6] His late third-century CE critique echoes parts of a statement attributed to Liu An (179–122 BCE), the king of Huainan during the Western Han dynasty (206 BCE–9 CE), three centuries earlier:

> When one investigates mountains, rivers, and strategic defensive positions on a *ditu*, their distance from each other is only a couple of inches, but the physical space between them is hundreds or thousands of leagues. The obstructing woods and bush cannot be exhaustively shown. To see them [on a *ditu*] seems simple, but to traverse them is extremely difficult.[7]

Liu An argues that no amount of detail on a terrestrial diagram could lead to actual military success, for a host of unforeseeable dangers and obstacles exists within the couple of inches of blank space between one mountain pass and another. To make terrestrial diagrams more useful, Pei Xiu offered six principles—"proportional measure (*fenlü*), standard or regulated view (*zhunwang*), road measurement (*daoli*), leveling (or lowering) of heights (*gaoxia*), determination of diagonal distance (*fangxie*), and straightening of curves (*yuzhi*)"—principles that he supposedly put into practice when making his *Map of the Regions of the World in "The Tribute of Yu"* (*Yugong diyu tu*) in eighteen *pian* for which he wrote the preface.[8] Pei's strategies link the process of making maps to survey and mensuration for the sake of representational accuracy. Everything in real, three-dimensional space must be represented as recognizable shapes on the two-dimensional surface of a terrestrial diagram and positioned according to a uniform system of spatial divisions.

It is unsurprising that Pei Xiu's preface appears at one point or another in all scholarship on Chinese maps.[9] Wang Yong, in his foundational research on Chinese cartography, argues that between Pei Xiu's treatise and the introduction of Matteo Ricci's *Map of the World* in the late Ming dynasty (1368–1644 CE), mapmaking in China did not progress beyond the former's six principles.[10] One other mention of scaled drawings that dates before the third century CE is found in the first-century BCE astronomico-mathematical text *Zhoubi suanjing* (*Arithmetical Classic of the Zhou Gnomon*). It prescribes the following procedure for devising a scale for the Diagram of the Seven Heng (*qiheng tu*): "[Previously] in making this diagram, a *zhang* has been taken as a *chi*, a *chi* has been taken as a *cun*, a *cun* has been taken as a *fen*, and a *fen* has been taken as 1000 *li*. [So overall] this used a silk 8 *chi* 1 *cun* square. Now a silk 4 *chi* 5 *fen* square has been used, [so] each *fen* represents 2000 *li*."[11] Armed with evidence of scaled renderings and Pei Xiu's treatise at its helm, historians of cartography pursue an elusive map scale—the ability to derive a numeric ratio of 1:x—to forge an evolutionary model for the history of Chinese cartography as an endeavor motored by a pursuit of representational accuracy through surveys and calculations.

Since Pei Xiu's treatise provides principles by which three-dimensional space is graphically transformed onto a two-dimensional surface, scholarship in the history of Chinese cartography mobilizes the treatise as a paradigmatic shift in mapmaking that echoes the birth of an "ideal of cartography" just after 1800 in Europe—a "belief system" in which there are accurate and inaccurate maps defined by how well they translate three-dimensional space onto a two-dimensional surface.[12] The convictions of this ideal of cartography, as Matthew Edney argues, "construe cartography to be the apparently transcultural endeavor of translating the world to paper or screen, with the shared goal of advancing civilization by perfecting a singular archive of

spatial knowledge through the use of universal techniques of observation and communication."[13] This cartographic ideal continues to colonize otherwise dynamic and heterogeneous practices of mapping under the hegemony of science and objectivity and to linearize spatial renderings into a single evolutionary model based on a drawing's representational accuracy. Under a strict cartographic framework, representational accuracy becomes a measure of success and failure, and the use of a numerical map scale is its main method of achieving the ideal.

At the heart of the cartographic ideal is representation. In most definitions, maps are representational in a narrow sense—they resemble the things that they depict.[14] Mapped forms are arranged on a two-dimensional surface that has been structured according to an artificial system of "scale, projection, and symbolization."[15] There have been crucial efforts on the part of historians of cartography to broaden the scope of the discipline to go beyond representation.[16] Sociocultural historians of cartography, like J. B. Harley, problematize the conception of maps as unmediated representations of space by mobilizing the method of iconology so that "maps cease to be understood as inert records of morphological landscapes or passive reflections of the world."[17] Another intervention conceptualizes maps as "propositions about territory."[18] Critical cartography similarly attends to the representational distortions inherent in all maps, for they are the mechanisms with which those in power convince others to see only what they deem seeable and how to see it. As Peter Bol argues, "A map—any map—is a proposition about the world that is being depicted."[19] Maps make "truth-claims" even if, as Karl Whittington reminds his readers, they are merely propositions that the mapmakers or patrons "assume or hope that their audience will accept as truth—whether or not it is actually true is of little importance."[20] This definition of maps as propositional relies on relative measures of fact and fiction. "Maps must inherently 'lie,'" Mark S. Monmonier asserts, with the understanding that maps are only lying if they are taken to be representations of spatial truths.[21]

Textual sources, discussed in the next section and referenced throughout the book, indicate that there were indeed drawings made to satisfy the criterion of representation, especially as propositions about territory, suggesting that in early China, there existed a world that valued survey and mensuration. Cao Wanru, for instance, examines technical devices for topographic surveys that existed in early China. These apparatuses include the gnomon (*biao*), navigational compass (*sinan*), sighting tube (*wang tong*), compass (*gui*), try square (*jü*), plumb line (*qianchuixian*), and all sorts of poles and rulers for measuring distances—instruments that doubled as devices for astronomical observation.[22] The use of these devices undoubtedly produced diagrams that possessed and prioritized some level of representational accuracy because they had real, practical effects on taxation, travel, agricultural

and resource planning, and military strategy in addition to symbolizing the ownership of territory.

This book, therefore, does not seek to dismantle but instead recontextualizes the meticulous work of historians of early Chinese cartography and geography who have shown how textual sources describe survey technology at work to provide users with diagrams that serve practical purposes or, at the very least, are what Garrett Olberding describes as "a ghostly assembly of collected footsteps, delivering to the map user the essentials of what, in a given landscape, would hinder or assist movement."[23] According to textual records, diagrams made to serve a singular mapping function—a representation of real space within varying degrees of mathematical accuracy—to assist in administrative and military affairs surely existed. My contention, however, is that the material evidence—the excavated terrestrial diagrams that are currently available to modern researchers—suggests that they also served additional functions apart from the ones written about in texts. To dwell in their representational inadequacies as normative maps or to situate them along a single teleology geared toward the gridded Song dynasty maps would be to reify the universalism of the ideal. Morphological likeness to real space was only one of the many strategies that made early terrestrial diagrams functional. Where they fall short of the cartographic ideal is precisely where they exceled in worldmaking.

Diagrams

To write a history of cartography in early China that bridges the available material evidence and textual sources would require overcoming two challenges that I describe in this section. First, currently, none of the available textual sources dated before Pei Xiu's treatise describes how terrestrial diagrams were made or includes any physical drawing. Second, textual references to "maps" are often inferred from just the character *tu* (diagram) without *di* (terrestrial,) which suggests that the "attribute *di* is facultative."[24] In other words, if there is anything to glean from early textual sources on the nature of early Chinese "maps," it is that they are first and foremost "diagrams." Without textual descriptions or physical examples of what maps looked like and the use of the single-character "diagram" as sufficient in denoting its function, the available resources require that we return to the objects themselves to consider their production processes and the full range of their potential functions.

Texts

With a dearth of extant examples, scholars invested in writing an early history of Chinese mapmaking depend on textual sources.[25] The most explicit

and extensive discussion of terrestrial diagrams appears in a chapter from the second-century BCE text *Guanzi*, conveniently titled "Ditu":

> All military commanders must first examine and know *ditu*. They must know thoroughly the location of winding, gatelike defiles, streams that may inundate their chariots, famous mountains, passable valleys, arterial rivers, highlands, and hills. They must also know where grasses, trees, and rushes grow, the distances of roads, the size of city and suburban walls, famous and deserted towns, and barren and fertile land. They should thoroughly store up the location of ways in and out of the terrain. Then afterward they can march armies and attack towns. In the disposition [of troops] they will know what lies ahead and behind and will not lose the advances of the terrain. This is the constant [value] of *ditu*.[26]

While useful in determining the content of the diagrams as terrestrial space and descriptive of the topographic features included in a military diagram, the text does not divulge details on what these diagrams looked like, how these topographical features were organized, or how these diagrams were made. Instead, texts, such as the *Guanzi* passage, describe the production, collection, and collation of information in all formats—whether as lists, diagrams, or pictures—as first and foremost projects that assist in further acts of procuring and securing power. When King Kang (r. 1005–978 BCE) of the Western Zhou dynasty granted his son, Marquis Ce, land from Yi in modern-day Jiangsu Province, he consulted a *tu* diagram devised for King Wu (d. 1043 BCE) and King Cheng (d. 1021 BCE) in their conquest against the Shang and a *tu* diagram of the eastern kingdom.[27] To memorialize this momentous occasion, Marquis Ce cast a bronze *gui* (a ritual vessel in the shape of a raised bowl with two handles) with an inscription that now contains one of the earliest appearances of the character *tu*. In the *Zhanguo ce* (*Strategies of the Warring States*), a text whose current form was probably a product of the Western Han dynasty, Su Qin (d. 284 BCE), a main proponent of the Vertical Alliance against the kingdom of Qin, observed a *tu* diagram of all under heaven and proclaimed that the territories of the other kingdoms combined were five times that of the Qin—a sign that an alliance between the kingdoms stood a chance against Qin incursions.[28] In a story from the "Biographies of Assassins" ("Cike liezhuan") chapter of the *Shiji* (*Records of the Grand Archivist*), Jing Ke was permitted into the closed quarters of King Zheng of Qin during the Warring States period to carry out his covert assassination plot because he brought with him the decapitated head of the former Qin general Fan Wuqi and claimed possession of a highly desirable terrestrial diagram (*ditu*) that would aid the eventual First Emperor in his eastern expansion.[29] In another equally famous example, Xiao He (d. 193 BCE), the Western Han chancellor, gathered the diagrams (*tu*) and writ-

ings (*shu*) from the Qin dynasty archives in Xianyang to advise the founding emperor of the Western Han dynasty, Emperor Gaozu (r. 202–195 BCE), in building the infrastructure of his new empire.[30]

In some instances, the sheer ownership of a diagram symbolizes the authority of its owner or recipient. As the *Zhouli* (*Zhou Rites*), a third-century BCE text, proclaims, one "holds a *tu* [diagram] of [all] under heaven, in order to hold [all of] the land under heaven."[31] Yet terrestrial diagrams simultaneously function as symbols of authority and the means by which authority is usurped or denied. As the mid-third-century BCE treatise *Hanfeizi* warns, "If one submits a *tu* [of one's territory], then the territory is severed. If territory is severed, then one's state is severed."[32] On a much smaller scale, in 31 BCE, toward the end of the Western Han, Kuang Heng, the chancellor to Emperor Cheng (r. 33–7 BCE), was stripped of his title when it was discovered that he not only did not report but also conspired with other officials to conceal a mistake on an administrative *tu* that granted him an extra four hundred *qing* of land as part of his fiefdom.[33] The Kuang Heng story is a reminder that the power of terrestrial diagrams comes in part from the ownership of data on a kingdom's territories, peoples, and resources and the organization of this information into legible, graphic form. Diagrams thus function much like textual lists such as the ones found in the "Treatise on Geography" ("Dili zhi"), a chapter from the *Hanshu* (*History of the Han*), which includes populations, topographical features, cities, temples, local specialties, and other such detailed information on two levels of administrative units—the commandery (*jun*) and the county (*xian*)—during the late Western Han.[34] Having features of a terrain presented in diagram form gives some measure of power to the holder of the document, whether a claimant to the terrain, such as Kuang Heng, or a supplier of the diagram's information, such as Jing Ke and Xiao He.

Those in the most powerful positions, however, were not the overseers of terrestrial diagram production, a role delegated to bureaucratic officials. The *Zhouli* gives a sense, no doubt idealized, of who might have been in charge of the production of terrestrial diagrams and their use in the Warring States period (ca. 472–221 BCE). For example, the grand supervisor of the masses (*dasitu*) "holds the preparation of *tu* relating to the territory of the kingdom and [the registration of] the number of their people in order to help the king settle disturbances in the territories."[35] The officer in charge of mines (*kuangren*) "holds land [containing] metals, jade, tin, and stones and establishes a perimeter [around the area] in order to preserve it. If there is an occasion to mine, then he observes and organizes the material goods of the land and makes a *tu* to confer it."[36] The officer in charge of obstacles (*sixian*) "holds *tu* of the nine regions in order to know their obstructions by way of mountains, forests, rivers, and marshes so that roads may reach them."[37]

Textual sources do not clarify whether these bureaucrats physically made the diagrams, but they probably did not. The "Biography of Wang Mang" ("Wang Mang zhuan") from the *Hanshu* cites the building of the Nine Temples in the Xin Interregnum (9–25 CE) as having required a "broad recruiting of the artisans [*gongjiang*] under heaven to draw [*tu*] using the methods of survey and the calculations of distances [*wangfa dusuan*]."[38] This passage tells us that artisans diagrammed according to surveys and calculations, but the specific divisions of labor, the process of diagramming, and what the diagrams looked like remain unknown. Excavated sources confirm that there were indeed different modes of diagramming, but again, without much detail on what their distinctions might be in practice. A wooden board excavated from Yinwan tomb 6 dated to the Western Han reveals slightly more information about diagram makers but introduces new complications. Hsing I-tien's analysis of the references to *hua tu* (draw diagrams) and *xie tu* (transcribe diagrams) on the wooden board suggests that there were two tasks associated with making diagrams that probably were performed by two different people.[39] Accordingly, the person recruited to *hua tu* in the Wang Mang story might have been trained in technical drawings. There might have also been a person involved in *xie tu*, but it is unclear just what skills and tasks were associated with such a role. The products of *hua tu* or *xie tu* are equally ambiguous. Perhaps, as Hsing hypothesizes, those who *xie tu* copied the drawings made by those who *hua tu*. Perhaps those who were trained in the skill of *hua* made more technical drawings like topographic or cadastral maps or engineering plans, while those who *xie* made representations or portraits of cultural phenomenon instead.[40] Either way, the people who *hua* or *xie tu*, how they were trained to do their jobs, and what the process of *hua* and *xie* might have been remain elusive.

Positions

In the citations above, the character *tu* appears alone more often than the term *ditu*. It is only through context that modern readers can distinguish the subject matter of the diagram as being related to the terrestrial. Without actual diagrams that accompany these texts, it appears that, at least in writing, "the Chinese themselves did not usually make analytical distinctions between different types of *tu*."[41] In turn, I think the more relevant question to the study of early Chinese *ditu* is not what is a map but instead what is a *tu* diagram?

Excavated artifacts only confirm the ambiguity of what constitutes the category of *tu*. Mawangdui tomb 3, for instance, contains over a dozen drawings that modern researchers have designated as *tu* diagrams.[42] These drawings range from compositions of simple lines to full representations of human bodies engaged in physical exercises, which account for information on

the structure of a time-space continuum to the coordination of arms and legs while engaged in stretches respectively. Since this book is primarily interested in renderings of terrestrial space, most of these Mawangdui drawings fall outside of its scope, but a project dedicated to working systematically through the functional specificity of them would greatly contribute to an understanding of the diagrammatic tradition in early China. For the purposes of this project, it suffices to say that a definition of *tu* must be broad enough to account for *all* these drawings that look nothing alike, which means that form alone cannot be a defining characteristic of *tu*. Put simply, diagrams in early China constituted "not a *stylistic* but a *functional* category."[43]

According to the first-century CE character compilation *Shuowen jiezi* (*Explaining the Graphs and Analyzing the Characters*), two semantic components make up the character *tu*—an enclosure that surrounds the character *tu* and the character itself, which is a "protoform" of the character *bi*—and is defined as "to draw [*hua*] that which is difficult to reconcile [*hua ji nan ye*]."[44] In my translation of the definition, I treat *hua* as a verb—"to draw"—rather than a noun—"a drawing"—but the character can function as both. The same applies to *tu*. There is only one instance in this book where the character appears as a verb—to diagram—on an artifact: the bronze mausoleum diagram discussed in chapter 1. On the Yinwan wooden board, artisans "draw" or "transcribe" *tu*, a noun. The *Zhouli* also uses *tu* as a noun. In yet another example, the "Bibliographic Treatise" of the *Hanshu*, a text completed in the second century CE, records *tu* that accompanied certain texts. In his philological reconstruction of the character, Wolfgang Behr argues that in the early Eastern Zhou, the term came to denote "magico-religious" or "protoscientific" charts, but it took until the late Warring States period for it to emerge as a single-character stand-in for "geographical maps" and to take on its "secondary verbal usage" as "planning" or "ordering."[45] The *Zuozhuan* (*Zuo Tradition*), a late fourth-century BCE commentary to the *Chunqiu* (*Spring and Autumn Annals*), contains *tu* as a noun and verb: by my count, the character only appears about five percent of the time as nouns, while the others are verbs, meaning "to consider," "to plan," or "to plot."[46]

Whether acting as a noun or verb, the term *tu*, in its usage and first-century BCE definition, does not stipulate representation as a prerequisite for diagrams and diagramming. As a verb, *tu* diagramming helped people make sense of the "difficult" world around them ("to consider," "to plan") by positioning elements of the visible world for the purposes of subsequent plotting, planning, or thinking. As a noun, *tu* diagrams were records of these positions that viewers could then act upon. What defined *tu* in early China, therefore, was not what they looked like but what they did—not their forms but their functions, not their referents but how they referenced. So long as these "manifestly selective packets of dissimilar data [were] correlated in an explicitly process-oriented array," viewers could draw useful conclusions

that satisfied their needs or worldviews, spatial or otherwise.[47] Put another way, and as Jeffrey F. Hamburger argues in the context of medieval European diagrams, "At a fundamental level a diagram is not a representation at all. One could even go as far as to say that diagrams ultimately have no object or referent in the world: rather than reflect the world as it is, they first identify, then rearrange its parts and enable, shape and structure our patterns of thought."[48] The standards by which early Chinese users and makers measured the successes and failures of terrestrial diagrams were *not* determined by how accurately graphic forms *represent* the morphologies of a static, real space. Terrestrial diagrams were the products of their makers' making sense of their worlds through concepts of *positionality* and *relationality*—two attributes that I will later define as *topological*—with the hope of generating (remaking) worlds that could provide alternative answers to their most pressing questions beyond what is merely visible.[49]

Heaven and Earth

To return terrestrial diagrams to the realm of diagrams is to reunite them with another group of objects that speaks directly to the display of positions: celestial diagrams. Heaven and earth are inextricable in early Chinese thought, with philosophers and strategists imaging in words the invisible relations between elements in the sky and on earth and making sense of their resonances with each other to derive the best course of human action. In the *Shuowen jiezi*, *di* (earth) is that which is "heavy, turbid, and *yin*," whereas that which is "light, clear, and *yang* is taken to be *tian* [heaven]."[50] Similarly, the "Treatise on the Patterns of Heaven" ("Tianwenxun") from the second-century text *Huainanzi*—a text that closely follows (at times even appropriates in full) passages from the *Daodejing* (*Classic of the Way and Virtue*)—explains that heaven and earth were created as a division of *qi*: "that which was pure and bright spread out to form Heaven; the heavy and turbid congealed to form Earth."[51]

This division between heaven and earth that stems from a single source holds practical consequences for early discourse on human governance, for the *Huainanzi* continues to argue that whatever happens on earth is reflected in what happens in the heavens and vice versa. Humans are situated at the heart of any interpretation of heaven and earth. In early China, heaven is that which is visible above the horizon from any standpoint. This heavenly expanse is divided according to various methods of field allocation (*fenye*): "the correlation between terrestrial regions and their celestial counterparts based on certain patterns of correspondences, for the purpose of divining the good or ill fortune of the terrestrial locations."[52] These heavenly divisions and, importantly, the imaging of them, derive from human perception and the desire to read the "writing" in the stars.

The inherent subjectivity embedded in astrological projects appears in early Chinese geography (*dili*, lit. "patterns of the terrain") as well, which also depended on a human perceiver. In early Chinese geography, the terrestrial realm was composed of the linear extensions of two perpendicular cords, with their directionality constituting the four cardinal directions and anchored by the observer's position.[53] Consequently, the modern assumption that north, south, east, and west should be positioned at the top, bottom, right, and left of a terrestrial diagram, respectively, does not apply. In most cases (but importantly not all), south is positioned at the top. This early convention of placing south at the top is not unique to terrestrial diagrams but is instead based on human activity. In rituals, for example, one turns one's back to the north and faces south.[54] The "proper" orientation is thus not based on geodetic, magnetic, or even grid north but rather based on the viewers' positions so that they face south.

To make sense of their resonance or to act according to heaven and earth requires first and foremost imaging the plans that they have in store for humans. Scholarship on celestial images and diagrams is immensely rich. To engage fully with early Chinese theories of astro-terrestrial resonance would require many more books.[55] I only (barely) scratch the surface with this project, which relies on a basic understanding of the fundamental role of diagrams in early China as a means by which the unseeable (the lay of the land or the cosmos) is ordered through a plotting of positions and "visibilized" on a single artifact so that it may be replicated and lead to subsequent action by its beholders.[56] To see how celestial diagrams serve these functions, I turn to two examples: astro-calendrical instruments and the legacy of the river diagram (*hetu*) and Luo river writing (*luoshu*).

In 1977 archaeologists discovered a set of three cosmographic diagrams (*shitu*) in the tomb of Xiahou Zao (ca. 165 BCE), the lord of Ruyin, located in the modern-day village of Shuanggudui, Fuyang, Anhui Province.[57] All three artifacts are black lacquerware with mostly incised inscriptions and markings and composed of two components. One device (*ershi ba xiu yuan pan*) has a smaller disk with the stars of the Northern Dipper that rests atop a larger disk. This bottom disk consists of twenty-eight *unevenly* distributed sections, each labeled with the twenty-eight lodges (*xiu*) in seal script along the periphery.[58] Another device (*liuren shi pan*) contains a round disk with months and lodges incised on its surface, which slots into a circular indentation dug into a square bottom plate. Two nested squares painted in red lacquer are centered on the square, dividing the surface into inner, middle, and outer zones, each of which contains the stems, branches, and the lodges *evenly* distributed on each side.[59] The final object of the trio (*Taiyi jiugong zhan pan*) also consists of a square base and a round disk. The square base is divided into an inner and outer zone by a painted red square. The outside contains incised inscriptions that refer to solstices and equinoxes

that correspond with inscriptions found inside the square that record auspicious and inauspicious prognostications.[60] The round disk on top is divided into eight equal parts with names of the nine palaces of heaven (*jiugong*) inscribed at the eight extremities of the lines and the center. As scholars have pointed out, each of these instruments serves a different function. The even distribution of the twenty-eight lodges on one device suggests that "its purpose is to relate sequences rather than register quantities," unlike the device composed of two round disks that have the twenty-eight lodges incised in uneven intervals measured by the number of *du* they occupy.[61] This latter instrument was probably "intended as a source of quantitative astronomical data" that was a useful tool to have on hand to use in tandem with the other devices.[62]

These instruments are doubtlessly about the sky, but a sky that has been filtered through human perception with an eye to human use.[63] Unlike a representation of the stars that might be derived from observation, these objects are cosmographic diagrams that present a digest of celestial information—namely, the relative positions of asterisms—intentionally distilled and structured according to functions that their users require rather than their representational value. The skies—no matter which position on earth humans occupy or what advanced technology they possess—do not look anything like these devices, yet these diagrams are perfectly functional in the hands of those privileged few who can interpret them.

While physical examples of cosmographic diagrams have been excavated, the river diagram (*hetu*) and Luo river writing (*luoshu*) remain elusive despite their status as possibly the earliest diagrams in China and their popularity in later imperial dynasties. There were certainly designs referred to as *hetu* and *luoshu* by the late Western Han, as attested by a passage from the *Hanshu* chapter "Treatise on the Five Phases" ("Wuxing zhi").[64] There are, however, no images contemporaneous with the text that show what the *hetu* and *luoshu* looked like, thus leaving much to the imagination in terms of their graphic construction, a particular interest of Northern Song dynasty (960–1127 CE) neo-Confucianists and Qing dynasty (1644–1912 CE) intellectual historians.[65] All that can be gleaned about the *hetu* and *luoshu* in the Western Han is merely the functional potential of these diagrams as heavenly images that inspire earthly efforts on the part of sage-kings to pattern their behavior accordingly. The Western Han "Commentary on the Appended Phrases" ("Xici zhuan")—one of the multiple commentaries that grew to accompany the core text of the *Yijing* (*Classic of Changes*)—presents the eight trigrams (*gua*) believed to have been inscribed on the *hetu* by the legendary sage-king Fu Xi as "a paradigm of Heaven and Earth, and so it shows how one can fill in and pull together the Dao of Heaven and Earth. Looking up, we use it [the trigrams] to observe the configurations of Heaven, and, looking down, we use it to examine the patterns on Earth."[66] Accordingly, the function of the

eight trigrams is to guide sage-kings in their quest to "resemble Heaven and Earth" and "not go against them."[67]

The *hetu*, *luoshu*, and the *gua* from the *Yijing* imply human subjectivity regardless of their divine origins. In their descriptive tradition, these designs are a technology with which people in early China made sense of their world by presenting graphic configurations generous enough to account for all earthly and heavenly phenomena and their resonances without pinning their forms to a single, observable truth about the universe. Similarly, excavated terrestrial diagrams that render earthly topography as straight and squiggly lines "encourage multiple readings while neatly balancing two contradictory propositions: that life is fated and so outside our control, ruled by unseen forces, and that humans construct their own fates."[68] While normative maps strive to represent an external world that appears to be outside of our control, diagrams present the encouraging possibility that humans are capable of drawing terrestrial connections to make worlds that best serve their interests.[69]

Diagramming as Worldmaking

The following section consists of explications of terms and concepts that appear throughout the book. In its analyses of early terrestrial diagrams, the book at times introduces terminology and concepts outside of early China, but those that derive from other times and places nonetheless offer language that captures and explains the specificities of the diagrammatic tradition.

Drawing

As discussed in the previous section, diagrams were made by humans with their use in mind, thus the perspectives of the maker(s) and user(s) of the diagrams are embedded within the object. In each chapter, I take seriously the implicit subjectivity in making and using diagrams by attending to the processes by which they were made.[70] Each of the following chapters includes reconstructions of the terrestrial diagrams' production processes. Despite their range of materials, I refer to all of them as drawings. "Drawings, the products of drawing," as Susan Feagin writes, "are more intimately connected with an identification of what actions are performed than pictorial representations."[71] In this characterization, emphasis is placed on the act of drawing as opposed to the content of what is drawn. As an example, Feagin turns to the act of drawing cats. Children can produce pictures of cats without actually "drawing" cats because they can be instructed to draw geometric shapes (a circle, two triangles, etc.) that, when combined, may be perceived by an onlooker as a representation of a cat. In fact, one could draw a circle and two triangles to make representations of all sorts. In each of

these cases, children are simply drawing circles and triangles and not whatever the combination of geometric forms might represent for their viewers.

Describing early terrestrial diagrams as drawings makes room for reexamining the formal and material aspects of these early Chinese artifacts as a series of actions that may or *may not* cohere into a representation of anything but are nonetheless functional. Before being studied as representations, these artifacts must first be examined as things made by someone who possessed the basic knowledge and training in how to *draw* but not necessarily *represent*. That these terrestrial drawings need not be representational means that they no longer require their viewers "to 'spot' every location registered on the earth's surface" in order to be considered functional.[72]

Topology

As mentioned earlier, in this book, I characterize early Chinese terrestrial diagrams as topological. Topology is not a term that appears in early Chinese sources, but its modern definition and applications offer terminology that is helpful in describing the functional design of diagrams.[73] Early Chinese terrestrial diagrams record what their users perceive as *invariant* or *permanent* properties of a designated topography but leave ample room for building out the space into one most useful for their needs. Similarly, in mathematics, while geometry is concerned with the shapes of things, topology—a branch of geometry in its origins—is interested in the permanent properties of a shape that can withstand any continuous deformation. In topology, shape is not permanent. One can tie two ends of a string together and make a circle but could pull on four points to make a square—same string, different shape. In topology, they are considered the same even if they look different; the circle and the square are *homeomorphic*. If one were to put numbered beads on the string and then manipulate it any which way, the *distance* between each of the beads would be different. Distance is therefore not a permanent property either. Yet the order of the numbered beads—their *positions* relative to each other—would remain the same if one followed the string from one end to the other.[74]

One of the clearest examples of a topological drawing is the London Underground Map. The "tube map" of 1908 (fig. I.2) consisted of thick lines superimposed on a geographic map of London. Stations were tightly compacted in central London but scattered loosely among its outskirts, thereby creating a dissonance between use and legibility. Geographical accuracy in this instance obstructed functionality. To remedy this problem among others, in 1931, Henry Charles Beck filtered out representational details (e.g., distances between stations) and amplified the basic positions and order of the stations—the essential information required to guide viewers from where they were to where they intended to go (fig. I.3). The 1908 drawing

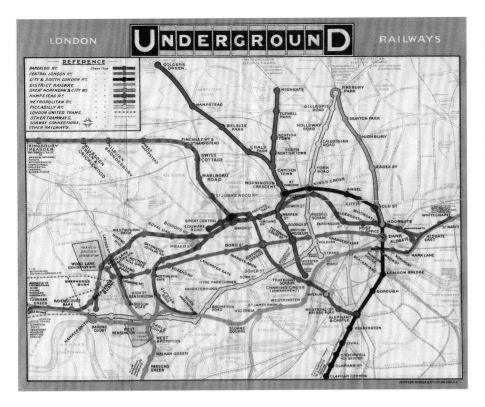

FIGURE I.2 *London UndergrounD Railways Pocket Map*, 1908, printed by Johnson, Riddle & Company Limited. 29 × 35.2 cm. © TfL from the London Transport Museum collection.

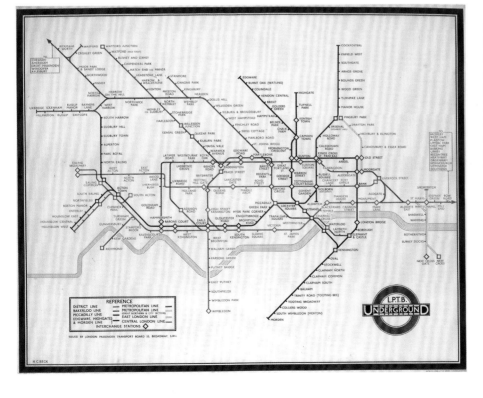

FIGURE I.3 Henry Charles Beck, *London Underground Map*, 1933, printed by Waterlow & Sons Limited, London. Lithograph, 127 × 100 cm. © TfL from the London Transport Museum collection.

was distorted continuously—stretched, shrunken according to an orthogonal system and diagonals at forty-five degrees—to make the 1931 version. In my analysis, terrestrial diagrams in early China are more like the 1931 diagram than the 1908 map.[75]

In topological terms, each station on the London Underground Map constitutes a *vertex*. Each line that connects one station to another is an *edge*. Throughout the book, these terms constitute my understanding of an alternative to the systems of map projection that are often assumed to be present in cartographic endeavors but are absent in early Chinese terrestrial diagrams. While there may not be a consistent map projection that flattens Earth's topography for the purposes of graphic representation, these early topological drawings nonetheless capture the transformation of three-dimensional space into two dimensions (and vice versa) by retaining the invariant properties of the vertices and edges that connect topographical elements. Ritual structures and platforms; river sources, confluences, bends, and mouths; mountain peaks and valleys are the vertices, and their transformed distances and heights are the edges.

Although extant early Chinese terrestrial diagrams were not consistently scaled and flattened with the use of a projection system, all of them nonetheless capture the topological invariants of the topography in question. The drawings may look like a series of two-dimensional points (vertices) and lines (edges), but as topologies their references extend to the third dimension. For an example of how these topological transformations across dimensions occur, we can visit (ever so briefly and cursorily) Euler's formula for polyhedrons—solid, geometrical figures, like tetrahedrons or cubes—as an analogy.[76] A polyhedron is composed of three different elements: flat planes (faces) bound by straight lines (edges) that converge at corners (vertices). Euler's theorem proves that, for convex polyhedrons—a polyhedron wherein any line segment that joins any of its two points will always remain within the polyhedron—"if you add the number of faces to the number of vertices, and subtract the number of edges, you *always* get 2 for an answer, no matter how complex the polyhedron."[77] To arrive at the proof topologically, one continuously distorts a convex polyhedron while retaining its permanent properties. Following Stephen Barr, we can label each vertex of a tetrahedron—a convex polyhedron with four triangular faces, six edges, and four vertices—A, B, C, and D. We can map the tetrahedron onto a sphere by inflating the edges AB, AC, and AD until they meet the contours of the sphere. Although the distances of the edges have changed and three of the four faces are now rounded, the two polyhedrons are nonetheless homeomorphic because their vertices maintain the same relationship to each other and their numbers of faces, edges, and vertices remain identical. In one more topological transformation, the rounded tetrahedron can be flattened into a two-dimensional triangle with round-

ed edges: vertex A now situated in the middle and edges AB, AC, and AD curving outward from vertex A. This two-dimensional triangle is, again, homeomorphic to the tetrahedron on the sphere and the tetrahedron with which we began, for it too contains the same number of faces, edges, and vertices despite all of them being different shapes and lengths. Euler's proof for three-dimensional polyhedrons can thus be derived from drawing two-dimensional planar graphs—networks of vertices and noncrossing edges in the Euclidean plane—that retain the topological invariants of the original shape. Returning to the early Chinese terrestrial diagrams, they may not look like the actual mountains and rivers that one could find in early China or record scaled distances between geographical elements or altitudes of specific mountain peaks, but they are nonetheless *homeomorphic* to the natural topography insofar as they retain the topological invariants of the original shape that are considered most meaningful and functional to their users.

Worldmaking

Topology provides terminology for the design of terrestrial diagrams, but it does not explain the actual mechanisms that enable pictures or objects to serve a worldmaking function for disparate audiences. For that, I turn to the work of Nelson Goodman, who provides an analytical framework geared toward explicating the question of how pictures function, or in Goodman's terminology, reference.

A single form contains multiple aspects that lead to different functions—what Goodman calls *modes of reference*—and those functions are determined by its viewers depending on what is most useful for their tasks at hand.[78] As Goodman explains, while "reference to an object is a necessary condition for depiction or description of it . . . [no] degree of resemblance is a necessary or sufficient condition for either."[79] Simply put, a picture can reference something without looking like the referent. Instead, pictures reference as descriptions on one end of a sliding scale and depictions on the other. Descriptions (at their extreme) reference by way of denotation, such as pictures commonly referred to as notations or notational systems. The field of topology, with its emphasis only on the permanent properties of a shape (e.g., the numbers of and relationships between vertices and edges), relies on a similar notational logic. On the other hand, depictions (at their extreme) reference by way of exemplification or expression. Most exemplary of this category of objects are those associated with the fine arts, such as paintings or sculptures.

The sliding scale is calibrated by measures of syntactic and semantic density. Catherine Elgin provides, to my mind, the clearest example of a notational system: zip codes. Every region in the United States has only one

zip code, and every address has only one zip code. Zip codes are, therefore, *semantically* unambiguous and disjoint and thus form a notational *system*. Zip codes are made up of numbers. No matter how one's handwriting or computer typeface might affect the legibility of the numbers, its marks must first satisfy the criteria of belonging to a discrete number between zero and nine in order to be recognizable in a zip code. The system of zip codes, then, is made up of a *syntactically* disjoint and differentiated *scheme*.[80]

While zip codes reference notationally (and are thus descriptive), most works that are often considered notational because of the way they look fail to satisfy the criteria for "maximum fineness of discrimination" on both semantic and syntactic fronts.[81] Maps and diagrams fall within this ambiguous zone. Goodman argues that an "ordinary road map" is a diagram that references by way of description (notational) *and* representation (nonnotational), with their mode of reference dependent on "how we are to read it," or, put another way, dependent on which aspect of the diagram's formal configuration viewers see and use.[82] Returning to the terrestrial diagram from Mawangdui (see fig. I.1), on the one hand, if a viewer wanted to know how to get from one corner of town to another using the bottom half of the diagram, she could use the diagram's descriptive function to discern how many roads to walk down and how many corners to turn. On the other hand, she may wish to use the depictive function, where the slightest change in line quality is meaningful insofar as it expresses or exemplifies an actual qualitative difference in the environment.[83] The same drawing can be placed in two frames of reference depending on which of the descriptive and depictive modes of reference its viewer wishes to follow. In turn, the diagram's functions or "modes of reference" (re)make worlds—worldmaking—so that its graphic lines, shapes, and inscriptions "*make* visual culture as much as they are *made* by it."[84]

This worldmaking power of images is not foreign to the early Chinese imagination. To convince the founding emperor of the Western Han dynasty, Emperor Gaozu, to spend immense resources in building Chang'an, the capital of the Western Han, despite the war-torn and depleted state of the budding empire, Xiao He, his chancellor, argued the following:

> It is precisely because the fate of the empire is still uncertain that we must build such palaces and halls. A true Son of Heaven takes the whole world within the four seas to be his family. If he does not dwell in magnificence and beauty, he will have no way to manifest his authority, nor will he leave any foundation for his heirs to build.[85]

In gathering all the diagrams from the Qin dynasty archives, Xiao He proposed that a magnificent world could be made by boiling down the plethora of information from these documents into neat built structures that mask

the messiness of an empire still struggling to consolidate authority. This made-up world may not represent reality but is nonetheless functional.

Space

The book thus shares Mark Edward Lewis's concept of space in early China as a construct rather than a given.[86] D. Jonathan Felt's mobilization of "metageographies" as "conscious and unconscious spatial frameworks that inevitably organize human understanding of the natural and human geography within which they exist" similarly resonates with this notion of space as constructions that are rooted in specific historical moments.[87] The book builds on these important studies with its emphasis on *how* space is constructed rather than what these constructs represent or what they might mean. In this way, it aligns with Vera Dorofeeva-Lichtmann's analysis of the *Shanhaijing* (*Classic of the Mountains and Seas*)—a first-century BCE *descriptio mundi*—wherein her emphasis lies in the "process-oriented scheme" in the form of a "network of routes" that produces an image of the world generated from the text itself.[88] By turning to the actual mechanisms of constructing space in each terrestrial diagram, this book does not posit a single, unified vision of space that these terrestrial diagrams represent. As Luke Habberstad explains with regard to the conception of the early Chinese court, "Transformations in early imperial institutions and political culture were not due solely to the adoption or rejection of an ideology" but were instead "rooted in the development of new practices and conventions . . . [by] people who sought to articulate their own status in a wealthy and politically treacherous world."[89] According to textual sources, there were terrestrial diagrams commissioned by imperial courts that were designed to represent the entire domain under a single ruler for the purposes of symbolizing unified power.[90] These objects might have been produced for the sole purpose of propagating a single ideology or source of authority. None of these *yudi tu* ("map of the earth" or literally "diagram of carriage-land") from the early period exist. Instead, each of the extant examples presents a personalized world-version that speaks to the disparate needs of its living or dead user. These individuals were a king (chap. 1), a low-level bureaucrat (chap. 2), and a son of a marquis (chaps. 3 and 4). With the help of diagrams, they ensured that their positions among the "politically treacherous world" of the living could be remade in the afterlife as a far more auspicious place.

The key word here is *remade*, especially in the context of the diagrams' functions upon their burial. Each of these terrestrial diagrams are homeomorphic to the terrestrial space of the living—be it a mausoleum site (chap. 1), the topography of a local region (chap. 2), or the distribution of towns and military units in a commandery (chaps. 3 and 4)—but what they retain are not the morphologies or measurements of topographical elements but

instead their relationships to each other—their topology. These diagrams thus occupy a curious position among theories of the diagram as proposed by Charles Sanders Peirce and by Gilles Deleuze and Félix Guattari. An early terrestrial diagram is an "icon of relations," using Peirce's terminology.[91] It is an icon not because of its semblance to the topography of a region but because of its semblance to the relations between terrestrial elements. For Peirce, a diagram still "remains inscribed within a representational regime" because its function, as Kamini Vellodi argues, is not geared toward producing "new outcomes each time a diagram is drawn, but to consolidate a *single outcome for all times* (such that successive diagrams will reveal the same conclusion)."[92] In topology-speak, Peirce is interested in the permanent properties of any shape. The positing of a single truth despite the continuous refinement of thought through diagrams sits in stark contrast to Deleuze and Guattari's theory of the diagram, in which diagrams must be distinguished from all signs—icons, indexes, and symbols. "The diagrammatic or abstract machine," they write, "does not function to represent, even something real, but rather constructs a real that is yet to come, a new type of reality."[93]

Extant early terrestrial diagrams are "icons of relations" but they also "[construct] a real that is yet to come." They are, at once, topologies of space that render the permanent properties of their referents in graphic form *and* that construct spaces of a better reality. They transgress what might appear to be a theoretical impossibility because they are objects buried in tombs. They were made by individuals for whom "relations" could only be those that were observable in life, and yet in their burial, the living hoped to make "a real that is yet to come" in the afterlife, for no living being knows what the "truth" might entail in an underground world.

Mingqi and Shengqi

The two-sided reference of early terrestrial diagrams in life and death is an instance of a problem that confronted early Chinese philosophers and continues to interest modern scholars. This project is no exception as it also engages with the distinction (or lack thereof) between *shengqi* (articles of the living) and *mingqi* (spirit articles). Rather than staking a definitive position on whether the excavated terrestrial diagrams are either *shengqi* or *mingqi*, each of the chapters complicates the binary by attending to the processes by which these artifacts were made. That the living conceived of the extant early terrestrial diagrams as being functional for the dead, I think, is an indisputable fact. After all, they were found in tombs. The only reason they would be found in tombs is that they were expected to do something in there. They are, therefore, unequivocally burial goods (*peizangpin*).

However, the forms of these diagrams, regardless of whether they were made as *mingqi* or *shengqi*, cannot be but based on the world of the living.

The living could only imagine what the afterlife consisted of based on what they saw around them, be it the space that they inhabited or the images that they owned, saw, or made. That *mingqi* and *shengqi* in fact share formal origins in the worlds of the living might have prompted the most famous Warring States textual passages that discuss their distinctions as one based on function.[94] According to the "Sandalwood Bow" ("Tangong") chapter in the *Liji* (*Rites Records*), Confucius despairs of people who use "articles of the living" (*sheng zhe zhi qi*) for the dead and praises those who use "spirit articles" (*mingqi*) as people who "understand the way of funerary rituals" (*zhi sang dao yi*).[95] For Confucius, to cut ties with dead relatives and send them along their merry way is heartless, but to treat the deceased as if they were alive is thoughtless.[96] Proper burial artifacts that walk the fine line between these two options must be "cautiously prepared objects that cannot be used" (*bei wu er bu ke yong ye*),[97] such as musical instruments that are recognizable and complete but ultimately "cannot be used" since they are out of tune, strung improperly, or lack stands.[98]

Xunzi, who was alive more than two hundred years after Confucius and a well-known adherent of the classicist philosophy attributed to Confucius and his disciples, offers a narrower definition of *shengqi* and *mingqi*. The term *shengqi* does not appear in the "Sandalwood Bow" chapter; its only reference is to "articles of the living," which implies that these objects were actively used by the living. Xunzi, however, broadens the scope of *shengqi*, wherein both *shengqi* and *mingqi* are categories of burial goods (*peizangpin*) and both formally resemble their counterparts—in their patterning (*wen*) and appearance (*mao*).[99] What makes them suitable for burial is the fact that, once again, they "do not function" (*bu gong*) and "cannot be used" (*bu yong*), respectively.[100] As Wu Hung argues, regardless of Confucius's lamentation of "articles of the living" being used for burial purposes or Xunzi's acceptance of *shengqi* as part of burial collections, they share a basic understanding of burial artifacts as dysfunctional from the perspective of the living.[101]

Certain methods—miniaturization, material transformation—become common strategies from the Warring States onward to ensure that these functional distinctions remain intact, with the understanding that making something too small or too porous would be the means by which objects could be rendered useless. As modern researchers, to know for certain whether an object was formally altered or remade in some way to satisfy the requirement of dysfunction for burial purposes often requires knowing what the object for the living looked like or how it functioned. For instance, and following Enno Giele's suggestion, to know whether a textual manuscript is a *mingqi* or *shengqi* might require discovering that the manuscript is an abbreviated version of an extant document or that it is formatted differently from other documents that share similar content.[102] If the manuscript is an abbreviation or awkwardly formatted, it may be the case that it is a

mingqi that is intentionally made to be dysfunctional for the living. Alain Thote circumvents the issue of needing a "before and after" comparison to argue that manuscripts are *shengqi* if they "strongly defined the person in life" and "commemorated and perpetuated the status achieved by that person in death."[103]

In this book I treat the terrestrial diagrams as burial goods but refrain from defining them explicitly as *mingqi* and *shengqi* because a turn to their production processes complicates these theoretical categories. All extant terrestrial diagrams are not wholly original compositions made *en plein air* during a survey expedition. In each of the chapters, I show how these diagrams are pictures of their makers' imaging of other reference materials. Parts or all of these diagrams must have circulated in another form at one point—as quick sketches, lists, distance charts, and/or survey drawings at different administrative levels. As discussed earlier, the *Zhouli* describes the making of terrestrial diagrams as an integral part of many administrative positions since at least the Warring States period. Each of these diagrams accounted for dramatically different magnitudes of territory and people. The *xiaozai* (administrative general), for instance, was in charge of drawing diagrams that encompassed local neighborhoods.[104] The *sikuai* (accountant) produced diagrams that recorded the expenditures of the peripheral territories.[105] The *sishu* (manager of writings) was charged with safekeeping terrestrial diagrams of an entire kingdom or *bang*.[106] Barring survey opportunities, the only method of compiling a terrestrial diagram of successively larger regions was to cobble together extant diagrams. Two excavated Qin dynasty bamboo slips from Liye tomb 1, located in modern-day Longshan County in Hunan Province, attest to the different regional magnitudes of terrestrial diagrams that were made and controlled by a specified chain of command and, importantly, indicate that to make terrestrial diagrams of increasing magnitude was often a job that entailed "combining" extant drawings rather than embarking on survey expeditions. The bamboo slips describe a clerk (*zushi*), who handled the diagramming (*caotu*) on a prefectural and county level, and an imperial counselor (*yushi*), who checked (*chou*) and combined (*bin*) these drawings to make a terrestrial diagram of the empire (*yuditu*).[107] In other words, all terrestrial diagrams—whether for the living or the dead—were made through complex chains of replication that required continuously imaging extant materials.

It is impossible to argue with certainty what the chains of replication might have entailed for the available corpus of terrestrial diagrams, but, for example, it is certainly within the realm of possibility that terrestrial diagrams were made expressly for burial by consulting the same reference materials and employing the same processes that went into making terrestrial diagrams for living use. It could also be the case that drawings made for

the dead are nearly identical copies of the drawings made for the living. These circumstances of production suggest that the categories of *mingqi* and *shengqi* are useful to an extent beyond which we must confront the physical evidence of which there is very little. Unlike Shang dynasty (ca. 1500–ca. 1045 BCE) bronzes that include the posthumous names of their owners or Han dynasty (206 BCE–220 CE) tombs that yield both miniature and life-size musical instruments, these terrestrial diagrams are unique not only in their respective tombs but across the early Chinese archaeological landscape. We might not know the auspices under which they were made or the full chain of replication in which they were but a few links, yet we can be certain that they ended up in tombs because the living conceived of these terrestrial diagrams as doing important work for the dead.

Art, Cartography, and Diagrams

From the outset, my interest in maps and cartography might seem a bit unconventional. As an art historian, I have been trained to see aspects of artifacts that reference by way of exemplification and expression, noticing, for instance, the line qualities of the Fangmatan drawings or the symmetrical placement of decorative motifs on the Mawangdui *ditu* more so than their geographic referents. In my world-version, these terrestrial diagrams did the work of art and not the work of maps, so I was especially drawn to Cordell Yee's proposal that it may be possible "to write a history of Chinese cartography showing its assimilation into the fine arts."[108] However, as I proceeded with my research, I immediately confronted a problem with the category of "fine arts" in early China. Although the term applies to later Chinese visual production and their attendant institutions and theories, preimperial and early imperial China saw the proliferation of objects that served a variety of functions, but fine art was not one of them. Some of these objects were lavishly and exquisitely made so that, to our modern eyes, they do the work of art, especially when individually placed in glass vitrines in a museum. No doubt they also dazzled their contemporaneous viewers, but these objects never did so at the expense of other important work. *Tu* diagrams are one such category of objects that appeared in all forms and media. To discursively assimilate early Chinese terrestrial diagrams into the categories of fine art and/or cartography narrows their functional variety and collapses distinctions between their viewers now and then.

A major intention of the book is to account for the diverse functions that terrestrial diagrams performed for their beholders. The first chapter focuses on a *tu* diagram cast on a late fourth-century BCE bronze plaque inlaid with gold and silver and buried with King Cuo of the Warring States kingdom of Zhongshan, located in modern-day Pingshan, Hebei Province. The diagram

builds a world for the king in the afterlife by operating as an architectural plan, a ritual map, and a nuanced image of kingly authority. The second chapter turns to a set of brush-and-ink drawings excavated from the tomb of a low-level bureaucrat located at Fangmatan in the modern-day city of Tianshui in Gansu Province. These terrestrial diagrams from the third century BCE may look like representations of space, but their lines and inscriptions are loosely tied together so that they can function as another type of "paperwork" to be filed. Moreover, these terrestrial diagrams not only narrowly represent a preexisting region above ground in their formal configurations but they also built an entire world in the afterlife modeled after the laws of nature in the land of the living. In chapters three and four, I examine two terrestrial diagrams excavated from Mawangdui in Changsha, Hunan Province, dated to the second century BCE. The Mawangdui *ditu*-makers filtered out and manipulated certain representational details of the natural topography in the two terrestrial diagrams by means of an ornamental structure that underpins the placement of individual motifs. Consequently, in place of representational accuracy, the *ditu*-makers turned the two terrestrial diagrams into images of auspiciousness catered to their deceased owner, a man who saw the art of war as the key to continued prosperity in the afterlife.

Each of these chapters approaches terrestrial diagrams on their own terms—from their modes of production to their audiences—rather than slotting them into ready-made categories of art and/or cartography born in a later period and, at times, indiscriminately and anachronistically applied elsewhere. As Svetlana Alpers contends in her exploration of Dutch painting in the seventeenth century, even though "cartographers and art historians have been in essential agreement in maintaining the boundaries between maps and art, or between knowledge and decoration," these boundaries "would have puzzled the Dutch."[109] Disciplinary boundaries that trouble the modern scholar did not keep the Dutch—and early Chinese diagrammers for that matter—awake at night. What early *ditu*-makers produced were diagrams capable of doing the work of art, the work of maps, along with other work depending on which aspect of their formal configuration their viewers see and enact at certain points in time.

The question, then, is less a matter of *what* is art or cartography, but instead, as Goodman proposes, it is a question of *when*:

> [Part] of the trouble lies in asking the wrong question—in failing to recognize that a thing may function as a work of art at some times and not at others. In crucial cases, the real question is not "What objects are (permanently) works of art?" but "When is an object a work of art?"[110]

For Goodman, the "when" of art emphasizes "what art does" as opposed to "what art is," which in turn suggests that the relationship between form and

function is mutable rather than fixed.[111] There is no single truth about *the* world that early Chinese terrestrial diagrams represent; it is only a matter of "fit" for the worlds in which their owners find themselves and the worlds that they recursively make in life and death.[112]

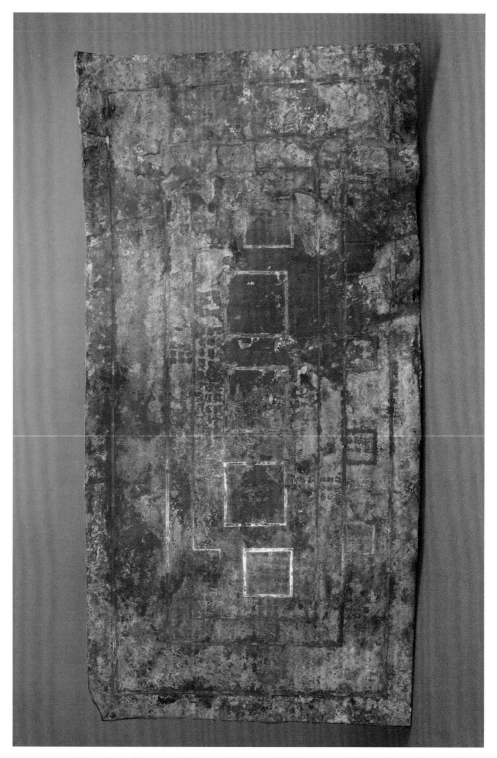

FIGURE 1.1 *Mausoleum Diagram* (Zhaoyu tu), ca. 313 BCE, excavated from Zhongshan tomb 1 located in Sanji, Pingshan County, Hebei Province. Bronze with gold and silver inlay, 48 × 96 × 0.7–1.2 cm. Reproduced by permission from the Hebei Provincial Institute of Cultural Relics and Archaeology.

Zhongshan and Plans for Life after Death

Plans emerge at the critical juncture between the conception of an idea and its execution, thus they are inextricable from the flow of time. On the one hand, plans bring the optimism and excitement that accompany emergent ideas, and on the other, they confront the brutal realities of following through. Planning is a function of *tu* diagrams in early China. In the fourth century BCE, King Cuo (d. ca. 313 BCE) of the Warring States kingdom of Zhongshan (ca. 475–221 BCE) extracted such a diagram from this life cycle of expectation and disappointment. The diagram cuts ties with its past by making permanent the present in which it was designed and cast on one side of a bronze plaque, and, in turn, it builds a world anew in the afterlife. How the diagram accomplishes this feat for the king is the subject of this chapter.

That the bronze plaque excavated from King Cuo's tomb diagrams time out of joint is most readily apparent in the disjuncture between what was planned and what was built (figs. 1.1 and 1.2). Its gold- and silver-inlaid drawing consists of five squares arrayed in a row and framed by three nested rectangles of different sorts: one rectangle with two missing corners, another slightly larger rectangle with four square appendages to one side, and one full rectangle. According to its inscriptions, the central square marks the placement of King Cuo's ceremonial hall (*xiang tang*) that would have sat atop a tomb mound, thus notating the location in which the bronze plaque was found in modern-day Sanji, Pingshan County, in Hebei Province, in 1974. Excavations of the site uncovered King Cuo's tomb underneath a burial mound and, to the east, his queen's tomb, which was also labeled in a square to the left of King Cuo's square on the bronze diagram. The presence of these tombs provides an orientation for the bronze plaque with south on top. Archaeologists found no evidence of the other structures indicated on

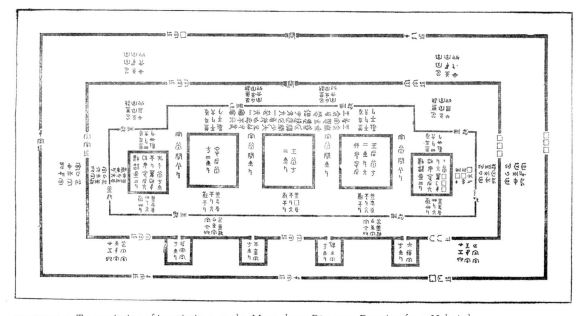

FIGURE 1.2 Transcription of inscriptions on the *Mausoleum Diagram*. Drawing from Hebei sheng wenwu yanjiusuo, *Cuo mu: Zhongshan guo guowang zhi mu* (Beijing: Wenwu chubanshe, 1996), 1:105. Reprinted by permission from Cultural Relics Press.

the plan. If the inlaid drawing is indeed a floor plan, then something interrupted its execution. Scholarly hypotheses all point to a historical explanation.[1] While King Cuo wished for his descendants to continue building the mausoleum complex that housed himself and his wives upon his death, the kingdom of Zhongshan was conquered by the kingdom of Zhao in 296 BCE before his vision could be realized by his son.[2]

Despite the incongruence of the diagram and the site, most scholars have studied the bronze plate as artefactual evidence of Warring States architecture by returning the artifact to the expected life of a plan as a working drawing that reveals early Chinese architectural practices and a document that should have been superseded by built structures upon their completion. The mobilization of the bronze plaque within this context is not unwarranted, as it is the earliest floor plan that has been excavated in preimperial and early imperial China. To acknowledge the singularity of the document, scholars recount its importance in the history of early Chinese architecture by pointing to its existence as a record of "the systematization and regulation [in mausoleum design] of the time" rather than a unique representation of King Cuo's tomb site.[3] That there was never a mausoleum built according to this plan does not detract from the object's value in exhibiting general features of Warring States burial architecture.

That the diagram functions as an architectural plan is also often supported by its longest inscription:

The king mandated [*ming*] Zhou to determine the dimensions of the grave [*zhao*] and for the various officials in charge to diagram [*tu*] it. Those who deviate from the fulfillment of the design will die without pardon. Those who disobey the king's mandate will implicate their descendants. One is to accompany the [king]; one is to be stored in the treasury.[4]

Although only forty-three characters—pithy compared to the more famous bronze inscriptions from this tomb—the inscription is brimming with clues that disclose the multifunctionality of the diagram beyond planning, two of which I will mention at the outset. First, there were two versions of the diagram, although only one remains. Scholars have hypothesized that the two versions of the diagram might have been "identical copies," but I remain skeptical.[5] For one, the bronze mausoleum diagram was most likely a compilation of information drawn from various images of the site, whether in the form of texts, pictures, or perhaps even other diagrams that would have been produced for such a large-scale project. The now-lost version of the diagram might have included information from the vast array of possible source materials that was not incorporated in the buried version—perhaps more data that would be useful for the living in the successive stages of the building project after King Cuo's death. The burial context in which the bronze version was discovered unequivocally identifies the artifact as the one that accompanied the king, meaning that the dead king is its primary audience and not the living. With the (dead) king as its primary beholder, the extant mausoleum *tu* might have entailed a more laborious production process and extravagant material, and the kinds of information that it includes might be different from what the living require.

Second, the object's modern Chinese name *zhaoyu tu* does not appear anywhere on the diagram but instead derives from the shared characters *zhao* and *tu* in the diagram inscription and a passage from the "Office of Spring" ("Chunguan zongbo") chapter of the *Zhouli* (*Zhou Rites*), a text first referenced in the Western Han dynasty (206 BCE–9 CE) but one that nonetheless purports to record the bureaucratic structure of the Western Zhou dynasty (ca. 1100–771 BCE). The passage reads, "The [royal] tomb officer is in charge of princely tombs. He determines the [location of] the gravesite (*zhaoyu*) and makes it into a diagram (*tu*)."[6] *Zhaoyu tu* thus refers to the "grave" (*zhao*) that officials made into a "diagram" (*tu*). Note that these textual references do not stipulate a function for the diagram or what it should look like—just that one was made. The term *zhaoyu tu*, or "mausoleum diagram," leaves open the possibility that the diagram could look a variety of ways and serve multiple purposes beyond architectural planning.

In fact I begin the book with this object not only because it is the earliest extant example of a terrestrial diagram but also because it is a *tu* par excellence. The cast diagram has long possessed an ambiguous identity, at

once characterized as an architectural plan on which reconstructions of early Chinese buildings are based and a map that evinces the existence of a cartographic tradition in China as early as the fourth century BCE. Supporters of the diagram as the earliest example of a Chinese map point to the presence of measured distances, scaled renderings, a simple symbolic system, and implied cardinal orientation as evidence.[7] Interestingly, neither identification—plan or map—depends on the diagram's resemblance to a real space, for no such site exists. The planning and/or mapping function of the diagram does not rely on representation but rather on design strategies that generate a different world altogether, one that the king hoped would become a reality in the hands of his descendants. Building on Wolfgang Behr's observation that the diagram "functioned as a rather sober technical plan of ground plots and *chi*-measures on the one hand, but as a highly ritual object, on the other," this chapter traces the multifunctionality of the diagram's formal design rather than presuming that its plan morphology can only lead to a singular planning function or that the presence of measurements and an implied map scale can only lead to a mapping function.[8] As I argue below, the bronze diagram functions as an architectural plan, a ritual map, and a display object that images kingly authority. Although I address each function separately in the chapter, it is important to note that they are in fact inextricable from one another. After all, the same inscriptions, shapes, and lines perform these different functions. Together, these aspects of the diagram build a world for the king in the afterlife that recognizes and sustains the power that he once possessed in life.

This chapter will proceed by first addressing the planning function of the diagram. The presumed referent of a two-dimensional plan is a three-dimensional site. However, rather than including the heights of the funerary structures that would bring the third dimension to an otherwise two-dimensional plan, the diagram is silent on this important measurement, choosing instead to include only an ambiguous reference to "slope" (*po*). In the second part of the chapter, I propose that missing measurements on the diagram make room for the repetition of certain inscriptions for the sake of amplifying the diagram's symmetrical composition. Together with the measurements for slopes, the diagram functions as a ritual map that takes imaginary visitors on a walk across a liminal space between life and death that is organized topologically and in accordance with ritual. Finally, through a reconstruction of the process of casting the bronze plate and a close examination of its formal design, I suggest that the bronze diagram functions as a display object that manifests a nuanced image of King Cuo's authority, tied on one end to ritual and another to its propagation through an administrative structure exemplified by Warring States legal statutes.

Flatland

The kingdom of Zhongshan was located in a highly vulnerable position in the "stomach and heart" of its neighboring kingdom of Zhao.[9] Therefore, Lingshou, its capital, was designed to take advantage of the natural terrain for a large part of its defensive strategy while augmenting the topography with additional fortification. Other than its northeastern quarter, which bordered the kingdom of Yan, Zhongshan was surrounded by Zhao on all sides. Its coterminous borders with Zhao were guarded by the Taihang Mountains, but its eastern plains were left without a formidable divide. To compensate, a smaller, fortified city was built 1.5 kilometers east of Lingshou.[10] Together with the city walls that ringed the entirety of Lingshou, four high terraces and a hill that sits in the northern part of the city (perhaps the landmark by which the kingdom was named) acted as watchtowers.[11] Because of these natural and artificial defenses, the demise of Zhongshan at the hands of Zhao took multiple tries, beginning in 306 BCE and culminating in a final five-year war[12] that required an alliance between the "ten thousand chariots" kingdoms of Zhao, Qi, and Yan to conquer this "one thousand chariots" kingdom of Zhongshan.[13]

King Cuo held court at Lingshou for fourteen years before his death in about 313 BCE. While his father, King Cheng, was laid to rest in the capital, King Cuo's mausoleum is situated on a hill two kilometers west of the city walls. His multilevel tomb comes in three parts: (1) an underground burial chamber accompanied by three storage pits and (2) an aboveground shaft, which connected the burial chamber with (3) a ceremonial hall that sat atop the burial mound.[14] The bronze plaque was discovered in the main underground burial chamber, which was unfortunately looted and burned long before archaeologists discovered the site, unlike the two underground storage chambers that remained untouched. While the bronze plaque was excavated underground, its drawing only describes structures aboveground: the gates, burial mound, and ceremonial halls. In this section I problematize the notion that these would-be three-dimensional structures are the direct referents of the diagram by examining the diagram's seemingly ambivalent relationship to an important consideration in royal architecture: height. Instead, I argue that the design of the diagram is committed to the two-dimensionality of its medium.

Height and Warring States Architecture

Despite the wear and tear of more than 2,300 years, the remaining portion of King Cuo's burial mound still visible today measures an impressive fifteen meters in height.[15] Its grandiose dimensions manifest the kind of lavishness

disparaged in *Lüshi Chunqiu* (*Master Lü's Spring and Autumn Annals*), a late Warring States text, as "a spectacle for the world to see and . . . a means by which to display one's wealth, but to employ such features as a way to treat the dead is improper."[16] The "Office of Spring" in the *Zhouli* similarly stipulates that the heights of burial mounds must correspond with the ranks of the deceased and not their wealth.[17] In practice, however, the symbolic import of a burial mound was too vital to a king's display of power to forgo for propriety's sake. For elite members of early Chinese society, height was a sign of might. Part of the popularity of terrace platform architecture (*taixie jianzhu*) (fig. 1.3), which characterizes the aboveground structures that would have been built on and around King Cuo's burial mound, was its symbolic value: "the taller the *tai* (platform), the stronger its patron."[18] These patrons' ambitions, however, were met with some technological challenges. Wooden architecture in the Warring States period had yet to develop to the point where it could bear the immense weight of multistoried constructions. Height, therefore, was achieved not by tall, stand-alone structures but by placing single-story halls atop rammed-earth platforms to give the illusion of a multistoried building.[19] Builders stacked earthen cores of decreasing sizes and built corridors (*huilang*) around the earthen core to give the look of lower levels. The main ceremonial hall, like the one that sat atop King Cuo's burial mound, would therefore be constructed directly on the top layer of its mound, but from afar it would look as if the surrounding corridors, which wrapped around each level of the mound, were bearing all its weight.

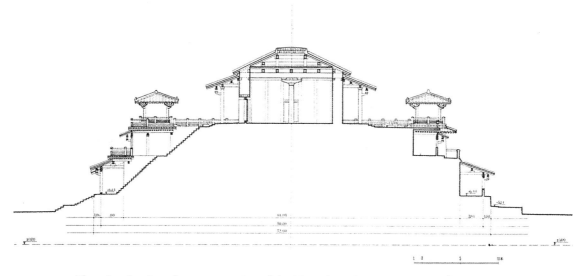

FIGURE 1.3 Elevation drawing of a reconstruction of the *Mausoleum Diagram*. Drawing from Fu Xinian, *Fu Xinian jianzhu shi lunwen ji* (Beijing: Wenwu chubanshe, 1998), 76. Reprinted by permission from Cultural Relics Press.

For all the work that it must have taken to build such a structure to satisfy a king's desire for height and to symbolize his power, it is somewhat odd that the bronze diagram does not include any direct reference to height among the details about the site's aboveground structures. Moreover, as a diagram that resembles a modern floor plan with nested squares, its drawings are unable to deliver height measurements, which are relegated to textual annotations. Floor plans provide views taken from a horizontal plane that cuts through a three-dimensional space so that everything above the plane is eliminated and everything below is flattened. A rectangle in a floor plan can therefore have walls of any height unless noted otherwise in an accompanying label. A floor above or below would require another floor plan or a cross-sectional drawing, the latter of which is the opposite of a floor plan since it takes as its projection a vertical plane cut through a three-dimensional space. Put simply, there is technically no three-dimensionality drawn in a floor plan or plan view. The main purpose of floor plans, therefore, is to turn three-dimensional space into what Edward Tufte refers to as "flatland." Rather than escaping it, as Tufte claims is the "essential task of envisioning information," floor plans hold tight to their graphic medium, relegating the third dimension to the world of description in the form of textual labels.[20]

By contrast, cross-sectional drawings exhibit the interiors of multiple floors. Archaeological evidence shows that these types of drawings were in fact done as early as the Spring and Autumn period (771–475 BCE). A lacquer plate excavated from tomb 1 at Langjiazhuang in Linzi, Shandong Province, dated to this earlier period, for instance, shows mirrored cross sections of a building made up of a flat roof held up by four posts and a basic bracket system.[21] Cross-sectional renderings of buildings also appear on Warring States pictorial bronzes, such as the image on a bronze basin (*jian*) excavated from Zhaogu village, Hui County, Henan Province, that contains a full banquet and hunting scene with a cross section of a multistoried building (fig. 1.4).[22] Within the early Chinese tradition of architectural drawings, extant artifacts, therefore, point to the presence of at least two standard views.

With only a smattering of evidence, it is impossible to adequately account for the development of these two modes of diagramming architecture. Were they entwined or parallel practices? Were their origins in technical drawings or decorative impulses? Ancient Egyptian architectural drawings, for instance, exemplify a tradition of hybridizing plan and elevation views rather than keeping them discrete. Ostracon 51936, excavated from the Valley of the Kings, contains a black line drawing of a descending stepped ramp and a door framed by corridors that scholars have identified as the entrance to the tomb of Ramesses IV (r. 1155–1149 BCE).[23] While the corridors and the steps are rendered in plan view, the door is rendered in elevation, albeit

FIGURE 1.4 Drawn copy of the building incised in a bronze basin (*jian*), Warring States period (ca. 475–221 BCE). Bronze *jian* excavated in Zhaogu village, Hui County, Henan Province. Drawing from Fu Xinian, *Fu Xinian jianzhu shi lunwen ji* (Beijing: Wenwu chubanshe, 1998), 89. Reprinted by permission from Cultural Relics Press.

FIGURE 1.5 *Tomb Plan of Ramesses IV*, 1156–1150 BCE, excavated from Deir el-Medina, Egypt. Cyperus papyrus and ink, 35 × 120 cm. Reproduced by permission from the Museo Egizio, Cat. 1885. Photographed by Nicole Dell'Acquila and Federico Taverni/Museo Egizio.

rotated ninety degrees so that its verticality in elevation merges seamlessly with the horizontality of the plan. Another drawing of the same site, the Turin papyrus plan, also mobilizes this hybridization for its doors "to obtain without perspective all the advantages of a perspective drawing" (fig. 1.5).[24] Moreover, the mountain, marked with a brownish-red line that frames the entirety of the extant plan, probably reached beyond the extant fragment to terminate on its own ground line, so the mountain was also rendered in elevation.[25] Like the bronze diagram, measurements in the Turin papyrus drawing also only appear in the accompanying inscriptions.[26]

With both options available, that the diagram included in King Cuo's tomb would be in plan view suggests the importance of flatness to the functions of the diagram. If the third dimension is impossible in plan view, and there is no evidence of hybrid technical drawings at this early stage, then the numerous inlaid inscriptions might provide the otherwise absent heights of the structures. They do not. The only reference to a third dimension in the inscriptions is the appearance of the character *po*, or "slope," a curious reference to which I turn next.

Slope

In his authoritative account on the viability of the diagram's inscriptions for building the mausoleum, Fu Xinian highlights several problems that are troubling for anyone who treats the diagram as an architectural plan that could lead to a (re)construction of the site. This leads him to conclude that the diagram yields many more questions than answers. For our purposes, the two most significant, interlocking problems are (1) the use of two different units of measurement—*bu* (pace) and *chi*—and (2) the ambiguous term *po*, both of which highlight the problems that ensue with an absence of information on height.[27]

There are two units of measurement employed in the plan: *bu* and *chi*. Fu calculates their conversion by first assuming that the following two inscriptions correspond with the plan view of the drawing (fig. 1.6): (1) "the level [portion] [*qiuping*] of the mound [is] 40 *chi*; its slope [*po*] is 40 *chi*," and (2) "the level [portion] of the mound [is] 50 *chi*; its slope is 50 *chi*." The first inscription appears four times, on the north and south sides of the consorts' halls. The second inscription appears five times, on the north and south sides of the queens' halls and on the south side of the king's hall. Since the distance between the northern and southern inner palace walls are consistent throughout the diagram and include measurements in both *bu* and *chi*, the variable distances of forty or fifty *chi* provide enough information to calculate the conversion of the two units of measurement. If the diagram is in plan view, then to figure out the distance between the two inner palace walls would involve simply adding all available measurements (e.g., using the queen's hall: 6 *bu* + 40 *chi* + 40 *chi* + 150 *chi* + 40 *chi* + 40 *chi* + 24 *bu*). According to this calculation, the *bu* to *chi* conversion in the plan is 1:5. This conversion, however, does not match the ones provided in received texts. The "Royal Regulations" ("Wang zhi") chapter of the *Liji* (*Rites Records*), a text compiled in the Han period but with portions from as early as the Warring States period, for example, stipulates that "people in the past took the Zhou *chi* of 8 *chi* as a *bu*; now [people] take the Zhou *chi* of 6 *chi* and 4 *cun* as a *bu*."[28] In order to reconcile the conversion of *bu* and *chi*, Fu hypothesized that perhaps the reference to *po*, or slope, is in fact not the lateral distance from the "foot of the hill" (*qiuzu*) to the edge of the "level portion of the burial mound" (*qiuping*) but instead refers to the length of the diagonal slope. Even with this revision, however, the conversion of *bu* to *chi* only ranges from 1:5 *chi* to 1:3.89 *chi*, leading Fu to conclude that in Zhongshan during the time of the mausoleum construction, the conversion from *bu* to *chi* was 1:5, in contrast to the ratio from received texts.[29] The use of two units of measurement on the plan is not unique and is, in fact, expected. As the "Record of Inspecting Crafts" ("Kaogongji") section of the *Zhouli* records, different units of measurement should be used for the interior,

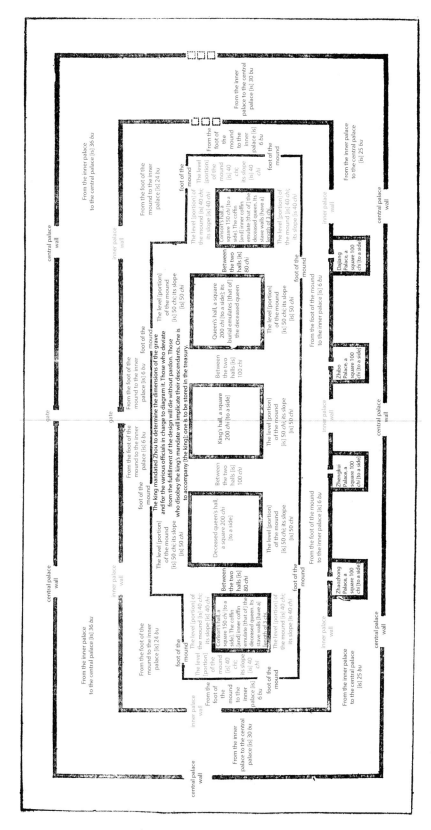

FIGURE 1.6 English translation of inscriptions on the *Mausoleum Diagram*. Diagram by author.

exterior, center, and periphery, and *bu* should be reserved for the peripheral or "untamed" (*ye*) regions.[30] The use of *bu* for distances beyond the burial mound and *chi* for measurements that are closer to the center is thus ritually proper even if somewhat cumbersome for builders who might have to convert *bu* into *chi*.

The issue with the conversion of *bu* and *chi*, however, is not simply a matter of inefficiency. Upon establishing the 1:5 ratio for *bu* to *chi*, Fu sets out to redraw the plan using only *chi*, but his reconstruction and the cast drawing looked different. Fu concludes that this discrepancy might stem from the fact that the bronze plan does not include wall thicknesses, which would alter all of the recorded distances, since thicker walls would enlarge the overall dimensions of the mausoleum site.[31] Without information on wall thickness, there is no way of knowing what the dimensions of the mausoleum were supposed to be. In defense of these missing wall thicknesses, Fu posits a difference between "concrete design" (*jüti sheji*) and "regulated process" (*guigehua de zuofa*) in early Chinese architecture.[32] For the former, certain features of the space were designed from scratch—its proportions, for example—in the hands of the patrons and builders. Other features (palatial walls, for instance) were understood to be possible only in certain standardized dimensions. The bronze plan, in neglecting to include wall thickness, only records architectural features that required "concrete design."

This attention to aspects of the site that are open to change as opposed to standardized practices makes sense in light of the status of the diagram as a plan that was never realized as opposed to a representation of a site that was already complete. Insofar as the mausoleum site was nonexistent when the plate was cast, the cast tomb diagram maintains flexibility by focusing on basic design principles in the proportions of the ceremonial halls, the relative distances between one wall and another, without providing the specific details required for building a site of this magnitude and importance.[33] As Margaret Graves notes, from the fifteenth century on, architectural drawings in the Islamic tradition, which relied on modular systems and not metrology, "permit a flexible application of designs during the actual processes of making, and hint at practices of projection, experimentation, and adaptation that were routinely practiced on site but not necessarily transcribed."[34] I think the same applies in the case of early Chinese building practices as exemplified by the mausoleum diagram: the drawing provides a scaffolding for the basic design of the site while staying silent on shared, common knowledge that is unfortunately lost on modern viewers but would have set basic parameters for the variations and contingencies that inevitably occurred during actual construction.

If the plan yields only measurements that are open to interpretation, then we run into the problem with which I began this section: height. In a royal structure, height probably belonged in the category of "concrete de-

sign," much to the dismay of some classicists. A decision on height based on a patron's ambitions would affect the dimensions of the site and its construction process. Yet there is no mention of height anywhere on the plan unless one chooses to follow the possibility that Fu lays out: that inscriptions on "slope" (*po*) refer to "slope length." As a plan, the bronze drawing can only show a single, flattened layer of the site. The inscriptions on "slope"—if understood as "slope length"—could be the notations that add a third dimension of height to an otherwise two-dimensional plane.

In order to support this interpretation of *po* as its slope length, however, we must follow both of Fu's proposals to their logical conclusions, the first being that the *po* measurement refers to the lateral distance from the "foot of the hill" (*qiuzu*) to the edge of the "level portion of the burial mound" (*qiuping*). This interpretation of *po* would fall in line with the form of the drawing as a plan, but I would argue that this proposal is the more unlikely option. "Slope" is mentioned in conjunction with "the level portion of the mound" in the inscriptions. There are technically two leveled parts of the burial mound—one on top that serves as the foundation for the ceremonial halls, and one down below at the base of the burial mound. Taking into account the inscriptions that record the distance between each ceremonial hall (located at the top of the mound), it seems most likely that the "level portion of the mound" refers to the *top* of the burial mound, where distances between ceremonial halls were taken, as opposed to the base of the mound. I would argue that Fu's second proposal—that *po* refers to slope length—is more likely.[35]

The plan thus provides us with the following measurements for a mound in the shape of a frustum: (potentially) the length of the slope from ground level to the top of the burial mound, the area of the burial mound occupied by the ceremonial halls, and the distances between each ceremonial hall—but still no heights for the mound or the structures. Despite not being recorded, height is a value that can be solved with mathematical algorithms of the time. Slope lengths suffice as useful measurements since slope length is the hypotenuse of a right triangle. With the measurements for the hypotenuse and the length of one side, artisans could solve for the missing height value. Mathematical texts of a later period, such as *Nine Chapters on Mathematical Procedures* (*Jiuzhang suanshu*) (ca. 100 CE) and *Writings on Calculating Numbers* (*Suanshu shu*) (ca. 186 BCE) excavated from Zhangjiashan in modern-day Hubei Province, include these sorts of problems.[36]

With these algorithms, it seems possible that a fuller picture of the mausoleum's dimensions could be derived from the available measurements provided by the diagram. But to even use mathematical formulas requires us to know, for certain, whether *po* refers to the slope or the parts of the frustum's base. Perhaps the exact referent of *po* is another instance of "regulated process." Even so, we find ourselves in a bind since there would still be

important information missing. If *po* refers to slope length (or hypotenuse), then we are missing a measurement for the base of the mound, or the height. If *po* refers to the base of the mound, then we are missing a measurement for the slope length, or the height. Either way, additional measurements are required—not to mention the missing wall thicknesses that would also dramatically change the overall dimensions of the mausoleum. While the archaeology report and some scholars derive a scale ratio (1:500) from the measurements included in the drawing, we must remain wary (like many scholars are) of the accuracy of this ratio since it is based on spotty information.[37] This prolonged discussion of the viability of the measurements thus leaves us with a question: under what circumstances is knowing the length of an incline useful?

Navigating the Graphic Realm

While retaining the formal characteristics of a floor plan, the mausoleum diagram in fact lacks information that would be important for it to function as a building plan. The two-dimensional nature of the diagram in both form and content despite the desire for height in the actual mausoleum site suggests that another aspect to the diagram must adequately reference the magnitude of its owner's self-importance. I would argue that the decision to keep beholders of the diagram on flatland is critical to understanding another one of the diagram's functions. The designers of the mausoleum diagram prioritized the graphic design of the drawing at the expense of the planning function of the diagram. While the latter requires a (present or future) referent in real space, the former rests comfortably in the two-dimensionality of the diagram. Matched with the inscriptions, the diagram keeps visitors' feet firmly planted on the ground as it guides them on a walk across the ritual space of the mausoleum. In other words, the diagram serves a ritual mapping function wherein slope lengths prove indispensable.

Design

The entire diagram was designed to enhance symmetry across a single vertical axis that runs through the center of the king's square. Readers may wish to use figure 1.6 as a guide for the following examples.

As previously mentioned, the tombs of King Cuo and his deceased queen are the only excavated tombs among the five, and the orientation of their tombs show that the top of the bronze plate corresponds to the south. The three center squares are the same size and flanked by two smaller squares. Inscriptions that name the person intended to be buried under the mound and the dimensions of the hall dedicated to him or her are perfectly centered in the middle of each square. Each of the gold-inlaid inscriptions provides

the area dimensions of the ceremonial hall that sat atop the burial mound. The three central squares in the middle with 200 *chi* on each side belong to the king in the center, the deceased queen (*ai hou*) to the left (east), and another queen to the right (west).[38] The presence of the character *ai* suggests that the first queen might have already died by the time the planning for the mausoleum was underway. The two smaller squares on either side of the main trio (also inlaid in gold) belong to the king's consorts. They are slightly staggered below the king's and his queens' squares and are shorter by 50 *chi* on all sides.[39] The first line of the inscription inside the far-right square is no longer visible, but from the size of the square on the plan and the extant parts of the inscription, it is probably very similar, if not identical, to the one on the far left—another instance of mirrored symmetry.

Surrounding the five central squares is a rectangle with its two top (or southwestern and southeastern) corners indented. Inserted in eight locations throughout the indented perimeter are the characters *qiuzu* or "foot of the mound." These two-character inscriptions are placed symmetrically across an invisible central axis that vertically cuts through the center of the king's square, with attention paid to aligning the two characters with the central squares. Six of the *qiuzu* inscriptions are aligned with the corners of the five squares, while two (on the northern perimeter) are situated between two squares. The cutouts from the rectangle perfectly align with the lowered placement of the consort squares.

Framing the "foot of the burial mound" is another rectangle. The inscription "inner palace wall" (*nei gong yuan*) appears in seven places along this rectangular frame. Each inscription, once again, is carefully arranged symmetrically and mirrored across the same central, vertical axis that cuts through the king's square. A single-character "gate" (*min*) appears in the dead center of the inner rectangle's south side, marked by square endpoints that cap both ends of the broken line. The square endpoints likely symbolize "gate" as shown in their reappearances at the centers of four squares evenly distributed along the north side of the "inner palace wall."[40] Each of these squares contains their own inscriptions, which scholars speculate are references to administrative palaces that would have been installed in the complex to handle the various affairs of mausoleum maintenance.[41] The distances between the "foot of the burial mound" and the "inner palace wall" are noted eight times and, once again, evenly distributed and symmetrically placed among the space between the two rectangles. Emanating from the inner palace wall is a full rectangle that serves as the main frame of the diagram and contains the inscription "central palace wall" (*zhong gong yuan*) in seven places. Each of these labels is aligned with the location of the "inner palace wall" inscriptions, and this alignment also applies to the "gate" character that is located just above the gate of the "inner palace wall." As with all distances that appear within the nested rectangles, the distance between

the inner and central palace walls are also recorded in six places, mirrored across the central axis of the diagram.

Ritual Mapping

The redundancy of the inscriptions throughout the diagram was a design decision meant to maintain symmetry and draw the viewer's attention to the vertical axis of symmetry that runs through the king's square. Artisans of the bronze diagram filtered out some information while amplifying other information that accentuates the structure of the drawing. The choice to include certain kinds of information and exclude other kinds of information reveals the aspects of the mausoleum project that the king deemed most amenable to the functions he hoped the document would serve. In its resistance to escaping flatland, the diagram captures a graphic moment that was loaded with promise but that never succeeded to the next moment wherein the plan would have to be built in real space.

To see how the diagram's ritual mapping function is embedded in the flatness of the diagram requires that we examine the drawing differently—as a two-dimensional rendering of a two-dimensional plane. Rather than treating the gold squares and rectangles as marking the perimeters of positive spaces reserved for three-dimensional ceremonial halls or mounds, we can treat them as intervals of different lengths. In this scenario, the gold-inlaid lines mark the intervals of an imaginary rope if it were stretched between two ends of the mausoleum site.[42] Each time the rope reaches a wall or ceremonial hall, different sizes of knots could be made to indicate their relative importance—a smaller knot for the walls, a slightly larger knot for the consort halls, and the biggest knots reserved for the trio comprised of the king's and queens' tombs. Conceived in this way, the diagram becomes a topological drawing of the mausoleum site that records hierarchical relationships. This knotted rope could be metaphorically twisted in all sorts of ways but still maintain the same number of connections (edges) between all the knots (vertices) and their relative sizes.[43]

To see the diagram as topological frees its viewers and its makers from needing the drawing to serve as a two-dimensional rendering tethered to three-dimensional structures and, as Patrick Maynard suggests, "from the pervading conception of drawing as tied to spatial indications in the narrow sense of 3D depth."[44] If each of the squares, lines, and inscriptions are analyzed not for their absolute distances from each other or as references to an imaginary three-dimensional structure but instead as intervals along a continuous horizontal surface, any distortion to the plan (as long as the number of edges and vertices remain the same) still yields a fully functional topological rendering of a ritual site whose main characteristic is its ordering of space according to proper social relations. Indeed, on the diagram all spaces are

designed with ritual propriety in mind, with its allegiance to a vertical axis and symmetrical squares—a metaphorical plumb line that serves as standards of propriety that emanate from the king's square.[45] Ritual, in graphic form, operates diagrammatically and topologically insofar as amplification and filtration are crucial mechanisms in harnessing "inexplicable changes occurring outside the confines of text and ritual" and "converting the incoherence and unintelligibility of the mundane and the merely personal into 'usable' insights of broader relevance."[46] Perhaps, as Xiaolong Wu avers, the most important of these relations is the one between the queens and the consorts, since none of King Cuo's queens had sons, and the inheritor of the crown was to be the son of a consort.[47] In Wu's interpretation, the bronze diagram thus functions as the king's "blueprint for the political power and positions of his consorts and their families" as always below that of the queen, even upon his death.

In death, without the resources to monitor the construction of his mausoleum, maintenance of these ritual relations in his afterlife is perhaps the most King Cuo could hope for. Paired with the gold and silver lines are inscriptions that enhance these ritual relations with the added benefit of predictability and repeatability in his descendants' treatment of the king's legacy in that they trace the movement of visitors as they *walk across* this flattened mausoleum site and encounter the ritual structures that lay ahead. Importantly, the diagram's mapping function here is not in service of a cartographic ambition to transcribe a static world seen from above. Instead, the mausoleum diagram's mapping function might more accurately be termed wayfinding, where "we *know as we go*, from place to place."[48] Quite unlike the plan view that visualizes the site from an aerial view, the inscriptions capture the perspective of the "ordinary practitioners of the city [who] live 'down below.'"[49] According to the diagram's inscriptions and design, a visitor approaches the mausoleum site through the southern gate (*min*) along the central palace walls (*zhong gong yuan*) and, traveling along the central axis, walks 36 *bu* to approach the inner palace walls (*nei gong yuan*). In another 6 *bu*, the visitor encounters the foot of the burial mound (*qiuzu*). Traveling up a slope (*po*) for a distance of 40 *chi*, the visitor reaches the top of the burial mound. Another 40 *chi* takes the visitor across the burial mound (*qiuping*) to King Cuo's ceremonial hall. By turning dimensions of ceremonial halls into travel distances—information necessary for building the site into navigational information for moving across the site—wall thicknesses and heights no longer matter. And, importantly, slope lengths become an indispensable piece of information for the visitor hiking up the burial mound. After all, for the deceased King Cuo, who intended to live in the afterlife with the bronze diagram, the annual rites, sacrifices, and visits from his descendants to the site ensured his prosperity in perpetuity.

No amount of distortion to the drawing or the inscriptions alters this ritual mapping function of the diagram. However, while distortion may be an inconsequential concern for a dead King Cuo in his tomb, it plays an unavoidable role in the production of the mausoleum *tu* since shrinkage in both the clay model and mold is part and parcel of the casting process of any bronze artifact. For the artisans charged with casting the mausoleum *tu*, they had distortion very much on their minds. Along with distortion, other steps and hurdles those artisans took and overcame to navigate the bronze material terrain also affect users' experience of the artifact. The process of casting the bronze mausoleum plaque and the additional function of display that it affords is where we turn next.

Displaying Authority

Excavations in the Valley of the Kings, the Valley of the Queens, and the town of Deir el-Medina have provided Egyptologists a glimpse into the complexities of building royal necropolises from the reigns of Thutmose I (d. ca. 1493 BCE) to Ramesses the XI (d. ca. 1078 BCE).[50] Besides the structures extant today, additional details are gleaned from daily journals, correspondences, account books, and building plans. These documents garner envy from specialists in early China looking to piece together the logistics of building a royal mausoleum beyond what transmitted texts deliver on theoretical terms.[51] The multiple examples of architectural drawings—from sketches on ostraca to elaborate papyrus paintings of tomb sites—indicate that plans were never singular in ancient Egypt but made in sets, and new plans were constantly drawn up to reflect real-time changes on the ground or aspirations that designers and their patrons hoped to make reality.[52] Like these Egyptian documents, a whole host of documents undoubtedly accompanied King Cuo's mausoleum project but were probably drawn on more perishable materials and therefore did not last. We only have access to a single entombed version—a product that values its permanence and opulence in addition to its planning and mapping functions.

Art historians have long been interested in bronze artifacts from King Cuo's tomb, for they model the excellence of Warring States bronze technology. The bronze plate, however, rarely undergoes the same scrutiny for its artisanal achievements, perhaps for fear that it would overshadow the diagram's practical function as a technical drawing. However, a reconstruction of its casting process reveals that its artisans paid plenty of attention to the artifact's appearance. A basic fact about the artifact (although rarely mentioned in scholarship) is that it weighs 32 kilograms. With this heft, it was probably made to remain stationary. Its dimensions are approximately 96 by 48 centimeters, with an uneven thickness ranging anywhere from 0.7 to 1.2 centimeters.[53] As Mo Yang suggests, the impressive 2:1 dimension of

the object might explain why certain lines, specifically the outer rectangles, deviate from the loosely conceived ratio of 1:500 used throughout the plan.[54] More attention was paid to keeping a specific dimension for the plate than a consistent scale for its inscribed contents.[55]

While the previous sections highlighted aspects of the diagram that served planning and mapping functions, this final section turns to the plaque's display function. In the first part, I attempt a reconstruction of the plaque's casting process with the acknowledgment that by the late Warring State period, bronze casting had advanced to such a degree that artisans had at their disposal all sorts of workarounds that were otherwise unavailable to their predecessors and techniques that were never recorded in textual records. Without microscopic investigation, the process of casting cannot be fully specified. Despite these uncertainties, two things are clear: plenty of thought was put into casting the plate, and many of these considerations have very little to do with retaining the connection between the diagram and the physical site in which it was entombed. In the second part, I provide a close analysis of the king's decree cast front and center on the plaque to suggest that the display function of the diagram builds a world in the afterlife that recognizes and sustains King Cuo's living authority.

Production Process

The first step of the diagram's casting process was putting the drawing portion of the diagram in a clay mold. These lines were a necessary first step because they served as a "grid" onto which, as the previous section explained, all the inscriptions could be arranged symmetrically across a vertical axis cut through King Cuo's square. All lines were carved into a clay slab (the model) in intaglio. Once the model dried, it was pressed into another clay slab (the mold). The lines that were initially intaglio (negative) on the model would be in relief (positive) on the mold so that the lines would be cast intaglio (negative) on the final product.

Unlike the rectilinear frames and square boxes (and unique among the bronze inscriptions from the site), the diagram's inscriptions are cast in relief (fig. 1.7). They were probably a third step in the process after the lines had been carved in the model and imprinted into the mold. Beyond this basic order of events, the remainder of the inscription casting process remains murky, taking what I gather to be two possible routes involving either initially putting the characters on the mold or the model, the latter of which I think is more likely. Regardless of the process, the characters eventually must be intaglio and mirror reversed on the mold to appear in relief and correct on the final bronze product.

A first possibility involves directly placing the characters on the mold after the rectangles and squares were transferred. There are two ways of

FIGURE 1.7 Close-up of inscriptions cast in relief on the *Mausoleum Diagram*. Photograph by author. Reproduced by permission from the Hebei Provincial Institute of Cultural Relics and Archaeology.

accomplishing this task, or a combination of the two. The first involves artisans incising mirror-reversed characters directly into the mold using perhaps a draft of the inscriptions provided by scribes. While this process seems tedious, the pervasive repetition in the inscriptions means that artisans would need to master reverse writing for far fewer than the total number of characters. The second possibility involves stamping. Artisans could have made small clay blocks with the positive characters in relief and pressed them into the mold to produce negatives of the characters in intaglio. Making clay stamps would not be difficult because so many of the inscriptions repeat, but, interestingly, if this were indeed the method chosen, it was probably used in tandem with handwritten inscriptions, as exemplified by the *min* (gate) character that appears throughout the diagram (fig. 1.8). A single clay stamp with the character would have sufficed, but the formal variations in each *min* on the cast diagram suggest that either a different stamp was used each time or the character was made by hand, the latter of which seems probable since *min* is a symmetrical character thus relieving artisans of the mirror-reversed work that applies to other characters.

The second possibility explains the different morphologies of the character *min* and significantly reduces the number of steps in the process. It

FIGURE 1.8 Close-up of the character *min* (gate) repeated twice. Photograph by author. Reproduced by permission from the Hebei Provincial Institute of Cultural Relics and Archaeology.

involves putting the characters on the model in relief using the lines of the drawing as a guide. In this scenario, the inscriptions would be written with brush and ink onto the clay model, which contains the "grid" made up of the rectangles and squares. Then, the bronze artisans would remove all of the clay (including the "grid" lines) around the inscriptions so that they appear in relief. The model would then be imprinted into the mold so that the characters become intaglio and mirror reversed. Given the relative simplicity of option two, I am tempted to argue that it is the more likely scenario. However, what might seem like a more efficient way of doing something today may not have been the case for bronze artisans more than two millennia ago.[56] I thus present both options with a preference for the latter, until further microscopic investigations and replication experiments can be conducted.

Once the rectilinear forms and inscriptions were placed into the mold (now the "front" of the plaque with the diagram), the artisan must make the other half of the piece mold that would become the "back." Two zoomorph-and-ring door knockers (*pushou xianhuan*) that face each other are located on the back of bronze plate (seen faintly at the top and bottom of the bronze plate in fig. 1.9).[57] To have the two zoomorphs in relief on the back of the plate means that this piece mold had the zoomorphs imprinted into its surface probably by way of a pattern mold stamped directly into it. Once the two clay halves of the plaque were complete, they were fired to make two

FIGURE 1.9 Back of *Mausoleum Diagram*. Reproduced by permission from the Hebei Provincial Institute of Cultural Relics and Archaeology.

piece-molds between which artisans would have poured molten bronze. As a final step, the intaglio lines and relief inscriptions were inlaid and covered, respectively, in silver or gold.

These working hypotheses on the production of the bronze plaque reveal that the bronze plate functioned as a display object. Four observations on the process outlined above support this conclusion. First, as I mentioned previously, shrinkage is unavoidable because early Chinese bronze casting technology depended on clay. A key step in the piece-mold process is drying, since only when the clay pieces have sufficiently dried can they be pressed into each other and/or detailed lines may be incised. Most importantly, only when clay has dried completely can it be fired. When clay dries, however, it shrinks. To produce an object that maintains a near perfect two-to-one ratio thus requires (presumably tacit) knowledge of the shrinkage rate of the particular kind of clay that is being used to cast the bronze plate. The shrinkage rates of clay molds, however, do not correlate with the lengths, widths, and proportions of incised lines, thus artisans can only rely on practice in hoping that the lines remain in proper ratio across the entire bronze plate.

Material intervention is only a problem for technical drawings that rely on representational accuracy for their functions. If each of the cast designs on the bronze plate is to be precisely scaled to aid in the building of the

mausoleum site, even the slightest variation from a uniform shrinkage rate is problematic for its functionality. A single centimeter of shrinkage either when the clay dries or when the bronze cools results in hundreds of meters of deviation in the dimensions of the site. As a material, bronze is one of the least effective means by which to ensure the consistency of scale in the drawing portion, since part of the project is in the hands of a material process that cannot be fully accounted for. Yet for diagrams like the mausoleum *tu* that depend less on looking like its three-dimensional referent (indeed, no such referent exists) and more on the basic topological connections between each notated form, these distortions do not hinder functionality.

Second, that the rectilinear frames were placed before the inscriptions is an indication of how important the overall composition of the drawing and the location of its inscriptions are to its function. In particular, the locations of the inscription *qiuzu* (foot of the mound) support the premise that the lines were placed on the mold first and then the characters pressed in (fig. 1.10). While transcriptions of the bronze plate often show gaps along the perimeter that leave room for the inscription, this is in fact not the case on the actual plate. On the artifact, the perimeter goes over the inscription, thus visibly marking a midline through each of the two-character inscriptions. Archaeologists who compiled the Zhongshan excavation report cite postproduction as the reason; when the inlay was being applied, artisans cleaned up the intaglio grooves of the lines and, in the process, chipped away parts of the inscriptions.[58] Why did artisans remove parts of the characters after they had been cast? The problem might have arisen when the relief inscriptions on the model were pressed into relief lines on the mold. The parts of the inscriptions that do not cross the lines can produce a clean impression when the model was pushed into the surface of the mold, but unevenness resulted when the inscriptions pushed against the lines. Thus, after the bronze plaque was cast, artisans had to "clean" parts of the inscription that overlapped the lines.

Another interesting moment in the confrontation between the lines and inscriptions occurs in the indented corners of the interior perimeter (see top-left corner of fig. 1.10). Mo Yang insightfully observes that the two indentations were at one point nonexistent since there are traces of intaglio lines that in fact make the rectangle with two missing corners into a full rectangle.[59] She argues that the perimeter was initially cast as a full rectangle, but the plate underwent discussion and revision even after its casting, resulting in the postproduction work of indenting the two corners in order to emphasize the lower status of the two consorts located on both ends of the five-square cluster.[60] While I also observed the shadows of a full rectangle during my time with the artifact and find her argument plausible, the location of the "foot of the mound" inscriptions located in the middle of the indented lines presents a challenge to this interpretation. If the lines were initially cast as

FIGURE 1.10 Close-up of the perimeter line crossing the midline of the characters *qiuzu*. Photograph by author. Reproduced by permission from the Hebei Provincial Institute of Cultural Relics and Archaeology.

full rectangles, then these inscriptions would appear hovering somewhere in the middle of the rectangle without referring to any specific line. The cast inscriptions nested within the indentations also complicate this argument, as the lines in this hypothetical situation would cut across part of the inscriptions detailing the distance from the "inner palace wall" to the "foot of the mound." Perhaps a way to amend Mo's observation would be to suggest the opposite, with the acknowledgment that, again, this alternative can only be verified with microscopic analysis. The indentations were part of the casting of the bronze plate, hence the placement of the inscriptions, but later discussion yielded the suggestion of making the perimeter a full rectangle, thus resulting in the postproduction "trial" of making the *tu* perimeter into a full rectangle. For whatever reason, the trial failed, and they resorted to their original plan of an indented rectangle.

Third, the use of gold and silver inlay bespeaks a technological leap that occurred in Zhongshan workshops and is intimately tied to certain political events during the time of its production that in turn enhance the display

value of the diagram. As Xiaolong Wu points out, gold and silver strand inlay was first used in the fourteenth year on King Cuo's reign, when his days were already numbered.[61] Before the use of gold strand inlay, Zhongshan bronzes were gilded with gold paste. Wu attributes the rise of gold and silver strand inlay, wherein individual strands of gold or silver were pressed into cast grooves, to the influx of migrants from the kingdom of Yan after King Cuo's successful military campaign.[62] These artisans were incorporated into the Zhongshan workshop structure and brought with them new technologies. To use gold and silver inlay, then, is more than simply an additional layer of opulence but rather a display of King Cuo's political power and reach beyond the boundaries of his kingdom alone.[63]

Finally, the two zoomorph-and-ring door knockers located on the back of the bronze plaque support the idea that the diagram was a display item. Zoomorph-and-ring door knockers are, as their name implies, composed of two parts: a zoomorph "mask" with a hole through which a ring is threaded. These door knockers appear throughout King Cuo's tomb complex in all shapes and sizes with varying degrees of artisanal excellence, and most notably, are found in abundance in the *guo* chamber, where the bronze plate was found.[64] Eight were scattered near the center, seemingly marking the four sides of an absent coffin. Another set of twelve were found around the inner set of eight, and a set of ninety-two, much smaller in size, were scattered along the outer perimeter of the chamber.[65] These door knockers were unfortunately removed from their original placement, so a reconstruction of the relationship between them and other artifacts in the main chamber is impossible, not to mention the loss of artifacts after robbery and arson.

It is unclear what function these appendages served on the bronze plaque. One explanation, following Lillian Tseng's analysis of stone-carved door knockers on an Eastern Han (9–220 CE) sarcophagus, might be that when these practical home accessories began to occupy a prominent and visible position on a variety of objects beyond doors, they took on a talismanic function by borrowing the power of the zoomorph to ward off evil spirits that may pay unwelcomed visits to the tomb.[66] Applying Tseng's interpretation to King Cuo's extensive use of door knockers, perhaps they served a symbolic function. When it comes to warding off evil, the more talismans the better, and thus the more zoomorphic masks, the more effective their powers in protecting the dead.

But the fact that the door knockers appear on the back of the bronze plate suggests that there might be a more practical explanation for their existence. Just as door knockers appear on the sides of vessels as handles, perhaps they are handles for whomever moved this hefty bronze artifact or lifted the plate out of a container that has long disintegrated. A similar argument based on practicality has been proposed for the smaller door knockers

FIGURE 1.11 Square wine vessel (*fanghu*) with 450 incised characters, ca. 310 BCE, excavated from Zhongshan tomb 1. Bronze, 63 cm tall, 35 cm at widest diameter. Reproduced by permission from the Hebei Provincial Institute of Cultural Relics and Archaeology.

found on the exterior of coffins, where they would have aided in the lowering of the coffin into the tomb.[67] But this practical explanation contains a logistical problem. If one uses the two door knocker rings, one would have to hold a vertical bronze plate (according to the orientation of the knocker), which must have been physically awkward. One might then assume that two people were required to move the bronze plate, with each person holding one handle, but if that were the case, handles would not be necessary. There is then the possibility, under the rubric of practicality, that the two door knockers were used as stabilizers for a pole of some sort that could be threaded through them in order to display the bronze plate vertically. Or, if the bronze plate were shown laid flat, the pole could secure the plate onto a frame. While plausible, these theories leave open the question of why artisans would use movable rings as stabilizers as opposed to bronze sockets of the sort found in the five *shan*-shaped tridents or the bronze scaffolding for a tent discovered in the king's tomb.

I would suggest that both symbolic and practical reasons, while possible for other places where door knockers are found, do not fully explain the presence of the two found on the bronze plate. I think a possible third option can be found, again, by turning to their casting process. The various loose door knockers that were scattered around the *guo* were cast in large quantities and put to decorative use. The door knockers on the back of the bronze plate, however, were built into the original design of the plate, just like the door knockers that are found on two sides of a square wine vessel (*fanghu*) (fig. 1.11) found in one of the side chambers of the tomb—cast alongside the actual vessel as opposed to attached later. The intentionality with which these door knockers were integrated into the bronze plaque and the clear design of the long inscription on the square wine vessel with the door knocker in mind—making sure, for example, that the zoomorphic mask was clearly demarcated and separated from the space of the text—suggest that the door knockers were ornaments used to designate objects that are intended for display, a meaning or purpose that is only strengthened by their material constitution in bronze and their drawing and inscriptions inlaid in gold and silver.

Kingly Authority

Similarities between the bronze plaque and the square wine vessel go beyond their door knockers and extend to the content of the king's decree on the former and the extensive inscription on the latter even though extant scholarship tends to deal exclusively with one or the other. Differences between the diagram and the longer bronze inscriptions from the tomb are usually drawn based on the inscriptions' forms. The several hundred char-

acters in the three longest bronze-vessel inscriptions, including the square wine vessel, are engraved, whereas the inscriptions on the mausoleum diagram were cast in relief and then covered in gold. The design of characters in the longer bronze inscriptions feature sinewy, elongated strokes of even width throughout, whereas the diagram's characters contain strokes that are also evenly weighted but much stockier.[68] A quick read of the inscriptions also seems to reveal more differences: while the bronze-vessel inscriptions proclaim macrolevel historical, political, and military success, the diagram inscriptions outline seemingly microlevel details of building construction. Yet upon closer reading, the inscriptions possess more similarities than meets the eye. The three bronze-vessel inscriptions and the king's decree inscribed at the center of the mausoleum diagram all describe a relationship between the king and his chancellor. While the longer bronze-vessel inscriptions warn against the chancellor's encroachment on the king's monolithic power, the diagram precludes such a possibility by evoking the ritual power of the king with its use of the character *ming* or mandate.[69] The diagram's main inscription images a concept of kingly authority as a two-part chain of command, beginning with a materialization of the king's oral mandate (*ming*) in a ritually efficacious manner, proceeding to its implementation in the hands of his chancellor, and concluding with the power for exacting punishment for himself.[70] In other words, King Cuo's authority is tied on one end to ritual as expressed by the materiality of the bronze plaque but also tethered on the other end to the budding legal system of the mid–Warring States period, where his spoken commands needed to proliferate to subauthorities through a bureaucratic system helmed by his chancellor.[71]

To see the significance of this bipartite source of power, we can turn to the long bronze inscriptions that outline the dangers in relinquishing too much authority to chancellors. One bronze wine vessel (*hu*) was placed by itself in the east storage chamber apart from the two other vessels that were found in the west storage chamber (fig. 1.12). This physical separation was perhaps due to the nature of its inscription as a dedication to King Cuo by his son Ci, who, in the inscription, eulogizes the benevolence and greatness of his father and describes a hunting ritual that took place during his father's burial proceedings. Curiously, the inscription also exalts the military leadership of his father's chancellor Sima Zhou, who, even more curiously, overshadows the king in the other two vessel inscriptions. The other two inscriptions on a tripod (*ding*) (fig. 1.13) and a square wine vessel (*fanghu*) (previously discussed for its door knocker handles, fig. 1.11) similarly refract the king's authority through his chancellor Sima Zhou. The tripod's 469-character inscription, for instance, extols the merits of Sima Zhou and laments the political turmoil in the kingdom of Yan, where the king, Zi Kuai, abdicated the throne to his chancellor, Zi Zhi, an act that ultimately weakened the kingdom and gave Sima Zhou an opportunity to wage a successful

FIGURE 1.12 Wine vessel (*hu*) with 182 incised characters, ca. 310 BCE, excavated from Zhongshan tomb 1. Bronze, 44.9 cm tall, 14.6 cm diameter at opening, 31.2 cm at widest diameter. Reproduced by permission from the Hebei Provincial Institute of Cultural Relics and Archaeology.

FIGURE 1.13 Tripod (*ding*) with 469 incised characters, ca. 310 BCE, excavated from Zhongshan tomb 1. Bronze, 51.5 cm tall, 42 cm diameter at opening, 65.8 cm at widest diameter. Reproduced by permission from the Hebei Provincial Institute of Cultural Relics and Archaeology.

attack against Yan. The 450-character inscription on the square wine vessel similarly repudiates the change in power between the king of Yan and his chancellor, praises Sima Zhou's successful campaign against Yan, and forewarns King Cuo's successors of the dangers in disrupting proper hierarchy.[72]

The Sima Zhou credited in these long bronze inscriptions is probably the same Zhou who was tasked with establishing the dimensions of the mausoleum as decreed in the diagram inscription. But unlike the bronze-vessel inscriptions, the king and his chancellor do not share agency even on "paper," for the king reserves the ritual authority to mandate (*ming*) action without dealing with the administrative tasks involved in following through, something that is reserved for his chancellor Zhou. This division of labor is similarly evident throughout Warring States legal statutes, which also contain the phrase "X king *ming* Y." For example, the "Statutes on Agriculture" ("Tianlü") (ca. 309 BCE), attributed to King Wu of the Qin kingdom (r. 310–307 BCE) and found on a wooden board buried in tomb 50 at Haojiaping, Sichuan Province, begin as follows:

In the second year [of the reign of King Wu of Qin], on the second day of the eleventh month, which fell on a *jiyou* day (September 27, 309 BCE), the king mandated [*ming*] the Chief Minister Mou and the Scribes of the Capital Area [for Grain] Yanmin and Bi to once again revise the "Statutes on Making Agricultural Fields."[73]

Following the preamble, new dimensions for agricultural fields are laid out in greater detail:

For agricultural fields [of one *mu* area, being] one double-pace wide and eight *ze* long, make lengthwise field paths. For every mu, there are to be two lengthwise field paths and one crosswide road. One hundred *mu* make one *qing*, and [each *qing* is to have] one lengthwise road, and the road is to be three double-paces wide. The feng boundary mound is to be four *chi* high and as thick as its height. The partition [between the feng] is to be one *chi* high and at the bottom two *chi* thick.[74]

This detailed description rehearses measurements involved in the marking of a field: the area of the field and all of the paths and roads that cross it. The dimensions of the partitions, from their base area to their heights, are explicitly stated. With such a statute in hand, a county magistrate and his underlings could visit any farm to ensure that the fields correspond with these numbers.

The kings in the Haojiaping and Zhongshan examples have no stake in the measurements of the fields and mausoleum site respectively. They did not write the statutes, but their presence looms large over their contents. This account of measurements from Haojiaping was proceeded by King Wu mandating (*ming*) his chief minister to perform essentially the same task that King Cuo had given Zhou. The gravitas of their verbal commands is encapsulated in the term *ming*—"one of the core terms of the Classical Chinese ritual vocabulary"—that not only invokes the king's authority at the helm of a chain of command but along with it the king's entire royal lineage, from one ancestor to the next, all the way down to the king whose words are cast in bronze.[75] The character *ming* positions the king's decree at an intersection between ritual and law; the term simultaneously references ritual prescriptions and their later iterations as legal statutes required for their implementation. In his examination of the five E Jun Qi bronze tallies dated to just a decade before the Zhongshan bronze plaque, Lothar von Falkenhausen characterizes their inscriptions as a "code [that] endowed the texts—and, through them, the inscribed objects—with legal validity, but also magical power" in that "the tallies themselves carried transformative, order-generating force."[76] The king's mandate on the bronze plaque similarly

frames the diagram as an image of the king's living authority within a ritual structure in order to perpetuate its "magical power" in the afterlife and to imply an underground royal bureaucracy that is required for propagating the king's mandates.

The E Jun Qi tallies, along with the Haojiaping statute and King Cuo's mausoleum *tu*, emerged at a "historical juncture at which legal forms began to emanate from ritual tradition."[77] Together, they bespeak the importance placed on the materialization of spoken commands in the form of ritual documents for their efficacy and their *replication* so that the king's command could proliferate among subauthorities. The materialization of the king's mandate on the mausoleum diagram is an extension of an infamous incident considered to be an important moment in the birth of written law in China. The anecdote relayed in the *Zuozhuan* (*Chronicles of Zuo*) involves Zican, a minister from the kingdom of Zheng in 536 BCE, who "established an administration that is widely reviled, fixed the three statutes, and cast the penal code" in a bronze vessel, thus spawning heated debates over the moral consequences of doing so.[78] Shuxiang, a statesman from the kingdom of Jin, responded to Zican's actions by lamenting that when "people have learned how to contend over points of law, they will abandon ritual propriety and appeal to what is written."[79] While Shuxiang of Jin purports a strong allegiance to ritual governance over written law, his court successors in Jin did not follow suit. Twenty-three years later, Zhao Yang and Zhonghang Yin of the Jin would cast and propagate their penal code on an iron *ding*, leading Confucius to condemn their actions. "Now that Jin has abandoned these [ritual] standards and made a penal cauldron, the people attend only to the cauldron," Confucius laments; "How are they to respect the exalted and how will the exalted maintain their hereditary duties?"[80]

What was deemed inappropriate about casting legal codes in bronze or iron was not so much the fact that such laws existed but rather that they were put on display and made public. To publicize these laws struck a classicist nerve because it prioritized laws over ritual, thus by extension, words over action, with the former being susceptible to craftiness and manipulation. In contrast, according to Xunzi, proper action follows when one knows one's place, a consequence of his and Confucius's support for a "rectification of names" (*zhengming*), wherein everything and everyone must be named and positioned according to ranks of distinction in order for society to function properly.[81] Xunzi's proposition aligns with the classicist critique of Zican's bold action of casting laws in bronze and making public behaviors that were supposed to be cultivated in every individual through a system of knowing one's place. As the *Analects* recounts, if a father behaves like a father, then his son will behave as a son should. If a king behaves in a kingly manner, then his subjects will behave accordingly.[82] While absent of absolute values, these standards of behavior nonetheless maintain sufficient distinctions between

ranks in which people should hold themselves accountable in order to maintain order.[83] Ritual space, in turn, is *made* according to human behavior. Its contours are delineated by virtue of the patterned relationships between people and therefore cannot and should not be boiled down to mere numbers that become susceptible to quibbles over their accuracy or validity.[84]

Returning to the mausoleum *tu*, we see how the bronze document rests comfortably at the interstices of ritual and law without falling victim to the improprieties attributed to Zican. On the one hand, the mandate on the mausoleum diagram invokes King Cuo's living authority by describing the ritualized order of events that must precede Zhou's establishment of dimensions. The designers of the diagram imaged ritual by means of structuring the drawing and inscriptions topologically without relying on stringent measurements, a more menial task reserved for the king's underlings. In this way, the diagram makes all sorts of spaces—one that details the relative positions of ceremonial halls, another that can be walked across, and yet another that holds its beholders accountable for its promulgation—none of which depend on precision in measurements or accuracy in mimetic representation but nonetheless imply that in the king's world underground, there would be a ritual space fit for a king and an administrative system ready to implement his demands.

Conclusion

By treating its burial context as seriously as all other aspects of the diagram, the formal and inscriptional hindrances to effective planning of the mausoleum project aboveground become loaded with functional possibilities that extend beyond the practical needs of the living. In death the king was incapable of verifying the dimensions of his dream mausoleum, exacting the ruthless punishment he purported to have set in place for any deviation from these standards, and ensuring that his living descendants would properly venerate him at the site. Instead, the best he could do was to bury himself with a diagram that could perform planning, mapping, and display functions in order to make a ritually efficacious world underground—an assurance that nothing will contravene his plans in the afterlife.

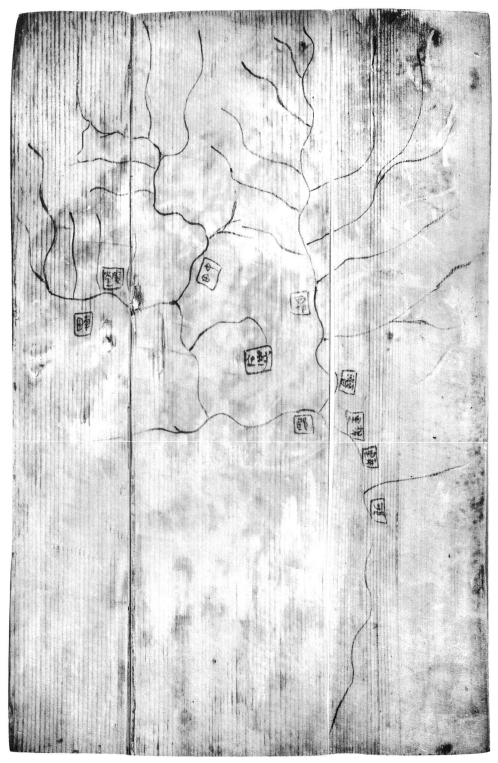

FIGURE 2.1 Infrared photograph of drawing 1A, ca. third century BCE, excavated from Fangmatan tomb 1 in Tianshui, Gansu Province. Ink on wood, board dimensions 26.7 × 18.1 × 1.1 cm. Photograph from *Qin jiandu he ji*, vol. 4, *Fangmatan Qin mu jiandu*, edited by Chen Wei (Wuhan: Wuhan University Press, 2014), 347. Reproduced by permission from the Gansu Jiandu Museum.

Fangmatan and the Bureaucratization of Space

If the bronze mausoleum diagram assuaged the anxieties of a dead king who was accustomed to holding power in the world of the political elite and wished to possess the same authority postmortem, then the terrestrial diagrams at the heart of this chapter speak to much humbler notions of the self and the afterlife as a mere cog in the wheel. The "cog" in this instance is a low-level scribe (*shi*), and the "wheel" the Qin empire. As scholars have pointed out, part of the kingdom of Qin's success in defeating its rivals during the Warring States period relied on its centralized bureaucratic system, whose tentacles reached deep into the hearts of local society. Even a minor administrator stationed in a county far from the capital remained securely linked to the Qin enterprise. From the perspective of the central court, every cog mattered and needed to be accounted for. The terrestrial diagrams found in one such person's tomb showcase their abilities to support these seemingly disparate aims—the self-identification of the deceased in the afterlife and the ambitions of the larger imperial project during his lifetime—and how intertwined their fates seemed to be.[1]

In April 1986 archaeologists discovered seven terrestrial diagrams on four wooden boards (figs. 2.1–2.7) from a vertical shaft tomb (hereafter, tomb 1) at the site of Fangmatan in the modern-day city of Tianshui, Gansu Province, within a cemetery that contained hundreds of tombs strewn across eleven thousand square meters. Fourteen of the tombs, scattered around the central and western parts, have been excavated and mostly (including tomb 1) date between the Warring States period (ca. 475–221 BCE) and the Qin dynasty (221–206 BCE), with one lone Western Han dynasty tomb (206 BCE–9 CE). Tomb 1 measured five meters long, three meters wide, and three meters deep, with a single burial chamber (*guo*) and a sin-

FIGURE 2.2 Infrared photograph of drawing 1B, ca. third century BCE, excavated from Fangmatan tomb 1. Ink on wood, board dimensions 26.7 × 18.1 × 1.1 cm. Photograph from *Qin jiandu he ji*, vol. 4, *Fangmatan Qin mu jiandu*, edited by Chen Wei (Wuhan: Wuhan University Press, 2014), 348. Reproduced by permission from the Gansu Jiandu Museum.

FIGURE 2.3 Infrared photograph of drawing 2, ca. third century BCE, excavated from Fangmatan tomb 1. Ink on wood, board dimensions 26.6 × 15 × 1.1 cm. Photograph from *Qin jiandu he ji*, vol. 4, *Fangmatan Qin mu jiandu*, edited by Chen Wei (Wuhan: Wuhan University Press, 2014), 349. Reproduced by permission from the Gansu Jiandu Museum.

FIGURE 2.5 Infrared photograph of drawing 3B, ca. third century BCE, excavated from Fangmatan tomb 1. Ink on wood, board dimensions 26.5 × 18.1 × 2.1 cm. Photograph from *Qin jiandu he ji*, vol. 4, *Fangmatan Qin mu jiandu*, edited by Chen Wei (Wuhan: Wuhan University Press, 2014), 351. Reproduced by permission from the Gansu Jiandu Museum.

FIGURE 2.4 Infrared photograph of drawing 3A, ca. third century BCE, excavated from Fangmatan tomb 1. Ink on wood, board dimensions 26.5 × 18.1 × 2.1 cm. Photograph from *Qin jiandu he ji*, vol. 4, *Fangmatan Qin mu jiandu*, edited by Chen Wei (Wuhan: Wuhan University Press, 2014), 350. Reproduced by permission from the Gansu Jiandu Museum.

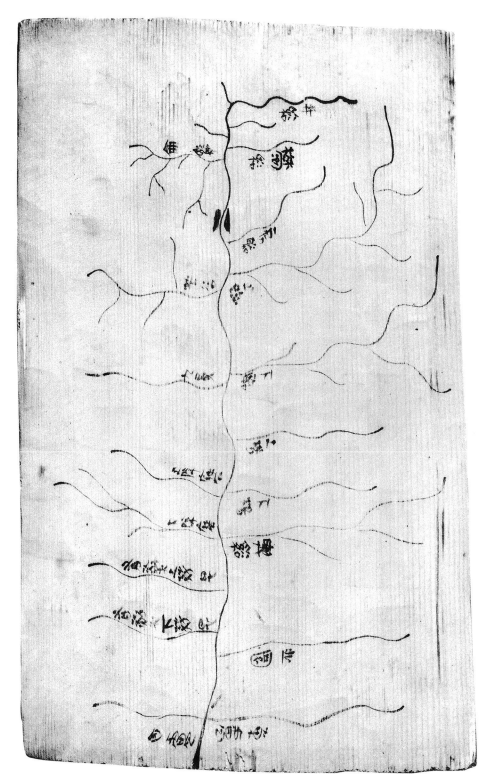

FIGURE 2.6 Infrared photograph of drawing 4A, ca. third century BCE, excavated from Fangmatan tomb 1. Ink on wood, board dimensions 26.8 × 16.9 × 1 cm. Photograph from *Qin jiandu he ji*, vol. 4, *Fangmatan Qin mu jiandu*, edited by Chen Wei (Wuhan: Wuhan University Press, 2014), 352. Reproduced by permission from the Gansu Jiandu Museum.

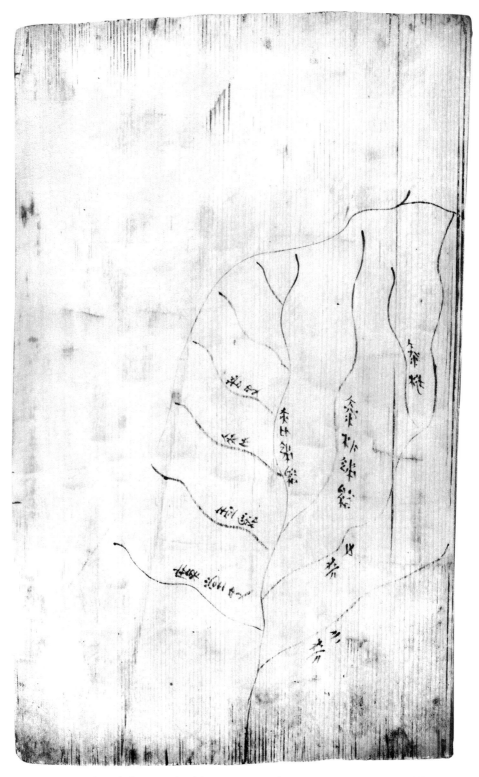

FIGURE 2.7 Infrared photograph of drawing 4B, ca. third century BCE, excavated from Fangmatan tomb 1. Ink on wood, board dimensions 26.8 × 16.9 × 1 cm. Photograph from *Qin jiandu he ji*, vol. 4, *Fangmatan Qin mu jiandu*, edited by Chen Wei (Wuhan: Wuhan University Press, 2014), 353. Reproduced by permission from the Gansu Jiandu Museum.

gle coffin (*guan*).[2] A total of thirty-three artifacts were excavated from the site, including a bamboo mat, counting sticks, a wooden knife, a brush and its holder, and bamboo slips that together form two versions of daybooks (*rishu*), all of which attest to the scribal status of the tomb occupant.[3] With the exception of the brush, bamboo slips, and a wooden board, which were found inside the coffin, all of the other objects were placed around the chamber.

While the terrestrial diagrams found in Fangmatan tomb 1 (like the Zhongshan mausoleum diagram discussed in chap. 1) are unique among early Chinese tombs, the tomb itself—its structure and other burial artifacts—are ordinary when compared with tombs that belonged to Qin scribes of similar social ranking from the Warring States period and the Qin dynasty. These sites include tomb 6 at Longgang and tombs 4 and 11 at Shuihudi, all three of which are in Yunmeng, Hubei Province, and tomb 50 at Haoji-aping, Qinchuan, Sichuan Province, where the "Statutes on Agriculture" discussed in the previous chapter were excavated. These vertical shaft tombs yielded administrative texts of some sort on bamboo slips and/or wooden boards, brushes, counting sticks, brush holders, shaving knives for bamboo slips, and even an ink cake and inkstone in one instance.[4] Recontextualized among its peers, Fangmatan tomb 1 is unremarkable. Yet the ordinariness of the tomb is precisely what makes the uniqueness of the seven terrestrial diagrams valuable in disclosing an alternative way in which a world of a low-level bureaucrat was imaged in the Qin and imagined in the afterlife.

Since their initial discovery, the Fangmatan terrestrial diagrams have been examined in order to determine (1) their maker(s), (2) their referenced geographical location, and (3) their function as a set of entombed objects. Underlying all three lines of inquiry is the basic assumption that these drawings are maps of the sort that administrators would have made as a part of duties that involved taxation, land registration, military strategies, travel, and surveys of natural resources. The Fangmatan drawings do indeed spatialize a particular geographic region around the tomb from which they were excavated (fig. 2.8). While there have been several debates on the exact locations shown in the drawings, recent scholarly opinion has coalesced around the identification of three major river systems that connect six of the seven drawings—Yongchuan River, Dongke River, and Huamiao River—and account for an area of approximately forty kilometers along an east–west axis and fifty kilometers along a north–south axis, centered on the tomb itself. Most scholars also agree that the single drawing found on one of the wooden boards (hereafter drawing 2) serves as a master map by covering regions that the other drawings, divided into two groups, show in detail: drawings 1A, 1B, and 4B can be fitted together since they diagram the Yongchuan River and Dongke River, and drawings 3A and 4A constitute another cluster that focuses on the Huamiao River.[5]

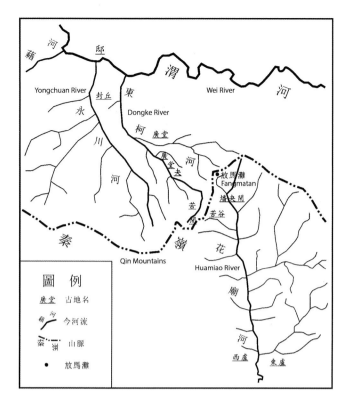

藕
河
河
邸
渭
河
河
Yongchuan River
東
Wei River
封丘
永
Dongke River
柯
廣堂
川
廣堂
河
河
廣堂去
放馬灘
Fangmatan
嶓冢閣
菖
秦
嶺
嶺
菖谷
Qin Mountains
花
Huamiao River
廟
河
西廬
東廬

圖　例

廣堂　古地名

河　今河流

秦　嶺　山脈

●　放馬灘

《放馬灘地圖》今地示意圖

FIGURE 2.8 Modern geography of the area covered by the Fangmatan diagrams. Drawing originally printed in *Qin jiandu he ji*, vol. 4, *Fangmatan Qin mu jiandu*, edited by Chen Wei (Wuhan: Wuhan University Press, 2014), 216. Drawing by Guo Tao, Assistant Professor at Central China Normal University's School of History and Culture. Reproduced by permission from the Center of Bamboo and Silk Manuscripts at Wuhan University.

While it is possible to derive the loose geographical contours of the region depicted, these drawings do not readily satisfy cartographic criteria. For example, semblance to natural topography seems to have been a rather low priority for the *ditu*-maker. A close examination of the drawings reveals that the curves in the brush-and-ink lines do not reference actual river bends. Where one line intersects with another is not measured, and every line is a different width throughout; distances between one line and another also are not uniformly scaled despite the inclusion of distance notations in *li* on some diagrams. The high level of variation in every graphic aspect of the drawings calls into question the usefulness of a strict cartographic framework that depends on mensuration and representation of real space.

To fit uncomfortably in these criteria, however, does not mean that the diagrams are inaccurate or dysfunctional. Rather than analyzing the terrestrial diagrams' formal attributes against a set of normative cartographic standards, this chapter reconstructs how they were designed in the first place to derive three of their functions. First, as I show through comparisons with brush-and-ink documents excavated from tomb 1 and from other tombs belonging to members of the same socioeconomic class in the Qin cultural sphere, these terrestrial diagrams were rendered topologically to serve

the same bureaucratic functions as other administrative documents. They may look like representations of topography, but their lines and inscriptions are loosely tied together to function as model forms (*shi*)—essentially, paperwork—to be filed.[6] A second function of the diagrams is indeed mapping as a mode of referencing topographical elements in real space but done according to a different set of expectations not based on representational accuracy but rather on their relationships to one another that together construct what Yong Jichun terms a "hydrostructure" (*shuixi kuangjia*).[7] Finally, by notating only certain points of the topography that are connected with lines of any shape and length, the terrestrial diagrams might not narrowly represent a preexisting region above ground with cartographic precision, but they make homeomorphic worlds with the use of mere brush-and-ink lines—worlds that are governed by the laws of nature and are meant to be remade upon their burial to ensure that the deceased is met with familiar territories and bureaucratic procedures in the afterlife.

The chapter begins with a close reading of a text from Fangmatan tomb 1 that narrates the story of a resurrected man named Dan. My extensive discussion of the story serves two purposes. First, the story provides a potential date for the tomb and hints at the person(s) responsible for making the funerary goods housed within it. Second, following Donald Harper's observation on the presence of an underground bureaucracy made evident in the text, I argue that the story and the terrestrial diagrams share topological affinities. Using insights gleaned from the comparison, I then analyze the terrestrial diagrams by reconstructing the process by which they were drawn. Finally, I compare the diagrams to two drawings excavated from Fangmatan tomb 14 to show that their multifunctionality was a desirable feature for images buried underground.

Identification

On a flight to Lanzhou, Gansu Province, my neighbor across the aisle asked why I was traveling to the provincial capital all the way from Portland, Oregon. When I explained that my ultimate destination was Fangmatan in the city of Tianshui some 180 miles southeast of Lanzhou, he immediately replied, "You came all this way to see horses?" His response, while offered in jest, speaks to the name and significance of Fangmatan as a historical site and the administrative tasks that befell local officials working in the region during its early history. The site's name is tied to the horse-raising talents of the purported founder of the kingdom of Qin, Qin Ying (d. 858 BCE), who Sima Qian, in the *Shiji* (*Records of the Grand Archivist*), a Western Han dynasty (206 BCE–9 CE) text, recounts as having been granted a plot of land around the Wei River valley by King Xiao of Zhou (r. 891–886 BCE) to put his talents to work.[8]

The upper Wei River valley, where Fangmatan is located, was a prime location not only for raising horses but also for logging as described in the "Treatise on Geography" from the *Hanshu* (*History of the Han*), a text from the Eastern Han dynasty (9–220 CE).[9] Many factors contributed to the kingdom of Qin's success in destroying its rivals and establishing the Qin empire in 221 BCE, and technological innovation engendered by access to natural resources is one of them.[10] The Fangmatan topography described in thirty-six inscriptions related to natural resources on the terrestrial diagrams underscores these advantages, leading Wang Zijin to identify these diagrams as resource maps.[11] Drawings 2, 3A, and 4B contain inscriptions that notate the distribution of timber in the area, such as poplar trees (*yang mu*) and pine trees (*song mu*),[12] the relative sizes of their groves qualified as large (*da*) or small (*xiao*) nestled between waterways,[13] their distances from each other calculated in *li*, and areas where logging took place (*kan*).[14] The site is surrounded by mountains and hills on all sides, with waterways threading in and out, creating pockets of well-irrigated land and waterways by which logs could easily be transported elsewhere.[15] Fangmatan drawings 1B, 2, 3A, and 4A contain evidence of water transportation in the recurrence of a symbol made up of two half-moons on either side of rivers that suggest checkpoints.[16]

The discovery of these terrestrial diagrams that contain vital information on the Qin empire at large in the tomb of a low-level scribe supports another explanation for Qin's success: its bureaucratic system that tied together successively larger communities, from "five-family units,"[17] the village or ward (*li*), then the district (*xiang*), followed by the county (*xian*) at the top of the local administration, which was overseen by a superstructure of thirty-six commanderies (*jun*).[18] This impressive bureaucratic structure mandates a robust collective of administrators in order to make such a system work at every level and strict accountability to ensure that each person is doing precisely what he was tasked to do. A single mistake at any administrative level would only snowball as it was sent farther up the food chain unless there were check points along the way operated by even more low-level scribes and officials. To keep scribes in check and the state machine in commission, Anthony Barbieri and Robin Yates suggest that "the real purpose of the Qin and Han laws was to serve as both the idealized blueprints for the construction of the engine of the state and the instruction manual for officials to operate its intricate and interrelated mechanisms."[19] In modern terms, legal statutes (*lü*) and ordinances (*ling*) that have been excavated from tombs belonging to local scribes detail the inner workings of highly complex legislative law. These statutes and ordinances standardized administrative practices.[20]

The burial items in Fangmatan tomb 1 suggest that its occupant was highly cognizant of the things that identified him in life and their importance in

the afterlife. To understand who the occupant might be, this section examines a short text excavated from the tomb that presents a tentative date for the site and serves as an important counterpart to the terrestrial diagrams in three ways: authorship, structure, and production.

Authorship

Buried alongside the seven terrestrial diagrams on wooden boards were seven bamboo slips measuring 23 centimeters long, 0.6 centimeters wide, and 0.2 centimeters thick that tell the remarkable story of a resurrected man named Dan (fig. 2.9):[21]

> On the *ji si* day of the eighth month of the eighth year, the administrator of Di, Chi, respectfully informs the Royal Scribe: in Daliang, there was a man from Wang Village named Dan. In the seventh year of the current reign,[22] Dan stabbed and injured someone in Yuanli Village, and because of it stabbed himself. [He was] displayed in the market for three days, [then] buried outside the southern gate of Yuanli. Three years [later], Dan was restored to life. Dan was able to be restored to life because "I [Dan][23] was Xi Wu's caretaker." Xi Wu disputed with the keeper of his caretaker's life that [Dan's crime] should not have been matched with death. Because of this, [the keeper] informed the Scribe of the Director of Life Gongsun Qiang, who thereby ordered a white fox to dig a hole for Dan to escape. [Dan] stood on [his] tomb for three days, whereupon he and the Scribe of the Director of Life Gongsun Qiang went north of Zhao to the northern land of Boqiu.[24] A full four years [later], he could hear dogs, wolves, and roosters call and could eat human food. His body had a knot at the throat, sparse, dark eyebrows, [and] four limbs that were unmovable. Dan said, "The dead do not covet more clothes. The dead take white blady grass as valuable. Their ghosts [consider it] to be valuable [because it is] superior to other [offerings]."[25] Dan said, "Those making offerings at ancestral halls must not cry. Cry, the ghosts will depart and respectfully withdraw. Should [one] cry when the ghost receives its offerings, then the ghost will not eat for the rest of its life."[26] Dan said, "Those making offerings at ancestral halls must diligently sweep and cleanse. Do not reuse water to wash the place of offering. Do not pour broth on top [of the sacrificial foods] for ghosts will not eat [it]."[27]

This text is fascinating on multiple levels, not least of which is the fact that it recounts a man coming back from the dead.[28] It is also the only place in the tomb where a date and a name are found, thus potentially revealing crucial information about the tomb and its occupant. Taken at face value, the text binds the tomb objects (such as the story) with a person (the

FIGURE 2.9 *Dan Story*, ca. third century BCE, excavated from Fangmatan tomb 1. Slips read from right to left. Ink on bamboo slips, 23 × 0.6 × 0.2 cm. Reproduced by permission from the Gansu Jiandu Museum.

tomb occupant), bestowing the latter with the role of author, maker, and/or owner. By extension, these objects presumably disclose the identity of the deceased as a literate bureaucrat-turned-convict named Dan.[29] This interpretation treats the resurrection story as a "record of the tomb occupant" (*muzhu ji*). Dan, in the story, is the person buried in the tomb. The person buried in the tomb owns and/or made all of the objects that are buried with him. By the transitive property, Dan, in the story, is the person responsible for drawing the maps, writing the daybooks, and deciding what types of burial objects will accompany him to the afterlife. While neat, to my mind, this chain of associations that begins and ends with the protagonist of the story is speculative at best. There is insufficient evidence to support the hypotheses that the man buried in the tomb is Dan and/or that Dan (or even the deceased) produced the texts and terrestrial diagrams.[30]

The text might not answer the question of who, but it does provide crucial information on when. Even if the date at the beginning of the text does not correlate with the exact year of the deceased's death or burial, it places the tomb in a temporal range, *range* being the operative term since there is no scholarly consensus on the corresponding year of the recorded date: "the eighth month of the eighth year."[31] The main contention is with the reign period that is implied by the "eighth year." Possible dates range from as early as the eighth reign year of King Hui of Qin (317 BCE),[32] to the eighth year of King Zheng of Qin (239 BCE),[33] and even as late as the early Western Han dynasty.[34] Among these various proposals, two, I think, are important to highlight. In Yan Changgui's analysis of the recorded date, he dispels another hardened assumption about the resurrection story, namely, that the place-name *Di* mentioned in the text must be in the kingdom of Qin where Fangmatan was located. According to Yan, there is no reason to believe that the contents of the story must refer to the place where the manuscript was found, since it could have been copied from other texts in circulation or recorded by a third party upon hearing the story being told in the deceased's place of residence.[35] Yan argues that the date and corresponding reign period are from the kingdom of Zhao (recall that Dan and the Scribe of the Director of Life Gongsun Qiang "went north of Zhao"), thus corresponding to the year 291 BCE.[36] Yan's important intervention loosens the ties between the text, the tomb, its artifacts, and the occupant, ties that problematically align the lives of people and things into a single, coherent narrative.

Despite proposing a later time frame, Ebine Ryosuke's tentative date for the manuscript based on paleographic analysis reiterates this point. By highlighting the presence of three characters that only appear after Qin unification but fall out of use by the Western Han, Ebine suggests that the text was copied in the Qin dynasty.[37] In the process, Ebine qualifies his method by noting that to date the manuscript by means of paleographic analysis alone runs the risk of assuming that characters fall out of use completely or

that characters are immediately put to use across an empire instantaneously. Therefore, he only posits a possible temporal range rather than a specific date. Scribes have their own preferences based on the kinds of habits that they retained or characters that they copied from manuals during their training. In copying texts from other places or time periods that conform to orthographies outside of their own, scribes are confronted with the problem of reconciling two possibly divergent orthographies, not to mention the idiosyncrasies of the texts that they are copying, which were also products that came from the hands of scribes who had other types of training encoded into their bodies or standards imprinted in their minds.

Repositioning the resurrection story within a "manuscript matrix" reframes this text as an image of a particular moment in manuscript production that was chosen to be buried in the ground.[38] Like the Zhongshan mausoleum diagram, this manuscript (albeit on more perishable material) is a record of what its owners thought was important at the time and an image of a particular way of seeing and writing in the time in which it was written—a time that I can only comfortably locate somewhere between the late Warring States and the Qin dynasty. The story's complicated recension history, which scholars have long put forth as the dominant interpretation of the multiple hands visibly at work on the two Fangmatan daybooks, permits the presence of an alternative writer/maker of the story and terrestrial diagrams other than Dan and/or the deceased and places the artifacts within broader patterns of production and consumption.[39] In so doing, I think the subject matter of the text suggests that whoever wrote the resurrection story can only be conservatively surmised as a scribe who was well versed in administrative documents and local religious customs.[40]

To argue that a low-level scribe wrote Dan's story does not preclude the possibility that Dan, in fact, was that very individual and/or that Dan is the person buried in the Fangmatan tomb. However, loosening the ties between the protagonist of the story and the role of author and owner constructs a more plausible scenario regarding the circumstances of the story's production and its function. It relinquishes a writer from the responsibility of having to produce an accurate retelling of an individual's experiences and wishes. For our purposes, this argument shifts the locus of meaning away from something inherent in the story that imputes intentionality on the part of its writer(s) and instead turns our attention to the ways in which the text's more general structure and themes might be deemed functional for its dead audience.

Structure

The ingenuity of Dan's story lies less in its content than its structure, which resembles a model form (*shi*), a staple in a bureaucrat's life. The text's literary

form as a "story of the strange" (*zhiguai gushi*) serves as a facade that obscures its comparatively mundane administrative functions that, in turn, make an underground bureaucracy reflected in the one among the living.[41] Indeed, Dan's awesome return from death is only possible under the auspices of an underground bureaucratic system.[42] The bureaucratic form of the text is twofold. The opening to the text frames the entire story as an official account by following the structure of model forms from as early as the Qin dynasty. A collection of such forms was excavated from tomb 11 at Shuihudi, Hubei Province, and has as their most "salient feature . . . [the] use of non-specific dates, names, and locations to serve as placeholders" that would later be replaced by specific dates ("eighth month of the eighth year"), names (Dan, Chi), and locations (Di).[43] Next, readers are introduced to yet another bureaucracy, this time anchored by another scribe—the underground doppelgänger of Chi from Di—who works for Gongsun Qiang, the underground bureaucrat who occupies the position of the Director of Life in charge of the life spans of the living.[44] Just as one appeals to the legal system when there is wrongdoing among the living, when a person is wrongly put to death, his death can also be brought by someone (in this case, Xi Wu) to the legal system of the underworld. The individual treated unfairly in life will at least benefit from fair treatment after death.

While the contents of the story that describe a man coming back from the dead fit neatly within the category of "stories of the strange"—a sensational story meant to entertain and reckon with an unknown world—the resurrection nestled between the two mirrored bureaucracies also speaks directly to the effectiveness of administrative procedures in calming the living's anxiety with ghosts starting in the Warring States period. Unlike the earlier Shang and Zhou religious activity that treated the spirits of the dead as "benevolent supernatural helpers," by the Warring States period the spirits of the dead were considered "potentially harmful spirits."[45] Dan, as a ghost, had to be vetted through a stringent bureaucratic entity so as to ensure that he would not return only to wreak havoc. While entertaining, the story thus also praises the legal system among the living by way of describing its underground twin.

Also buried within the gripping narrative is the possibility of redemption afforded by correcting improper sentencing since Dan was only granted resurrection upon Xi Wu's convincing argument for his caretaker's wrongful death at the hands of the legal system. Stripped of the sensationalist pardon, this act of redemption and reversal of sentencing is in fact reflected in another excavated text, this time from tomb 6 at the site of Longgang in modern-day Yunmeng, Hubei Province. This contemporaneous, late Qin dynasty text brush-and-inked on two sides of a wooden board and found near the waist of the deceased reads as follows:[46]

This is formally inquired: "Bisi should not have been sentenced to the hard labor of wall building. The clerks who made the mistake in his sentence have been punished because of this. In the ninth month, on day *bingshen*, the assistant of Shayi [county] A and clerk C acquitted Bisi, and he became a commoner again."[47]

Not only are Longgang tomb 6 and Fangmatan tomb 1 similarly structured (a single coffin in a vertical shaft tomb) and their burial appurtenances reflective of similar social standings but also their short texts have been subject to similar debates about whether the named protagonist is indeed the entombed individual. While some scholars suggest that Bisi is a personal name and that his exoneration reflects the deceased's actual exoneration of crimes that he committed while alive,[48] it is just as likely that Bisi, which literally translates to "avoiding death," could have been a fictitious name or a generic placeholder much in the way of "the assistant of Shayi A" (*Shayi jia*) and "clerk C" (*shi bing*).[49] According to Guolong Lai, the use of generic terms such as *jia*, *bing*, and even the name Bisi suggests that "the text was probably a fictitious, rather than an actual, legal document of a magico-religious nature." The text could also be a model form of the sort that Anthony Barbieri describes.[50] In either case, this piece of fiction buried in Longgang tomb 6 functions not as a legal document specific to the deceased but rather, much like Dan's story, as a reminder of the possibility of exoneration in the face of wrongful sentencing under the protection of a well-oiled bureaucratic machine.[51] The presence of these texts in Fangmatan tomb 1 and Longgang tomb 6 certainly attest to the status of the deceased as low-ranking bureaucrats insofar as they simultaneously entertain and remind their readers of the responsibilities that came with their living occupation.[52] But perhaps more importantly, they speak to the dual obligations that burden the low-level scribe: on the one hand, the need to adhere to strict bureaucratic procedure to ensure that no one suffers unnecessarily harsh and unfair punishments, and on the other, the precariousness of their own positions as members of the lower rungs of the bureaucratic structure susceptible to punishments according to the legal system in which they operate and which operate on them.

Its bureaucratic form also puts Dan's story in good company with other documents addressed to authorities in the afterlife, notably "relocating to the underworld documents" (*gaodishu*). These burial texts were funerary and not administrative despite their formal resemblance to similar documents produced for the living. However, as Guo Jue argues, their burial contexts do not mean that these documents were false or subpar in their content or production. In fact an emphasis on the funerary context of *gaodishu* shifts the conversation away from questions of true or false, accurate or

inaccurate, to consider the agency of its makers so that "imitating becomes appropriating, and being made-up becomes active making."[53] The individuals in charge of making these burial documents were usually local officials, ritual specialists, and scribes, although these occupations were not mutually exclusive in their assigned tasks. Local officials and scribes needed to know legal statutes that applied to religious activity in order to report them. Similarly, ritual specialists were employed to oversee sacrifices and advise on matters related to the most opportune time to conduct rituals.[54]

If the first two parts of the story divulge the bureaucratic system in which the writer of the Dan story was embedded, the third part reveals the active participation of specialists in the making of ritual, albeit, in the context of the story, a specialist who was once dead himself. Dan prescribes to readers a list of dos and don'ts should they wish to do right by the dead. Dan's new identity as a resurrected man imbues him with the authority to speak on behalf of the dead, thereby inverting the power structure from Dan as a helpless murderer wrongly punished and needing the help of his employer to appeal his case to Dan as a voice of authority.[55] While Dan may or may not have been the name of the individual who physically wrote the story, through Dan the writer gestures toward the efficacy of making writing as a way of making ritual by delivering advice in Dan's voice with his hand.

Production Process

While Dan's story is about the dead and serves the dead, its structure echoes the kind of model forms and legal processes that ran the lives of low-level bureaucrats. The story could have been a copy or excerpt based on official documents used during the tomb occupant's lifetime,[56] like the early Western Han dynasty legal texts from Zhangjiashan in Jiangling, Hubei Province, that were either "produced in a scriptorium as practice texts and later sold as funerary products for burial or were copied in a funerary workshop specifically for inclusion in a burial."[57] The story, in other words, lived a complicated discursive life, functioning for the deceased but retaining a chain of replication rooted in a world of the living.

The "manuscript matrix" in which Dan's story was embedded probably applied to the Fangmatan terrestrial diagrams as well. These drawings could have been copies or revised versions of other diagrams drawn in situ on a survey expedition or drawn from memories of having traveled to these parts or of seeing other diagrams of the region at some earlier point in time. The Fangmatan drawings are pictures that also image long chains of descriptive and depictive practices among the living. What might some of these source documents be? While there is no direct evidence at the Fangmatan site, three wooden tablets (numbered 16–52, 16–12, and 17–14) excavated from Liye and dated between the years 222 and 208 BCE contain lists of distances

between counties (*xian*) measured in *li*.[58] Like the notations of distances in *li* between resources on Fangmatan drawing 2, these distance markers served vital administrative functions. As the compilers of the Liye archaeological report suggest, these distance charts (*licheng biao*) were integral to the postal service of the Qin administrative system. Alongside strict protocols that accompanied the treatment of each document depending on its sender and recipient at the offices,[59] the physical documents had to move from one place to another with the help of postal personnel or "runners"—referred to as *qingzu* in the Shuihudi slips and *youren* or *youlizu* in the Liye slips.[60] These distance charts would be essential in calculating how long it would take for a runner to move mail from one place to another and required knowing the distances between places. The charts were important not just for postal service but also for traveling officials: one Liye wooden tablet records an unfortunate incident wherein a county vice magistrate with the surname Chang was visiting Erchun District, but his local guides, a district official and a scribe, misled him, resulting in a detour of 167 *li*. Chang fined the district official and scribe three armors each for the misdirection.[61] Chang probably noticed that he was misled on an "uncharted route" (implicit in the fact that he needed local officials to help him) because he could "[multiply] travel time by applied speed standards" to calculate distance, a method that Maxim Korolkov further speculates was how the distances on the distance charts were also calculated.[62]

These distance charts, like all documents that pass through the hands of county or commandery offices, stand as one link among a long chain of copying, revising, and recopying. Documents were sent from each level of administration by way of a strict forwarding system. For instance, documents at the village level had to be copied and approved at the county offices. One copy would stay with the county office, and the original, along with the letter of approval, would then be forwarded to the commandery office.[63] This administrative process of duplication applies to all documents that must eventually be forwarded from lower administrative levels to the central government, and, along with it, the process of compression. As Tsang Wing Ma's research shows, an account book compiled at the county level may contain details such as household registries, land registries, and agricultural registries, but by the time it reaches the commandery, these minutiae are summarized into "aggregated account-books" that provide a bigger picture than what these individual registries provided.[64]

Like Dan's story, the seven terrestrial diagrams buried underground are conceivable as copies or summaries of these other administrative documents in circulation. As copies, they might look the same as their source materials, but they could have been copied to serve a different function, especially if they were ultimately buried in tombs.[65] And, as summaries, these manuscripts forsake representational accuracy to make room for contingencies.

In Relief

Dan's story is a work of fiction that tracks the inner workings of a functional bureaucratic system in life and the afterlife. Written by a scribe sufficiently versed in religious customs and administrative procedure and their forms of address—a date, a place, a name to be held accountable for the report—the short text transforms the underground world into a space governed by a top-down power structure in which every individual, regardless of their rank, is registered and responsible for discrete tasks. With this bureaucratic structure set in place, the details of the story become open to all sorts of literary embellishment, such as Dan's resurrection, his reacquisition of human senses, and his physical appearance. The amplification of these details lends the report an air of representational accuracy, as if someone witnessed these events. However, the lack of a transition from Dan's demeanor in the middle of the story to his previous experiences as a ghost in the last part leaves a gaping hole, a filtering out of details for the sake of expeditiously moving from point A (Dan's resurrection) to point B (ritual prescription). Read in this way, the discreteness of each section in Dan's story becomes a topological retelling of a tale aimed at a dead readership rather than a first-hand witness report of a miraculous event. The dead, at least in the mind of the writer, only hopes to know that he will be recognized for his occupation and treated properly by his living relatives. All other details are nice to have but unnecessary for the story to function.

A bureaucratic framework derived from Dan's story recontextualizes the terrestrial diagrams among other images produced in their time, thereby tempering the uniqueness of the terrestrial diagrams among modern excavations. Much like Dan's story, the terrestrial diagrams only provide an adequate summary of the lay of the land.[66] Accordingly, these images, unlike normative maps, do not depend on representational accuracy to the geography of the region in order to function.[67] Instead, by making topological drawings of his administrative region, the *ditu*-maker captured the meaningful positions and relationships between geographic features to make diagrams that for the living image the basic laws of nature as opposed to details of topographic features, and that for the dead image his home and occupation as dual forms of identification and protection.

The producer of these lines was trained to write, paint, and map with the same basic materials of brush and ink on wooden boards and bamboo slips.[68] This seemingly minor observation has resounding implications for how we think about the production of diagrams. It means that whoever made diagrams did not necessarily have the sole intention of representing space in mind but rather understood his act of making marks with brush and ink as shared among all of the possible ways of rendering forms on a two-dimensional surface.[69] In the disregard to hide his hand, we see that

the *ditu*-maker produced drawings that require attention paid to the *act* of drawing in order to decipher the multiplicity of its referents. And, most surprisingly of all, it was precisely his graphic practice—staunchly two dimensional—that *made* a three-dimensional world, one that manifested the laws of earthly physics. The following section will proceed by first describing how the drawings were made and its implication for the orientation of the boards. Building on the process of diagramming, I show that while the brush-and-ink lines do not cohere into a scaled representation of real space, they nonetheless build a functional, three-dimensional world on the wooden boards.

Orientation

For over three decades, scholars have debated the relationship between six of the seven drawings, noting that similarities in their linear compositions and shared textual labels must imply that they fit together in some way.[70] While early studies of the drawings focused on piecing the drawings into a single master diagram, Fujita Katsuhisa's observation—that the drawings are on both sides of the wooden boards—marked a major turning point in scholarly approaches to the drawings.[71] If they cannot be visible at the same time, then the drawings must not cohere into a single diagram. Instead, the drawings can be grouped into clusters that show parts of three major rivers. Drawings 1A, 2A, and 4B show in varying details the Dongke and Yongchuan River systems that run to the northeast of Fangmatan, whereas drawings 3A and 4A focus on the Huamiao River system south of Fangmatan. The Qin Mountains (*Qinling*) that appear on drawings 2, 3A, and 4B are the drainage divide that separates the Dongke and Yongchuan watersheds in the north from the Huamiao watershed in the south (see fig. 2.8).[72]

In addition to noting that the drawings do not come together as a single diagram, Fujita observes that all the inscriptions on the drawings are written in the direction of the river flows so that to read them, one rotates the boards.[73] Taking Fujita's observation one step further, Qu Kale notes that in all the drawings, the maker "[used] the river source as the top of the map. This matches the continuity of brush lines from their beginnings to their ends, thus we can surmise that the beginning of the brushstroke is the top of each map."[74] The directions of the brushstroke can be deduced by noticing how the line begins thicker where the brush is first laid down, its ink lighter as it is dragged across the wooden surface, until it terminates in a thinner point than its origin. Fujita and Qu's observations hold significant consequences for the relationship between cardinal directions and the orientation of the boards, for the "top" of the board does not correlate with the same cardinal direction across the drawings. They change depending on the orientation of the board as the *ditu*-maker was drawing (figs. 2.10–2.15).

Drawing 1B includes the only evidence of cardinal directions among the seven drawings—the characters "north" or *beifang* appear on the bottom (fig. 2.11).[75] That "north" is positioned at the bottom of the board is attested by the northbound trajectory (and corresponding brushstroke) of Dongke River marked in red in figure 2.10. Equipped with this orientation, drawing 1A can be similarly oriented with south on top. The correspondence between drawings 1A and 1B is also evinced by their similar morphology and two shared labels (shown in brown in figs. 2.10 and 2.11)—*zhongtian* and *guangtang*—which are written along two perpendicular, curvilinear lines that appear on both drawings, one of which is Dongke River (shown in red in figs. 2.10 and 2.11) and the other an unnamed tributary (show in green). While absent in drawing 1B, drawing 1A also includes Yongchuan River (indicated in purple in fig. 2.10), identified as such by the five tributaries on one of its sides that resemble the river in modern geography.[76] Yongchuan River also flows north, thus reaffirming that the top of the drawing 1A is south. The clear relationships between drawings 1A and 1B, however, are not shared with drawing 4B, whose main river (shown in purple in fig. 2.15) remains disputed as either a detail of Yongchuan River[77] or a detail of a tributary near the label *guangtang* in drawings 1A and 1B, since a label with the characters *guangtang* (in brown) also appears in drawing 4B.[78] In either scenario, however, drawing 4B remains firmly within this first group of diagrams.

Shared textual labels on both sides of Huamiao River also signal a correspondence between drawings 3A (fig. 2.13) and 4A (fig. 2.14). The additional labels that appear on drawing 3A that are absent in drawing 4A suggest that the former is an image with finer resolution than the latter.[79] While neither drawing includes a definitive orientation, drawing 4A contains two labels, *xilu* and *donglu* (in purple near the bottom of fig. 2.14), that include the directions west (*xi*) and east (*dong*) respectively. They appear on either side of the river, thus providing cardinal directions for both drawings. The Huamiao River line on drawing 4A is in an L shape that was drawn in one continuous stroke, with the brush first laid down with the board oriented with east on top and then turned ninety degrees clockwise so that the *ditu*-maker could continue the line down the middle of the board as the backbone of the river system. Knowing the orientation of drawing 4A solves the orientation of drawing 3A. The top of the board in both drawings primarily corresponds with north.

Applying the correspondence between the direction of the main brushstroke and the top of the board, drawings 1A and 1B can be oriented with south on top, while drawings 3A and 4A are mostly positioned with north on top. Drawing 2 (fig. 2.12), however, disrupts this consistency of a single cardinal direction matched with a single orientation of the board. Its two most prominent lines (Yongchuan River in purple and Huamiao River in light blue in fig. 2.12) are painted in opposite directions, so there are in fact

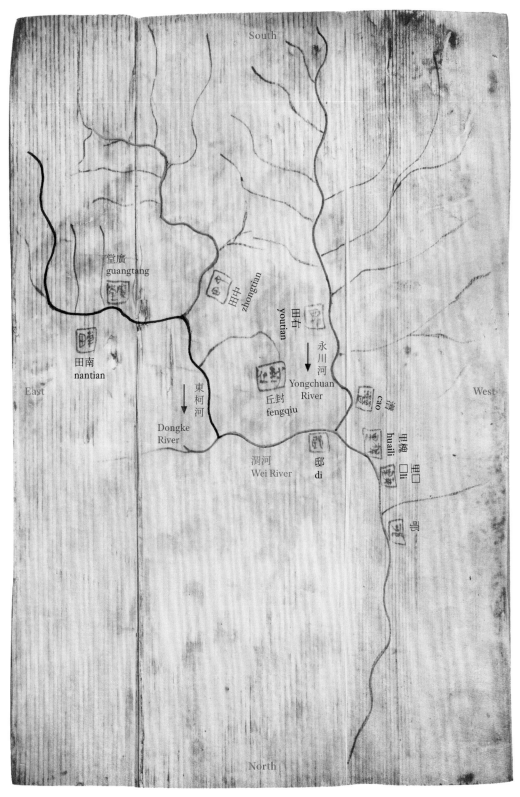

South

堂廣
guangtang

田中
zhongtian

田右
youtian

永川河
Yongchuan
River

田南
nantian

東柯河
Dongke
River

丘封
fengqiu

曹
cao

里槐
huaili

濬

里□
lii

邸
di

渭河
Wei River

East

West

鄂

North

FIGURE 2.10 Infrared photograph of drawing 1A with author's color coding and transcriptions from *Qin jiandu he ji*, vol. 4, *Fangmatan Qin mu jiandu*, edited by Chen Wei (Wuhan: Wuhan University Press, 2014), 216–17. Arrows indicate direction of brushstroke.

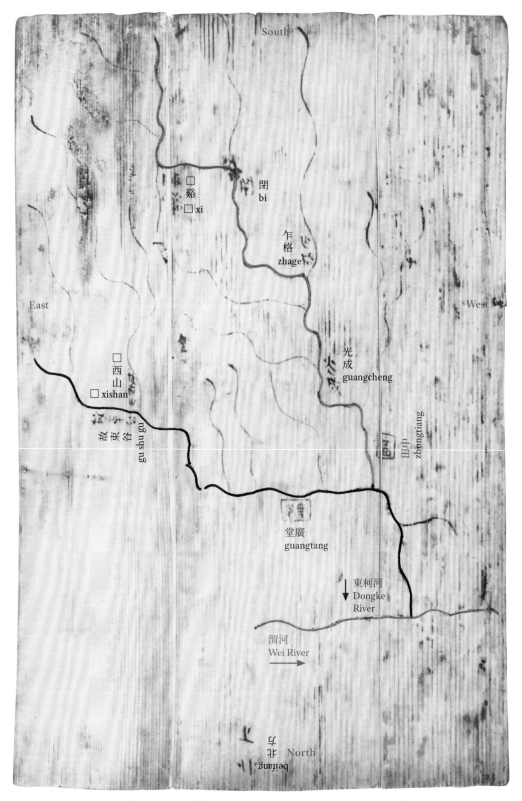

FIGURE 2.11 Infrared photograph of drawing 1B with author's color coding and transcriptions from *Qin jiandu he ji*, vol. 4, *Fangmatan Qin mu jiandu*, edited by Chen Wei (Wuhan: Wuhan University Press, 2014), 216–17. Arrows indicate direction of brushstroke.

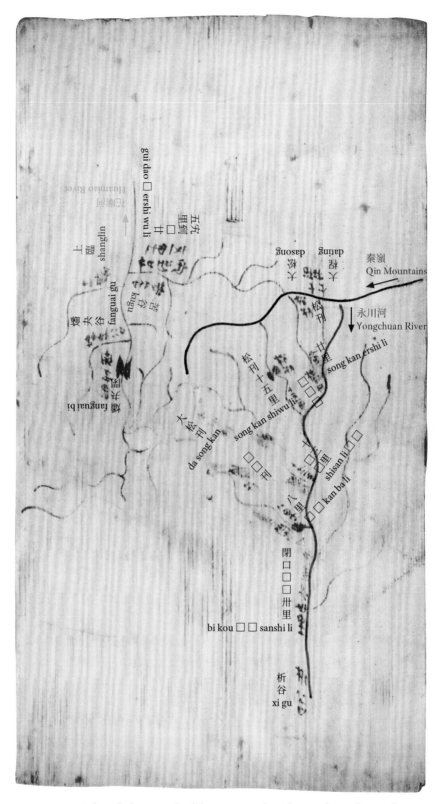

FIGURE 2.12 Infrared photograph of drawing 2 with author's color coding and transcriptions from *Qin jiandu he ji*, vol. 4, *Fangmatan Qin mu jiandu*, edited by Chen Wei (Wuhan: Wuhan University Press, 2014), 216–17. Arrows indicate direction of brushstroke.

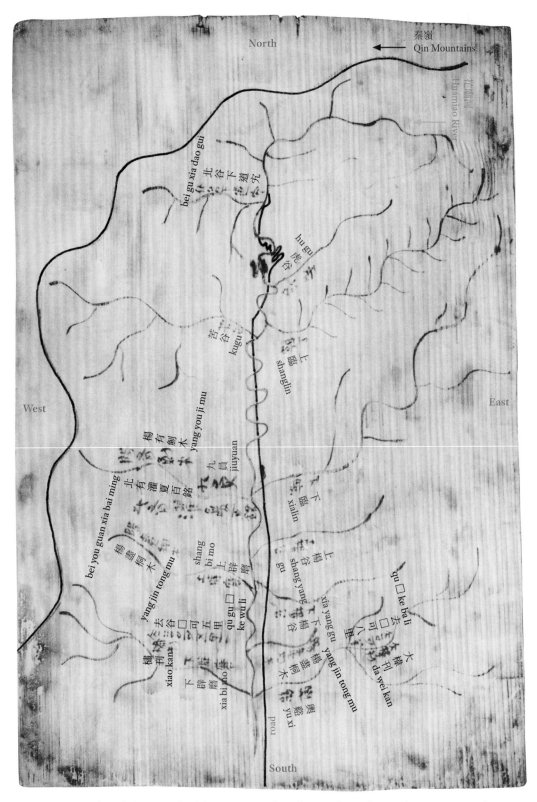

North

秦嶺
Qin Mountains

花頭河
Huamiao River

West

East

South

bei gu xia dao gui 北谷下渣宄

hu gu 隍谷

kugu 苦谷

shanglin 上臨

yang you ji mu 楊有劑木

jiuyuan 九員

bei you guan xia bai ming 北有灌夏百銘

yang jin tong mu 楊盡桐木

shang bi mo 上辟磨

xialin 下臨

shang yang gu 上楊谷

qu gu □ ke wu li 去谷□可五里

qu □ ke ba li 去□可八里

xiao kan 小刊

xia bi mo 下辟磨

xia yang gu yang jin tong mu 下楊谷楊盡桐木

da wei kan 大椲刊

yu xi 輿黎

road

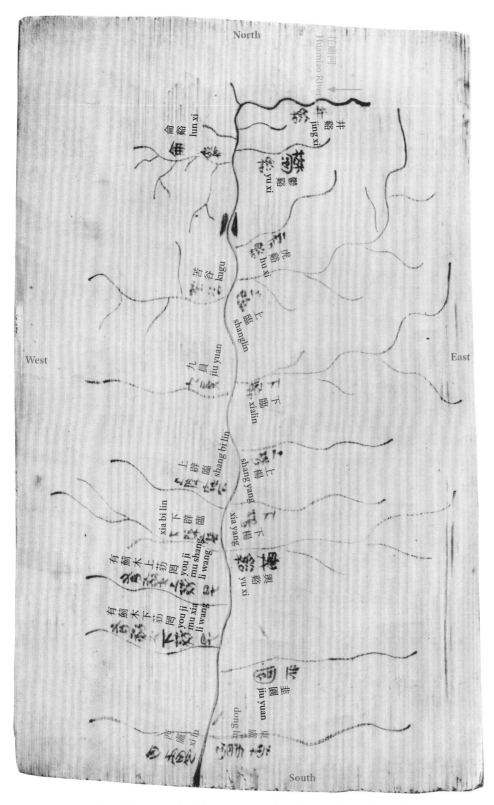

FIGURE 2.14 Infrared photograph of drawing 4A with author's color coding and transcriptions from *Qin jiandu he ji*, vol. 4, *Fangmatan Qin mu jiandu*, edited by Chen Wei (Wuhan: Wuhan University Press, 2014), 216–17. Arrows indicate direction of brushstroke.

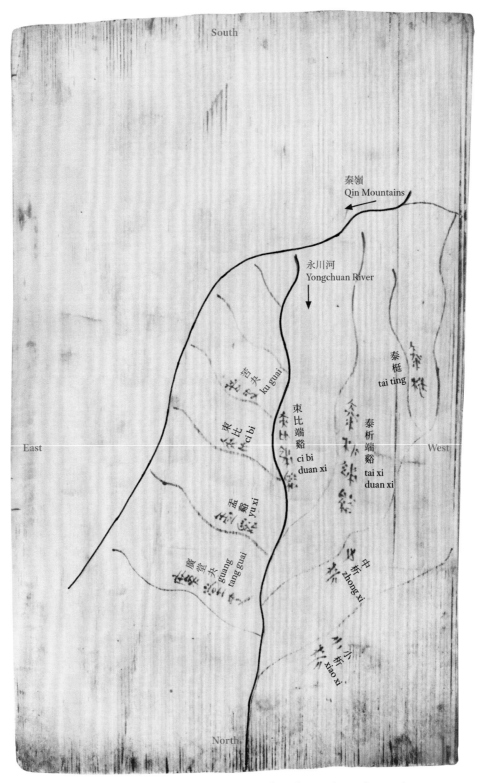

South

泰嶺
Qin Mountains

永川河
Yongchuan River

泰梃
tai ting

苦乖 ku guai

束比 ci bi

束比端谿
ci bi
duan xi

泰析端谿
tai xi
duan xi

East West

盂谿 yu xi

中析 zhong xi

廣堂乖 guang tang guai

小析 xiao xi

North

FIGURE 2.15 Infrared photograph of drawing 4B with author's color coding and transcriptions from *Qin jiandu he ji*, vol. 4, *Fangmatan Qin mu jiandu*, edited by Chen Wei (Wuhan: Wuhan University Press, 2014), 216–17. Arrows indicate direction of brushstroke.

two tops to the board. To read the inscriptions, one also needs to rotate the board 180 degrees to read the labels held together by the two major rivers. The northbound trajectory of Yongchuan River appears once again in the direction of the brushstroke that moves from top to bottom, with top corresponding to south. The Qin Mountains mark the source of the various Yongchuan tributaries, only this time, they also serve as a physical marker of the *ditu*-maker's turn of the board 180 degrees in order to render Hua-miao River, identified as such for its two labels *kugu* and *shanglin* that appear on drawings 3A and 4A and the pass (*bi*) rendered in the symbol of two half-moon shapes mirrored across the river. This turn of the board to draw Huamiao River correlates with the direction of its southbound flow, in the opposite direction of Dongke and Yongchuan Rivers and on the other side of the Qin Mountains. Drawing 2 had two tops when it was being drawn, thus its north and south are interchangeable for its users.

A combination of Fujita and Qu's hypotheses—that the direction of the brushstroke is equivalent to the direction of the river and the top of the board—is a modern testament to the need for prioritizing the drawings' processes of production as opposed to their representations of an external, *static* topography. In following their drawing processes, it becomes clear that the *ditu*-maker had in mind rivers in *motion* from higher to lower altitude and sought to trace their movement rather than their forms.

Take drawing 4B (fig. 2.15) as an example. Regardless of its identification as Yongchuan River or a tributary that feeds into Dongke River, the direction of the main line in drawing 4B corresponds with both rivers in drawing 1A, where the two main lines are also rendered from top to bottom, matching their northbound river flow that feeds into Wei River (in blue in fig. 2.11). Wei River's westbound trajectory is also notated by the direction of the brushstroke in drawings 1A and 1B. This river in drawing 4B, marked in purple (fig. 2.15), was drawn with south on top. The curvilinear line that frames the river system (in brown in fig. 2.15) references a mountain range, where shorter tributaries originate. This linear composition produces a form that is the *opposite* of how rivers actually look. On the drawings, the starting points of the brushstrokes are always thicker than their endpoints, yet in nature, as waterways maneuver through uneven terrain, from higher to lower altitudes, river sources are always narrower than river mouths, the former beginning in the mountains as streams, and the latter ending in a larger body of water. On the drawings, river flow is notated by comparing the sizes of start and endpoints of a line segment rather than matching the morphology of the lines to an actual river. In fact, the lines can wiggle any which way between their start and endpoints without affecting the notational value of the lines. Put simply, the *ditu*-maker was recording his movement in drawing the lines and, by extension, the directions of the river flows, not the forms of the rivers.

To establish an equivalence between directions of brushstrokes and river flows is tantamount to the replacement of a symbolic system or map scale with another system, now dependent on the movement of the brush. This revised rubric, like standardized symbols or projection system, must in turn apply to every line in the drawings: the direction of flow for every waterway must correspond to the direction in which the lines were rendered. The main rivers were often drawn according to this system, but the smaller tributaries that fill the spaces between their sources reveal the system's fault lines. Most of the shorter lines were not painted with the intention of capturing topographic reality (every line must be analogous to the shape of the tributary in real space) or even necessarily following the movement of their water flow (every brushstroke must follow the direction of the water flow) but were instead drawn with an eye to efficiency. Brushstrokes were always drawn from top to bottom, never sideways or bottom to top. This means that all of the strokes (including the inscriptions) that required one orientation of the board were all done at once, and then the board was turned to paint another set of strokes. What these smaller lines depict, then, is the *ditu*-maker's *practice* on a graphic plane rather than an external referent in three-dimensional space, and what they notate are the internal relationships between one line and another. Topographical accuracy to the region around the three main rivers is of much less concern for the *ditu*-maker than a topological structure indigenous to the wooden boards.

For evidence of this efficient practice of turning the boards to provide ease in painting, we can return to the longest, continuous line on drawing 1B (see green line in fig. 2.11 and corresponding line in fig. 2.2). According to the orientation of drawing 1B, this tributary should travel north. Yet a careful look at how the line was drawn indicates that the "top" of the board changed at every right-angle pivot of the line, as evidenced by thickened curves and disjunctures at each of the right angles (fig. 2.16). A barely visible disconnection between two lines of an angle also appears in the Dongke River line (see red line in fig. 2.11 and corresponding line in fig. 2.2) in drawing 1B, whereby a long line that extends into the far east and terminates at the Wei River in the north looks from afar as though it were continuous but is in fact composed of three individual segments, each rendered with a different orientation of the board, with west or south on top.

That the *ditu*-maker consistently drew lines from top to bottom is also clearly shown in drawings 3A (fig. 2.17) and 4A (fig. 2.18). In both drawings, all of the lines that are on one side of the Huamiao River are painted in the same direction, always from top to bottom, with either east or west positioned at the top. Their accompanying inscriptions, as Fujita points out, are also written vertically in the direction of the brushstroke; to read the writing requires turning the board. For our purposes, it is important to note that the only places where the board was oriented with north or south on

FIGURE 2.16 Photograph of drawing 1B. Photograph by author. Reproduced by permission from the Gansu Jiandu Museum.

top appear in the very short lines that stem from two tributaries located on the northern end of drawing 4A with the labels *kugu* and *lunxi* (on the top left of fig. 2.18). The lines attached to the *lunxi* tributary were drawn with south on top, and the lines attached to the *kugu* tributary (regardless of which side of the tributary) are rendered with north on top. That these brushstrokes—shorter in length than the others and unlabeled—are drawn with different orientations of the board seems rather inconsequential. But, in fact, their implications are quite impressive because what they reference, by laying bare the origins and trajectories of their brushstrokes, is the varying elevation of the natural topography, the topic of the next subsection. If the origin point of every brushstroke references the source of the waterways and every brushstroke always moves from top (whichever side that might

FIGURE 2.17 Photograph of drawing 3A, ca. third century BCE, excavated from Fangmatan tomb 1. Ink on wood, board dimensions 26.5 × 18.1 × 2.1 cm. Reproduced by permission from the Gansu Jiandu Museum.

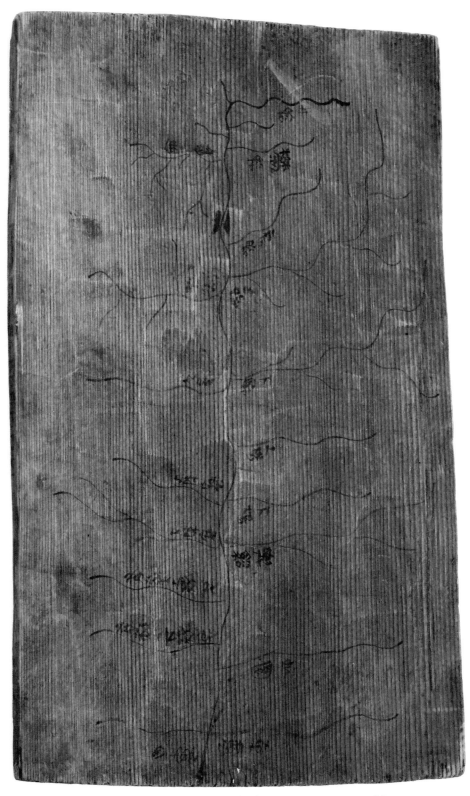

FIGURE 2.18 Photograph of drawing 4A, ca. third century BCE, excavated from Fangmatan tomb 1. The characters *lunxi* and *kugu* are the top two inscriptions on the left. Ink on wood, board dimensions 26.8 × 16.9 × 1 cm. Reproduced by permission from the Gansu Jiandu Museum.

be) to bottom, then every turn of the wooden board effectively references a change in altitude. The Fangmatan *ditu*-maker managed to escape the two-dimensionality of his working surface without textual labels, contour lines, or linear perspective. He built a three-dimensional world with a brushstroke and a turn of the wooden board.

Making Space

To posit a set of cartographic standards based on representational accuracy as standards by which to distinguish successful terrestrial diagrams from inaccurate ones is to preemptively set up the Fangmatan drawings as a case of the latter. Cardinal directions and distances were certainly among the *ditu*-maker's considerations, as seen through the inclusion of "north" on drawing 1B and distances measured in *li* on drawings 2 and 3A, but the directions and their correlation to the orientation of the boards are inconsistent across the drawings, and distance markers have thus far yielded no consistent map scale that systematically applies to the drawings.[80] Moreover, for scholars who have meticulously reconstructed the geography referenced by these diagrams—scholarship to which the preceding analysis is deeply indebted—the lack of these cartographic principles means that these two-dimensional diagrams are imprecise in a specific way. As Can Wanru points out, a characteristic of early Chinese mapmaking, and a flaw when measured against cartographic standards, is its disregard for Earth's curvature.[81] Early Chinese mapmaking depended on scale, direction, and distance without projection, a necessary step in flattening the three-dimensionality of Earth onto the two-dimensional surface of a map. Pei Xiu's contributions to early mapmaking, such as leveling (or lowering) of heights (*gaoxia*), diagonal distance (*fangxie*), and straight-end curves (*yuzhi*), attend to changes in elevation so that they can be translated into scaled drawings, but they nonetheless do not account for Earth's curvature.[82] Equipped with only scale, direction, and distance, terrestrial diagrams such as the Fangmatan drawings seem to only function as maps in the same way as King Cuo's mausoleum *tu*: by recording the distances that visitors to the site would have to traverse, the directions that they would travel, and the landmarks that they might encounter along the way. Topography, in these graphic instances, seems only to be represented as horizontal expanse, from the perspective of a traveler walking across a flat plane.

Ingeniously, and unlike the designers of King Cuo's mausoleum diagram, while the Fangmatan *ditu*-maker does not use a projection system to flatten the three-dimensional topography of the terrain on a two-dimensional surface, he nevertheless accomplishes the opposite. He makes a third dimension within the two-dimensional confines of the wooden boards with only a brush and ink by leaving behind the evidence of his painting process

and, by extension, the directions of river flows. In so doing, he references the relative positions of waterways within a river system and topographic undulations, for water, again, always flows from higher to lower altitude. While a lack of precision and representational accuracy detracts from the normative mapping function of the drawings, it makes room for another form of ingenuity that allowed the *ditu*-maker and his audience to escape flatland by making a world of their own through the laws of nature.

While the curvatures in the lines do not depict specific features of the rivers and their tributaries in the natural topography, they denote the basic logic of waterways—there is always one major river into which smaller tributaries feed, and waterways always travel from higher to lower altitude. The major rivers—Dongke, Yongchuan, and Huamiao—act as metaphorical gridlines—a "hydrostructure"—that divide each side of the wooden boards into sections. In making visible the process of rendering each of them, the *ditu*-maker, in turn, built elevation into the sections—where each of these longer lines begins is higher than where it ends.

Placed between these longer lines are shorter lines that also reference the direction of their flows. But the exact tributary in the region or the location of its confluence with its main stem are ultimately of little consequence to the functions of the drawing. The drawings might not pinpoint their precise locations, but they certainly tell their viewers that such confluences exist. And in retaining the direction of their water flow, they reference topographical undulations because water always flows from higher to lower altitudes. In other words, rather than being topographical in their referring to a space external to themselves, these drawings are topological in that their linear organizations are based entirely in the relationality of the lines as they cluster around main stems and the orientations of the board with which the lines were drawn. The main rivers are like the nested bureaucratic structure of the Dan story, while these shorter tributaries are the sensational details. Without the former, the latter would be sheer fantasy with no references to the world of the living. Without the latter, the former would simply be another model form waiting to be filled during a day at work.

Curvy lines not only reference waterways but also mountain ranges. As mountain ranges, these lines similarly depend less on accurately depicting the shapes of mountains for their function. Instead, these mountain ranges were drawn as a graphic frame for the compositions. The direction of their brushstrokes tells viewers nothing of their altitude. Their morphology does not accurately depict the rise and fall of their ridges. Mountain-range lines only symbolize by virtue of being a long continuous line without smaller segments that stem from them and their relationship to the more elaborate linear configurations that they frame. Their function is dependent on their relationships with other lines in the drawings rather than an external topographic referent.

The use of a mountain-range line as a framing device appears in drawings 2, 3A, and 4B (see figs. 2.13 and 2.15), wherein the lines hug the contours of the river systems. The direction of the mountain brushstroke in drawing 4B, which required the board to be oriented with west on top, suggests that the mountain was either the first line that was drawn to provide a frame for the subsequent lines or the result of a final turn of the board after all of the waterways had been drawn with south on top. The mountain brushstroke in drawing 3A was painted with east on top as shown through its highly pigmented starting point, and then the board was rotated ninety degrees clockwise so that the *ditu*-maker could more easily complete the rest of the line as it trails off. The mountain range in drawing 2 was painted with a long side of the board positioned at the top (see fig. 2.12). The brush began close to the edge of the board and wound its way diagonally down to the opposite long side. As the current condition of the board makes it impossible to determine where the line ends, the visible trajectory implies that the line loosely divided the board into two right trapezoids. After the board was divided, the *ditu*-maker filled in each half with the Yongchuan and Huamiao river systems, each drawn with a different orientation of the board.

As a pictorial frame, mountain ranges delineate the meaningful zones of the wooden boards, but importantly, as notational devices, these lines that required intentional turns of the wooden boards also mark a region of the graphic surface as being *higher altitude*. Paired with river lines that are always thicker on the end closest to the mountain-range lines, the thinning of these curvilinear strokes as they move *away* from the mountain ranges also signal a decrease in altitude. Unlike modern topographic maps that might use contour lines to indicate changes in elevation or landscape paintings that might render forms progressively smaller as they receded into the pictorial plane, the Fangmatan *ditu*-maker took advantage of his medium to build a third dimension with the use of lines and the physical turning of the wooden boards. In fact, this formal strategy suffices in rendering height even without a clearly delineated mountain-range line.

To narrowly define the functions of the *ditu* as mapping privileges three-dimensional topography. In such a scenario the two-dimensional terrestrial diagrams can only be seen as three-dimensional if they represent spaces external to them. But, a turn to their processes of production reveals that the *ditu*-maker also made three-dimensional space by manipulating the two-dimensional medium of brush and ink on wooden boards. To build the rise and fall of his graphic topology, he did not utilize a specific projection system, scaled elevation, or any such specialized cartographic techniques. Instead, by exposing the points at which he put down and lifted his brush and keeping all of the lines in relationship to one another, he built watersheds that project into our real space, as if turning the flatness of the wooden boards into the uneven surfaces of a relief map. The Fangmatan terrestrial

diagrams make three-dimensional space by means of a topological "hydro-structure" on top of the board. The directions with which the ink flows are the directions and altitudes from which the tributaries flow in this virtual space.

By describing the space around him topologically through the art of brushwork and the physical manipulation of the wooden boards, the *ditu*-maker successfully built a functional three-dimensional ecosystem, one where tributaries begin as streams high in the mountains and feed into larger rivers, which flow according to the changes in altitude. The number of lines in the terrestrial diagrams is infinitely expandable, and their morphology indeterminate as their only reference is the line that came before and after and the directions in which the line was rendered. In this way, the world that the *ditu*-maker built only requires making legible the beginnings and ends of waterways (brushstrokes) to construct a framework that can be infinitely manipulated without losing its basic functionality in the life of the living. Like Dan's story, all of the details—a zombie, a white fox, the location of confluences, the exact origins of streams in the mountains—are nice to have, but unnecessary. The laws of the bureaucratic system and topography remain even if their content is filtered out. Just as Dan's story retains the general framework of a living bureaucracy to imbue the underground bureaucracy with the same authority and efficacy, the terrestrial diagrams retain the relationships among natural topographic features and the law of gravity to make its spaces believable. In filtering out scale and projection and amplifying brush quality, the *ditu*-maker made diagrams that are not bound by the morphology of an external reality but instead build their own—materially as flat as wooden boards but capable of building a three-dimensional world in the minds of their beholders.

Drawing 3B

For Yong Jichun, the look of efficiency on six of the seven drawings discussed thus far suggests that they were made as sketches drawn by a map-maker as he was traveling around the Fangmatan area.[83] His observation is supported by the contrast posed by a single drawing that looks more carefully made than the other six (thus not a survey sketch): drawing 3B (see fig. 2.5). Although its evenly weighted lines bespeak a level of care that went into rendering each line with a brush and ink, the drawing is incomplete, consisting of only a few curvilinear lines that occupy a corner of the wooden board. Drawing 3B's presence on one side of a wooden board, which contains a seemingly more "complete," albeit more efficiently drawn, diagram on its other side (drawing 3A), leads to two observations that I think are safe to make but counter the uniqueness that is often attributed to drawing 3B: (1) it was also the product of an efficient use of space, and (2) even though it

might look as though it took more time, it was not considered by its maker or patron to be any more important than any of the other drawings. While Yong suggests that drawing 3B might have been made with a specialized implement to provide a look of uniformity absent in the other six drawings, interestingly, the brush excavated from tomb 1 could have produced both types of lines.[84] One end of the 25.5 centimeter brush (with a handle of 23 centimeters) contained the hairs of the brush, but the other end was shaved down to a point.[85] The two ends of the brush, then, could produce two different types of lines—one end makes lines highly susceptible to the pressure changes of the hand, and another that is materially and structurally stiff enough to make lines that are less sensitive to its wielder's skills in muscle control. In other words, rather than a wholly separate implement dedicated to the purpose of making lines in equal width, the *ditu*-maker could have just as easily turned his brush around and used the other end, a move that might signal curiosity, ingenuity, or common practice but that does not serve as definitive evidence of exceptional effort put into making drawing 3B fancier than the other six.

Rather than an exception that proves the lesser quality of the other six drawings, the inclusion of drawing 3B as an integral part of the set suggests a more modest point: this group of drawings presents two different ways of diagramming terrestrial space in this early period. While six of the Fangmatan drawings present a fuller picture of one method, the closest formal analogue to drawing 3B is a brush-and-ink drawing on a fragment of hemp paper (measuring only 5.6 centimeters wide) excavated from Fangmatan tomb 5 that has been dated to the Western Han dynasty (fig. 2.19).[86] Like drawing 3B, the hemp paper fragment contains lines that look uniform, but uniformity does not equate to standardization in symbolic value or accuracy in representation. From the thick straight line that cuts across the center of the fragment to the curvilinear lines that border the bottom right-hand corner and the left side of the drawing (it is impossible to reconstruct an orientation of the drawing based on its fragmentary nature), most of the lines could reference mountains, rivers, or roads. The differences in line weight might also be functionally important insofar as the thicker lines and thinner lines might reference different topographical elements. The shorter lines in pairs and trios that appear in the alcove of the curves could be symbolic but it is unclear of what.

There is similarly too little of drawing 3B from tomb 1 to deduce a consistent application of a symbolic system.[87] Some of the curves contain triangular peaks that house a mark inside, for example, that echo the location of the shorter lines in the hemp paper fragment. Do size or shape differences in the peaks correspond to topographical distinction? Or, as Ma Xianxing argues, are they precedents to the ornamental use of the elongated peaks on the *Garrison Diagram* (ca. 168 BCE), excavated from Mawangdui tomb 3 and

FIGURE 2.19 Drawing on a fragment of hemp paper, Western Han dynasty, excavated from Fangmatan tomb 5 in Tianshui, Gansu Province. Brush and ink on hemp paper, 5.6 cm wide. Reproduced by permission from the Gansu Jiandu Museum.

the subject of chapters 3 and 4?[88] While these forms cannot be pinned to a specific meaning or function, it is evident that there were already multiple ways of diagramming space during the lifetime of the occupant of tomb 1. Whether their differences in morphology were keyed to different functions, whether the *ditu*-maker was privy to all sorts of methods in diagramming and chose to copy two of them, whether the two methods led to different afterlives (one of which is exemplified by the hemp paper fragment), or whether the two modes are related to each other in specific ways remains a mystery.

Worlds in the Palm of a Hand

The method of analyzing the terrestrial diagrams by their brushstrokes is shared with studies on Chinese landscape painting familiar to art historians. While Alexander Soper wrote that "the evidence [that] exists in the [field of cartography] hardly justifies a claim that Han mapmaking had any important

effect on the development of a landscape art," his observation from 1941 was made long before the excavation of the Fangmatan drawings.[89] Since then, Jessica Rawson, for instance, posits that "map drawing was one of the roots of landscape painting."[90] That the two practices, often divided along modern disciplinary lines, may have more in common than previously understood is largely dependent on their shared medium in brush and ink. Brush and ink have driven a substantial portion of traditional Chinese visual culture. Their omnipresence in academic discourse is attributable to the fact that the brush-and-ink line retains evidence of every physical movement of its maker unless effort was put into hiding these traces. Perhaps more importantly, their material presence in all forms of image making (at times appearing only in the drafting stages of written communication) suggests that for someone like the Fangmatan *ditu*-maker, painting, writing, and diagramming required only basic competence in wielding a brush and ink without consciously needing to differentiate between the forms as being pictorial, scriptural, or diagrammatic so long as whatever he made served the purpose of what he was tasked to do.

This ambivalence toward the "what" on the part of the maker becomes rife with functional possibility for viewers, especially the dead. Despite differences in the way they look, that all Fangmatan terrestrial diagrams were buried means that they satisfied the presumed needs of their dead audience. To see the usefulness of terrestrial diagrams that perform multiple functions within a burial context, in this section I compare the terrestrial drawings from tomb 1 with two drawings on either side of a wooden board excavated from Fangmatan tomb 14. While they look nothing like the terrestrial diagrams previously discussed, they served similar functions for the dead once they were buried. They showcase the power of brush and ink in the hands of low-level scribes to conjure worlds that ensure a good (after)life.

The four wooden boards with terrestrial drawings were not the only ones found loose in tomb 1. A single, blank wooden board was found inside the coffin intentionally laid over the deceased.[91] This practice of placing a wooden board across the dead also appears in Fangmatan tomb 14—a tomb comparable in size, structure, appurtenances (albeit even more modest),[92] and date (late Warring States to early Qin dynasty) with tomb 1—wherein a man about thirty-five years old was found with a wooden board (much smaller this time) laid over his stomach.[93] Unlike the blank board from tomb 1, the board from tomb 14 contained two brush-and-ink drawings on its two sides—one of a tiger chained to a tree (fig. 2.20), and another of a "cord-hook" diagram (fig. 2.21).[94] I think the two drawings serve as productive comparisons to pursue an interpretation of the terrestrial diagrams' functions, since the two tombs share more similarities than differences. As I suggest in what follows, the functions of these drawings from tombs 1 and 14 were both apotropaic and bureaucratic. They ensure a safe and auspicious

FIGURE 2.20 Drawing of a tiger chained to a tree on one side of a wooden board, ca. third century BCE, excavated from Fangmatan tomb 14 in Tianshui, Gansu Province. Brush and ink on wooden board, 5.8 × 12.7 × 0.3 cm. Reproduced by permission from the Gansu Jiandu Museum.

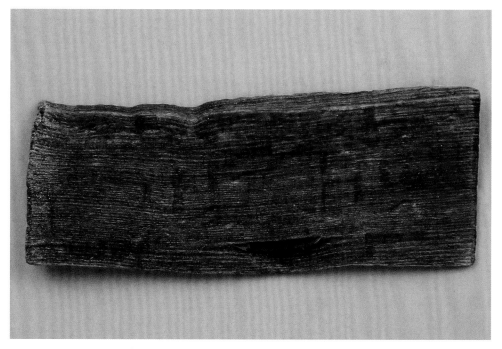

FIGURE 2.21 Drawing of the "cord-hook" design on the other side of the wooden board in figure 2.20, ca. third century BCE, excavated from Fangmatan tomb 14. Brush and ink on wooden board, 5.8 × 12.7 × 0.3 cm. Reproduced by permission from the Gansu Jiandu Museum.

afterlife *and* identify the deceased as someone worthy of certain exemptions in the afterlife due to his diligence during his living tenure as a low-level administrator.

A tiger occupies half of the 12.7 by 5.8 centimeter wooden board from tomb 14, balanced on the other side only by a wispy tree whose thin tree trunk and branches look barely strong enough to withstand a gust of wind, not to mention the leaping tiger chained to it. Rather than balancing the composition horizontally, the painter anchors the tree to the bottom edge of the board, grounding it vertically to counterbalance the horizontal asymmetry of the composition. A slender chain, composed of small ovals, does not wrap around the tiger's elongated neck but tenuously connects the right side of the tiger's neck to the tree, leaving ample freedom for the tiger to twist in an effort to pry free from his constraints. The same care put into rendering the chain appears as patterns on the tiger's body and tail and the delineation of the tiger's disproportionate thighs and calves. Whoever made this drawing also paid close attention to the form of the creature; the tiger's back is made up of two lines, traces of the painter correcting one line with the other. In its play with proportions, composition, and line variation, the tiger is an example of the representational potential of the brush-and-ink line. The tiger expresses a sense of urgency and animation in the face of captivity.

The "cord-hook" (*shenggou*) design found on the flipside of the wooden board is a very different kind of picture. While all of its lines are different widths when compared to one another, each individual line is the same thickness throughout. Lines on this drawing function quite differently from the lines of the tiger—while the latter suggest movement, the former are static, segmenting the surface of the wooden board into angular portions with the help of the TLV pattern, as it is commonly known in Western scholarship. This pattern appears in various guises on all sorts of materials and artifacts, such as bronze vessels, like the steamer from King Cuo's tomb; the bottoms of coffins in late fourth-century Chu tombs, the cosmic boards discussed in the introduction; and most famously mirrors and *liubo* game boards.[95] The excavation of the *liubo* game pieces and game board from Longgang tomb 6 and Shuihudi tomb 11, respectively, attest to the game's popularity among low-level bureaucrats.

Unlike the archaeology team that named the Fangmatan tomb 14 drawing *liubo* after the game board, I refer to the pattern as "cord-hook," following Donald Harper, Marc Kalinowski, and Phyllis Brooks, in order to foreground its astro-calendrical functions when it appeared, for instance, in the Han dynasty text *Huainanzi* as a way of describing celestial space as composed of two cords and four hooks—cosmic connotations that are inherent in the design regardless of its repurposing as a game board.[96] The astro-calendrical implications of the diagram are affirmed by the excavation of a number of artifacts inscribed with the four directions, specific times of

day, seasons, and prognostications strategically placed in and around the pattern: the *liuren* manual drawn on bamboo slips excavated from Shashi in Hubei Province dated to the late Qin dynasty,[97] the *Xingde* silk manuscripts from Mawangdui (ca. 168 BCE), and a wooden board excavated from Yinwan tomb 6 (ca. 10 BCE). In each of these diagrams, space is notated by the drawing, while time is allotted to the inscriptions. Together, the texts and drawings create diagrams of a time-space continuum. The "cord-hook" pattern in this way is an extreme example of diagrammatic flexibility that allows for all sorts of connections to be made between its various components.[98] In turn, it denotes concepts as complex as the inner workings of the cosmos. The occurrence of the pattern on one side of the wooden board from tomb 14 suggests that its maker and/or owner recognized the basic diagrammatic function of the pattern, namely, that it "constituted a set of signs that reinforced the idea of a universe that was knowable, communicable, and applicable to human affairs."[99]

As Lillian Tseng explains when examining the "cord-hook" pattern on the Yinwan wooden board, a single, simple design of *T*'s and *L*'s can function in multiple ways depending on its reference—"to prevent misfortune," "bestow a prospect of immortality," or "grant a wish for longevity"—all of which "can be further considered as a whole standing for auspiciousness" by calling on cosmological principles.[100] Similarly, the captive tiger on the wooden board from Fangmatan tomb 14 also contains multiple references depending on the particular world from which it is seen and used. Jiang Shoucheng identifies the iconography of the tree as a pine tree, which, together with tigers, are described in the *Fengsu Tongyi* (*Comprehensive Discussion of Customs*) by Ying Shao in 195 CE as talismans placed in front of the tomb to ward off evil spirits.[101] Jiang's approach to the tiger as a magical creature capable of protecting the tomb from unwelcomed spectral visitors provides the drawing with a talismanic function.[102] There is, however, another function to the drawing that treats the tiger as a feared creature among the living rather than a protector in the fight against evil spirits.

The image of a tiger in captivity reached mythical status by the medieval period in China. The *Hou Hanshu* (*History of the Later Han*) by Fan Ye (d. 445 CE) recounts a lavish reward that was promised to anyone who caught a supernatural white tiger who led other tigers on a killing rampage through Qin territory in the third century BCE.[103] The story, while unbelievable, probably began with more practical origins. In a well located in Liye, a Qin site in Hunan Province, archaeologists discovered a bamboo slip dated to June 17, 219 BCE, with the following fragmented inscription: "For catching tigers, six persons match being released from government service."[104] While this particular document records an exemption from labor services to the government (*fuchu*) that is possible should one capture a tiger, there are excavated texts that discuss the problem of tigers in other contexts.[105]

Among the fragmented bamboo slips excavated from Longgang tomb 6, one fragment discusses the appearance of a tiger in an imperial garden,[106] while another fragment mentions the capturing of tigers to bring to officials.[107] Shuihudi tomb 11 provides another example of tiger hunts, wherein failure to capture the animal resulted in penalties of one suit of armor.[108]

According to these excavated sources, tigers were a real problem in the Qin that required practical solutions. The success of capturing a tiger also had tangible consequences, ones that would encourage persons of lower social status to engage in the dangerous activity in hopes of being released from labor or tax obligations or, if they were part of tiger hunts, to avoid fines should they fail in their quest. Returning to the painted tiger chained to a tree, the form of captivity thus functions in two ways. Not only is it to keep the tiger permanently in the tomb to protect the deceased but it also references the taming of the tiger as a good deed in the eyes of a bureaucracy that provides concrete rewards. Just as the "cord-hook" pattern references celestial and terrestrial space organized according to simple geometry and structured topologically across the wooden board, the captive tiger similarly references both the talismanic tigers that ward off evil and the successes in navigating a bureaucratic system of punishment and reward. Together, they constitute two pictures of the structures of heaven and earth, diagrams flexible enough to bring "the entirety of existence within a space that could fit comfortably in a human hand and be taken in at a single glance."[109]

While the terrestrial diagrams are only found in tomb 1 and the drawings of the "cord-hook" pattern and tiger in tomb 14, their shared material constitution and similarities between the two tombs in which they were found point to their overlapping functions. The drawings from tomb 1 contain inscriptions that firmly ground the lines in terrestrial space, but the lines themselves, in operating topologically and containing a notational scheme native to the graphic surface, are flexible enough to produce new relations and connections depending on which aspects viewers choose to see. This referential flexibility of diagrams, which similarly fuels the "cord-hook" pattern, the captive tiger, and their multitude of references and functions, becomes an organizational device like model bureaucratic forms. They are standardized insofar as the lines reference standard features of topography— rivers, mountains, and roads in the case of the terrestrial diagrams and time and space in the case of the "cord-hook" design—but retain a high level of flexibility by filtering out representational details to make room for individual circumstances. In the burial context, they become ways for the living to ensure that their dead relatives could reside in a world-version of the afterlife structured after a world of the living. These cosmographic motifs and terrestrial diagrams become ways of "dealing with the unknown, of creating a vision that extends beyond the local, so that temporal progress can be mapped in terms of orbits and cycles, and physical surroundings can be

arranged around registers of social organization that impact the way the terrain takes shape."[110]

Conclusion

The importance of taming wild (*ye*) territory beyond the knowable and see-able is of utmost significance for travel, which Guolong Lai convincingly shows as a well-documented practice in life and the afterlife from at least the Warring States period onward, in particular through daybooks that have been excavated from a number of tombs belonging to the scribal class, such as the two versions from Fangmatan tomb 1.[111] Included in the Fangmatan daybook is a road ritual, the Pace of Yu, to be performed outside the gates or walls that mark the boundaries of state, county, or town jurisdiction:

> When one is about to go out of the gate of the village, [he should] make three Yu-steps and face toward the Northern Dipper, use the shield to draw on the ground, watch, and say: "Emperor Yu has five horizontal lines. Now in order to facilitate travel and travel with no danger, [I shall] prepare [the way] for Yu." This should be appropriate.[112]

Found buried in the tombs with the deceased bureaucrats, these road ritu-als, administrative texts, and diagrams were expected to make the unknown worlds in the afterlife manageable. For the occupant in tomb 14, there was perhaps no better symbol of taming the wild and materially benefiting from successes in doing so than a tiger in captivity. In his world in the afterlife, he probably wanted to present as someone who accomplished this feat in order to reap the merits that might be bestowed on him by the underground bureaucracy. While the occupant in tomb 1 did not seem to have as specific of a character profile in mind, he, too, wished that his lifetime occupation as a bureaucrat might afford him certain accommodations and protect him as he traveled through the netherworld.

For the local scribe who drew the seven terrestrial drawings, the per-sistence and consistency with which he embedded his hand in the drawing of each line may not prove who he is (whether Dan, the deceased, or some-one else), but it manifests a living subject's attempt at making forms that function in as many ways as possible in order to engender homeomorphic worlds of the living and, in burying them in a tomb, to calm the anxieties of a dead traveler as he moved through unknown spaces that would nonethe-less be governed by familiar bureaucratic procedures. Within this frame-work, the ambiguity of each line in the Fangmatan diagrams is not due to the drawings' status as inaccurate maps or process drawings of would-be finished products. Instead, each line successfully captures a space without presuming a singular truth. They claim that there is not one way of depicting

or describing a place. The *ditu*-maker built worlds that need not be comprehensible, functional, or true for anyone other than their intended audience; they only need to be real for the person for whom it matters.

Mawangdui and Earthly Topologies of Design

In 183 BCE, Zhao Tuo (ca. 240–137 BCE), the king of the Nanyue kingdom, launched an attack on the southern border of the Western Han empire (206 BCE–9 CE) in response to a ban on iron exports ordered by Empress Dowager Lü (r. 187–180 BCE), who took control of the court upon the death of her husband Emperor Gaozu (r. 202–195 BCE), the founding emperor of the dynasty.[1] Zhao Tuo's reign as king of Nanyue began in the Qin dynasty (221–206 BCE), when the First Emperor of Qin appointed him as the general in charge of quelling the Baiyue peoples who lived in the modern-day provinces of Guangdong and Guangxi and in Northern Vietnam. Following the fall of the Qin dynasty, Zhao Tuo declared himself king in 214 BCE in opposition to the Western Han court in the north, where Changsha stood as a strategically located principality in defense against Nanyue.[2]

Evidence of Changsha's importance in defending the Han empire's southern border is found at the site of Mawangdui, which houses three tombs: tomb 2 belonged to Li Cang, the chancellor of Changsha, who died in 186 BCE; tomb 3 belonged to his son, who was buried in 168 BCE; and tomb 1 belonged to Li Cang's wife, Lady Dai, who was probably buried soon after her son. Two terrestrial diagrams from tomb 3 point to the strategic position of Changsha in guarding against potential threats. Titled *Garrison Diagram* (*zhujun tu*) (figs. 3.1 and 3.2) and *Topography Diagram* (*dixing tu*) (figs. 3.3 and 3.4) by some modern scholars, they converge at a location labeled Shenping. While the *Topography Diagram* shows the location of Shenping and the entire border region between Shenping and the northern rim of the Nanyue kingdom, the *Garrison Diagram* focuses on Shenping and the garrisons placed within Changsha without indication of what lies beyond the southern border. Using the date 168 BCE recorded on a wooden

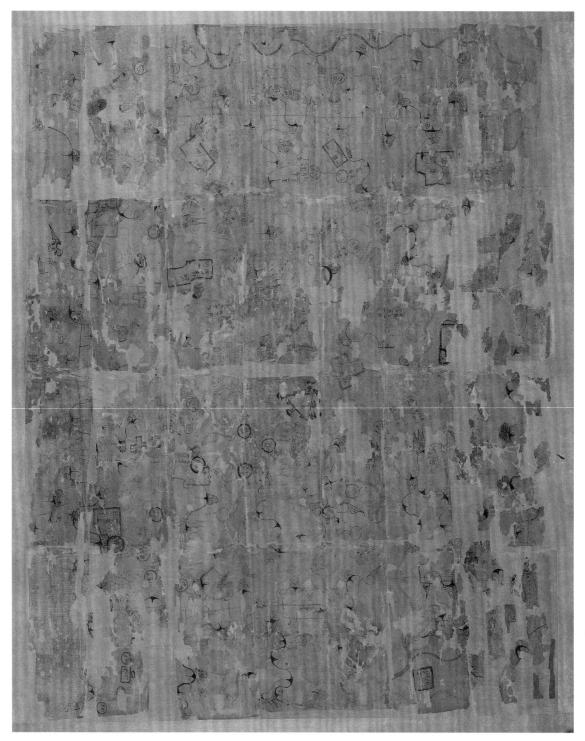

FIGURE 3.1 *Garrison Diagram* (Zhujun tu), Western Han dynasty (206 BCE–9 CE), excavated from tomb 3 at Mawangdui, Changsha, Hunan Province. Ink and pigment on silk, 98 × 78 cm. Reproduced by permission from the Hunan Museum.

FIGURE 3.2 Drawing of *Garrison Diagram*. Reproduced by permission from the Hunan Museum.

FIGURE 3.3 *Topography Diagram* (Dixing tu), Western Han dynasty (206 BCE–9 CE), excavated from Mawangdui tomb 3. Ink and pigment on silk, 96 × 96 cm. Reproduced by permission from the Hunan Museum.

FIGURE 3.4 Drawing of *Topography Diagram*. Reproduced by permission from the Hunan Museum.

board in tomb 3 and matching it with military activity described in received texts, scholars suggest that the *Garrison Diagram* shows the defensive position of the Changsha military units in anticipation of Nanyue's attack in 183 BCE.[3] This interpretation of the *Garrison Diagram* suggests (1) that the *Garrison Diagram* was made at least fifteen years before its burial in tomb 3, and therefore (2) that the *Garrison Diagram* was made to serve the military agenda of the deceased while he was alive. These two assumptions also inflect interpretations of the *Topography Diagram*, which, according to some scholars, was produced earlier than the *Garrison Diagram* and presents a more general perspective on the advantages and disadvantages of the natural topography for military activity in the region.[4] Taken together, current scholarly opinion suggests that these terrestrial diagrams were probably made while Li Cang's son was alive and that while he may not have made the drawings himself, he was deeply involved in military affairs in Changsha or was at least acquainted with high-ranking military officials.[5]

However, as Hsing I-tien cautions his readers, military paraphernalia such as weapons and manuscripts are commonly found in the tombs of high-ranking officials who were stationed at garrison posts; they need not be military commanders or affiliates.[6] More conservatively (and putting identity and dates aside for now), we can surmise that when the occupant in Mawangdui tomb 3 was planning his burial, these terrestrial diagrams, regardless of how useful they were in plotting military strategy among the living, were going to do something for him in the afterlife. As Hsing writes, "[The] value of the two Mawangdui maps perhaps lies not in their accuracy and not in how they can be recovered on modern maps, but rather [in] how an official on the margins of the empire once intentionally brought maps like these to the world of the dead."[7] Cordell Yee similarly contends that representational accuracy must have been a low priority for the makers of the *Garrison Diagram* as so few of its formal attributes seem to have been derived from actual surveys of the region.[8]

The goal of this chapter and the next is to pursue Hsing and Yee's propositions—to explore other possible functions of the drawings beyond mapping, ones that explain their presence in the tomb. To do so is not to stake a definitive position on whether the two terrestrial diagrams are *mingqi* (articles made for the purpose of burial) or *shengqi* (objects that could have been used by the living) but rather to take as a point of departure their status as *peizangpin* or burial items. They were put in tombs because the living believed that the diagrams could do something for the dead in the afterlife. While both chapters support the conclusion that the deceased was someone involved, at least tangentially, in military affairs, they take Hsing and Yee's interventions into account in arguing that the particular phase of the drawings' lives to which we are privy requires that these forms not function narrowly as maps but rather more generally as diagrams that de-

pict and describe military success in order to make an auspicious world. As I suggest in this chapter through a reconstruction of the drawing processes that underlie the production of the two terrestrial diagrams, to attend to the multifunctionality of these two terrestrial diagrams requires that we see a different aspect of them beyond representation of natural topography.

An initial glance at the Mawangdui drawings might discourage this turn away from a cartographic interpretation, as the drawings manifest certain qualities that are aligned with our modern expectations of maps. For comparison, we can return to the Fangmatan drawings, where it is possible to track the direction in which the diagrammer laid down his brush and dragged it across the wooden surface, leaving a trail of evidence on his drawing process. The drawing process of the Fangmatan diagrams reveals the direction of the river flows, by marking the origin with a thicker point, where the brush is first laid down, and tapering as the line approaches its tail end at the mouth. This process results in the opposite of what tributaries look like. By contrast, in the Mawangdui drawings, rivers are rendered thinnest at their sources as streams in the mountains and consistently grow in width in the direction of the river flow with no trace of the beginnings and ends of the lines.[9]

While there exists a unified system that governs the forms on the two Mawangdui diagrams, uniformity must not be conflated with cartography's preconception of representational accuracy as a defining quality of maps.[10] As this chapter observes, the drawings' uniformity derives not from representation of an external topography—thus measures of accuracy or inaccuracy fall short as evaluations of these diagrams' efficacy—but instead, from the application of a coherent ornamental program that transforms natural elements into a series of positions on the graphic surface so that their connections can make an auspicious world for the dead, with *auspicious* defined as the most advantageous spatial configuration of humans among the natural landscape that yields positive outcomes. Artisans restructured mountains and rivers in nature to make patterns (*wen*) that depend on repetition and regularity in visual rhythm.[11] In these Mawangdui terrestrial diagrams, natural elements that are part and parcel of the cosmic order are patterned according to an ornamental topology that governs viewers' visual engagements with the object.

These ornamental patterns produce a look of "completion or fulfillment" that transforms the diagrams into highly charged presentations of the most auspicious and decorous confluence of heaven, earth, and humans—a subject to which the next chapter turns.[12] For now, in this chapter, I proceed by first discussing the problems with slotting the *Topography Diagram* and *Garrison Diagram* into a cartographic framework as, once again, narrowing the possible functions of the diagrams to that of representing real space. Instead, as I examine through a comparison with the Western Han dynasty text

Huainanzi, the lay of the land was conceptualized differently in the world of Western Han elite—not as measured distances between natural elements but as positions relative to one another. On the *Topography Diagram* and *Garrison Diagram*, the process of distorting topography into a topology is shared with the practice of embroidery as seen on silk textiles excavated from Mawangdui, a comparison that I pursue in the second half of the chapter. While the patterns on the diagrams and the embroidered textiles are not formally alike, they follow a similar notational logic in their processes of production. The goal of the comparison is to highlight the ways in which a turn to material processes deprioritizes the representational functions of the drawings to reveal other modes of reference.

Forms of Accuracy

Most scholarship on the *Topography Diagram* and *Garrison Diagram* tackles the problem of matching place-names, rivers, and mountains with received texts and concludes that the Mawangdui terrestrial diagrams are in fact accurate representations of the region. To reach this conclusion, however, scholars have had to relax cartographic requirements to accommodate the inconsistent map scales of both drawings.[13] In the Mawangdui terrestrial diagrams, claims of accuracy downplay "distant" or "subsidiary" territories that are integral parts of the drawings. For instance, Tan Qixiang divides the *Topography Diagram* into three sections: command area, near territory, and distant territory.[14] The command area, which Tan considers the most accurately rendered section of the drawing, centers on the Xiao River system (labeled *Shenshui* on the *Topography Diagram*) and contains a map scale of 1:150,000 to 1:200,000.[15] Tan describes the other two areas of the map as lacking a consistent scale and having misplaced rivers and towns. While he argues that actual survey informs the drawing of the command area, Tan concludes that the other two areas were not surveyed and therefore lack precision. Zhang Xiugui similarly segments the *Garrison Diagram* into four sections based on map scale—the main area, the southern area, the northern area, and the subsidiary area—that range from being accurate to being symbolic and to being decorative.[16] A red rectangle with rounded corners that runs parallel to the artifact's physical borders serves as the divider between the main and subsidiary areas. According to Zhang, the main area of the drawing centers on the triangular symbol in the northwest quadrant of the map with the label *jiandao*—identified as the command center—and is the most accurate since this area was properly surveyed.[17] Zhang suggests that other areas were drawn for decorative purposes, since they do not correlate with the actual topographic organization of rivers in the region.[18] For example, the Xiao River, which flows westward and beyond the edge of the drawing, is nonetheless kept visible to accentuate the river as a north–south

axis for the drawing. To do so, the *ditu*-maker anchors one of its tributaries, Liushui, at its source but rotates its direction of flow counterclockwise so that, on the map, the tributary flows north (and not west), thereby sacrificing accuracy for visual effect in the outer reaches of the drawing.[19]

One possible reason for the inconsistency in map scales could be the fact that the Mawangdui drawings encompass a much larger region than local terrestrial diagrams. Unlike the Fangmatan diagrams, each of which captures a slightly different part of the local environs of the tomb site, the *Topography Diagram* goes so far as to register a neighboring kingdom. Not only did every administrative division of the Western Han empire—*guo* (principalities), *jun* (commanderies), *xian* (counties), and *xiang* (villages)—possess its own terrestrial diagrams but also different terrestrial diagrams were overseen and used by different people for different purposes.[20] Each of these *ditu*, which renders only parts of a territory and records limited information deemed necessary for the function of the drawing, probably adopted different scales to serve their individuated functions. The Western Han military general Li Ling (d. 74 BCE) might have been able to supply the gaps in territorial knowledge on the strategic location of Juyan during the Western Han by drawing terrestrial diagrams as he marched his troops through the area, but barring these survey opportunities, the average bureaucrat could only know about an area outside his immediate place of employment by accessing other diagrams drawn up to serve other people and functions.[21] To build a terrestrial diagram much larger in scope, then, required not surveys of the natural topography but access to local diagrams and the skills of copying and compiling. The *Topography Diagram* and *Garrison Diagram*, in accounting for a rather large part of the Changsha kingdom, probably would have entailed piecing together a number of these different kinds of drawings. In so doing, the amount of care relegated to reconciling the various map scales specific to the "original" drawings could vary. With little attention paid to recalculating the map scales, terrestrial diagrams like the *Garrison Diagram* and *Topography Diagram* may contain incommensurate scales, from being more accurate in the center to much less so along the periphery. The opposite is also possible. If each diagram were drawn to consistent, deducible scales, it is also possible to recalibrate them when compiling a "master map." It is impossible to say whether the decision to retain inconsistent map scales on the two Mawangdui drawings owes to some intentionality on the part of their makers, but we can say that these drawings in their totality are by no means accurate in their scaling of the region.

In each of the above accounts, the search for an elusive map scale depends on a preconception embedded in the cartographic ideal that the terrestrial diagram makers were keen on representing a topographical landscape and that the more consistent they were in holding fast to a 1:*x* ratio across an entire drawing, the more functional the diagrams would be for

their users. As I explain in the remainder of this section, however, the formal attributes of the two terrestrial diagrams reveal a different world altogether, one in which topographical space did not consist of *measured distances* from one natural element to another but was instead based on *relative positions*.

Highs and Lows

In its 96 × 96 cm square frame, the *Topography Diagram* captures the southern region of modern-day China, from southern Hunan, northeastern Guangxi, to northern and central Guangdong provinces. Scattered among rivers and mountains in the area are over eighty communities that fall into three categories: eight prefecture-level locations marked by rectangles, seventy-four encircled town-level locations, and three military outposts labeled as *zhang* in either a square or circle cartouche.[22] Twenty or so roads also appear as solid lines that link seven of the eight prefectures.[23] Road lines are differentiated from rivers because one of their endpoints touches the square or circle of a textual label, which suggest that they begin or terminate in a particular place. Also, unlike river or mountain lines, road lines are weighted equally throughout.

While roads are difficult to see because of the short, fine lines with which they are rendered, the river system is difficult to miss. The Xiao River system (labeled as *Shenshui* on the drawing) comprises over thirty waterways, with at least nine branches named and labeled at the point where they meet the Xiao River.[24] As previously described, river lines consistently grow in width, thin at their origins in the mountains and thicker at their endpoints as they feed into the Xiao River. Another major water system appears, disconnected from the Xiao River. The separation between this river system in the far south (the top of the drawing) and the one centered on the Xiao River is marked by the label *fengzhong*, two tiny characters that sit between Changsha in the north and the Nanyue kingdom to the south, with the darkened mass at the southern edge of the map indicating what is now known as the South China Sea.[25]

The mountain lines are equally striking, prominent, and pervasive, yet unlike the river lines, the mountains are unnamed.[26] All mountains, except for one notable exception that will be explored in the next chapter, are shown as mountain ranges using lines that some scholars have characterized as approximating modern contour lines (*denggao xian*).[27] When used in the context of modern topography maps, contour lines are made by drawing the boundaries of the area occupied by mountains. A single, closed contour line represents all points along a mountain at the same elevation. Thus, to show elevation change, contour lines are nested within each other. There are certain formal similarities between the mountain-range lines on the *Topography Diagram* and contour lines. In general, these closed-circuit lines

on the *Topography Diagram* delineate the shapes and locations of mountain ranges, as if mountains were laminated and then traced. The formal similarity between the ancient and modern mountain-range lines informs the modern title of the drawing as *Topography Diagram*, since contour lines are a requisite feature of modern topography maps.

But beyond basic formal resemblance, these mountain-range lines on the *Topography Diagram* could not have served the same function as modern contour lines. No matter what mountainous forms looked like in second-century BCE China, they could not have looked anything like their appearance on the drawing for two reasons. First, if mountain ranges on the *Topography Diagram* are only composed of a single "protocontour line," then the implication is that they exist on a single level above sea level with no change in elevation.[28] Instead of including contour intervals (the distance between two nested contour lines), the diagrammer(s) simply filled them with hatchings, essentially obscuring the most meaningful gap of the modern contour line system with seemingly meaningless patterning. Second, at best, the *Topography Diagram* lines may be referred to as form lines: "a line drawn on a map to depict surface configuration in a generalized manner and usually without indicating elevations."[29] But the *Topography Diagram* lines fall short when measured against the function of form lines as well. The space contained within every contour line is nearly identical in width, which, translated into real space, would mean that every mountain in this region takes up the same amount of space in its lateral dimension.

Why would a mapmaker eliminate such important information about the area occupied by mountain ranges and their heights? I would argue that these formal configurations emphasize the design of the map as topological under the guise of topography, particularly with regard to the heights of mountains, which was conceived differently in early China, as exemplified by the chapter "Terrestrial Forms" ("Dixing") in the compendium *Huainanzi* (ca. 139 BCE) that Liu An (d. 122 BCE), the king of Huainan, presented to his nephew Emperor Wu (r. 141–87 BCE).[30] The *Topography Diagram* and the *Huainanzi* evoke similar conceptions of space. Examining the *Topography Diagram* according to the standards set by the "Terrestrial Forms" chapter clarifies the need to shift our emphasis from formal resemblance or scaled projection of an external referent to considering the importance of binaries and correspondences within the design of the mountain symbol.

"Terrestrial Forms" describes mountains as only consisting of highs and lows correlated with other natural phenomena and *qi*. The emphasis placed on the highs and lows suggests elevation but in a drastically different way than contour lines do, which scale the measured incline of mountains. Instead, as the "Topography" chapter lays out, mountain heights are understood as the antithesis of their valleys: "Mountains are the cumulative [result of] accretion; valleys are the cumulative [result of] cutting away.

High places give birth; low places govern death."[31] According to this textual description, what is most important in mountain ranges is not that their surveyed altitude is translated into scaled contour lines but that their highest and lowest points constitute a binary and are made distinct. Similarly, in all of the mountain-range lines on the *Topography Diagram*, apexes of their curvatures are thickened to reference mountain tops. Read alongside the "Terrestrial Forms" chapter, what should otherwise be considered a depiction of space becomes a description of space wherein only the thickened apexes matter and everything in between is malleable. Put another way, the mountain ranges on the *Topography Diagram* may not look like accurate, mimetic representations of actual mountain ranges in the region, but in the topological world of the diagram, they need only contain vertices connected by edges.[32]

No amount of distortion changes the basic relationship between the highs and lows of the mountain ranges, even reserving the possibility of one transforming into the other. Accordingly, mountain-range lines on the *Topography Diagram* need only notate the distinction between a high and a low point that may even be interchangeable so long as the two points are sufficiently differentiated—an apex (vertex) in one curve (edge) always descends into an apex (vertex) in the next curve (edge). Rather than operating as a scaled depiction of the elevations of a specific mountain range, the *Topography Diagram* shows the correspondent relationship between the high points (mountain tops) and low points (valleys) within the territory. As such, the mapping function of graphically representing space becomes a more general diagramming function founded on a basic operational principle in nature—the highs will inevitably be accompanied by the lows; what goes up must come down.

Patterning Rivers and Mountains

The relationship between mountains and rivers extends to another aspect of how the terrestrial diagram parallels textual descriptions of natural terrain.[33] The "Terrestrial Forms" chapter of the *Huainanzi* lists individual rivers (despite some of their mythical origins) according to where they begin: "The Yellow River issues from the Piled-Stone Mountain. The Qu River issues from Mount Jing. The Sui River issues from Feather Mountain," and so on.[34] Certain rivers were given additional information but also in the form of a list: "The waters of the Yellow River issue from the northeast corner of the Kunlun Mountains and enter the ocean, flowing [eastward] along the route of Yu through the Piled-Stone Mountains."[35] The structure of the *Topography Diagram* echoes the structure of the description in transforming the density of natural topography into a series of discrete topological points. While the drawing never clarifies the exact trajectories of the river system, it notates

a similar list structure as that of the "Terrestrial Forms" chapter by way of formally sequencing the origins of each tributary somewhere in a mountain, one after the next.

It is the "beguiling plainness" of a textual list such as the one in the "Terrestrial Forms" chapter—river after river, mountain after mountain, all phrased in the same syntax—that makes the list efficacious as an all-encompassing vision, an objective similar to that of an aerial perspective in depictions.[36] As Hajime Nakatani wrote, "Within the optics of the early Chinese regimes of signs, the facticity of the list takes unambiguous precedence over the intentions informing it. That certain types *can* be arranged in such a fashion self-sufficiently validates the list's implications regardless of *how* its internal arrangement is achieved."[37] Applying Nakatani's argument to the listing of rivers and their sources, the fact that topographical elements *can* be listed justifies whatever distortions are necessary when they are placed in the list form even if doing so amplifies certain details at the expense of others or reframes certain kinds of relationships for the sake of argument.

When translated into the *Topography Diagram*, the fact that natural topography can be visually listed implies an order to the natural world. Rivers in a map can be depicted in such a way as to retain all of their semantic density—the degrees of river bends, distances from one bend to another, etc. And yet in the case of the *Topography Diagram*, these details are filtered out to make a topological diagram that boils down these morphological variations into their essential structure. Doing so does not deprive the drawing of its rhetorical force. It compensates for its lack of specificity with the ability to integrate any information that is introduced into the structure and reconciles two seemingly incommensurable impulses: "the desire to record and describe everything (on the one hand), and the need to reduce and classify on the other."[38]

The form of the *Topography Diagram* fulfills a similar function as the list in the "Terrestrial Forms" chapter. In the chapter, once an item is named, emphasis shifts from the specificity of each item to the relationships between them. A similar potential exists with diagrams. On the one hand, only through treating each tributary line as dense and replete can one claim that one line is not interchangeable with another (hence each tributary is unique even if unaccompanied by a textual label). On the other hand, the discreteness with which a series of tributary lines is formally sandwiched between the curvatures of mountain ranges functions similarly to the list—such and such a river issues from such and such a mountain, repeatedly. This discreteness of the "list" in visual form ultimately undermines the particularities of the individual elements listed or drawn. While the tributary lines and their relationships with mountain ranges may appear morphologically distinct and representationally accurate of an external topography, a closer look reveals that it is impossible for them to be "accurate" within the frame

FIGURE 3.5 Detail of the *Topography Diagram.* Labels by author.

of reference in which they are embedded, since all of them are graphically interdependent even if miles apart in the natural terrain. The shape of one tributary relies on the shape of the mountain ranges, which is in turn dependent on the shapes of other tributaries in their vicinity. In other words, the mountainous pattern that winds through the *Topography Diagram* informs the graphic design of waterways.

Take, for instance, a series of waterways just southeast of the Shenping text label (fig. 3.5). A tributary labeled Canshui begins in the midpoint of a mountain-range curvature and flows north into the Xiao River. Along the way, the tributary follows the curvatures of the two mountain ranges on either of its sides. Another tributary, positioned two mountain ranges east of Canshui, is rendered in a similar fashion. It begins somewhere in a curve of the mountain range and follows the curve to its east, just barely grazing the edge of a mountain peak as it approaches the Xiao River. Further southeast, near the inscription Guiyang and the edge of the drawing, a stream begins in the deep curve of a mountain range and flows south, winding parallel to

the mountain range that extends west, until it reaches a river that connects to the South China Sea at the top of the drawing. These formal observations suggest that the arrangement and curvilinearity of the tributary lines are based on the design of the drawing. In terms of design, the diagrammers were concerned with maintaining distinctions between mountains and rivers by ensuring that the two kinds of lines never overlap but are always wiggling in tandem through the graphic space. Mountains and rivers are shaped to create parallel curvatures so that the undulation of the mountain lines frames the wavy water lines and vice versa. As these examples show, mountain ranges on the *Topography Diagram* establish a pattern that guides the shape and placement of the river lines.

Like the Zhongshan mausoleum diagram and the seven Fangmatan drawings, making the *Topography Diagram* involved translating other descriptions and depictions of space that were probably transcribed on a series of perishable materials as texts (maybe lists), diagrams, charts, paintings, and maps. Some versions of this digested material may have involved carefully surveyed materials and data translated into scaled renderings of the topography to aid in military strategy among other administrative business. For the makers of the extant *Topography Diagram*, however, they explored and implemented formal structures that go beyond what is visible in the natural topography. As Martin Powers argues, early Chinese artisans charged with the task of painting lacquer clouds were not simply making pictures of what they saw in nature, for they "could not 'see' without interpreting." Instead, artisans were simultaneously "inventing spatial structures for conveying [clouds'] fundamental character," structures that were reliant on the knowledge artisans gathered from rendering clouds in "a viscous, fluid medium [that] may have offered more than one insight."[39] The *Topography Diagram* that the Hunan Provincial Museum now houses in its collection is therefore a picture composed of all sorts of previous imaging processes that operated under different modes of reference to space, none of which were immune to artisanal and scribal imaging of the world and other artifacts around them.

The "accuracy" that scholars wish to ascribe to the *Topography Diagram* is therefore no more than what Caroline Arscott describes as a "degree of credible variation" in reference to the fishing motifs in William Morris's (1834–1896) wallpaper designs. While these motifs "can be described in terms of naturalism, a sort of honest and faithful record-making," Arscott argues that the purpose of Morris's fishing designs is more "an exploration of the capability for death-dealing combat, not laborious and pious truth-telling."[40] I think Arscott's proposition serves as an apt analogy for thinking through the formal qualities of terrestrial diagrams. The *Topography Diagram* retains sufficient differentiation between the forms of its symbols (a mountain range looks nothing like a river) and credibility in its design (wa-

terways are thinnest near the mountain ranges and widen as they flow away or down) as the result of using other images of surveyed information that serve as the inspiration for enough formal variation to suggest "naturalism." However, these representational moments nonetheless succumb to strategic manipulations in the realm of graphic design—the all-too-neat rhythm and forms of mountain curvatures, the elimination of height in favor of a horizontal patterning of mountains, and the visual listing of the river and mountain lines, one after the other—all of which imply an "exploration of the capability for death-dealing combat" much more so than a "laborious and pious truth-telling." As I clarify in the next chapter, the fear of death and defeat (ironically), rather than a desire to capture a world of the living, underpins the strategic manipulations of the drawings' designs. However, before exploring the functions and purposes of these manipulations, we must further attend to the structure of this design.

Technologies of Design

The two Mawangdui terrestrial diagrams were drawn on silk with multi-colored ink, precious materials that would not have been used for drafting or sketching. Two pieces of silk were sewn together, painted, and then hemmed along its four sides.[41] The *Topography Diagram*, as previously noted, measures 96 × 96 cm, and the *Garrison Diagram* measures 98 × 78 cm. At this large scale, they were not conducive to being picked up and turned during use. Instead, they were most likely placed on a flat surface or hung up, and their viewers would have gathered or moved around them in order to see their various parts. On the *Garrison Diagram*, the directions for "south" and "east" are written along the top and left-hand edges, respectively, while no cardinal directions are provided on the *Topography Diagram*. The materials used in painting them were also important, as exemplified by the use of a different kind of ink to render the South China Sea in the *Topography Diagram*. This ensured that even after two millennia of being folded and soaked underground, the densely inked, semicircular form has not bled, unlike the other brush-and-inked lines and inscriptions.[42] These two artifacts were most likely considered final products and not process drawings.

A reconstruction of the production processes involved in making the two Mawangdui terrestrial diagrams once again shifts our focus from the topographic aspect of the drawings that one expects from a map of natural terrain to the topological structure of their designs derived from an ornamental system. The previous section already gestured toward the prominence of ornamentation by way of patterning rivers and mountains. This section supports the previous observations through a close examination of how the processes of making these terrestrial diagrams further accentuate the primacy of an ornamental system in governing the placement of topo-

graphic elements. To posit this kind of argument requires a reconstruction of how the drawings were painted. While we do not have evidence of every stage in their production, I compare the diagrams to another set of Mawangdui artifacts that shares a similar logic in their production: silk embroidery.

In this section, I suggest that the process of silk embroidery renders visible the ornamental topology that undergirds the structure of the *Garrison Diagram* and *Topography Diagram*. To clarify, the following comparison of embroideries and the terrestrial diagrams does not rest on formal similarities. That is, the goal is not to show that the shape of embroidered clouds looks like the shape of clouds on the terrestrial diagrams. Instead, I argue that the *process* of embroidering exemplified by the Mawangdui textiles reveals the underlying design structure of the terrestrial diagrams. I am interested in the shared notational underpinnings of their technologies, which is neither medium specific nor necessarily visible from a distance but rather requires a reconstruction of their production processes. I aim to register their parallel systems of production that are connected by the same topological and notational logic: for diagrammers and embroiderers, lines are not continuous; they are punctuated by sets of discrete (or disconnected) points.

While the discreteness of the list form masks its density of content, it is the continuity of the embroidered line seen from afar that masks the discreteness of each stitch in its execution. The embroidered silks from the Mawangdui tomb sites and the two terrestrial diagrams share in the myth of representation made possible by their two pairs of implements—needle/thread and brush/ink—and the freedom that is often associated with them because of the amount of control that painters and embroiderers are often envisioned as having over their tools. The dominance of skilled practitioners over their mediums—the ability to make embroidery or painting look "easy"—suggests the possibility of an "accurate" transcription of the concepts and images that occupy the embroiderer or mapmaker's mind and vision. While the strict laws of the loom prohibit threads from going in any direction other than vertically and horizontally, needle and thread and brush and ink encourage pattern innovation, where the technology, theoretically, makes it possible for the embroiderer or painter to make any shape with seemingly continuous lines.[43]

And yet when the drawn mark is stripped of its "mimetic imperative of pictorial illusion" and embroidery is released from its comparison to painting, drawing and embroidery can be studied without recourse to representation (product) and examined as a practice (process)—a necessary methodological maneuver if we are to extract a new structure from the patterning of mountains and rivers that opens up a multiplicity of functions that does not depend on resemblance to actual mountains and rivers.[44] Importantly, a turn to practice entails making a further distinction between techne and

technology. While embroidery in the hands of seasoned practitioners can produce all imaginable patterns, when skill level is put aside, the technology of embroidering is far from an exercise in absolute freedom. Unlike brush-and-ink painting, which might be considered gestural—recording, for example, every change in pressure and turn of the wrist—embroidery is in fact as regulated as weaving. In what follows, I show that the technology of drawing the *Garrison Diagram* and *Topography Diagram* is akin to the technology of embroidery more so than landscape painting.

Techne and Technology

The most famous textiles from the Mawangdui tomb complex do not come from tomb 3 but from tomb 1 even though tomb 3 actually contained more textiles, including nineteen silk layers used to wrap the deceased's body (just one layer short of the twenty that were used to transform Lady Dai's body in tomb 1 into a silk brick).[45] The silk textiles from tomb 3, however, are in worse condition. Therefore, the following analyses (and scholarship on Mawangdui textiles more generally) rely on textile fragments and techniques that appear in tomb 1. While there are plenty of embroidered designs from the two tombs, three are named in an inventory list excavated from tomb 1: "abiding faith" (*xinqi*) (fig. 3.6), "longevity" (*changshou*) (fig. 3.7), and "riding cloud" (*chengyun*) (fig. 3.8).[46] The "abiding faith" pattern consists of swallow-like figures interspersed among floral and cloud designs. The "longevity" pattern is characterized by cloud patterns that resemble a dragon form in profile. And "riding clouds" is defined, again, by cloud scrolls but considered distinct from the other two patterns for its inclusion of a phoenix eye.[47]

Like the two terrestrial diagrams, multiple steps stood between conceptions of the textile patterns and their execution, beginning with drafting the embroidery pattern on a different material. As Zhao Feng describes, for everyday objects, drafts were usually first drawn with chalk. Then a woven textile was placed on top, and the two were pressed together to transfer the pattern. For objects made for visual pleasure, the ground textile would be stretched on an embroidery frame and then another material containing the pattern rendered in ink would be placed underneath. A light would be shone on the two layers, and a drafter would trace the pattern onto the textile. The two transfer methods differ in that the former method would yield a less articulated transference of the pattern than the latter.[48] Since there is no evidence of the drawing process involved in the terrestrial diagrams, we can only speculate as to whether tracing constituted a step in its process. Most of the embroideries from tombs 1 and 3 were stitched on top of *juan*, a plain silk weave that also serves as the ground for the two terrestrial diagrams. The tracing method is thus possible for the drawings as the level of transparency

FIGURE 3.6 "Abiding faith" embroidery on *luo* silk textile fragment, Western Han dynasty (206 BCE–9 CE), excavated from Mawangdui tomb 1. Silk, 41× 54 cm. Reproduced by permission from the Hunan Museum.

FIGURE 3.7 "Longevity" embroidery on *juan* silk textile fragment, Western Han dynasty (206 BCE–9 CE), excavated from Mawangdui tomb 1. Silk, 41 × 54 cm. Reproduced by permission from the Hunan Museum.

afforded by the silk weave might have permitted their makers to see through the textile and/or the tightness of the weave might have allowed for a transference of chalk lines. Because no lines on the drawings show any signs of hesitation in their brushstrokes and/or a reworking of the shapes, we can assume that they were either the results of extremely skilled artisans who had made versions of these drawings before or they were copying or tracing previous drafts.

After transferring patterns onto the silk textiles, Mawangdui embroiderers used a number of techniques to render the lines in thread: chain stitch (*suoxiu*), back stitch (*jiezhen xiu*), braid stitch (*bianzi xiu*), seed stitch (*dazi xiu*), and the earliest Chinese example of needlepoint embroidery (*purong xiu*).[49] Most of the embroidery was done with the chain stitch. A few examples of the back stitch were employed to make the ends of cloud scrolls finer. The braid stitch was used in a check-patterned *juan* fragment from tomb 1,[50] and there is one example of needlepoint embroidery that covered the entirety of a polychrome brocaded silk (*jin*) textile that decorated the

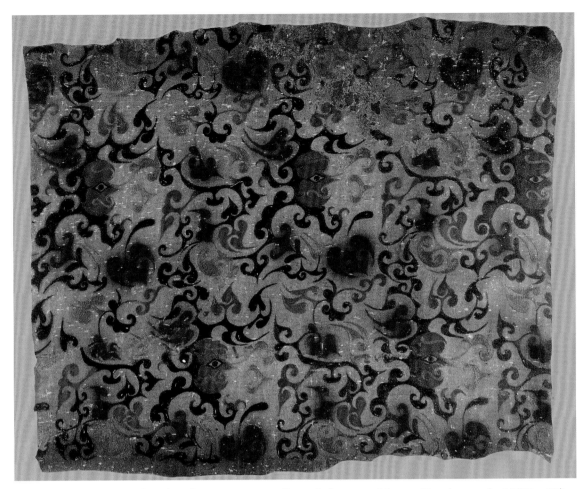

FIGURE 3.8 "Riding cloud" embroidery on woven *qi* silk textile fragment, Western Han dynasty (206 BCE–9 CE), excavated from Mawangdui tomb 1. Silk, 34 × 39 cm. Reproduced by permission from the Hunan Museum.

top of the innermost coffin in tomb 1.[51] For brevity, I will only address the chain stitch in comparison with the lines on the *Garrison Diagram*.

There are two types of chain stitches used in the Mawangdui embroideries: open and closed (fig. 3.9).[52] For a line of open chain stitches, one pulls the needle up from the bottom of the textile at a point A and then threads the needle back down at a point B, next to where the needle was initially brought up. Rather than pulling the thread all the way through point B (which would result in a tight, straight line connecting points A and B), one leaves some thread loose on the surface of the textile. The length of this segment of the thread becomes the perimeter of the loop in the chain. Then, one pulls the needle up again at a point C located above point A (and diagonal to point B) and lowers it at a point D, which is situated above point B and diagonal to point A, and so on. This chain stitch is "open" because

each loop is anchored at two points on the preceding loop that are set apart from each other.[53] In contrast, closed chain stitches are so named because each loop connects at a single point (or two points that are so closely placed next to each other that they are indistinguishable from a distance). To make closed chain stitches, one begins by pulling the needle up at a point A and then drawing the needle down at the same point A, leaving a loop of thread. The needle and thread are then pulled up at a point B set a stitch length away from point A and pulled through the thread loop previously left behind on the surface. Thread is once again left loose on the surface as the needle is drawn back down through point B, and the process continues. This form of chain stitching is "closed" because the loop begins and ends at (what is perceived to be) a single point.

Unlike weaving, where patterns are dependent on perpendicular threads that alternate in various combinations of up and down and angularize every form that they make, embroidery, as a manual technique unencumbered by a mediating technology such as a loom, seems to permit all kinds of nonangular marks. Yet I would argue that embroidery is equally reliant on an underlying digital system that establishes certain parameters for an otherwise seemingly analog process.

All stitches are dependent on the point at which a needle is pulled up and down through a ground weave (fig. 3.10). While the possible points where a

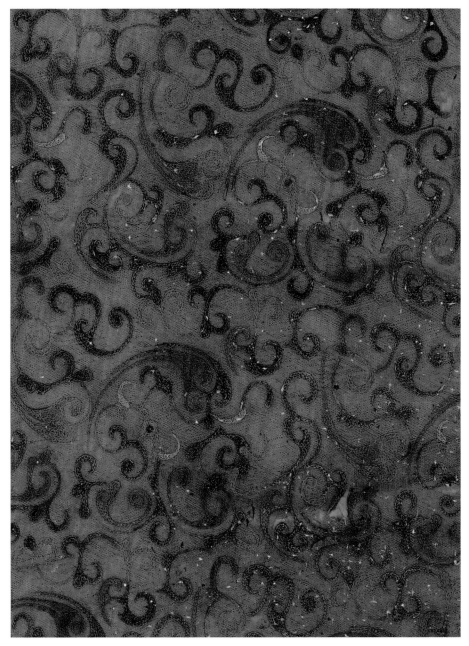

FIGURE 3.10 Detail of "abiding faith" embroidery on *luo* silk textile fragment.

needle can move up and down are theoretically endless within the physical limits of a given textile, the *type* of stitch restricts the possible interactions between a needle and the ground weave. In closed chain stitches, for example, the needle must go up and down at the same point (or two points very close to each other) in order to close the loop, whereas in an open chain stitch, a needle must go up and down at points located a set distance apart from each other to ensure even stitched "line" quality. A single line on

a previously drawn pattern on the ground weave is thus divided into segments whose endpoints are notated by needlepoints through the ground weave. While the initial drawing on the ground weave may have been dense throughout, the technology of embroidery segments the line into discrete points set a stitch length apart, all of which hold topological value since regardless of deformations made to the ground weave or the lengths of each loop, each point is still connected to another. Put another way, embroidery segments drawn lines so that in the translation process, lines and the shapes that they make are inherently distorted (a continuous brush-and-ink line, upon very close looking, becomes a series of discrete loops). However, the *order* of the points, which notate the beginning and end of each loop, and the connection between each of these points in a sequence remains intact. And most importantly, each of these embroidered loops in the chain are meaningful when compared to each other without relying on an external referent. A single loop in a chain stitch takes as a referent the loop before and after and not the overall shape that the embroidered motif supposedly references in the world out there. A single loop in a chain stitch does not reference a single point in a cloud formation in nature; it only references the points at which the needle was pulled up from the ground weave and will be pushed back down.

To be sure, this analysis of embroidery is descriptive of its technology and *not* the techne (the know-how or the skill) of its seasoned practitioners. As one masters different kinds of stitches, one could easily embroider without giving much thought to where the needle is being brought up and pulled down. A toddler taking her first steps must learn how high to lift her knees, how firmly to plant each foot, and how far apart to make each step. But for the competitive speed walker, the breakdown of these leg movements become seamlessly integrated into a single motion so that the average onlooker would barely be able to distinguish speed walking from running. Similarly, a cloud embroidered by a novice would look disjointed since each stitch would register the lack of skill and experience required to make a visually seamless line from a distance. The discreteness of the stitches would in turn hamper the illusion of the pattern as a representation of a cloud and amplify the notational qualities of embroidery technology. By contrast, the expertise of a seasoned embroiderer could mitigate the discreteness of the technology by ensuring that every link in the chain stitch is not only smaller (so less visible) but also that they are near identical to each other. Any slight variation between stitches would reference an actual qualitative difference in the pattern's reference to a cloud. While the skill levels of embroiderers affect (perhaps inevitably) the modes of reference on the part of viewers, their skills do not change the technology, which, regardless of how one might wield it, is dependent on translating a continuous line into discrete points.

Like the needlepoints in embroidery, the lay of the land shown on the *Garrison Diagram* follows a similar emphasis on topological order and connection rather than topographical representation. In addition to the artificial regularity to which all of the curves in the *Garrison Diagram* are subjected, mountain ranges are bracketed by cloud scrolls on either end and punctuated by a decorative combination of three stacked mounds filled with striated marks on one side matched with a curved triangular peak on the other that cap each apex of a mountain curve (fig. 3.11). Like the rhythmic three-dimensional motions of an embroiderer's hand that punctures the silk

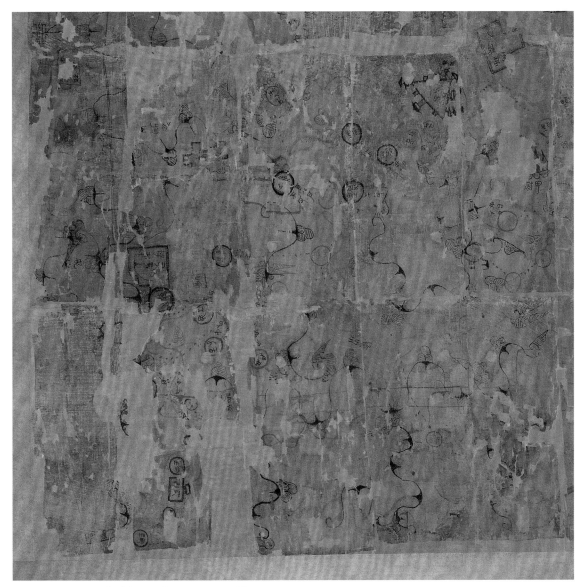

FIGURE 3.11 Detail of the northeast corner of the *Garrison Diagram*.

surface at set intervals, the cloud scrolls and stacked mounds are positioned rhythmically along the undulation of a single curvilinear line as they thread through the silk surface. These ornamental devices turn a single curve in the line into what some scholars have read as a series of the character *shan* (mountain) and highlight the regulated distance between each peak.[54]

The ornamental structure that guides the design of the *Garrison Diagram* effectively turns what has otherwise been considered a "graphic representation" of space (a depiction of the topography "out there" in three dimensions) into a "graphic diagram" of space (a topology in two dimensions). Transposed onto the previous discussion of embroidery, I would argue that the conception of embroidery as capable of looking like an analog depiction despite being a digital technology also applies in the case of the *Garrison Diagram*, wherein an apparent representation of space is in fact the product of discrete points placed in relationship to one another rather than an external referent. On a macrolevel and as previously described, each curvilinear line is positioned among other such lines as a matter of graphic design rather than as a scaled projection of measured distances between mountains or rivers in nature. And on a microlevel, this means that each ornamental device attached to the apexes of the curvilinear mountain lines references each other rather than the natural features of mountains.

These set intervals further contort natural landforms into an ornamental pattern that emphasizes symmetry and repetition contained within the logic of the drawing. The application of human design to natural topography, however, does not mean that form is subjugated to function. Instead, as Patrick Maynard describes design symmetries, "bringing in pattern frees *form*—that essential difficult concept of drawing—from its usual confinement to object shape, contour, and boundary."[55] By turning on its head the expected topographic rendering of mountain ranges into a line (edges) evenly punctuated by apexes (vertices) loaded with topological value, the makers of the *Garrison Diagram* accomplished two tasks. First, despite the two-dimensionality of the ornamental devices (clouds and mounds) and the curves that connect them, topologically, the flatness of the vertices and edges, respectively, on the silk surface can be nonetheless homeomorphic to a three-dimensional topography, one that is albeit native to the diagram. Second, these ornamental devices transform specific, identifiable mountain ranges into elements of design that are infinitely repeatable and malleable and provide a graphic order to the composition. Like the embroidered clouds on Mawangdui silk textiles, where each stitch notates a discrete point set a certain distance from the next point, the mountain ranges similarly build a notational scheme within the *Garrison Diagram* that points to itself as opposed to the topography external to it. While we might be tempted to claim that the *Garrison Diagram* references things "out there," the mountain-range lines show that they instead reference things that are "in here"—"here" being the space built

from the formal elements of the drawing—by repeating the symmetry of the curves that wind through the entire drawing.

Stitching Mountain Ranges

Formally, the *Garrison Diagram* and *Topography Diagram* each present distinct symbols for mountain ranges—the former relies on a single, undulating line that is incrementally marked by a peak and three striated mounds, while the latter utilizes elongated forms that resemble modern form lines and contour lines but do not serve the same functions. In a single tomb, we are therefore privy to multiple symbols for mountains that were circulating in diagram-making circles during the Western Han.

Despite lacking the kind of rhythmic regularity presented on the *Garrison Diagram*, the mountain-range lines in the *Topography Diagram* similarly prioritize descriptive connections in their graphic lines over accurate depictions of actual land masses. As scholars have often noted, in the *Topography Diagram*, special attention was paid to mountain peaks in the form of little dots, crescent caps, or thickened arcs (see fig. 3.5). Although the modern transcription of the *Topography Diagram* does not distinguish between these different marks, their differences are quite visible on the actual artifact despite having been buried for thousands of years. What remains ambiguous, however, is what each of the three marks might reference. All three appear randomly along a single mountain-range line. Their sizes are, moreover, inconsistent: some dots are noticeably larger than others, while some crescent caps verge on semicircular.

In other words, each of these marks seems to reference nothing more than the graphic lines and their curvilinearity—the formal configurations on the page and not some referent in the natural topography beyond the drawing—since, for example, there is no clear sense for the modern viewer whether a dot or a crescent cap at the apex refers to a different kind of mountain peak. Instead, the graphic rhythm in the *Garrison Diagram* is reconstituted as a series of syncopated points along mountain lines in the *Topography Diagram*. These notations also effectively turn their viewers' attention away from the actual lines that connect two apexes toward the apexes themselves. They transform what might otherwise be interpreted as a depiction of a mountain range into a description of mountain tops that hold, at best, some basic connection to one another as they lie on the same line. How one moves from one "peak" to another is evidently deemed irrelevant in the drawing so long as there are peaks that string together to form a single closed circuit.

This topologic transformation of the mountain-range lines implies a third possibility to the processes of transference and tracing in embroidery patterns and graphic spaces. As I stated earlier, the *Topography Diagram* and

Garrison Diagram are products of long chains of survey, copy, and revision that involved a whole host of possible sources of information that range in form. From lists to charts, pictures to maps, the *Topography Diagram* and *Garrison Diagram* are probably collages of separate graphic renderings that each served, at one point, a number of functions—from organizing low-level administrative tasks to garnering high-level symbolic authority. The production of the *Topography Diagram*, like the *Garrison Diagram*, might have involved copying relevant parts of these renderings and piecing them together to construct a provincial-level terrestrial diagram. In addition to transferring chalk patterns and tracing brush-and-ink drawings as possible ways of copying, pouncing is another plausible technique that involves poking incremental holes along a pattern to make a template.[56] The template (complete with the pattern as holes) is then placed on top of the material on which the copy will appear, and using some mark-making implement, the holes are filled in, resulting in the transference of the holes (now, dots) onto the copy. To complete the transference, then, only requires connecting each of the dots. The pouncing technique makes it theoretically impossible to make an "exact" copy of a drawing, since it is, by definition, the digitization of an analogical line. Like the process of embroidering a previously brush-and-inked line, pouncing requires dividing otherwise continuous lines into discrete points. The closest any skilled artisan can get to an "exact" copy is by minimizing the distance between each poke.

What might this technique have to do with the *Topography Diagram*? I propose that the inked dots, crescent caps, and thickened curves on the apexes of the mountain-range lines were marked *prior* to the drawing of the actual lines. The fact that these accents denote nothing more than their placement along a continuous line suggests that they might have played a practical role in the production process. They were, in other words, conceived *not* as ornamental at the outset—excessive and mere decorative flair added at the end of an "accurate" representation of actual mountain ranges—but were instead the first step to the entire process of copying mountains from other drawings. Actual holes might not have been punctured into the previous drawings, but in the tracing process, perhaps only the apexes of mountain ranges were marked. When the diagrammers returned to these dots, they were left only with the task of connecting them. In this scenario, the exact curvature that links one apex with another is irrelevant as long as they are connected. In marking apexes in the process of transference, certain details, such as where one line ends and another begins, are transposed as a single dot, leading to situations such as the ones to the top left and top right of the Canshui label in figure 3.5, wherein two mountain ranges share a single peak (or valley) and two coterminous mountain ranges share a single curve respectively. As a final step in the completion of the mountain-range lines, depending on the shape of the dots during its initial transference, they

were accentuated in the final drawing—an ornamental facade that masked their original, practical function.

A Box within a Box within a Box

Both the *Topography Diagram* and *Garrison Diagram* are underpinned by an ornamental structure that transforms a would-be graphic representation of space—a map—into a more inclusive diagram of space wherein precise measurements give way to the importance of graphic positions and relations between discrete formal elements. It is through this topological transformation of space that the *Topography Diagram* and *Garrison Diagram* perform broader functions associated with diagramming and not only mapping. An examination of silk embroideries from the Mawangdui tombs provides another example of topology at work. The embroidered line that looks continuous from afar is ultimately composed of lines that connect discrete points. The transformation of topography or a painted image into graphic topologies becomes a visible aspect of the two drawings and silk embroideries if we shift our attention to their production.

The silk artifacts, however, are not the only examples of topology at work in Mawangdui tomb 3, with other examples also participating in the project of worldmaking for the afterlife. From the black lacquer box that held the silk manuscripts to the physical tomb itself, Mawangdui tomb 3 is an exercise in compartmentalizing meaningful moments from the deceased's life while gesturing toward the possibility of endless connections that can be drawn between them in hopes of generating an auspicious world in the afterlife.

The two terrestrial diagrams were found folded in an undecorated, black lacquer box measuring 59 cm long, 37.5 cm wide, and 21 cm deep, along with another seventy-seven more intricately decorated lacquer artifacts (fig. 3.12).[57] The lacquer box's lack of embellishment disguises its laborious production process, a process that was used to produce only thirteen of the 319 lacquer artifacts excavated from the site.[58] Instead of containing a wooden core, the black lacquer box was built around a core of ramie cloth (*jia zhu tai*). The process entails first constructing a wooden core mold on which layers of cloth dipped in a mixture of lacquer, sand, and dirt would be placed. Once dried, the wooden core was removed, leaving only the thin cloth core. Multiple layers of lacquer would then be successively applied. This process produces a lighter artifact that is less susceptible to warping by eliminating the shrinkage and expansion of wood under different weather conditions. The box contained two stacked trays. The bottom tray was subdivided into five compartments and held the deceased's library in bamboo and silk. The silk manuscripts were either rolled on a wooden rod or folded, as in the case of the two *ditu*.[59]

FIGURE 3.12 Excavation photograph of the black lacquer box from Mawangdui tomb 3. Reproduced by permission from the Hunan Museum.

The black lacquer box is not only a container for the precious documents attesting to deceased's desire to be buried with his library—a wish that portrays the buried individual as a learned gentleman or, at the very least, keen on presenting as one in the afterlife—but also what brings the manuscripts together as a library or a collection.[60] Collections rely on boundaries (at times in the physical form of boxes, shelves, or compartments) and a "principle of organization" that determines the (in)finitude of the collection as it serves to "naturalize" any object into "the landscape of the collection itself."[61] Like a list, the power of the black box lies in its ability to build a (scholarly) world—a frame of reference—for the deceased.

FIGURE 3.13 Excavation photograph of Mawangdui tomb 3. Reproduced by permission from the Hunan Museum.

The manuscript lacquer box is just one of many boxes that appear in the tomb, the largest of which is the overall tomb structure (*guo*) divided into parts, with each tomb chamber holding other collections of objects (and boxes) attuned to the deceased's conception of himself in life and death.[62] There is no way in and no way out of this giant box filled to the brim with objects. The ramp that probably facilitated the movement of burial goods into the burial chambers hits 0.4 meters above the lid of the *guo* in tomb 3.[63] The *guo* was constructed as a self-contained, self-sustaining entity upon its closure. At the center of the *guo* were a set of three coffins (*guan*)—boxes within boxes (fig. 3.13). The three nested coffins were wedged into the central chamber of the *guo*, collapsing the space underground to leave no wiggle room. The occupant in tomb 3 rested in three coffins that clung to each other

with barely any room between them. The care put into the construction of such perfectly nested coffins speaks not only to the careful measurements and craftsmanship necessary to make such tightly nested coffins but also the importance of eliminating space in this tomb that demanded such invested labor.

While horizontal, underground palaces popular among the elite in mid to late Western Han might represent the topographical arrangement of palatial space above ground and therefore propose a similar or scaled conception of space, in Mawangdui tomb 3, space is compressed to include as many artifacts as possible.[64] Moreover, this compression of space—without reference to the way space might operate among the living—provides each entombed collection the freedom of coalescing based on "principles of organization" independent of the world of the living and the possibility of engendering new worlds. To suck the air out of Mawangdui tomb 3 and pack its individual chambers with a wealth of goods is to imply never-ending possibilities in the generation of connections and functions for the burial artifacts. How far one object is located from another or whether it is physically possible to maneuver within spaces is irrelevant so long as there are enough artifacts to conjure potential connections between them to make worlds within worlds: the worlds of the terrestrial diagrams housed in a lacquer box world that is, in turn, fitted within a tomb chamber world, all for the purposes of ensuring an auspicious afterlife for the deceased, a subject to which the next chapter turns.

Mawangdui and the Art of Strategy

As I suggested in the previous chapter, the *Garrison Diagram* (figs. 3.1 and 3.2) and the *Topography Diagram* (figs. 3.3 and 3.4) makers transformed natural topography into an ornamental pattern for the purposes of broadening the drawings' possible functions beyond mapping. This chapter specifies one such function vis-à-vis their deceased owner—the making of an auspicious world in the afterlife. I argue that the tomb occupant, a man invested in Changsha's military affairs during the early Western Han dynasty, conceived of auspiciousness as predicated on specific notions of military success that were articulated in excavated military treatises dated to his lifetime and military divination texts discovered in the same lacquer box as the two terrestrial diagrams. As these contemporaneous texts explain, success on the battlefield depends on the strategic positioning (*shi*) of troops in the natural terrain and ritualized forms of human intervention that correspond with heaven and earth, both of which do not rely on accuracy but rather on positionality. In this chapter, I suggest that the terrestrial diagrams function as auspicious images, with auspiciousness defined as the most advantageous spatial configuration of humans among the natural landscape to produce good outcomes.

Scholars have long disputed the specific identity of tomb 3's occupant as either Li Xi, the older son of Li Cang (the marquis of Changsha buried in tomb 2), or Li Xi's brother. Regardless of his name and birth order, scholars typically agree that he was involved in the military affairs in the Changsha region. Many artifacts from tomb 3 support this conclusion. Archaeologists found thirty-eight weapons buried in tomb 3, but none of them would have been functional in battle. Other than a few component parts, the weapons were made from either animal horns or lacquered wood. Two crossbows, for instance, were made of wood and painted with lacquer, and two swords

were made of ox horn.[1] The weapons' materiality, which rendered them impractical for inflicting lethal harm, identifies them as *mingqi* or "spirit articles" produced for the purposes of burial.[2] Further supporting evidence for the identity of the deceased includes a silk painting hung on the western wall

FIGURE 4.1 *Procession of Chariots and Horses* (Chema yizhang tu), Western Han dynasty (206 BCE–9 CE), excavated from tomb 3 at Mawangdui, Changsha, Hunan province. Ink and pigment on silk, 94 × 212 cm. Reproduced by permission from the Hunan Museum.

142 CHAPTER 4

of his *guan* coffin. The silk painting, which measures 2.12 m. long and 0.94 m. wide, is divided into four parts.[3] Each section of the painting is composed of chariots, horses, cavalrymen, and soldiers arranged neatly in columns and rows and drawn from an aerial perspective (fig. 4.1).[4] The one exception, in

the upper left, is a group of enlarged human figures. The archaeological report identifies the leader of the pack as the buried individual, who is about to walk up a nine-step platform. Iconographic studies of this painting abound, with scholars positing different meanings for the painting: a visual exaltation of the entombed individual's military accomplishments,[5] a visual narrative of a funerary procession,[6] a depiction of an extravagant agricultural sacrifice to show the Dai family's wealth and power,[7] and a military exercise led by the deceased during the heyday of his career as a military general.[8]

Despite strong evidence gleaned from his burial appurtenances, the military background of the individual buried in tomb 3 has met resistance from scholars such as Hsing I-tien, who, as I mentioned in the previous chapter, argues that the presence of these two terrestrial diagrams in tomb 3 does not necessarily imply that the entombed individual was affiliated with the Changsha army. Hsing's argument is partly based on the fact that the omission of significant information—detailed topographic renderings and information on enemy territory and troops on the *Garrison Diagram*, for instance—suggests that the drawing must have been an administrative map rather than one used expressly for military purposes.[9] While the argument put forth in this chapter also rests on these visual silences, I diverge from Hsing's interpretation of the drawing's function by highlighting the ways in which the absence of certain topographic details discloses other sorts of information that nonetheless support the importance of military affairs for the deceased. Rather than accuracy in measurements, consistency in scale, or likeness in form, the entombed individual considered the art of military action as a path to a successful afterlife. In other words, the mapping function of the drawings does not speak to their owner's military affiliation. Instead, their more general diagrammatic functions reveal the owner's belief that military success plays a vital role in death. Even if the tomb occupant was not an active member of the military, he nevertheless saw the *art* of war as a potent image of auspiciousness.

The art of the terrestrial diagrams in a world of the dead requires conceiving these drawings as "strange." For Alva Noë, "Art is interested in removing tools . . . from their settings and thus in making them strange. . . . A work of art is a strange tool, an alien implement. We take strange tools to investigate ourselves."[10] This form of investigation constitutes a second-order reorganization by taking as its source material "first-order activities that organize us—walking, talking, singing, thinking, making, and deploying pictures for this task or that."[11] The Mawangdui terrestrial diagrams are a type of picture that displays basic military units required for successful combat (such as garrisons and a command center) even if the organization of these elements on the silk surface is not an accurate depiction of reality. However, because of its ultimate resting place in a tomb, the inability to

enact the troop formations or conduct the rituals incumbent on military personnel before a campaign inhibits this first order of activities for the deceased. Instead, the functional aspect of these diagrams is in the second order wherein the Mawangdui terrestrial diagrams prompt their beholders—the deceased owner and modern viewers—to consider the "strangeness" of their configuration and what it might reveal about the people who made and used them.

Art of War

On the *Topography Diagram* and the *Garrison Diagram*, conscious design is revealed through the insistence on symmetry and repetition and the marking of increments along mountain-range lines. It is the strategic positioning of the formal elements on the two diagrams that discloses the art of military strategy. I think the modern Chinese term for "design" (*sheji*) warrants a brief digression here, as its early Chinese usage, which mostly relates to warfare, conjures a different set of references than its modern connotation. The earliest textual mention of *sheji* can be found in the *Sanguo zhi* (*Records of the Three Kingdoms*), a third-century CE text that recounts the historical events of the late Eastern Han (25–220 CE) through the Three Kingdoms period (222–263 CE). The term was used to mean "to plot" or "to scheme" an entrapment.[12] Before the *Sanguo zhi*, the two characters *she* and *ji* appear in a number of transmitted texts and hold different philological roots, with *she* offering the most insight into the concept of design in early China. The first-century CE character compilation *Shuowen jiezi* (*Explaining Graphs and Analyzing Characters*) defines *she* as "to present an arrangement" (*shi chen ye*), or, as I would argue, "to design," since to *she* requires making visible (*shi*) an articulation of positions (*chen*) in an arrangement.[13] However, as Qiu Xigui argues, in excavated texts, *she* is often used interchangeably with another character, *yi*. According to the *Shuowen jiezi*, *yi* means to "to plant" (*zhong*).[14] Just as to *she* requires the establishment of positions, to plant similarly requires systematic planning and placement.[15] As Qiu argues, the semantic and phonetic similarities between the two characters have yielded significant errors in the transcription of excavated texts in modern sources wherein instances of *yi* have been mistakenly transcribed as *shi* rather than *she*, the former of which will be of concern for us in this chapter.[16]

The philological similarities of *she*, *yi*, and *shi* is at the heart of the two drawings because they diagram strategy with an emphasis placed on position and placement in their designs (by definition, *she* and *yi*) rather than mapping actual distances or altitudes in the natural topography. While our modern sense of military maps might demand more precision in terms of

distance or scaled projections in planning offensive and defensive strategy, the usage of terms such as *she*, *yi*, and *shi* suggests that in the early Chinese understanding of military success, relative positionality was just as important.

How to Win a War

Military treatises signal the importance of strategic positioning, like that found in these terrestrial diagrams, to higher-level military strategy. A text that speaks to the primacy of strategic positioning vis-à-vis the natural terrain is *Sunzi bingfa* (*Sunzi's Art of War*), which is often attributed to an elusive historical figure by the name of Sun Wu who was alive in the Spring and Autumn period but was probably the work of multiple people across the late Warring States period.[17] While a copy of the text was not found among the bamboo slips and silk manuscripts in Mawangdui tomb 3, we know that it was in circulation in the Western Han since a version was excavated from tomb 1 at the site of Yinqueshan in modern-day Linyi, Shandong Province.[18] Discovered alongside *Sunzi bingfa* was another military treatise, *Sun Bin bingfa* (*Sun Bin's Art of War*), previously known only through its mention in the "Bibliographic Treatise" in the *Hanshu* and attributed to followers of the military general Sun Bin, a military strategist of the Warring States period. Based on its burial artifacts, which include Western Han coinage, archaeologists date Yinqueshan tomb 1 to some time between 140 and 118 BCE and surmise that while the military treatises from the tomb originated in the Warring States period, the buried versions were probably copied during the early Western Han dynasty.[19]

Each character transcribed as *shi* in modern sources appears as *yi* on the Yinqueshan bamboo slips, serving as evidence for the clerical script character *yi* as the equivalent of *shi* in some cases despite also standing in for the character *she* in other instances. The notions of visible arrangement (*she*), plotting or planting (*yi*), and position (*shi*) all make an appearance in the concept of *shi* as mobilized in the *Sunzi bingfa*. In the text, *shi* refers to "disposition or strategic position,"[20] as Michael Nylan translates, for the purposes of "wresting advantages from conditions at hand and controlling contingencies."[21] A crucial step in establishing positions requires first knowing the lay of the land, since the natural terrain serves as the template on which a military commander places his troops. The chapter "Conformations of the Land" ("Dixing") directly addresses the importance of knowing the topography as a first step in acquiring success. While the transmitted chapter "Conformations" is missing in the Yinqueshan finds (only a title slip suggests its presence at one point), eight slips that archaeologists have grouped together as a variant on the transmitted chapter outline some basic terrestrial guidelines akin to that of "Conformations."[22] Notably, slip 160—the first of

the eight strips, identified as such because of a title, *Dixing er*, inscribed on its back—contains the following cardinal orientations that match the two Mawangdui *ditu*: "[As for] the topography, east is to be on the left, west is to [the right]," which implies that south is positioned at the top and north at the bottom.[23]

This brief description provides the spatial orientation of the six kinds of land listed at the beginning of the transmitted "Conformations" wherein different natural formations prescribe certain military actions. For instance, "hanging," or *gua*, land "describes lands where advance is possible, but return is hampered,"[24] and in the case of "defiles," or *ai*, "should your enemy occupy the defile first, filling it with *his* men, never go after him. However, if he fails to fill the space within the pass, go after him."[25] An example of hanging land might be a precipice, where, with enemy troops chasing closely behind, the only option is to engage in a frontal attack since there is no retreat other than to fall to one's death. If enemy troops fill a defile—enclosed on both sides by the sloping sides of hills or mountains, which the text urges not to scale even in dire circumstances—there is nowhere to run other than to engage within the narrow pass. It is most prudent, as the text warns, to run away and not toward one's enemy when caught between a rock and a hard place.[26] While cause and effect in "Conformations" stems from six kinds of terrain that mandate six types of military action, the chapter "Nine Kinds of Ground" ("Jiu di") (present among the Yinqueshan finds) operates in the opposite direction: military action and outcomes determine the kind of terrain.[27] For example, among these nine kinds of ground, "whenever the incursion into the enemy territory is not deep, it is 'land taken lightly,'" or *qingdi*,[28] and "contested ground whose occupation confers an advantage to either side, theirs or ours, is 'land worth fighting for,'" or *zhengdi*.[29] The two chapters, however, with the first arguing for topographic features as determining proper military action and the second categorizing types of land based on advantages and disadvantages to troops, are inextricably tied to a more fundamental understanding of the role of a commander: if he "does not know its mountains and forests, its passes and defiles, its wetlands—[he] cannot deploy an army on [the land]," and "unless [the commander employs] local scouts, [he] cannot take advantage of the terrain."[30]

To know which positions and actions to take during an attack requires first knowing the natural terrain. "The best commander," the *Sunzi bingfa* declares, "assesses the enemy's position and creates the conditions for victory. He analyzes the hazards and calculates distances. Applying his understanding of such factors to the battle at hand, he is certain to win, but should he disregard them, he is certain to lose."[31] Notably, however, the *Sunzi bingfa* does not provide the actual know-how for commanders "to calculate" (*ji*) distances of the terrain despite claiming its importance as the first step to

victory. In the chapter "Forms" (*Xing*), the text explicitly hierarchizes the steps of the art of war: "The terrain leads to measurements; the measurements lead to estimates; the estimates lead to calculations; the calculations lead to weighing the options; the weighing leads to victory."[32] The text treats the measuring of the terrain as a technology: a tool to be wielded by its users to deliver the kinds of results they desire. But in foregoing details on actual measurements or how to take them, the text is not interested in being a technical manual that describes the lay of the land as a military technology. Instead, in tethering natural topography to the human activities of estimating, calculating, and weighing, the text explains to its readers the importance of "reading" topography as a set of organizational principles within which humans must ask critical questions about how they should reorganize their formations to best take advantage of the technology. Thus, *Sunzi bingfa* posits an *art* and not techniques.

While practical military strategy requires measurements of the land, the text suggests that the art of war requires land to be typologized based on human action—the kinds of terrain that a commander might encounter in enemy territory in plotting an offensive attack but also the terrain in which one's garrisons are situated to best organize one's defensive strategy. This terrestrial epistemology built from prescribed military action also appears in the excavated fragment of the "King's Army" (Wang Bing) text from Yinqueshan, which shares many of the same lines from the "Seven Standards" ("Qifa") and the "Terrestrial Diagram" ("Ditu") chapters of the *Guanzi*. This brief passage once again characterizes the work of the commander as requiring a close examination of the natural topography, with the understanding that when topography has been made legible, a commander need only place his troops according to the general structure extracted from the natural terrain rather than its exact morphology:

> Examine forms of the land, select capable officials, measure abundant stores, assemble brave soldiers, investigate and know all under heaven. . . . [Manage] technical calculations, and diagram dangers and obstacles [in the terrain]: dangers of boats and chariots, water that immerses wheels, mountains, highlands, valleys, wetlands, reeds, level lakes, salt marshes, lowlands, mudlands, large fields, deep foundations, arterial waterways, lower marshes, depths of water deep and shallow, towns small and large . . . [,]then [one] can march armies and surround towns. In actions and patterns of behavior, [one] can know what comes before and after without losing territorial advantages.[33]

In "King's Army," a successful military campaign once again requires diagramming these categories of natural obstacles, for only by knowing the lay of the land can armies successfully position themselves within it—

topography and human intervention are again inextricable.[34] After all, as the *Sunzi bingfa* advises, to "know the enemy and your own" is only half the battle; "know the terrain and timing, and the victories will be total."[35]

Lines of Defense

When compared with the *Sunzi bingfa* and "King's Army," the two Mawangdui drawings put forth a similar art of war that depends on relative positions and basic distinctions between types of terrain more than tracking measurements of distance and height. To take an example, we can turn to the placement of the garrisons on the *Garrison Diagram*. As Hsin-Mei Agnes Hsu and Anne Martin-Montgomery posit, the *Garrison Diagram* manifests a defensive position on the part of Changsha principality.[36] While the *Sunzi bingfa* and "King's Army" provide an outline of offensive military strategy, we can assume that whether on the offensive or defensive, a commander must know the natural terrain of his and his enemy's territory in order to strategize. Indeed, the *Garrison Diagram* similarly emphasizes the topological organization of garrisons amid the pattern of the natural terrain without divulging any additional details on their precise locations or distances from specific mountains or rivers.

All garrisons are labeled and enclosed in rectilinear frames. They fall into four groups (fig. 4.2). The first group consists of three garrisons led by a field commander with the surname Xu (*Xu du jun*) that occupies the southwestern corner of the drawing and its single detachment (*Xu du wei bie jun*) located in the southeastern corner (labeled *A* in fig. 4.2). These four garrisons form a first line of defense along the southern border. Two garrisons under the leadership of the field commander Zhou (*Zhou du wei jun*) and its detachment (*Zhou du wei bie jun*) are placed closer to the center of the *Garrison Diagram* (labeled *B* in fig. 4.2), with the former lying just across the river from the triangular command center and the latter a ways south of the river and north of field commander Xu's detachment unit. A third group of two garrisons led by Sima (*Sima de jun*) occupies the northeastern quadrant of the drawing (labeled *D* in fig. 4.2). A single garrison is stationed just outside the eastern boundary of the territory and labeled *Guiyang jun* or "troops of Guiyang" (labeled *E* in fig. 4.2).[37] Most scholars have rigorously and rightly pursued an identification of these garrisons as a means of dating the drawing,[38] defining it as either an administrative or military map,[39] and locating more precise locations for the garrisons among the rivers and mountains.[40] Hsu and Martin-Montgomery, with the help of GIS, outline the historical narrative embedded in the *Garrison Diagram* through an analysis of its inscriptions that record "three phases representing tactical planning and periods of time."[41] Their analysis is a welcome intervention into primarily spatial accounts of the *Garrison Diagram*.

FIGURE 4.2 *Garrison Diagram*, Western Han dynasty (206 BCE–9 CE), excavated from Mawangdui tomb 3. Ink and pigment on silk, 98 × 78 cm. Labels by author. Photograph reproduced by permission from the Hunan Museum.

Another temporal axis that can be traced based on the *Garrison Diagram*'s graphic symbols rather than its inscriptions is the process by which the *ditu* was drawn. Formal details of the garrisons supply evidence for its drawing process: only after establishing the pattern of mountains and rivers—a process discussed in the previous chapter—did the *Garrison Diagram* makers decide where and how to place the individual garrisons. What guides the placement of these military units, in other words, is less a matter of their actual location in real space, but their role within the graphic design of the drawing.

Examples that highlight these compositional considerations can be found throughout the *Garrison Diagram*. On the left-hand side of the drawing, the Sima garrison looks as if it were an extension of a military outpost labeled *she zhang* (fig. 4.3). The characters of the garrison label occupy only the left side of the rectangular frame. The label, however, is doubly bound; a curve in a mountain-range line provides a second frame, nudging the characters toward one side. The triangular peak in the mountain-range line also perfectly aligns with the left side of the character *ma*, as if providing a left-hand margin for the character. A similar design consideration that places garrisons based on a terrestrial structure appears in the Zhou detachment unit located near the center of the drawing. It is framed by a rectangle with two elongated curves cut out from two opposing sides (fig. 4.4). A cutout from the box follows the curvature of the three mounds that protrude from the apex of the mountain-range line. With no hint of another mountain range or river that might have contorted the garrison frame on its left side, the left-hand cutout seems to mirror the right-hand cutout for the sake of symmetry rather than as a representation of the garrison's actual layout. In one last example, in the upper right-hand corner of the drawing, the *Xu du jun* label is superimposed on a mountain-range line (fig. 4.5). Unlike the mountain-range line that creates a second frame for the *Sima de jun* label (see fig. 4.3), this mountain-range line cuts neatly between the two columns of text, with its three mounds occupying the empty space left by a three-character inscription divided into two columns.

Each of these instances that manifest deliberate design (*she*) decisions contains a twofold function. On the one hand, the garrisons' arrangement and placement among the mountains and rivers gesture toward the importance of strategic placement (*shi*) within the natural terrain and manifest the importance of knowing the lay of the land before a commander arranges the proper positions for his stations. On the other hand, the attentiveness to graphic design rather than representational accuracy makes visible the shared foundation of design, strategy, and diagram in early China: they all depend on discrete positions that rely on certain topological principles. The connections and correspondences between these positions remain regardless of unforeseen circumstances that may happen between them.

FIGURE 4.3 Detail of Sima garrison from the *Garrison Diagram*.

FIGURE 4.4 Detail of Zhou detachment unit from the *Garrison Diagram*.

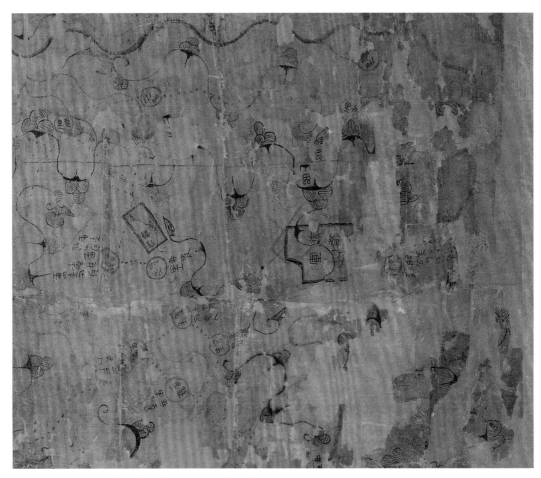

FIGURE 4.5 Detail of Xu detachment unit from the *Garrison Diagram*.

Art of Auspiciousness

While the *Sunzi bingfa* proclaims the importance of premeditated strategy in warfare, it simultaneously offers two qualifications: (1) strategy should not be equated with predictability, for predictability is the enemy of success, and (2) as such, there is a higher order that dictates the success and failures of war beyond human control. With regard to the first qualification, the text posits only two main battle strategies—"the surprise and the conventional"[42]—but when they are used in combination, they yield myriad variations to simulate the variety and inexhaustibility of heaven and earth.[43] Like the capriciousness of natural phenomena, a successful military commander understands the inevitability of contingencies, and when confronted with such changes, the commander is prepared to (re)act accordingly.

To act according to the natural course of the sun, moon, and seasons and to prepare contingency plans in the face of an unknown enemy—both qualifications speak to a basic truth that every commander must keep in mind:

absolute human control is unattainable and thus impractical. Strategic positions come about through careful observation of natural conditions, but a commander should never underestimate what his opposition might counter in these circumstances or what curveballs nature might throw his way. A strong commander must then possess what I would crudely call a bottom line or what the *Sunzi bingfa* enumerates as the nine contingencies (*bian*) when confronted by unpredictable events, such as "paths he will not follow, armies he will not strike, walled cities he will not attack, terrain he will not contest, ruler's commands he will not accept."[44] Without these bottom lines, "even if [the commander] knows the conformations of the land, he will not be able to wrest advantages from the terrain."[45]

Accordingly, there are situations for which no amount of meticulous planning will suffice, especially when humans are involved. Thus, the *Sunzi bingfa* calls for ritual practices aimed at aligning human action with heavenly and earthly patterns. There is, I think, no better proof of this sentiment in the text than its advice for the fateful day when war is declared. "Close off the passes," it advises, "break tallies, forbid further contact with emissaries. Organize [the troops] in the palace and the ancestral temple, so that you may execute your plans."[46] As transmitted texts corroborate, as early as the Spring and Autumn period, military campaigns began in the ancestral temple with rites. Entire wars were segmented into a series of rituals in ancestral temples and beyond: when commanders received their charges, when troops were organized and weapons allocated, not to mention the rituals that were conducted during battle.[47] Mark Edward Lewis has written at length about the history and philosophy of war from the Spring and Autumn period through the Warring States period and the dramatic changes that occurred in the "role, distribution, and sanction of authority" of war from being "derived from service to the ancestral cult" to "the imitation of Heaven by a cosmically potent ruler," respectively.[48] While in the Spring and Autumn period, warfare was tied to kin lineages, the Warring States period saw rulers and commanders invoke their privileged power of seeing and imaging the patterns of heaven as a way of justifying, strategizing, and enacting war. By the Western Han, "every form of sanctioned violence that had defined the Zhou nobility had its ritual form," and specialists were careful to bring these rituals "into accord with the actions of Heaven and Earth and thereby claim a cosmic pattern for the conduct of human violence."[49]

The two Mawangdui terrestrial diagrams image this divine authority that holds sway over the success and failure of military campaigns. As much as a commander's strategic dispositions might win half the battle, wars are ultimately won when heaven is in the commander's favor. One need not look far to find evidence of this attribution of military authority to cosmic sources. As the excavated manuscript "The Features of Warfare" (*Bing rong*) from Mawangdui tomb 3 explains, "If warfare does not derive its form from

Heaven, warfare cannot be initiated. If it does not take Earth as its model, warfare cannot be managed. If this form and model do not rely on Man, warfare cannot be brought to a successful conclusion."[50] This passage underscores warfare as not wholly a human endeavor but rather, as Robin Yates summarizes, "as a rite, and [it] was thought especially appropriate to divine about, because it involved matters of life and death in which the outcome, and survival itself, was in the hands of the ancestors, gods, and spirits, and subject to hemerological taboos like all culturally significant activities."[51]

As I discuss below, the ornamental program of the *Topography Diagram*—the rhythmic striations that fill the spaces between mountain-range lines and their accentuated peaks—is an extension of the decorative attributes applied to the ritual site of Mount Jiuyi, the most prominent mountain range in the terrestrial diagram and the resting place of the mythical Yu the Great. Furthermore, the *Garrison Diagram* makers imaged heavenly endowed auspiciousness by bracing the natural terrain within an elaborate system of clouds—a pattern that follows an ornamental topology discussed in chapter 3. By generating a ritually efficacious ornamental program for the *Topography Diagram* and applying an auspicious cloud trellis across the rendered territory in the *Garrison Diagram*, their makers diagrammed a world of military success in accordance with heaven and earth for the afterlife.

Topography Diagram as Ritual

The most prominent motif of the *Topography Diagram* is Mount Jiuyi (*Jiuyi shan*) (the curvilinear shape seen in the center of fig. 4.6), an identification secured by the textual label *dishun* found embedded in the right side of the mountain that refers to the mythical Emperor Shun, who was believed to have been buried at the site. The textual label and the design of Mount Jiuyi suggest that imaging ritual is the primary function of the *Topography Diagram*.[52]

The *Topography Diagram* makers might seem to have used a proto-orthographic projection to render Mount Jiuyi. Its concentric circles arranged like fish scales seem to indicate the rise and fall of its mountain peaks and, as such, resemble modern contour lines insofar as each ring suggests a single altitude so that their nesting effect implies the differential heights of the mountain peaks. But on closer examination, these concentric circles do not function as contour lines, just as the hatchings do not in the other mountain ranges. In fact, it appears that the same design strategies employed in the other mountain-range lines are simply restructured to constitute the symbol for Mount Jiuyi. For example, the spaces between concentric circles are almost always equal. More care was clearly put into creating evenly spaced concentric circles than in scaling the actual changes in elevation for each mountain, just as attention was paid to ensuring that each of the

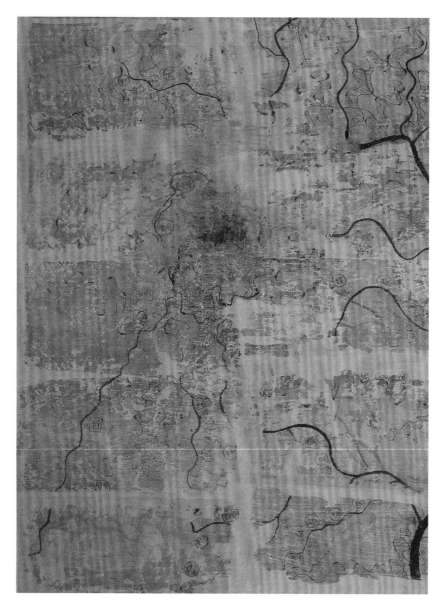

FIGURE 4.6 Detail of Mount Jiuyi on the *Topography Diagram.*

hatched lines within the other mountain-range lines was evenly spaced. Moreover, the apexes along the outer contour of Mount Jiuyi are thickened just like the apexes of the other the mountain-range lines. While formally distinct, the winding mountain-range lines and Mount Jiuyi partake of the same topological principles in their design: (1) the placement of interior rings and hatchings reference the internal order of the pattern rather than actual changes in elevation, and (2) the patterning of the mountains and the capping of apexes along the curvilinear lines highlight their spacing one after the next rather than actual distances between one peak and another. Going one step further, I think that this congruency in their ornamental

features suggests that the ritual function of Mount Jiuyi extends throughout the entire drawing.

The ritual aspect of Mount Jiuyi does not merely rely on the two-character textual label *dishun* but also on an overlay of two sets of columns that appear on the top and left sides of the mountain: one set of nine rectangular columns, evenly spaced and each segmented into three parts, and one set of seven evenly spaced columns at a ninety-degree rotation from the nine columns. These angular columns contrast with the rest of the amoebic form, signaling to their viewers a different type of structure, concept, or activity. Interpretations of what these columns might describe or depict run the gamut. The Mawangdui excavation team, for example, sees the nine columns as a symbol for the nine peaks of the mountain and the seven columns as recording the relative heights of the peaks.[53] Jiang Sheng argues that the nine columns chart the varying heights of the nine peaks.[54] You Shen views the columns as symbols of human-made structures similar to Emperor Shun's temple built somewhere in the mountains, since each column contains decorations added to each of their segments and each set is placed on a "ground line."[55] Most recently, Hanmo Zhang, in reidentifying the two-character inscription as *zongbi* or "ancestor and ancestresses," argues for the two sets of columns as mostly likely "symbols of the mountains" that hold significance for the deceased's lineage as a way of further proving the "otherworldly life usually associated with immortality"[56] that the deceased hoped to partake in after death.[57] Underpinning each of these possibilities is the understanding of Mount Jiuyi as holding some kind of significance beyond the mere mapping of three-dimensional space onto a two-dimensional surface. They share the same basic assumption that the design of Mount Jiuyi clearly establishes ritual significance for the deceased.[58]

The variety of modern iconographies—from topographical data and a specific ritual structure to a symbol of ancestral lineage—emblematizes the different ways a single form can reference. To examine the mountainous motif through the lens of design offers an additional alternative, one that nonetheless reifies its ritual significance and extends it to the entire diagram.

Cloud-Pictures

The two terrestrial diagrams indicate that in the early Western Han, there were multiple motifs for mountains: some that make a ritual space as in the case of the *Topography Diagram*, and others, like the *Garrison Diagram*, that picture cloud-worlds to image an afterlife of eternal success.[59] In the *Garrison Diagram*, cloud scrolls are attached at both ends of all mountain-range lines. While the presence of clouds compromises the accuracy of the *ditu* measurements by taking up precious space, clouds manifest the alternative function of the drawing as an auspicious omen. One example of military

strategy benefiting from or structured by the auspices of clouds is the location of the arsenals in the northwestern quadrant of the territory, where security—consisting of only a mountain range and two garrisons—is surprisingly light when compared to the southern and eastern areas.[60] This region is also sparsely populated, with only one of three towns suggesting that it was still occupied and the other two labeled "presently no inhabitants" (*jin wu ren*).[61] Nestled within a river bend, two interlocking mountain ranges house four arsenals labeled *jia* that contain different sorts of weapons: two arsenals labeled *jia gou* for metal weaponry, one labeled *jia ying* for horse tack, and one labeled *jia you* for archery equipment (fig. 4.7 and locations labeled *C* in fig. 4.2).[62]

The defining feature of the arsenal symbol is a series of triangular peaks, outlined in black and filled in with red, hovering above or below the three mounds that appear on the apexes of mountain-range lines and bracketed by cloud scrolls. The placement of the arsenals on the *Garrison Diagram* discloses no practical information on the exact location of the weapons, the distance one might have to travel, or the height one might need to climb to reach them. Yet it clearly describes the proper placement of weaponry somewhere among the mountains to prevent easy access. Additionally, these drawings highlight the critical importance of these arsenals. All of them are embedded where clouds and mountains meet, or more precisely, when clouds and mountains become one and the same. As the arsenal symbols attest, while strategic positioning is vital to military success, it is only half the battle. The rest relies on the ways in which earth resonates with heavenly patterns, a parallel epistemology of divination and omen reading implied in the philosophy of war as espoused in early texts.

In the Western Han imagination, cloud formations served as prognostications.[63] The "Treatise on Celestial Patterns" ("Tianwen zhi") chapter of the *Hanshu* describes the practice of "watching the cloud-vapors" (*wang yunqi*) to determine the proper time to engage in military action.[64] Important to this practice, however, is not only the act of seeing recognizable forms in the clouds but also picturing these forms. Shao Weng, an intermediary, for example, advised Emperor Wu (r. 141–87 BCE), "Unless your palaces and robes are imaged [*xiang*] after the shapes of the spirits, they will not consent to come to you," which led Emperor Wu to commission five chariots, each blanketed in cloud patterns (*yunwen*).[65] While this textual anecdote dates to a later period of the Western Han, the inclusion of the silk manuscript *Miscellaneous Prognostications on Celestial Patterns and* Qi *Phenomena* (*Tianwen qixiang zhazhan*) in Mawangdui tomb 3 supports the prevalence of omen reading and military divination in the early Western Han and, importantly, the significance of cloud-pictures to the buried individual (fig. 4.8).

The long silk manuscript, measuring 150 by 48 centimeters, is divided into six rows and includes drawings of clouds, rainbows, eclipses, comets,

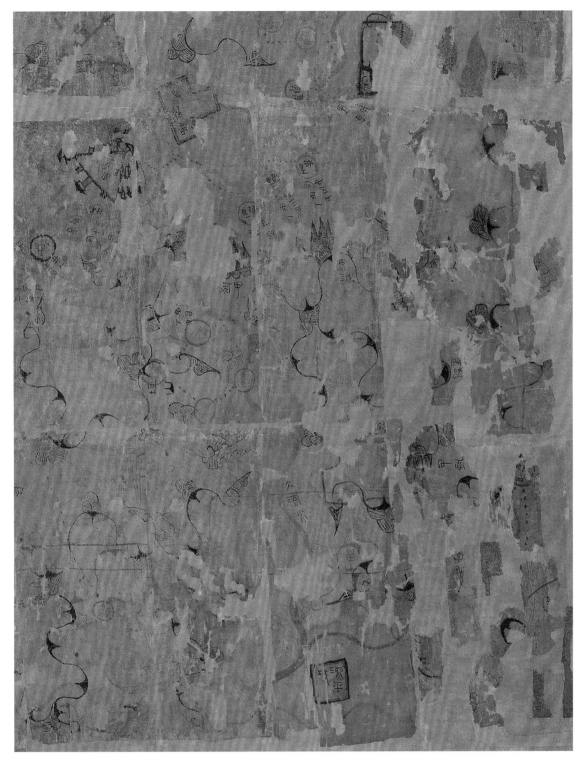

FIGURE 4.7 Detail of the northwest corner of the *Garrison Diagram* where the arsenals are located.

FIGURE 4.8 *Miscellaneous Prognostications on Celestial Patterns and* Qi *Phenomena* (Tianwen qixiang zhazhan), Western Han dynasty (206 BCE–9 CE), excavated from Mawangdui tomb 3. Ink and pigment on silk, 150 × 48 cm. Reproduced by permission from the Hunan Museum.

and halos and all their prognostications.[66] Chen Songchang dates the manuscript to between 195 BCE and 177 BCE and, along with other scholars, suggests that the version enclosed in the tomb was probably copied from earlier sources that trace their origins to the late Warring States period based on the organization of the clouds with the "Chu cloud" first and on the prognostic statements declared from a Chu perspective.[67] The three hundred fifty entries of "Miscellaneous Prognostications" begin with cloud drawings and textual labels that occupy the first row and continue into the first half of the second row. These labels often include military prognostications, as with a series of five silhouetted animals listed in the middle of the first row (fig. 4.9). On the far right, a tigerlike creature, with accentuated claws on its four feet, sharp teeth, and a striped tail, is accompanied by an inscription that reads, "If this appears over the town, [one will] not be able to retreat."[68] To its left, a pig with an angular snout that signals to its viewers the impending death of a general[69] is followed by a horse with the inscription, "If this appears over the army, there will be victory."[70] Following the auspicious horse, the drawings of a cow and a deer are both paired with dismal predictions: "If this appears over the army, there will be defeat."[71]

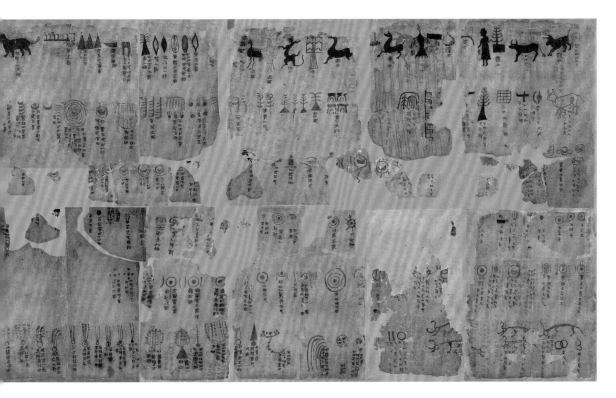

FIGURE 4.9 Detail from *Miscellaneous Prognostications on Celestial Patterns and Qi Phenomena.*

FIGURE 4.10 Detail from *Miscellaneous Prognostications on Celestial Patterns and Qi Phenomena.*

A survey of these drawings foregrounds two observations that support an identification of this silk manuscript as a *tu* diagram that, like terrestrial diagrams, carries multiple modes of reference. First, the mode of reference for each cloud pattern spans the entire spectrum from denotational to representational, with recognizable creatures, such as those listed above, alongside more schematic drawings (fig. 4.10). On the right side of the second column, for instance, there are cloud formations rendered in black ink that look like nothing more than simple patterning. A line drawing of a gridded square is followed by an inscription that proclaims success should such a formation appear in the sky: "If clouds are like this, battles [will be] victorious."[72] A few entries to its left, a cloud frames its inscription, with each of its right angles branching off one side of a long vertical line and housing a couple characters each.[73] While certain characters are unreadable, the first two characters name the cloud as a hook (*gou*). The labeling of an otherwise unrecognizable form also applies to the cloud formation to the left of the cloud-hook, where an arched frame houses two smaller linear configurations within it and is referred to as a bow (*gong*) in its label: to attack a town under the auspices of this particular cloud in the sky is bound to be successful.[74]

Second, the manuscript contains cloud animals that look quite similar. The first and the third creatures (from the left) in figure 4.9 look like kingdom of Wei's cloud formation near the beginning of the manuscript (see fig. 4.8). The cloud-cow associated with the kingdom of Zhongshan resembles the central creature among the five silhouetted animals that predicts defeat, not to mention the line drawing of another cloud-cow at the start of the second row that similarly predicts a loss of land in five days when it appears in the sky.[75] Their minute differences suggest that their portentous value is based on minor formal details, for example, in the direction of the animals' tails—perhaps an upturned curl for an auspicious horse, a simple down stroke for an inauspicious one, and a single uptick for the kingdom of Wei? Or, perhaps, a thicker tail on a cow to signal absolute defeat versus a feathered tail for the kingdom of Zhongshan and a thin single line for a loss of land? To notice the finest distinctions between the various cloud-images would imply that they function representationally; for every two cloud-horses depicted, there are infinite possible cloud-horses that have slightly different tails. But this is only one possible function for the drawings. One can only imagine how difficult it would be to differentiate between a thicker and thinner tail of a cow in clouds, and I doubt a Western Han diviner would want to confuse the two.[76]

The ambiguous status of these drawings as depictions—the problem of locating a fineness of distinction between them and what these distinctions might mean—leaves room for its descriptive function. As a notational diagram, the drawings provide a commander and his ritual specialist some wiggle room in their interpretation. They simultaneously hold enough distinc-

tive marks to suggest difference, thus depictive and representational, while maintaining enough resemblance to constitute a type, thus descriptive and notational. Depending on which aspect of the drawings one wants to make functional—the minute differences in their body parts or the general shapes in their bodies—the cloud-pictures reveal different kinds of information. As such, the manuscript's contemporary users can see in the drawings whatever is most beneficial for their circumstances by choosing which aspect of the drawings to make functional as prognostications.[77] In other words, these drawings function not as a "record of empirical observation in our modern sense of the term" but are "purposefully polyvalent so as to set observed phenomena into a larger scheme of significance."[78] The Han compilers of the manuscript, however, may have expressed a preference. Following all the drawings of clouds, halos, rainbows, and comets, the compilers transcribed a series of predictions unaccompanied by drawings. In reference to these inscriptions, they explain that the inscriptions that appear alone correspond to previously drawn diagrams.[79] By suggesting that users match the inscriptions with the drawings that appear earlier in the manuscript, the compilers encourage their viewers to see the diagrams as notational, with the minute formal differences between each drawing understood as subordinate to the underlying principles that connect them.

Whether functioning as representations or as notations, the point of these cloud-pictures is ultimately less a matter of viewers seeing them *as* representations of real cows, horses, or pigs but rather that all of these shapes are seen *in* clouds. As the "Treatise on Celestial Patterns" records, "Cloud vapours image [*xiang*] the mountains and rivers there, and the place where people collect,"[80] and later, "When the heavens open [to display] the objects suspended [in it], when the earth moves and tears apart, when mountains crumble and shift, when rivers are blocked and valleys are filled, when the waters bubble up and the earth grows, when marshes are emptied—these are visible images [*xiang*]."[81] Images, or *xiang*, according to the treatise, arise from natural phenomena, and they share their medium with the stuffs of heaven and earth. For cloud-pictures like those on Emperor Wu's chariots to be functional, they must be seen *not* as representations but as presentations.[82] The efficacy of the cloud drawings from "Miscellaneous Prognostications," conceived within the framework of the "Treatise on Celestial Patterns" passage, lies in their medium: a cloud-horse and not just any representation of a horse. The cloud-pictures in silk diagram image or *xiang* auspicious omens and, in turn, have the capacity to make auspicious worlds.

Thus, the most auspicious display of military success is not a representation of topography composed of mathematically precise, scaled distances between rivers, mountains, inhabited communities, and garrisons. Instead, it is the presentation of cloud-mountains that spatialize rivers, towns, and garrisons within its auspicious haze, turning each of them into cloud-rivers,

cloud-towns, and cloud-garrisons to make cloud-worlds. Seen in conjunction with "Miscellaneous Prognostications," the presence of clouds in the *Garrison Diagram* supports its interpretation as a drawing related to military affairs in constituting an aspect of the drawing that makes it function as a heavenly omen for success on the battlefield. The fact that these cloud-mountains are part and parcel of the *Garrison Diagram* signals their unmediated presence in the tomb, and, in turn, their presence makes a world of auspiciousness for the deceased underground.

Pictures like the Mawangdui drawings help us understand the visual culture in which they were made and used, but by the same token they also teach their viewers *what* and *how* to see. By imaging omens, humans fix what would otherwise be a rare, "momentary, evanescent thing," into visible and replicable pictures.[83] Buried underground, the two Mawangdui terrestrial diagrams made visual culture by presenting rather than representing a world; they effectively made auspicious worlds in the afterlife so that viewers believe themselves to be in the very presence of whatever is depicted, unmediated. Moreover, things, people, and importantly omens underground do not come and go but are instead fixed in place forever. The art of military success and the permanence of omens, together, compose a permanently auspicious image of the afterlife for the dead.

Conclusion

A single wooden board included in the eastern chamber of tomb 3 proclaims the following:

> In the twelfth year [of Emperor Wen] (i.e., 168 BCE), in the second month, which began on a day *yisi*, on day *wuchen*, the household assistant named Fen transferred [the goods] to the gentleman of the interior in charge of burial. [Fen] transmitted a batch of documents listing burial goods. As soon as the documents arrive, check [the goods according to the list], and report fully to the lord in charge of burial.[84]

The dating of tomb 3 to 168 BCE derives from the date included in the thirty-two-character inscription found on the wooden board, thus securing the place of this short inscription among the most valuable documents housed within the tomb. However, the inscription is valuable for another reason. Like the Fangmatan resurrection story, it evinces a Western Han iteration of an underworld governed by the same kind of bureaucratic structure as that of the living.[85] The living attendant, Fen, "transferred" the treasure trove of burial artifacts to the "gentleman of the interior in charge of burial" along with an inventory of the items for his consideration. This transference becomes more than an innocuous handing over of material goods but an

irrevocable moment in the life of the objects when they leave the hands of the living and are given to bureaucrats in the land of the dead. From that moment onward, these artifacts become forever enmeshed in a world of the dead and are no longer tethered to a world of the living.

This inscription conveys a death and rebirth for each artifact found in tomb 3, a death in the lives of the living but a rebirth in the afterlife of the deceased. By virtue of being transferred underground, these objects function in new ways that the deceased deemed necessary and amenable to his new identity in his afterlife. To claim that the two terrestrial diagrams kept in the black lacquer box in tomb 3 functioned solely as a map for actively planning military strategy or visualizing the Changsha territory would be to constrict the dead to his identity while living—a military official, a member of the Dai family—when his entire lifetime of twenty to thirty years (as shown through tests conducted on the twenty bones that remain of his corpse) is negligible in comparison to the eternity that he hoped to live in his afterlife.[86] His most exigent concern in the face of an afterlife could only be the hopes of success and auspiciousness regardless of how long he must remain in his underground abode, where this place might be, or how far he must travel. It is this wish that he hoped would come true with the help of the two terrestrial diagrams that make worlds of military success in accord with heaven and earth.

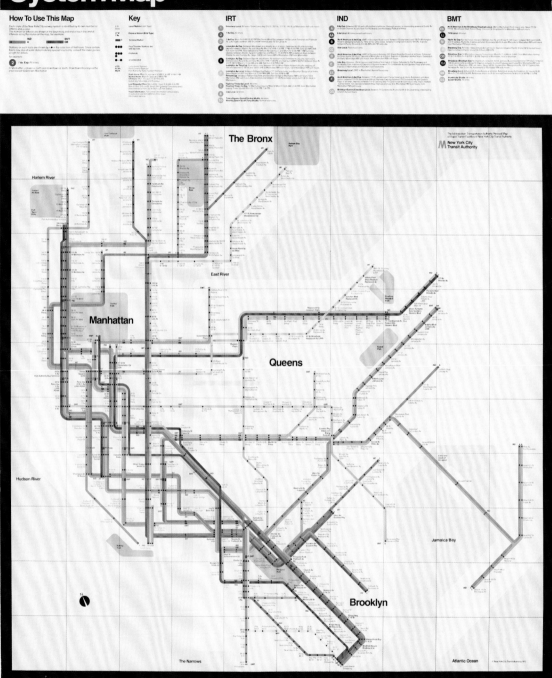

FIGURE C.1 Massimo Vignelli, Joan Charysyn, Bob Noorda, Unimark International Corporation, New York, *1972 NYC Subway Map*, 1970–1972. Lithograph, 149.9 × 118.7 cm. Museum of Modern Art, New York. © Metropolitan Transportation Authority. Used with permission.

Tunnel Vision

In 1972 Unimark International redesigned the New York City Subway Map by shifting attention from an "objective" view of a space to its "subjective" use as a place (fig. C.1). Inspired by Harry Beck's 1931 London Underground Map (see figure I.3), Unimark's modernist take on a then-tripartite subway system received and confronted equal parts praise and resistance. While graphic designers lauded the simplicity of the map, the city's residents were enraged by the transformation of their beloved five boroughs into a diagram of geometric forms. Unimark International designed the New York subway map to satisfy what they deemed to be its sole function—wayfinding from place to place, dot to dot. By amplifying subway routes with black dots strewn across brightly colored "spaghetti lines" projected onto horizontal and orthogonal planes and filtering out or manipulating all aboveground features for the sole purpose of accentuating the geometry of the lines (e.g., turning Central Park into a square and angularizing surrounding bodies of water), the redesign succeeded in realizing a vision of modernist design— form in full service of function.[1]

Unimark's New York subway map was replaced just seven years after its introduction. In 1979 the new subway map—a version of which is still in use in the city today—was deemed more representationally accurate than Unimark's diagram. Once again, this replacement received equal praise and criticism. For critics of the update, the question that lingered in their minds was this: the updated version is more accurate to what and for whom? Designed by Michael Hertz and Associates and guided by an MTA committee helmed by John Tauranac, the current New York subway map is unlike most metro maps around the world in that its lattice of subway lines is overlaid on top of a geographic map of the five boroughs. Yet its geographical accuracy is only

aspirational because its designers nonetheless distorted parts of the city to facilitate its usability. For example, the trunk line design, wherein multiple trains that run parallel to each other are consolidated into a single line, fails to resemble the actual, multitrack subway system. Trunk lines were devised to solve the problem of graphic congestion in certain denser parts of the city, but they failed to do so in all cases, thereby still requiring that the designers enlarge (essentially distort) parts of lower Manhattan and downtown Brooklyn to make room for the multiple trains and stations in these parts. In another instance, while the spacing between stations follows the streets laid out on the geographic map, the turns of each train as they move through the city were designed to match the designer Nobuyuki Siraisi's embodied experience when riding the trains with his eyes closed.[2] Despite the intention of making an accurate representation of the city, the subway map nonetheless succumbed to the subjective pressures of user experience in its design.

Tauranac justified the stylization of the curves by arguing that subway riders, in not being able to see where they are, could use their bodily movements to gauge where they might be.[3] His justification hints at the irony of a vision-based design of subway maps, an issue that Massimo Vignelli, the head designer at Unimark, foregrounds in his response upon seeing the new subway map:

> I hate this map. I see no reason whatsoever for curving and doing all this kind of thing. Who cares? You're underground, or you're above, you don't even know where you're going.[4] Who cares how the subway goes? And then trying to put the subway diagram over a geographic street map, is like trying to put five pounds in a one-pound bag, it's bound to break.[5]

For Vignelli, the graphic mess that resulted from reconciling a diagram and a street map is only half the problem. The other half is characterized by the strangeness of vision as a guiding principle of subway map design. About 60 percent of the New York subway is below ground, which means that, more often than not, riders do not see what the map claims they should be seeing. The other 40 percent of the time, riders are moving through space above ground but seeing it unfold in a manner distinct from any perspective that a geographic map provides. One could never see New York the way a subway map or any map represents the city. The current New York subway map may look more like *other* geographical maps of New York than the Unimark diagram, but when measured against the actual geography of New York, it is still inaccurate.

Unimark's subway diagram also was not immune to editorial decisions that went against its initial design, only those revisions operated in the other direction—to make the user-based design of the diagram more representational of the city's geography. In 1976 the designers were asked to move the

station at 50th Street and Broadway from west of Eighth Avenue to its east in order to reflect its actual geographic location. Despite knowing that the station was put in the "wrong" place on the diagram, Vignelli and his team put the station on the west side anyway for purely design reasons: there was more room for the text there than on the other side. While for some viewers this placement was a mistake, "under the rules of designing a diagrammatic transit map, its position was valid."[6] For a rider on the 1 train, the diagram clearly shows the order of the stations. Underground, no one can see on which side of Eighth Avenue the train is located. Equipped only (literally) with tunnel vision, she sees Penn Station, 50th Street, and then, the next time she emerges into the light, Columbus Circle. The Unimark diagram, for all its geographic inaccuracies and failures as a representation of New York City, captures the experience of seeing underground—blips of light with swathes of darkness in between.

As topological drawings, each terrestrial diagram in this book was also designed with tunnel vision, for they, too, were made by people who could not account for every experience of their user base. And when they were buried underground, these drawings guided a dead audience in early China from point to point along their postmortem journey through a world homeomorphic to the one they were used to above ground. Unlike subway riders, who expect to be greeted by light after a short duration of time, the makers and users of these terrestrial diagrams were clueless as to how long the darkness would last or what might greet them at the next stop. To harness the unknowns, the makers of the terrestrial diagrams made sure that these moments of blindness were filled with graphic elements that present an auspicious journey even if it meant that their morphologies deviate from places above ground. The lack of crucial measurements on King Cuo's mausoleum diagram made room for the strict symmetry that ordered the afterlife and the additional layers of legal and ritual prescriptions that prove far more important in death. The emphasis on material process rather than representational accuracy in the Fangmatan drawings formalized space into a series of lines that operated like paperwork familiar to the occupant of the tomb when he was alive. When the drawings were buried, regardless of what the afterlife might look like, the deceased could rest assured that he knew how to navigate the system. In formalizing the journey from one inscribed "station" to the next by way of an ornamental structure, the makers of the Mawangdui terrestrial diagrams ensured that no matter how long it took to get from one place to another or what topographical feature stood in the way, the deceased would only be met with success.

Early Chinese terrestrial diagrams were fitted for the diverse functions that the living and the dead needed them to serve and the worlds that were built from them. In each of these instances that were ultimately buried, what the dead could see would be familiar enough—the lingering shadows

of reference materials consulted during the (re)making of these terrestrial diagrams. But even in moments when seeing was impossible, the dead would be comforted in knowing that in darkness they were safe and that there would be, eventually, a light at the end of the tunnel. A postmortem journey equipped with a diagram governed by the logic of tunnel vision characterizes the function of the diagram with which this book began (see fig. I.1). Unlike the relatively low stakes of merely having to squint our eyes from the discomfort of emerging from a dark underground station to one above ground in the sun, the diagram depicts and describes the dramatic experience of traversing worlds of the living and the dead across a sea of visual silence.

Complications with this diagram begins with the problem of naming. Dong Shan proposes the name *Diagram of the Residence and Burial Ground* (*jūzang tu*) by arguing that the top portion represents the burial site of Marquis Dai, the patriarch of the Dai family buried in Mawangdui tomb 2, and at the bottom, his private residence (*sizhai*) where he, his son (the occupant of Mawangdui tomb 3 and purported owner of the object as it was found in his tomb), and his wife (the infamous resident of Mawangdui tomb 1) lived.[7] To identify the top portion as Marquis Dai's burial site, Dong compared the curvilinear form and the positioning of the *jia* shape within it against the actual burial mound and the location of the Marquis's tomb and concluded that the two are similar. In this comparison Dong also discovers that the burial ramp, indicated on the map as the smaller rectangular space with the inscription, is on the north side of the burial site, which means that the drawing is oriented with south on top, much in line with the cardinal orientation present on other Mawangdui *ditu*. Moreover, the inscription reveals actual measurements for the burial ramp and shaft, measurements that, once converted into modern units, are similar to the dimensions of Mawangdui tomb 2. In supporting Dong's identification, Cao Lüning provides textual evidence: on the "Statutes on Burials" excavated from the tomb 77 at Shuihudi in modern-day Yunmeng County, Hubei Province, the term *mao*—found on the diagram—appears when describing the proper measurements for burials.[8]

While he agrees that the burial site belongs to Marquis Dai in tomb 2, Cao suggests that the built structures in the bottom half of the drawing refer to its accompanying sacrificial halls and not the Dai family's private residence, and thus he provides an alternate title for the drawing, *Diagram of the Auspicious Domain* (*zhaoyu tu*).[9] Basing his argument on the Western Han trend in moving sacrificial halls away from the burial site and enlarging them into full complexes, Cao posits that the gridded space is a sacrificial complex intended for living descendants to perform rituals honoring their deceased relatives.

Upon first glance, I was also drawn to the prospect of being able to

identify the forms of drawing in order to find meaning. As an art historian, my desire to uncover meaning in the forms could be characterized as an iconographic impulse when confronted with what looks like a depiction, an impulse that I seem to share with Dong and Cao. Having gathered the necessary textual sources, both scholars "read" the forms as representations of certain kinds of spaces belonging to the Dai family. From there, one can easily move into iconology.[10] Under this iconological examination, questions related to the symbolic value of the forms emerge, such as why the diagrammers paired the burial site with the Dai family's private residence and, relatedly, what the presence of both sites on a single painting reveals about early Chinese notions of death.

These are certainly important questions that attend to the symbolic horizon of the diagrammatic forms, but strictly speaking, to study the drawing's iconography—to identify the bottom half of the object as a private residence or a ritual complex—does not reveal the function of the drawing. In being primarily concerned with the drawing's representation, these readings open the individual elements of the Mawangdui drawing to dense interpretation, and by extension, endless rounds of revision between their visible forms and corresponding texts become possible in the pursuit of an iconology of the drawing. The built structures on the bottom can be a walled city, walled private residence, walled ritual complex, and so on depending on what textual sources one consults and how much meaning one wants to read into every line, color, and shape.

But, as the preceding chapters have argued, meaning rests on unstable ground because different aspects of forms yield different functions, which recursively establish different frames of reference within which meaning is generated. Rather than deciphering the meaning of the two halves of the drawing through an identification of what they are, I suggest that we delineate the ways in which they describe or depict a world—how they reference—in order to establish the drawing's overall function regardless of what the forms might actually be or mean. In other words, while my approach does not provide an answer to whether the diagram represents a residence and burial ground or a ritual complex and a burial ground, it reaffirms that there are two worlds that are pieced together on a single diagram.

To take one example, we can turn to the only formal element shared between the two portions of the diagram: the red squares outlined in black, three of which are located at the bottom, with four smaller ones at the top. While formally similar, their different modes of reference suggest that the two sets of rectangles function very differently. The four smaller red rectangles at the top, rendered in a lighter wash so that the bottom layer of black crosshatch marks remain visible, are scattered randomly around the burial site (see fig. I.1). Perhaps as Dong speculates, they mark the locations of satellite tombs that have yet to be excavated.[11] These red rectangles are ac-

companied by yellow rectangles, indicating a kind of color coding at work, where red symbolizes one kind of structure and yellow another. The use of different colors, matched with crosshatched and empty areas between the tomb and its tumulus, produce a discreteness to the symbols that suggests that they notate real spaces when seen from a position high above the tumulus itself.

In contrast, the opaque red rectangles on the bottom of the drawing do something very different even while formally resembling their cognates at the top. Unlike the red rectangles above that are embedded in a closed space among other color-coded shapes, the two largest red rectangles on the bottom are abruptly truncated along their bottom edge, even bleeding across the black hemlines that mark the edge of the picture plane. The large red rectangles on the bottom extend into the viewer's space and work to position the viewer vis-à-vis the drawing. The series of gates that appear along the north–south axis suggests inner (*cheng*) and outer (*guo*) parts of a complex marked by walls, gates, and watchtowers. The gates indicate movement from the bottom to the top and provide an orientation for the drawing—with their ground lines at the bottom and their roofs on top.[12] This north–south axis serves as the main structural device of the drawing; the other gates located on either side of the complex have their flat bases oriented toward this central axis. Together, these red rectangles place the viewer at the bottom of the drawing, and the gates along the vertical axis guide the viewer through an upright walk through the depicted space, with gates situated the furthest away from the main axis flattened onto the horizontal plane of the ground.

The red rectangles are ambiguous on two levels. Their differences in meaning may lie in the varying intensity of the red pigment, but without a legend, it is impossible to pin down a clear one-to-one relationship between form and meaning. Their functions or modes of reference diverge. While the red rectangles at the top position the viewer above the tumulus to notate the locations of the red squares among other color-coded squares, the ones on the bottom pull the viewer down from the sky into street view to simulate the experience of walking through the town. According to the drawings, a single form—red rectangles in this case—contains two aspects, one seen from an aerial view and another that is available from ground level. The visible parts of the drawing—whether Marquis Dai's home in life and in death or a ceremonial hall built in his honor—formalize two frames of reference in which a single red rectangle can function in two ways. Separating these two worlds is a gulf of emptiness that guards the two halves against each other, a distinction that must be carefully martialed, for it is a matter of life or death.

The diagram simultaneously describes and depicts a world of the living and a world of the dead. The absence of information in the space that separates the two parts of the terrestrial diagram implies that what matters most

in this drawing is not the actual distance between the two compounds at the top and bottom or that the drawings look like the particular places that they reference. Instead, the two structures need only be sufficiently differentiated by their modes of reference to sustain two independent nodes in a topology of the space—one for a world traversable by the living and another only visible from high above or below ground. Insofar as the space between life and death is unrepresentable, it is nonetheless diagrammable. If maps represent the visible, then diagrams make sense of the invisible spaces in between, leaving room for ambiguity and contingencies.

Acknowledgments

Although I began this project a few years after graduate school, it is indelibly shaped by important mentors during my time at the University of California, Berkeley. No words can describe how Pat Berger has transformed me as a person—from the way I think and the way I write to the way I see the world. I am sincerely grateful for her presence in my life. With his endless patience, Whitney Davis showed me that everything can be diagrammed. This book would not have been possible without his initial guidance and, of course, his diagrams. Here, I would also like to express my admiration for the work of Michael Nylan. Her scholarship and dedication to the field of early China remain a source of inspiration and aspiration.

I am grateful for the immense generosity of institutions and scholars in China, beginning with my time at Fudan University's Center for Research on Chinese Excavated Classics and Paleography, where I not only witnessed firsthand the rigor and commitment required to produce scholarship on excavated manuscripts to which this book is deeply indebted but also the joy of being part of such a community. I am especially grateful to Liu Jiao for her friendship and wise counsel. Yang Mei and the wonderful staff at the Gansu Jiandu Museum granted access to the Fangmatan drawings and manuscripts featured in chapter 2, and through our conversations, enriched my understanding of the artifacts. I thank them, along with the Hunan Museum, the Hebei Provincial Institute of Cultural Relics and Archaeology, the Center of Bamboo and Silk Manuscripts at Wuhan University, the Cultural Relics Press, the London Transport Museum, the Museo Egizio, and the Metropolitan Transportation Authority for permission to publish their images in this book.

The greatest gift of my academic career has been the friends that I have made along the way. Despite being (physically) thousands of miles apart, Aglaya Glebova and I lived together on Google Hangouts as we wrote our manuscripts in side-by-side virtual boxes daily for almost a year. It is not often that one gets to write alongside a brilliant scholar who offers live edits to word choices, answers to methodological questions about art history, and life advice. Micki McCoy read many chapters of the book many times over, each time pushing me to answer the difficult question of "so what" and patiently waiting on the phone as I fumbled my way to a response. Thanks to her perspicuity, humor, and generosity, I was able to work through some of the trickiest parts in the manuscript. Luke Habberstad likewise read so much of the manuscript so many times that I often imagined that he may, one day, decline. He never did; instead, each time, he drew my attention to closer readings of classical texts that revealed crucial evidence and urged me to be more historically precise with my use of terms. Kris Cohen read the introduction to offer the broader perspective that I was unable to find myself; Dana Katz cotaught a course with me on maps that became my first foray into the history of cartography; and Daniel Morgan shared much needed comments and suggestions on a draft of chapter 1. Through our conversations, many other friends made the book better and/or the process far more enjoyable: Georgia Barnett, Wen-shing Chou, Alex Dubilet, Victoria Fortuna, Ellen Huang, Jing Jiang, Kristopher Kersey, Shiamin Kwa, Michele Matteini, Jeffrey Moser, Garrett Olberding, Kyle Ormsby, Lisa Saltzman, Lei Xue, Damon Young, Dora Zhang, and Zhang Zhaoyang.

With the dean's fellowships and the art department funds at Reed College, I held a manuscript workshop where Pat Berger, Guolong Lai, and Anthony Barbieri braved pandemic conditions and traveled to Portland for a daylong discussion of the manuscript. My Reed colleagues Douglas Fix and Ken Brashier, who shared numerous helpful insights throughout my book-writing process, were also in attendance. I am deeply indebted to these scholars who, despite the extraordinary circumstances, came together to discuss my work with me. With Reed's support I also worked with two research assistants who bookended the project: Chloe Truong-Jones began the project by laying out the possible paths this book could take with her thoughtful bibliographies on space and cartography; Stephanie Shu concluded it by highlighting the loose ends that needed to be tied up with her meticulous examination of my sources and citations. The book advanced in important ways with the help of thoughtful questions that I received after presenting parts of chapter 2 and chapter 3 for the "Asia-in-Depth" lecture series at Georgetown University and the "Drawing and Weaving" workshop at the University of Bern, respectively. I am grateful to the organizers and attendees of these events for providing me a platform to share the project.

I am extremely lucky to have worked with Susan Bielstein, Dylan Montanari, and the manuscript editing, production, and marketing teams at the University of Chicago Press, who shepherded me through the book-publishing process. Susan's incisive and discerning suggestions on the book's early drafts gave it coherence. Dylan's patience and clear responses to my many confused emails made the process more approachable. I must also thank the anonymous reviewers of the manuscript for their insightful and constructive feedback. I am also grateful to Vanessa Davies, whose editorial acumen ensured that I convey my ideas with clarity in writing. Despite the extensive help that I received from friends, colleagues, reviewers, and mentors, mistakes likely linger in the pages of this book, all of which remain my own.

I always thought that I grew up in two incommensurable worlds, one that my father built from a lifelong dedication to reading and writing about early Chinese history and texts, and one that my mother built from years of experience as the owner of a fashion boutique. My father would be delivering lectures on life lessons from the *Zuozhuan*, and, simultaneously, my mother would be convincing me that the key to success is careful attention paid to clothing proportions to signal confidence. My father would tell me that books are my best friends; my mother would ask me why I haven't made more human friends. While superficially my parents could not be more different, together, they taught me two sides of the same lesson: think hard, work harder, but never do so in isolation. My two sisters exemplify the success that comes with hard work and the graciousness and generosity that are nonetheless possible even with limited time and energy. They were and continue to be my role models, especially when I welcomed my daughter into my life at the start of this project. What began as a survey on the history of Chinese maps became, at its core, a book about seeing the world anew at every turn. Thank you, Ren, for bringing new meaning to my work and life. You are my motivation. Finally, Brian—my love, my light—thank you for being you and making a world with me. This book is dedicated to my family.

Notes

Introduction

1. For studies that note this distinction, see Guolong Lai, "The Diagram of the Mourning System from Mawangdui," *Early China* 28 (2003): 46; Florian C. Reiter, "Some Remarks on the Chinese Word *T'u* 'Chart, Plan, Design,'" *Oriens* 32 (1990): 308.

2. One map, *Map Tracing the Tracks of Yu*, references the chapter "The Tribute of Yu" from the *Shujing* (*Classic of Documents*) that follows Yu the Great's mythical travels through the nine subdivisions of the empire (*jiuzhou*), with each division described according to its natural topography, resources, and populations. The *Map of Chinese and Non-Chinese Territories* (*Huayi tu*), found on the other side of the stone stele, includes foreign places that lay along the fringes of the Southern Song border in the 1120s. The dating of the *Map Tracing the Tracks of Yu* has been a subject of debate, but most scholars agree that the map was conceived decades before it was carved on the stele that now stands in the Beilin Museum in Xi'an, Shaanxi Province. Cao Wanru, for example, argues that the earliest version of this map seen on the 1136 stone stele was probably made some time before 1080 and 1094. See Cao Wanru, Zheng Xihuang, Huang Shengzhang, et al., eds., *Zhongguo gudai ditu ji–Zhanguo Yuan* (Beijing: Wenwu chubanshe, 1990). For more on these two maps, see Hilde De Weerdt, "Maps and Memory: Readings of Cartography in Twelfth- and Thirteenth-Century Song China," *Imago mundi* 61, no. 2 (2009): 145–67. Other maps from around the same period include the *Map of Nine Territories* (*Jiuyu shouling tu*), dated to 1121 CE, originally erected at the Confucian Temple in Rong County, Sichuan Province. It was discovered by archaeologists in 1964 and moved to the Sichuan Museum. Another example is the *Map Tracing the Tracks of Yu*, dated to 1142, originally found on a wall of the Confucian Temple at Zhenjing, Jiangsu Province.

3. The diagram itself does not come with a title. Cao Lüning, "Han chu 'zang lu' yu Mawangdui sanhao muzhu Li Xi," in *Jinian Mawangdui Han mu fajue sishi zhounian guoji xueshu yantaohui lunwen ji*, ed. Hunan Provincial Museum (Changsha: Yuelu chubanshe, 2016), 52–55. Dong Shan, "Mawangdui san hao Han mu chutu de jüzang tu," in *Jinian Mawangdui Han mu fajue sishi zhounian guoji xueshu yantaohui lunwen ji*, ed. Hunan sheng bowuguan (Changsha: Yuelu shushe, 2016), 404–9.

4. Dong Shan, "Mawangdui san hao Han mu chutu de jüzang tu," 407.

5. Tan Qixiang has offered four explanations regarding the sparse archaeological evidence for early Chinese *ditu*: (1) *ditu* are more difficult to copy than geographical treatises, so fewer of the former were made; (2) *ditu* were probably drawn on materials of different dimensions that correspond to their map scales and were thus unwieldly in their physical compilation with other texts; (3) most *ditu* would have been kept in court archives, so any political upheaval that might have resulted in the sacking of palaces would lead to their destruction, leaving only those that were engraved on stone or buried in tombs intact; (4) while textual miscellanea can be compiled into *jing* (classic) or *shi* (history) and passed down, the status of some *ditu* as illustrations to texts complicates their classification. Tan Qixiang, "'Zhongguo gudai ditu ji' xu," *Wenwu* 7 (1987): 70–71.

6. *Jinshu*, comp. Fang Xuanling (Beijing: Zhonghua shuju, 1974), 5.1039.

7. My translation slightly revised from Garrett Olberding, "Movement and Strategic Mapping in Early Imperial China," *Monumenta serica* 64, no. 1 (2016): 41n102. Original text found in *Hanshu*, composed by Ban Gu et al. (Beijing: Zhonghua shuju, 2009), 64.2778.

8. Translations of principles taken from Cordell Yee, "Taking the World's Measure: Chinese Maps between Observation and Text," in *History of Cartography*, vol. 2, bk. 2, *Cartography in the Traditional East and Southeast Asian Societies*, ed. J. B. Harley and David Woodward (Chicago: University of Chicago Press, 1994), 110.

9. For Mei-Ling Hsu, Pei's preface outlines "the methodology of the analytical tradition" of mapmaking as opposed to the "descriptive tradition" that characterizes early Chinese cartography. Mei-Ling Hsu, "The Han Maps and Early Chinese Cartography," *Annals of the Association of American Geographers* 68, no. 1 (March 1978): 57.

10. Wang Yong, *Zhongguo ditu shigang* (Beijing: Shangwu yinshu guan, 1959), 18.

11. Translation only slightly altered from Christopher Cullen, *Astronomy and Mathematics in Ancient China: The* Zhou bi suan jing (Cambridge: Cambridge University Press, 1996), 185. Cordell Yee proposes the following translation : "Whenever a scale of one *fen* to a thousand *li* was used, one drew a square map of eight *chi* and one *cun*. In present usage, one draws a square map of [half the size, or] four *chi* and five *fen*. A *fen* [in this case] is equal to two thousand *li*." Cordell Yee, "Reinterpreting Traditional Chinese Geographical Maps," in *History of Cartography*, vol. 2, bk. 2, *Cartography in the Traditional East and Southeast Asian Societies*, ed. J. B. Harley and David Woodward (Chicago: University of Chicago Press, 1994), 42–43.

12. Matthew H. Edney, *Cartography: The Ideal and Its History* (Chicago: University of Chicago Press, 2019), 1.

13. Edney, *Cartography*, 5.

14. Rasmus Grønfeldt Winther, *When Maps Become the World* (Chicago: University of Chicago Press, 2020), 10. According to J. B. Harley and David Woodward, maps are "graphic representations that facilitate a spatial understanding of things, concepts, conditions, process, or events in the human world." J. B. Harley and David Woodward, "Preface," in *History of Cartography*, vol. 1, *Cartography in Prehistoric, Ancient, and Medieval Europe and the Mediterranean*, ed. J. B. Harley and David Woodward (Chicago: University of Chicago Press, 1987), xvi.

15. Mark S. Monmonier, *Maps, Distortion, and Meaning* (Washington, DC: Association of American Geographers, 1977), 1.

16. For a summary of these interventions and a description of different philosophical approaches to maps, see Martin Dodge, Rob Kitchin, and Chris Perkins, "Thinking about Maps," in *Rethinking Maps: New Frontiers in Cartographic Theory*, ed. Martin Dodge, Rob Kitchin, and Chris Perkins, Routledge Studies in Human Geography (New York: Routledge, 2009), 1–25.

17. J. B. Harley, *The New Nature of Maps: Essays in the History of Cartography* (Baltimore: Johns Hopkins University Press, 2001), 53.

18. Denis Wood, *Rethinking the Power of Maps* (New York: Guildford Press, 2010), 1.

19. Peter Bol, "Exploring the Propositions in Maps: The Case of the 'Yuji tu' of 1136," *Journal of Song-Yuan Studies* 46 (2016): 211.

20. Karl Whittington, *Body-Worlds: Opicinus de Canistris and the Medieval Cartographic Imagination* (Toronto: Pontifical Institute of Mediaeval Studies, 2014), 52.

21. Monmonier, *Maps, Distortion, and Meaning*, v.

22. Cao Wanru, "Zhongguo gudai ditu huizhi de lilun he fangfa chutan," *Ziran kexue shi yanjiu* 2, no. 3 (1983): 246. Joseph Needham similarly described survey methods in early China. See Joseph Needham and Wang Ling, *Science and Civilisation in China*, vol. 3, *Mathematics and the Sciences of the Heavens and the Earth* (Cambridge: Cambridge University Press, 1959), 569–83. See also Ge Jianxiong, *Zhongguo gudai de ditu cehui* (Beijing: Shangwu yinshu guan, 1998), 11–14.

23. Olberding, "Movement and Strategic Mapping," 23–24.

24. Vera V. Dorofeeva-Lichtmann, "Conception of Terrestrial Organization in the *Shan hai jing*," *Bulletin de l'École française d'Extrême-Orient* 82 (1995): 62n26.

25. See, for instance, Wang Yong, *Zhongguo dili xue shi* (Shanghai: Shanghai san lian shudian, 2014). See also Linda Rui Feng, "Can Lost Maps Speak? Toward a Cultural History of Map Reading in Medieval China," *Imago mundi* 70, no. 2 (2018): 169–82.

26. Slightly modified translation from W. Allyn Rickett, ed. and trans., *Guanzi: Political, Economic, and Philosophical Essays from Early China*, vol. 2 (Princeton, NJ: Princeton University Press, 1998), 389–90. Original text found in *Guanzi Jiaozhu, Xinbian zhuzi jicheng* ed., selected by Li Xiangfeng and ed. Liang Yunhua (Beijing: Zhonghua shuju, 2004), 2:529–30.

27. For analyses on the Ce *gui*, see Li Xueqin, "Yi Hou Ce gui yu Wu guo," *Wenwu* 7 (1985): 13–16, 25; Wang Keling, "Yi hou Ce gui mingwen ji 'Wu wang, Cheng wang fa Shang tu,' 'Dong guo tu' ji Xi Zhou ditu zongxi," *Ditu* 1 (1990): 49–52. For an English translation and analysis of the Ce *gui*, see Constance A. Cook and Paul R. Goldin, eds., *A Source Book of Ancient Chinese Bronze Inscriptions* (Berkeley, CA: Society for the Study of Early China, 2016), 23–27. For an analysis of the earliest bronze inscriptions containing the character *tu*, see Wolfgang Behr, "Placed into the Right Positions," in *Graphics and Text in the Production of Technical Knowledge in China: The Warp and the Weft*, ed. Francesca Bray, Vera Dorofeeva-Lichtmann, and Georges Métailié (Leiden: Brill, 2007), 110–12.

28. Wang, *Zhongguo ditu shigang*, 12.

29. *Shiji*, composed by Sima Qian, with Sima Tan (Beijing: Zhonghua shuju, 2010), 86.2526–38.

30. *Shiji*, 53.2014.

31. *Zhouli jin zhu jin yi*, ed. Wang Yunwu and annotated by Lin Yin (Taipei: Taiwan shangwu yinshu guan gufen youxian gongsi, 1997), 8.344.

32. *Han Feizi jijie, Xinbian zhuzi jicheng* ed. (Beijing: Zhonghua shuju, 1998), 453.

33. *Hanshu*, 81.3346. For a detailed analysis of this incident, see Garret Pagenstecher Olberding, *Designing Boundaries in Early China : The Composition of Sovereign Space* (Cambridge: Cambridge University Press, 2022), 77–80.

34. Tan Qixiang, "'Zhongguo gudai ditu ji' xu," *Wenwu* 7 (1987): 68. For a more detailed examination on the "Treatise on Geography" chapter, see Lee Chi-Hsiang, "The *Hanshu* Geographic Treatise on the Eastern Capital," trans. Michael Nylan, in *Technical Arts in the Han Histories*, ed. Mark Csikzentmihalyi and Michael Nylan (Albany: State University of New York Press, 2021), 135–80.

35. *Zhouli*, 3.97.

36. *Zhouli*, 4.174.

37. *Zhouli*, 7.311.

38. *Hanshu*, 99.4161.

39. Hsing I-tien, "Zhongguo gudai de ditu—cong Jiangsu Yinwan de 'hua tu', 'xie tu' shuo qi," *Yishu shi yanjiu* 6 (2005): 106.

40. Hsing I-tien, 107.

41. Francesca Bray, "Introduction: The Powers of *Tu*," in *Graphics and Text in the Production of Technical Knowledge in China: The Warp and the Weft*, ed. Francesca Bray, Vera Dorofeeva-Lichtmann, and Georges Métailié, Sinica Leidensia 79 (Leiden: Brill, 2007), 4.

42. Archaeologists and compilers of the Mawangdui archaeology report and a catalog of its silk manuscripts respectively titled thirteen drawings as diagrams, but they do not account for the diagrams that accompany texts. A more complete list is provided in Lai, "Diagram of the Mourning System," 47–48. There are only a few examples of the *tu* designation physically written on early artifacts. Bray, "Introduction," 13.

43. Bray, "Introduction," 2.

44. Analysis of the *tu* character from Qiu Xigui, *Chinese Writing*, trans. Gilbert L. Mattos and Jerry Norman (Berkeley, CA: Society for the Study of Early China and the Institute of East Asian Studies, 2000), 203. Definition found in *Shuowen jiezi zhu*, comp. Xu Shen and ed. Duan Yucai (Taipei: Hanjing wenhua shiye youxian gongsi, 1985), 6.277.

45. Behr, "Right Positions," 120.

46. For the tallying of *tu* appearances and their translations, I consulted *Zuo Tradition–Zuozhuan: Commentary on the Spring and Autumn Annals*, trans. Stephen Durrant, Wai-yee Li, and David Schaberg, 3 vols. (Seattle: University of Washington Press, 2016).

47. John Bender and Michael Marrinan, *The Culture of Diagram* (Stanford, CA: Stanford University Press, 2010), 11.

48. Jeffrey F. Hamburger, *Diagramming Devotion: Berthold of Nuremberg's Transformation of Hrabanus Maurus's Poems in Praise of the Cross* (Chicago: University of Chicago Press, 2020), 28.

49. Behr argues that what ties the various usages of *tu* together is the concept of "positioning in space." Behr, "Right Positions," 125.

50. *Shuowen jiezi zhu*, comp. Xu Shen, 13.682.

51. Liu An, *The Huainanzi: A Guide to the Theory and Practice of Government in Early Han China*, trans. and ed. John S. Major, Sarah A. Queen, Andrew Seth Meyer, and Harold D. Roth (New York: Columbia University Press, 2010), 62.

52. David W. Pankenier, *Astrology and Cosmology in Early China: Conforming Earth to Heaven* (Cambridge: Cambridge University Press, 2015), 268. A useful description of the purposes of *fenye* appears as the job description of the Western Han court's Astrologer Royal (*bao zhang shi*) included in the "Treatise on Celestial Offices" chapter of the *Shiji*. For translation and discussion of the passage, see Pankenier, 302. For an extensive discussion of astral science in early China and how it encompasses two modes of inquiry, *tianwen* and *li*, see Daniel Patrick Morgan, *Astral Science in Early Imperial China: Observation, Sagehood, and the Individual* (Cambridge: Cambridge University Press, 2017).

53. Li Ling, *Zhongguo fangshu xukao* (Beijing: Dongfang chubanshe, 2001), 257–58.

54. Li Ling, 273.

55. For a survey of terrestrial-celestial resonances, see John B. Henderson, "Chinese Cosmographical Thought: The High Intellectual Tradition," in *History of Cartography*, vol. 2, bk. 2, *Cartography in the Traditional East and Southeast Asian Societies*, ed. J. B. Harley and David Woodward (Chicago: University of Chicago Press, 1994), 203–27.

56. Whitney Davis, *A General Theory of Visual Culture* (Princeton, NJ: Princeton University Press, 2017), 10 and 293.

57. My translation of *shi* as cosmographic model follows Christopher Cullen, "Some Further Points on the 'Shih,'" *Early China* 6 (1980/1981): 31. The translation of the term, however, has been a source of scholarly debate. Donald Harper, for example, translates *shi* as "cosmic board." See Donald Harper, "The Han Cosmic Board (*Shih*)," *Early China* 4 (1978/1979): 1–10. Unlike Harper, whose translation retains the physical artifact on which astro-calendrical diagrams were found, Li Ling, in coining the term *tu* or *shi* diagram, preferred to treat the astro-calendrical designs as extractable and comparable to similar designs found on other artifacts. Li Ling, "'Shi' yu Zhongguo gudai de yuzhou moshi," *Zhongguo wenhua* 1 (1991): 1–30. For a summary of the debates and an alternative analysis of *shi* and its uses, see Marc Kalinowski, "The Notion of *Shi* and Some Related Terms in Qin-Han Calendrical Astrology," *Early China* 35/36 (2012/2013): 331–60.

58. Yin Difei, "Xi Han Ruyin hou mu chutu de zhanpan he tianwen yiqi," *Kaogu* 5 (1978): 339.

59. Yin Difei, 338.

60. Yan Dunjie, "Guanyu Xihan chuqi de shipan he zhanpan," *Kaogu* 5 (1978): 335–36.

61. Cullen, "Some Further Points," 34. According to Cullen, "One *du* in the early imperial period was taken to be the amount of displacement of the sun from one day to the next as it makes its annual circuit of the heavens—an amount which at that time was assumed to be constant." Christopher Cullen, *The Foundations of Celestial Reckoning: Three Ancient Chinese Astronomical Systems* (New York: Routledge, 2017), 13.

62. Cullen, "Some Further Points," 34.

63. Donald Harper, "Warring States Natural Philosophy and Occult Thought," in *The Cambridge History of Ancient China: From the Origins of Civilization to 221 BC*, ed. Michael Loewe and Edward L. Shaughnessy (Cambridge: Cambridge University Press, 1999), 843. In her examination of a celestial mural dated to late first century BCE and excavated at Jiaotong University in Xi'an, Shaanxi Province, Lillian Tseng adeptly shows how the depiction of asterisms and their placement on the mural evince the artists' priorities in their iconography drawn from archaic sources, contemporary lore, and an oral tradition rather than astrological or observational accuracy. Lillian Lan-Ying Tseng, *Picturing Heaven in Early China*, Harvard East Asian Monographs (Cambridge, MA: Harvard University Press, 2011), 335–36.

64. *Hanshu*, 27A.1315.

65. Henderson, "Chinese Cosmographical Thought," 213. For a historiography on the *hetu* and *luoshu* during these later dynasties, see Sun Yanzhe, "The Interpretation of Hetu and Luoshu," *Linguistics and Literature Studies* 8, no. 4 (2020): 190–94.

66. *The Classic of Changes: A New Translation of the I Ching as Interpreted by Wang Bi*, trans. and introduced by Richard John Lynn (New York: Columbia University Press, 2004), 51.

67. *Classic of Changes*, 52.

68. Michael Nylan, *The Five "Confucian" Classics* (New Haven, CT: Yale University Press, 2014), 207.

69. For an example of a diagram that explicitly displays the possibility of controlling one's fate in light of what heaven has in store, see what may be one of the earliest game boards ever excavated in East Asia, found in Kongjiapo, in modern-day Hubei Province, and described in Luke Habberstad, *Forming the Early Chinese Court: Rituals, Spaces, and Roles* (Seattle: University of Washington Press, 2018), 3–9.

70. In studies on cartography, this turn to a map's production is marked by a theoretical shift from Harley and Woodward's representational cartography to postrepresentational cartography, with the latter treating maps as "constellations of ongoing processes"

and "a set of unfolding practices." Dodge, Kitchin, Perkins, "Thinking about Maps," 16 and 21.

71. Susan Feagin, "Pictorial Representation and the Act of Drawing," *American Philosophical Quarterly* 24, no. 2 (April 1987): 161.

72. Dorofeeva-Lichtmann, "Conception of Terrestrial Organization," 63.

73. Although not specific to early China, for a definition of diagram as topological, see Patrick Maynard, *Drawing Distinctions: The Varieties of Graphic Expression* (Ithaca, NY: Cornell University Press, 2005), 55–56.

74. Examples taken from Stephen Barr, *Experiments in Topology* (Mineola, NY: Dover, 1989), 3.

75. Terms for defining the London Underground Map have ranged from "cartogram" to "schematic or diagrammatic map," or, in characterizing its form, as possessing a "diagrammatic style." Catherine Delano-Smith, "The Grip of the Enlightenment: The Separation of Past and Present," in *Approaches and Challenges to a Worldwide History of Cartography*, ed. David Woodward, Catherine Delano-Smith, and Cordell D. K. Yee (Barcelona: Institut Cartogràfic de Catalunya), 284–85.

76. For a far more detailed and careful reconstruction of Euler's theorem, see Barr, *Experiments in Topology*, 10–19.

77. Barr, 10.

78. An example of this kind of theoretical framework can also be found in Donald Harper's explication of the functions associated with the *Diagram of Banner Tokens* (*fanxin tu*), which is often referred to as *guaxiang tu* or *Diagrams of the Images of Mantic Figures*. He argues that "in Han times the magico-religious uses of the drawings in *Fanxin tu* were not distinguished from administrative and other uses of the manuscripts' drawings to make tokens, banners, or contracts," thereby suggesting that a single drawing on the diagram performs multiple functions. Donald Harper, "Communication by Design: Two Silk Manuscripts of Diagrams (*Tu*) from Mawangdui Tomb Three," in *Graphics and Text in the Production of Technical Knowledge in China: The Warp and the Weft*, ed. Francesca Bray, Vera Dorofeeva-Lichtmann, and Georges Métailié (Leiden: Brill, 2007), 185.

79. Nelson Goodman, *Languages of Art* (Indianapolis, IN: Hackett, 1976), 40.

80. Catherine Elgin, *With Reference to Reference* (Indianapolis, IN: Hackett, 1983), 104.

81. Goodman, *Languages of Art*, 161.

82. Goodman, 70. Goodman discusses the notational and nonnotational in ordinary road maps in relation to the digital and analog respectively, which is echoed in Emanuela Casti's consideration of the presence of both analog and digital systems at work in maps. "Cartographical communications," Casti writes, "rest on a double system: a map is both digital and analogical. More precisely, one might say that a map is *a reconstruction of the real that is based on differences—a reconstruction that uses an analogical language which is, in its turn, subject to codification*." Emanuela Casti, *Reality as Representation: The Semiotics of Cartography and the Generation of Meaning* (Bergamo: Bergamo University Press, 2000), 42. For Casti, the "analogical language" inheres in the work of topography while the digital refers to the codification of distinctions between features of the geography (43). For explications of Goodman's theories of notation more generally but also narrowly as it pertains to the analog and digital, see Whitney Davis, "How to Make Analogies in a Digital Age," *October* 117 (Summer 2006): 71–98.

83. For an alternative example, see Goodman's comparison of a Hokusai drawing of Mount Fuji and an electrocardiogram. Goodman, *Languages of Art*, 229.

84. Whitney Davis, *Visuality and Virtuality: Images and Pictures from Prehistoric to Perspective* (Princeton, NJ: Princeton University Press, 2017), 21. As Goodman writes, "Worldmaking as we know it always starts from worlds already on hand; the making is a remaking." Nelson Goodman, *Ways of Worldmaking* (Indianapolis, IN: Hackett, 1978), 6.

For a discussion on worlds and worldmaking in the Buddhist context in medieval China, see Eugene Wang, *Shaping the Lotus Sutra: Buddhist Visual Culture in Medieval China* (Seattle: University of Washington Press, 2005), xv–xvi.

85. Translation from Sima Qian, *Records of the Grand Historian*, vol. 1, *Early Years of the Han Dynasty, 209–141 B.C.*, trans. Burton Watson (New York: Columbia University Press, 1961), 79.

86. Mark Edward Lewis, *The Construction of Space in Early China* (Albany: State University of New York Press, 2006), 1.

87. D. Jonathan Felt, *Structures of the Earth: Metageographies of Early Medieval China* (Cambridge, MA: Harvard University Asia Center, 2021), 3.

88. Dorofeeva-Lichtmann, "Conception of Terrestrial Organization," 86.

89. Habberstad, *Forming the Early Chinese Court*, 10.

90. Hilde De Weerdt, "Maps and Memory: Readings of Cartography in Twelfth- and Thirteenth-Century Song China," *Imago mundi* 61, no. 2 (2009): 148.

91. Charles Sanders Peirce, *The Collected Papers of Charles Sanders Peirce*, ed. Charles Hartshorne and Paul Weiss (Cambridge, MA: Harvard University Press, 1960), 4:341.

92. Kamini Vellodi, "Diagrammatic Thought: Two Forms of Constructivism in C. S. Peirce and Gilles Deleuze," *Parrhesia* 19 (2014): 82.

93. Gilles Deleuze and Félix Guattari, *A Thousand Plateaus: Capitalism and Schizophrenia*, trans. Brian Massumi (Minneapolis, MN: University of Minnesota Press, 1987), 142.

94. The Warring States period witnessed a surge in the use of *mingqi*. Lothar von Falkenhausen, *Chinese Society during the Age of Confucius (1000–250 BC): The Archaeological Evidence* (Los Angeles: Cotsen Institute of Archaeology Press, 2006), 302. Guolong Lai suggests that the growing use of *mingqi* in burials during the Warring States period may have spurred the interest of Warring States philosophers to explain their religious significance. Guolong Lai, *Excavating the Afterlife: The Archaeology of Early Chinese Religion* (Seattle: University of Washington Press, 2015), 51.

95. *Liji jin zhu jin yi*, ed. Wang Yunwu and annotated by Wang Meng'ou (Taipei: Taiwan shangwu yinshu guan gufen youxian gongsi, 1992), 4.161.

96. *Liji*, 3.127.

97. *Liji*, 4.161.

98. *Liji*, 3.127.

99. *Xunzi jijie*, comp. Wang Xianqian, *Xinbian zhuzi jicheng* ed. (Beijing: Zhonghua shuju, 2013), 13.436.

100. Wu Hung, "'Shengqi' de gainian yu shijian," *Wenwu* 1 (2010): 88.

101. Wu Hung, 89.

102. Enno Giele, "Using Early Chinese Manuscripts as Historical Source Material," *Monumenta serica* 51 (2003): 432.

103. Alain Thote, "Daybooks in Archaeological Context," in *Books of Fate and Popular Culture in Early China: The Daybook Manuscripts of the Warring States, Qin, and Han*, ed. Donald Harper and Marc Kalinowski (Leiden: Brill, 2017), 53.

104. *Zhouli*, 1.19.

105. *Zhouli*, 2.66.

106. *Zhouli*, 2.67. In addition to these local and provincial-level maps, there is textual evidence that by the Warring States period, individual kingdoms not only possessed a *ditu* of their own kingdoms, but they probably found ways to compile much larger *ditu* (*tianxia zhi tu*) that recorded the territories of other kingdoms in order to plot their military strategies. Hence, as Wang Yong argues, King Cheng of Qin's eagerness to meet Jing Ke, when the latter claimed to bring a prized *ditu* of the kingdom of Yan. Wang Yong, *Zhongguo ditu shigang*, 12.

107. For a transcription of the two bamboo slips, see *Liye Qin jiandu jiaoshi* (*diyi juan*), ed. Chen Wei (Wuhan: Wuhan University Press, 2012), 1:118. For an analysis of these bamboo slips, along with three other fragments that refer to *tu* and borders, see Huang Kejia, "Qian xi Liye Qin jian zhong youguan ditu huizhi xijie de can jian," *Zhongguo wenwu bao*, January 17, 2014, http://www.kaogu.cn/cn/xueshuyanjiu/yanjiuxinlun/qita/2014/0123/45106.html. Wang Yong also suggested that these early empire maps were produced by piecing together various local and partial maps that were submitted to the court. Wang Yong, *Zhongguo ditu shigang*, 18.

108. For Yee, "This requires an adjustment in the sorts of artifacts selected for attention, artifacts chosen not only for signs of quantification and mensuration, but for expressive and aesthetic value." Cordell Yee, "Chinese Cartography among the Arts: Objectivity, Subjectivity, Representation," in *History of Cartography*, vol. 2, bk. 2, *Cartography in the Traditional East and Southeast Asian Societies*, ed. J. B. Harley and David Woodward (Chicago: University of Chicago Press, 1994), 164.

109. Svetlana Alpers, *The Art of Describing: Dutch Art in the Seventeenth Century* (Chicago: University of Chicago Press, 1984), 126.

110. Goodman, *Ways of Worldmaking*, 66–67.

111. Goodman, 70.

112. Goodman, 128.

Chapter 1

1. Fu Xinian, "Zhanguo Zhongshan wang Cuo mu chutu de 'Zhaoyu tu' jiqi lingyuan guizhi de yanjiu," *Kaogu xuebao* 1 (1980): 97.

2. *Shiji*, composed by Sima Qian, with Sima Tan (Beijing: Zhonghua shuju, 2010), 43.1813.

3. Yang Hongxun, "Zhanguo Zhongshan wang ling ji zhaoyu tu yanjiu," *Kaogu xuebao* 1 (1980): 119.

4. My translation follows Zhu Dexi and Qiu Xigui's transcription of the inscription. Zhu Dexi and Qiu Xigui, "Pingshan Zhongshan wang mu tongqi mingwen de chubu yanjiu," *Wenwu* 1 (1979): 42–52.

5. Xiaolong Wu, *Material Culture, Power, and Identity in Ancient China* (Cambridge: Cambridge University Press, 2017), 178.

6. *Zhouli jin zhu jin yi*, ed. Wang Yunwu and annotated by Lin Yin (Taipei: Taiwan shangwu yinshu guan gufen youxian gongsi, 1997), 5.227.

7. See Sun Zhongming, "Zhanguo Zhongshan wang mu 'zhaoyu tu' de chubu tantao," *Dili yanjiu* 1 (March 1982): 87; Liu Laicheng, "Zhanguo shiqi Zhongshan wang Cuo zhaoyu tu tongban shixi," *Wenwu* 1 (1992): 31.

8. Wolfgang Behr, "Placed into the Right Positions," in *Graphics and Text in the Production of Technical Knowledge in China: The Warp and the Weft*, ed. Francesca Bray, Vera Dorofeeva-Lichtmann, and Georges Métailié (Leiden: Brill, 2007), 119. Or, as Francesca Bray describes the drawing, "Planning of this kind was as much ritual as architectural." Bray, "Introduction: The Powers of *Tu*," in Bray, Dorofeeva-Lichtmann, and Métailié *Graphics and Text*, 15.

9. *Shiji*, 43.1806.

10. Wu, *Material Culture*, 35.

11. Wu, 35.

12. Hebei sheng wenwu yanjiu suo, *Cuo mu: Zhongshanguo guowang zhi mu* (Beijing: Wenwu chubanshe, 1996), 1:5.

13. *Zhanguo ce*, annotated by Gao You, in *Sibu beiyao* (Taiwan: Zhonghua shuju, 1990), 33.2b.

14. For an analysis on the "aboveground burial chamber" (*dishang mushi*), see Jie Shi, "The Hidden Level in Space and Time: The Vertical Shaft in the Royal Tombs of the Zhongshan Kingdom in Late Eastern Zhou (475–221 BCE) China," *Material Religion: The Journal of Objects, Art, and Belief* 11 (2015): 76–103.

15. Hebei sheng wenwu yanjiu suo, *Cuo mu*, 1:11.

16. Translation taken from Jeffrey Riegel, "Do Not Serve the Dead as You Serve the Living: The 'Lüshi chunqiu' Treatises on Moderation in Burial," *Early China* 20 (1995), 310. Riegl's article provides a full translation of the two most relevant chapters, "Jiesang" and "Ansi," to the promotion of moderation in burials from *Master Lü's Spring and Autumn Annals*.

17. *Zhouli*, 5.227.

18. Wu Hung, *Monumentality in Early Chinese Art and Architecture* (Stanford, CA: Stanford University Press, 1995), 102.

19. Fu Xinian, "Zhanguo Zhongshan wang Cuo mu chutu de 'Zhaoyu tu' jiqi lingyuan guizhi de yanjiu," 102. See also Robert L. Thorp, "Architectural Principles in Early Imperial China: Structural Problems and Their Solution," *Art Bulletin* 68, no. 3 (September 1986): 360–78.

20. Edward R. Tufte, *Envisioning Information* (Cheshire, CT: Graphics Press, 1990), 12.

21. Fu Xinian speculates that while this motif ornamentalizes cross sections, it was nonetheless derived from technical architectural drawings. Fu Xinian, "Zhongguo gudai de jianzhu hua," *Wenwu* 3 (1998): 75.

22. For more on early Chinese architecture, see Nancy Steinhardt, "Genesis of Chinese Buildings and Cities," in *Chinese Architecture: A History* (Princeton, NJ: Princeton University Press, 2019), 8–19. For a survey of Warring States artifacts that contain architectural drawings, see Fu Xinian, "Zhanguo tongqi shang de jianzhu tuxiang yanjiu," in *Fu Xinian jianzhu shi lun wenji* (Beijing: Wenwu chubanshe, 1998), 82–102.

23. I would like to thank Anthony Barbieri for bringing this comparison to my attention. For an in-depth comparison of New Kingdom Egypt (ca. 1548–1086 BCE) and Han dynasty China (206 BCE–220 CE), see Anthony J. Barbieri-Low, *Ancient Egypt and Early China: State, Society, and Culture* (Seattle: University of Washington Press, 2021). Nicholas Reeves, "Two Architectural Drawings from the Valley of the Kings," *Chronique d'Egypt bulletin périodique de la Fondation égyptologique reine Élisabeth* 61 (1986): 45.

24. Howard Carter and Alan H. Gardiner, "The Tomb of Ramesses IV and the Turin Plan of a Royal Tomb," *Journal of Egyptian Archaeology* 4, no. 2/3 (April–July 1917): 132.

25. Carter and Gardiner, 132.

26. A. G. McDowell, *Village Life in Ancient Egypt: Laundry Lists and Love Songs* (New York: Oxford University Press, 1999), 205. Carter and Gardiner, "Tomb of Ramesses IV," 132. As Carter and Gardiner note, the measurements on the plan were quite accurate when compared with the actual tomb site, which suggests that the plan was probably drawn after the completion of the site, unlike the mausoleum diagram. Carter and Gardiner, 158.

27. While by the Qin dynasty, 1 *chi* is the equivalent of 23.1 centimeters, according to Fu Xinian's calculations, 1 *chi* is closer to 22 centimeters on the diagram. Qiu Guangming, Qiu Long, and Yang Ping, *Zhongguo kexue jishu shi: Du liang heng juan*, ed. by Lu Jiaxi (Beijing: Kexue chubanshe, 2001), 196. Fu Xinian, "Zhanguo Zhongshan wang Cuo mu chutu de 'Zhaoyu tu' jiqi lingyuan guizhi de yanjiu," 117.

28. *Liji jin zhu jin yi*, ed. by Wang Yunwu, annotated by Wang Meng'ou (Taipei: Taiwan shangwu yinshu guan gufen youxian gongsi, 1992), 5.249.

29. Fu Xinian, "Zhanguo Zhongshan wang Cuo mu chutu de 'Zhaoyu tu' jiqi lingyuan guizhi de yanjiu," 98. Fu Xinian provides a brief explanation for why the conversion might be so drastically different from the received texts by suggesting that the conversion between *bu* and *chi* had always been evolving. Since the origins of *chi* lie in taxation purposes for

farmland, this measurement was always in human hands who wanted to ensure more taxes and therefore the length of *chi* kept increasing. As *chi* grew and *bu* remained consistent, there became fewer *chi* within each *bu* (117–18).

30. *Zhouli*, 11.471.

31. Fu Xinian, "Zhanguo Zhongshan wang Cuo mu chutu de 'Zhaoyu tu' jiqi lingyuan guizhi de yanjiu," 98.

32. Fu Xinian, 101.

33. In Liu Laicheng's interpretation of a line in the king's decree, he transcribes one of the characters as *xuan* rather than *guan*, which changes the meaning of the second phrase from "for the various officials in charge to draw [*tu*] it" to "those in charge may summon the drawing [*tu*] of it," suggesting that if there were problems in construction, the *zhaoyu tu*, the buried version or the other version, may be brought forth for clarification. Liu's interpretation implies that the drawing serves as a kind of standard by which to judge the construction. Liu Laicheng, "Zhanguo shiqi Zhongshan wang Cuo zhaoyu tu tongban shixi," 30.

34. Margaret Graves, *Arts of Allusion: Object, Ornament, and Architecture in Medieval Islam* (New York: Oxford University Press, 2018), 40.

35. Sun Zhongming also supports the interpretation of *po* as slope length. Sun Zhongming, "Zhanguo Zhongshan wang mu 'zhaoyu tu' de chubu tantao," in *Zhongguo gudai ditu ji–Zhanguo Yuan*, ed. Cao Wanru, Zheng Xihuang, Huang Shengzhang, et al. (Beijing: Wenwu chubanshe, 1990), 1–3. If this is indeed the case, this early Chinese example is not an isolated instance but rather in the company of Egyptian plans that also record slope lengths rather than their projection on a horizontal plane, as in modern plan views. For more on this, see, Corinna Rossi, *Architecture and Mathematics in Ancient Egypt* (Cambridge: Cambridge University Press, 2007), 141.

36. For examples, see problems 19 to 22 in chapter 5 of *Nine Chapters* translated in Lam Lay Yong, "Jiu Zhang Suanshu (Nine Chapters on the Mathematical Art): An Overview," *Archive for History of Exact Sciences* 47, no. 1 (June 1994): 25. The same kind of problem (with different numerical values) also appears as problem 56 in the *Writings on Reckoning*, which is translated in J. W. Dauben, "*Suan Shu Shu* (A Book on Numbers and Computations): English Translation with Commentary," *Archive for Exact Sciences* 62, no. 2 (March 2008): 158. For a translation of the relevant section on calculating volume, see Christopher Cullen, *The Suàn shù shū: "Writings on Reckoning": A Translation of a Chinese Mathematical Collection of the Second Century BCE, with Explanatory Commentary* (Cambridge: Needham Research Institute, 2004), 89–102. There were no *tu* diagrams in the texts beyond an indirect reference in the *Nine Chapters* to "a surface on which practitioners represented numbers with counting rods and made computations." Karine Chemla, "Changes and Continuities in the Use of Diagrams *Tu* in Chinese Mathematical Writings (Third Century to Fourteenth Century) [I]," *East Asian Science, Technology and Society* 4 (2010): 312. See Chemla's article for more on the earliest references of *tu* in mathematical practice and their evolving role in later imperial China.

37. Hebei sheng wenwu yanjiu suo, *Cuo mu*, 1:108. Also, Yang Hongxun, "Zhanguo Zhongshan wang ling ji zhaoyu tu yanjiu," 129.

38. Zhu Dexi and Qiu Xigui, "Pingshan Zhongshan wang mu tongqi mingwen de chubu yanjiu," 45.

39. The inscriptions in the consort square also include a measurement of three *chi* for their *ticou*, which Aurelia Campbell translates as "stave wall." Aurelia Campbell, "The Form and Function of Western Han Dynasty 'Ticou' Tombs," *Artibus Asiae* 70, no. 2 (2010): 227.

40. Liu Laicheng argues that the character *min* could also contain another layer of

meaning that refers to mourning. Liu Laicheng, "Zhanguo shiqi Zhongshan wang Cuo zhaoyu tu tonbban shixi," 28.

41. Hebei sheng wenwu yanjiu suo, *Cuo Mu*, 1:107.

42. This analogy was inspired by the medieval manuscript illumination of Saints Peter, Paul, and Stephen using ropes to render the plan of the Romanesque church at Cluny in the abbot Gunzo de Baume's dream. Armen Ghazarian and Robert Ousterhout, "A Muqarnas Drawing from Thirteenth-Century Armenia and the Use of Architectural Drawings during the Middle Ages," *Muqarnas* 18 (2001): 141.

43. For a more detailed discussion of the topological definitions of *edge* and *vertex*, see the introduction.

44. Patrick Maynard, *Drawing Distinctions: The Varieties of Graphic Expression* (Ithaca, NY: Cornell University Press, 2005), 59.

45. Xunzi, "A Discussion of Rites," in *Xunzi: Basic Writings*, trans. Burton Watson (New York: Columbia University Press, 2003), 99.

46. Michael Nylan, "Toward and Archaeology of Writing: Text, Ritual, and the Culture of Public Display in the Classical Period," in *Text and Ritual in Early China*, ed. Martin Kern (Seattle: University of Washington Press, 2008), 9–10.

47. Xiaolong Wu, *Material Culture*, 178.

48. Tim Ingold, *The Perception of the Environment: Essays on Livelihood, Dwelling, and Skill* (New York: Routledge, 2011), 229.

49. Michel de Certeau, "Walking in the City," in *The Practice of Everyday Life*, trans. Steven Rendall (Berkeley: University of California Press, 1984), 93.

50. Corinna Rossi, *Architecture and Mathematics*, 139–40.

51. As A. G. McDowell notes, however, these documents are official records that probably only reflect sanctioned rhetoric and practices. McDowell, *Village Life*, 202.

52. See, for instance, ostracon 51936, excavated from the Valley of the Kings and now kept at the Cairo Museum, where mistakes in calculations were scratched out. Reeves, "Two Architectural Drawings," 48. Rossi posits this ostracon was probably a drawing made "on the spot" but reflects the artisan changing his mind. Rossi, *Architecture and Mathematics*, 147.

53. Exact measurements of the lengths of the bronze plate are 95.6 on one side and 96.6 on the other. Hebei sheng wenwu yanjiu suo, *Cuo mu*, 1:104.

54. The Zhongshan archaeology report also notes this inaccuracy in scale particularly in the outer regions of the diagram where *bu* appears as the unit of measurement. The archaeologists argue that this suggests that areas measured in *bu* were not rendered to scale. Hebei sheng wenwu yanjiu suo, *Cuo mu*, 1:107.

55. Mo Yang, "Zhongshan wang de lixiang: Zhaoyu tu tongban yanjiu," *Gudai meishu shi* 1 (2016): 47.

56. Robert Bagley, "Anyang Mold-Making and the Decorated Model," *Artibus Asiae* 69, no. 1 (2009): 89.

57. Hebei sheng wenwu yanjiu suo, *Cuo mu*, 1:104.

58. Hebei sheng wenwu yanjiu suo, *Cuo mu*, 1:104.

59. Mo Yang, "Zhongshan wang de lixiang," 47.

60. Mo Yang, 48.

61. Xiaolong Wu, *Material Culture*, 140.

62. Xiaolong Wu, 141.

63. Xiaolong Wu, 145.

64. Miao Xia, "Zhongguo gudai pushou xianhuan qianxi," *Yindu xuekan* 3 (2006): 30.

65. Archaeologists speculate that the smaller ninety-two door knockers were probably used to decorate the wooden *guo* chamber as they were found in tandem with other

bronze building parts such as hinges discovered along the periphery of the *guo*. Hebei sheng wenwu yanjiu suo, *Cuo mu*, 1:55–56.

66. Lillian Lan-Ying Tseng, "Funerary Spatiality: Wang Hui's Sarcophagus in Han China," *RES: Anthropology and Aesthetics* 61/62 (Spring–Autumn 2012): 126.

67. Miao Xia, "Zhongguo gudai pushou xianhuan qianxi," 32.

68. Xiaolong Wu argues that these formal distinctions constitute a difference in intended audience—the bronze-vessel inscriptions for the public and the diagram inscriptions for private consumption. Xiaolong Wu, *Material Culture*, 168.

69. Or, as Yuri Pines suggests, the three long bronze inscriptions may have been "manufactured" by the chancellor himself. Yuri Pines, review of *Material Culture, Power, and Identity in Ancient China*, by Xiaolong Wu, *Journal of Asian Studies* 77, no. 3 (August 2018), 792.

70. Anthony J. Barbieri-Low and Robin D. S. Yates, *Law, State, and Society in Early Imperial China: A Study with Critical Edition and Translation of the Legal Texts from Zhangjiashan Tomb No. 247* (Leiden: Brill, 2015), 1:71–72.

71. For more on the problem of attributing agency in early texts due to the "hidden transcripts" that are unavailable to modern readers, see Wang Haicheng, "Inscriptions from Zhongshan: Chinese Texts and the Archaeology of Agency," in *Agency in Ancient Writing*, ed. Joshua Englehardt (Boulder: University Press of Colorado, 2013), 209–30. Xiaolong Wu similarly argued that the drawing carries legal connotations in suggesting that the drawing is a "ground plan . . . [set] up by the king in the form of a law" in order to maintain political order by "[thwarting] potential political profiteers who would emerge after Cuo's death," namely, "the power struggle among consorts in the court." Xiaolong Wu, *Material Culture*, 177.

72. Also notable is the part of the inscription following the date, which reads, "King Cuo of Zhongshan mandated the chancellor Zhou to select the auspicious metals of Yan to cast a ceremonial wine vessel [*hu*] with measurements according to a pure ritual." Translation in Xiaolong Wu, *Material Culture*, 189, with my modifications. Clearly stated in this opening is the acknowledgement of the value placed on materiality as not merely a neutral surface on which meaningful inscriptions are placed but a material with inherent value capable of endowing the inscriptions with authority.

73. Transcription in *Qin jiandu he ji*, vol. 2, *Longgang Qin mu jiandu, Haojiaping Qin mu mudu*, ed. Chen Wei (Wuhan: Wuhan University Press, 2014), 190. Translation slightly modified from Barbieri-Low and Yates, *Law, State, and Society*, 71.

74. Barbieri-Low and Yates, 70–71.

75. Lothar von Falkenhausen, "The E Jun Qi Metal Tallies: Inscribed Texts and Ritual Contexts," in Kern, *Text and Ritual in Early China*, ed. Martin Kern (Seattle: University of Washington Press, 2007), 101.

76. Von Falkenhausen, 101. The E Jun Qi tallies (323 BCE) are five Warring States bronze tallies that form two groups: wagon tallies and boat tallies that permitted tax exemptions for merchants who were transporting goods throughout the Warring States Chu kingdom. Cast in bronze with gold-inlaid inscriptions, the tallies are in a "vaulted shape and a 'node' in the center," so that when they are configured together, the five tallies form a cylinder, like a single bamboo stalk (81). For more on the Chu kingdom's taxation policies as described by the E Jun Qi tallies, see Chen Wei, "'E Jun Qi jie' yu Chu guo de mianshui wenti," *Jianghan Kaogu* 3 (1989): 52–58.

77. Von Falkenhausen, "E Jun Qi Metal Tallies," 98.

78. "Lord Zhao," in *Zuo Tradition–Zuozhuan: Commentary on the Spring and Autumn Annals*, trans. Stephen Durrant, Wai-yee Li, and David Schaberg (Seattle: University of Washington Press, 2016), 3:1404–5.

79. *Zuo Tradition–Zuozhuan*, 3:2404–5.

80. *Zuo Tradition–Zuozhuan*, 3:1703.

81. *Lunyu jishi, Xinbian zhuzi jicheng* ed., selected by Cheng Shude (Beijing: Zhong-hua shuju, 1992), 13.3. Xunzi, "Rectifying Names," 144–45.

82. Xunzi, "The Regulations of the King," 47. For a similar passage, see *Lunyu jishi*, 12.11.

83. Xunzi, "Regulations of the King," 38 and 47.

84. Another interesting later example to note is a "clay document" (*washu*) dated to 334 BCE from the kingdom of Qin. The rectangular clay tablet contains a two-part inscription that includes not only a reference to the artifact as a "clay document" but also a bestowal of a plot of land on the border where the clay document was to be buried. Charles Sanft suggests that this clay document, essentially a land deed that was to be passed down to descendants, was probably made in multiple copies—one to be buried at the border and others to be kept among the living. Charles Sanft, *Communication and Cooperation in Early Imperial China: Publicizing the Qin Dynasty* (Albany: State University of New York Press, 2014), 69. For more on the clay tablet, see Chen Zhi, "Qin taojuan yu Qin ling wenwu," *Xibei daxue xuebao* 1 (1957): 68–70; Guo Zizhi, "Zhanguo Qin feng zongyi washu mingwen xinyi," *Guwenzi yanjiu* 14 (June 1986): 177–96; Shang Zhiru, "Qin feng zongyi washu de jige wenti," *Wenbo* 6 (1986): 43–49.

Chapter 2

1. In his examination of excavated account books from the Qin and Han periods, Tsang Wing Ma similarly shows how scribes, particularly those of the lower ranks, found themselves negotiating between their self-interests, those of their superiors, and the larger state. Tsang Wing Ma, "Between the State and Their Superiors: The Anxiety of Low-Ranked Scribes in Qin and Han Bureaucracies," *Asia Major* 33, no. 2 (2020): 25–59.

2. Tian Jian and He Shuangquan, "Gansu Tianshui Fangmatan zhanguo Qin Han muqun de fajue," *Wenwu* 2 (1989): 2.

3. As Tsang Wing Ma describes, there were two groups of low-ranked administrative officials in this period: scribes (*shi*) and assistants (*zuo*). While to be a scribe was hereditary, the assistants needed only to be of a mature age, around thirty, to aid in the administrative workload. Tsang Wing Ma, "Scribes, Assistants, and the Materiality of Administrative Documents in Qin-Early Han China: Excavated Evidence from Liye, Shuihudi, and Zhangjiashan," *T'oung Pao* 103, no. 4/5 (2017): 304–5.

4. Hubei Xiaogan diqu di er qi yi gong yi nong wenwu kaogu xunlian ban, "Hubei Yunmeng Shuihudi shiyi zuo Qin mu fajue jianbao," *Wenwu* 9 (1976): 53.

5. Yan Changgui, "Tianshui Fangmatan muban ditu xintan," *Kaogu xuebao* 3 (2016): 376. In this chapter, I follow Chen Wei, Sun Zhanyu, and Yan Changgui's numbering system for the drawings found in *Qin jiandu he ji*, ed. Chen Wei, 4 vols. (Wuhan: Wuhan University Press, 2014). Each board is given a number, with its two sides labeled A and B. This enumeration is different from the original numbering of the drawings (1 through 7) in the archaeology report, which does not take into account that most of the drawings were on two sides of a single board.

6. Anthony Barbieri-Low, "Model Legal and Administrative Forms from the Qin, Han, and Tang and their Role in the Facilitation of Bureaucracy and Literacy," *Oriens Extremus* 50 (2011): 125.

7. Yong Jichun, *Tianshui Fangmatan muban ditu yanjiu* (Lanzhou: Gansu renmin chubanshe, 2002), 176–78.

8. *Shiji*, composed by Sima Qian, with Sima Tan (Beijing: Zhonghua shuju, 2010), 5.177.

9. *Hanshu*, composed by Ban Gu et al. (Beijing: Zhonghua shuju, 2009), 28B.1644.

10. Wang Zijin, "Qin tongyi yuanyin de jishu chengmian kaocha," *Shehui kexue zhanxian* 9 (2009): 222–31.

11. Wang Zijin and Li Si, "Fangmatan Qin ditu linye jiaotong shiliao yanjiu," *Zhongguo lishi dili luncong* 28, no. 2 (April 2013): 5–10. For a detailed analysis of all the inscriptions, see Yong Jichun, *Tianshui Fangmatan muban ditu yanjiu*.

12. Yong Jichun, *Tianshui Fangmatan muban ditu yanjiu*, 99.

13. Wang and Li, "Fangmatan Qin ditu linye jiaotong shiliao yanjiu," 8.

14. Yong, *Tianshui Fangmatan muban ditu yanjiu*, 152.

15. Brian Lander, *The King's Harvest: A Political Ecology of China from the First Farmers to the First Empire* (New Haven, CT: Yale University Press, 2021), 185. Lander proposes that the terrestrial diagrams were made for the offices established in this area that dealt with a "resource extraction operation that probably had parallels throughout the empire" (187).

16. Wang and Li, "Fangmatan Qin ditu linye jiaotong shiliao yanjiu," 8.

17. For examples of excavated household registries that record the "five-family units," see Hsing I-tien, "Qin-Han Census, Tax, and Corvée Administration: Notes on Newly Discovered Materials," in *Birth of an Empire: The State of Qin Revisited*, trans. Hsieh Mei-yu and William G. Crowell and ed. Yuri Pines, Gideon Shelach, Lothar von Falkenhausen, and Robin D. S. Yates. (Berkeley: University of California Press, 2014), 157–58.

18. Robin D. S. Yates, "State Control of Bureaucrats under the Qin: Techniques and Procedures," *Early China* 20 (1995): 333.

19. Anthony Barbieri-Low and Robin D. S. Yates, *Law, State, and Society in Early Imperial China: A Study with Critical Edition and Translation of the Legal Texts from Zhangjiashan Tomb No. 247* (Leiden: Brill, 2015), 1:210.

20. Barbieri-Low and Yates, 1:212.

21. For my translation, I follow the transcription provided in *Qin jiandu he ji*, 4:202–7. Donald Harper provides a translation for the text following Li Xueqin's earlier transcription. Li Xueqin, "Fangmatan jian zhong de zhiguai gushi," *Wenwu* 4 (1990): 43–47. Donald Harper, "Resurrection in Warring States Popular Religion," *Taoist Resources* 5, no. 2 (1994): 13–28.

22. I follow Donald Harper's translation of this line. Harper, "Resurrection in Warring States Popular Religion," 14.

23. Song Huaqiang argues for the character as *yu*, and thus *wu* becomes a variant of "to speak." In Song's translation, then, Dan speaks of himself as "Xi Wu's caretaker." Song Huaqiang, "Fangmatan qin jian zhaji," *Wuhan jianbo yanjiu zhongxin jianbo wang*, March 5, 2010, http://www.bsm.org.cn/?qinjian/5427.html. Huang Jie explains the phrase as a quotation. As he points out, Dan is cited as speaking ("Dan yan") later in the text, so it is possible that he spoke other lines from the retelling of the story without explicit markers. Huang Jie, "Fangmatan Qin jian 'Dan' pain yu Beida Qin du 'Taiyuan you sizhe' yanjiu," *Renwen luncong* (2013): 436–37.

24. Chen Kaili suggests that *boqiu* is a term for the underground world of the dead. Chen Kaili, "Fangmatan Qin jian 'Dan' pian zhaji," *Wuhan jianbo yanjiu zhongxin jianbo wang*, September 25, 2012, http://www.bsm.org.cn/?qinjian/5925.html.

25. My translation of this sentence modified from Armin Selbitschka, "Sacrifice vs. Sustenance: Food as a Burial Good in Late Pre-Imperial and Early Imperial Chinese Tombs and Its Relation [to] Funerary Rites," *Early China* 41 (2018): 203.

26. My translation of these two lines, again, modified from Selbitschka, "Sacrifice vs. Sustenance."

27. For a description of broth or *geng* and its ingredients and preparation, see Roel Sterckx, *Food, Sacrifice, and Sagehood in Early China* (Cambridge: Cambridge University Press, 2011), 15–17.

28. While another resurrection story appeared as part of a larger cache of bamboo slips acquired by Peking University in 2010, I chose to forgo a close study of it because a comparison between the two stories yields questions that fall outside the scope of the chapter and because of its unknown provenance. For extensive analyses on this set of bamboo slips, see Li Ling, "Beida Qin du 'Taiyuan you sizhe' jianjie," *Wenwu* 6 (2012): 81; Chen Wei, "Beida zang Qin jian 'Taiyuan you sizhe' shi xiao," *Wuhan jianbo yanjiu zhongxin jianbo wang*, July 14, 2012, http://m.bsm.org.cn/?qinjian/5904.html; Jiang Shoucheng, "Beida Qin du 'Taiyuan you sizhe' kaoshi," *Zhonghua wenshi luncong* 115, no. 3 (March 2014): 145; Huang Jie, "Fangmatan Qin jian 'Dan' pain yu Beida Qin du 'Taiyuan you sizhe' yanjiu," 447; Fang Yong, "Ye tan Beida Qin du 'Taiyuan you sizhe' zhong de 'huang quan' yici," *Wuhan jianbo yahji zhongxin jianbo wang*, September 28, 2013, http://m.bsm.org.cn/?qinjian/6099.html; Jiang Wen, "To Turn Soybeans into Gold: A Case Study of Mortuary Documents from Ancient China," *Bamboo and Silk* 2, no. 1 (September 2019): 32–51.

29. See, for instance, Zhang Xiugui, "Tianshui 'Fangmatan ditu' de huizhi niandai," *Fudan xuebao* 1 (1991): 44–48; He Shuangquan, "Tianshui Fangmatan Qin jian zongshu zong shu," *Wenwu* 2 (1989): 23–31.

30. For scholarship that expresses skepticism about this correlation between the text, the occupant, and the tomb, see Sun Zhanyu, "Fangmatan Qin jian yi 360–366 hao 'muzhu ji' shuo shangque," *Xibei shi da xue bao* 47, no. 5 (2010): 46–49; Hu Pingsheng and Li Tianhong, *Changjiang liuyu chutu jiandu yu yanjiu* (Wuhan: Hubei jiaoyu chubanshe, 2004), 230; Yan Changgui, "Fangmatan jian 'di cheng ye yushi' zhong de shijian yu didian," in *Chutu wenxian* 4 (2013): 297–303.

31. Li Xueqin's initial transcription of the text includes the character for "thirty" in front of the first "eight," which translates to the year 297 BCE, but later infrared tests show that the "thirty" was a smudge on the slip. Li Xueqin, "Fangmatan jian zhong de zhiguai gushi," 43.

32. Yong Jichun, *Tianshui Fangmatan muban ditu yanjiu*, 39.

33. *Tianshui Fangmatan Qin jian*, ed. Gansu sheng wenwu kaogu yanjiusuo (Beijing: Zhonghua shuju, 2009), 128.

34. Hu Pingsheng and Li Tianhong, *Changjiang liuyu chutu jiandu yu yanjiu*, 222.

35. Yan Changgui, "Fangmatan jian 'di cheng ye yushi' zhong de shijian yu didian," 299–300.

36. Yan Changgui, 302.

37. Ebine Ryosuke, "Fangmatan Qin jian chaoxie niandai lice," *Jianbo* 7 (2012): 161–69.

38. Donald Harper, "Daybooks in the Context of Manuscript Culture and Popular Culture Studies," in *Books of Fate and Popular Culture in Early China*, ed. Donald Harper and Marc Kalinowski (Leiden: Brill, 2017), 109.

39. Liu Lexian, "Daybooks: A Type of Popular Hemerological Manual of the Warring States, Qin, and Han," in *Books of Fate and Popular Culture in Early China*, ed. Donald Harper and Marc Kalinowski (Leiden: Brill, 2017), 68. Ma Yinan, in line with other scholars, believes that the resurrection story is a part of version B of the daybook excavated from Fangmatan. The two parts together should be read as a single text that guarantees the auspiciousness of the deceased in the afterlife. Ma Yinan, "Fangmatan Qin jian 'Dan' pian wenben xingzhi de zai sikao," *Guoxue xuekan* 2 (2019): 19. See also *Tianshui Fangmatan Qin jian*, ed. Gansu sheng wenwu kaogu yanjiusuo, 127.

40. Robin D. S. Yates, "Introduction: The Empire of the Scribes," in *Birth of an Empire: The State of Qin Revisited*, ed. Yuri Pines, Gideon Shelach, Lothar von Falkenhausen, and Robin D. S. Yates (Berkeley: University of California Press, 2014), 148. For more on the categories of religious specialists in the Qin and Han, see Roel Sterckx, "Religious Practices in the Qin and Han," in *China's Early Empires: A Re-appraisal*, ed. Michael Nylan

and Michael Loewe (Cambridge: Cambridge University Press, 2010), 416–18. In the excavated "Statutes on Scribes" from the legal text *Statutes and Ordinances of the Second Year* (*Ernian lüling*), excavated from Zhangjiashan and dated to 186 BCE, "the specialist functions of diviner and invocator, as well as regular scribe" were a part of "the general category of 'scribe' at the time." Barbieri-Low and Yates, *Law, State, and Society*, 2:1086. According to the "Statutes on Scribes," scribal students began their education with three years of formal training but took different tests depending on their specialty, whether as a regular scribe, a diviner, or an invocator (2:1087). For more on the contents of the "Statutes on Scribes," see Cao Lüning, *Zhangjiashan Han lü yanjiu* (Beijing: Zhonghua shuju, 2005). For dating of the statutes, see Barbieri-Low and Yates, *Law, State, and Society*, 1:62–64.

41. Harper, "Resurrection in Warring States Popular Religion," 15. Donald Harper divides the Dan story into three parts, a division that I follow in my analysis as well. For more on *zhiguai* stories, see Robert F. Campany, *Strange Writing: Anomaly Accounts in Early Medieval China* (Albany: State University of New York Press, 1996). The application of the genre *zhiguai* to the Dan story was first proposed by Li Xueqin, "Fangmatan jian zhong de zhiguai gushi," 43.

42. Harper, "Resurrection in Warring States Popular Religion," 17.

43. Barbieri-Low, "Model Legal and Administrative Forms," 126.

44. *Qin jiandu he ji*, 1:205.

45. Guolong Lai, *Excavating the Afterlife: The Archaeology of Early Chinese Religion* (Seattle: University of Washington Press, 2015), 80.

46. Liu Xinfang and Liang Zhu, *Yunmeng Longgang Qin Jian* (Beijing: Kexue chubanshe, 1997), 45. Liu Xinfang and Liang Zhu speculate that the last three characters put on the other side of the board were probably written there because the scribe ran out of room on the front.

47. Translation from Lai, *Excavating the Afterlife*, 152.

48. Liu and Liang, *Yunmeng Longgang Qin Jian*, 48.

49. Lai presents another example of the use of *mou*, an indefinite pronoun, as a generic placeholder that appears on bamboo slips excavated from Jiudian tomb 56 in Jiangling County, Hubei Province, and that was used as a "general template" rather than "a 'real' incantation for the tomb occupant." Lai, *Excavating the Afterlife*, 155.

50. Lai, 152.

51. The deceased buried in Longgang tomb 6 did not have feet, which suggests that he may have endured the punishments that the character "Bisi" in the redemptive story avoided by having the ruling overturned. Enno Giele, "Excavated Manuscripts: Context and Methodology," in *China's Early Empires: A Re-appraisal*, ed. Michael Nylan and Michael Loewe (Cambridge: Cambridge University Press, 2010), 127.

52. Robin Yates and Anthony Barbieri-Low, for example, characterize the *Book of Submitted Doubtful Cases* excavated from tomb 247 at Zhangjiashan in Jingzhou, Hubei Province, as a kind of "literary hybrid"—part official document and part entertainment. Barbieri-Low and Yates, *Law, State, and Society*, 1:102.

53. Guo Jue, "Western Han Funerary Relocation Documents and the Making of the Dead in Early Imperial China," *Bamboo and Silk* 2, no. 1 (2019): 209. Guolong Lai similarly argues that ritual specialists were "active agents in the construction of the religious imagination." Lai, *Excavating the Afterlife*, 157.

54. Yates, "Introduction: The Empire of the Scribes," 148.

55. Sun Zhanyu suggests that the main purpose of the text lies in this final portion, in the retelling of what the dead prefers from the perspective of someone who once was dead himself. Sun Zhanyu, "Fangmatan Qin jian yi 360–366 hao 'muzhu ji' shuo shangque," 48.

56. Hsing I-tien, "Qin-Han Census," 178. Alain Thote characterizes objects like Dan's story or the terrestrial diagrams as *shengqi*. Alain Thote, "Daybooks in Archaeological Context," in *Books of Fate and Popular Culture in Early China: The Daybook Manuscripts of the Warring States, Qin, and Han*, ed. Donald Harper and Marc Kalinowski (Leiden: Brill, 2017), 53.

57. Barbieri-Low and Yates, *Law, State, and Society*, 1:107.

58. For transcriptions and annotations of the tablets, see Hunan sheng wenwu kaogu yanjiusuo, *Liye fajue baogao* (Changsha: Yuelu shushe, 2007), 196–203.

59. Fujita Katsuhisa, "Liye Qin jian suo jian Qin dai jun xin de wenshu chuandi," *Jianbo* 8 (2013): 179–94.

60. Wang Zijin, "Liye Qin jian 'youlizu' kao," *Shoudu shifan daxue xuebao* (*shehui kexue ban*) 2 (2018): 41–48.

61. For a translation and a more extensive discussion of Liye tablet 8-2262, see Maxim Korolkov, "Empire-Building and Market-Making at the Qin Frontier: Imperial Expansion and Economic Change, 221–207 BCE" (PhD diss., Columbia University, 2020), 487–89.

62. Korolkov, 489–90.

63. Fujita Katsuhisa, "Liye Qin jian de jiaotong ziliao yu xian shehui," *Jianbo* 10 (2015): 173–74.

64. Tsang Wing Ma, "Between the State and Their Superiors," 40–47.

65. In grouping the Fangmatan terrestrial diagrams among other "travel paraphernalia" in the tomb as "contributions to a postmortem ritual journey," Guolong Lai recontextualizes the functions of these drawings for the deceased—functions that need not depend solely on a living user's needs in navigating terrain or knowing exactly where certain resources are located. Lai Guolong, *Excavating the Afterlife*, 183.

66. Tsang Wing Ma has shown how excavated account books dating to the Qin and Han periods also required an elaborate scribal system of "compress[ing] useful information to present it in a relatively more efficient form to the higher level of the bureaucratic hierarchy." Tsang Wing Ma, "Between the State and Their Superiors," 40.

67. He Shuangquan groups the drawings into administrative, topographic, and economic maps for living use. He Shuangquan, "Tianshui Fangmatan Qin mu chutu ditu chutan," *Wenwu* 2 (1989): 18.

68. Cordell Yee, "Chinese Cartography among the Arts: Objectivity, Subjectivity, Representation," in *History of Cartography*, vol. 2, bk. 2, *Cartography in the Traditional East and Southeast Asian Societies*, ed. J. B. Harley and David Woodward (Chicago: University of Chicago Press, 1994), 137; Nathan Sivin and Gari Ledyard Scope, "Introduction to East Asian Cartography," in *History of Cartography*, vol. 2, bk. 2, *Cartography in the Traditional East and Southeast Asian Societies*, ed. J. B. Harley and David Woodward (Chicago: University of Chicago Press, 1994), 29.

69. Agnes Hsu-Tang suggests that bureaucrats may possess the know-how to paint and map in brush and ink, but the shared knowledge that applies to both practices does not translate to similar intentionality, wherein a bureaucrat draws with the intention of making something functional as opposed to the painter who is more invested in the "creative process." Agnes Hsu-Tang, "Structured Perceptions of Real and Imagined Landscapes in Early China," in *Geography and Ethnography: Perceptions of the World in Pre-Modern Societies*, ed. Kurt A. Raaflaub and Richard J. A. Talbert (Oxford: Blackwell, 2009), 43.

70. For a survey of these reconstructions, see Yong Jichun and Bo Pengxu, "Jin ershi nian lai Tianshui Fangmatan muban ditu yanjiu zongshu," *Tianshui shifan xueyuan xuebao* 36, no. 4 (July 2016): 21–25; Yong Jichun, "Jinnian lai guanyu Tianshui Fangmatan muban ditu yanjiu de huigu yu zhanwang," *Zhongguo shi yanjiu tongtai* 5 (1997): 10–17; Yong Jichun and Dang Anrong, "Tianshui Fangmatan muban ditu banshi zuhe yu ditu fuyuan xintan," *Zhongguo lishi dili luncong* 4 (2000): 179–92; *Qin jiandu he ji*, 4:208–16.

71. Fujita Katsuhisa, "Zhanguo shi Qin de lingyu xingcheng he jiaotong luxian," trans. Li Shuping, *Qin wenhua luncong* 6 (1998): 367. Contrary to previous suggestions that the drawings were for military use or for mapping natural resources along the Wei and Huamiao Rivers, Fujita argues that they actually show the transportation route from Tianshui to Wudu, a city south of Tianshui also in Gansu Province, along the Xihan River (Western Han River). With the various notations for towns, distance markers, and checkpoints, Fujita argues that this route ultimately led to the Shu kingdom during the Warring States period in modern-day Sichuan Province (375).

72. *Qin jiandu he ji*, 4:216.

73. Fujita, "Zhanguo shi Qin de lingyu xingcheng he jiaotong luxian," 367. Following Fujita's lead, Yan Changgui similarly argues that there is no set orientation of the boards for viewing or use. Instead, users turn the boards however they wish in order to satisfy their needs. Yan Changgui, "Tianshui Fangmatan muban ditu xintan," 375.

74. Qu Kale, "Tianshui Fangmatan muban ditu xinyi," *Ziran kexue shi yanjiu* 32, no. 4 (2013): 502.

75. Infrared tests conducted by the Center for the Study of Bamboo and Silk Manuscripts at Wuhan University on the maps in 2010 indicate that the characters on drawing 2 located at the bottom of the map, previously deciphered as *shang*, or "up," are actually the two characters *beifang*, or "north." Interestingly, the two characters read in the opposite direction of the main river flows. Following Qu's argument, then, south may be on top according to the brushstrokes, but this orientation renders the two characters *beifang* upside down.

76. Yan Changgui, "Tianshui Fangmatan muban ditu xintan," 377.

77. Qu Kale, "Tianshui Fangmatan muban ditu xinyi," 498.

78. Yan Changgui, "Tianshui Fangmatan muban ditu xintan," 376.

79. For the use of resolution as opposed to map scale, see Matthew H. Edney, *Cartography: The Ideal and Its History* (Chicago: University of Chicago Press, 2019), 226–27.

80. Yong Jichun attempts to find a scale for each of the drawings, but none can be found. Even so, Yong concludes that the drawings must have been drawn to some scale but that they were imprecise. Yong Jichun, *Tianshui Fangmatan muban ditu yanjiu*, 84–88.

81. As Cao points out, however, for maps of a smaller region, Earth's curvature should not significantly affect their accuracy. Cao Wanru, "Zhongguo gudai ditu huizhi de lilun he fangfa chutan," *Ziran kexue shi yanjiu* 2, no. 3 (1983): 246.

82. Cao Wanru, "Youguan Tianshui Fangmatan Qin mu chutu ditu de jige wenti," *Wenwu* 12 (1989): 85. For a discussion of Pei's principles, see the introduction. Translations of principles taken from Cordell Yee, "Taking the World's Measure: Chinese Maps between Observation and Text," in *History of Cartography*, vol. 2, bk. 2, *Cartography in the Traditional East and Southeast Asian Societies*, ed. J. B. Harley and David Woodward (Chicago: University of Chicago Press, 1994), 110.

83. Yong, *Tianshui Fangmatan muban ditu yanjiu*, 175.

84. Yong, 174–75.

85. Gansu sheng wenwu kaogu yanjiusuo, "Tianshui Fangmatan muzang fajue baogao," in *Tianshui Fangmatan Qin jian*, ed. Gansu sheng wenwu kaogu yanjiusuo, 119.

86. No corpse was found in Fangmatan tomb 5, but based on the location of the hemp paper fragment, it was probably placed over the deceased's chest. *Tianshui Fangmatan Qin jian*, ed. Gansu sheng wenwu kaogu yanjiusuo, 127. For more information on the hemp paper material of the drawing and its dating, see Li Xiaocen, "Gansu Tianshui Fangmatan Xi Han mu chutu zhi de zai yanjiu," *Kaogu* 10 (2016): 110–14.

87. Qu Kale argues that drawing 3B could be a map of the Yongchuan River valley based on its morphological similarity to lines found in drawings 1A and 2. Qu Kale, "Tianshui Fangmatan muban ditu xinyi," 497.

88. Yong Jichun and Bo Pengxu, "Jin ershi nian lai Tianshui Fangmatan muban ditu yanjiu zongshu," 24.

89. Alexander Soper, "Early Chinese Landscape Painting," *Art Bulletin* 23, no. 2 (June 1941): 149.

90. Jessica Rawson, "The Origins of Chinese Mountain Painting: Evidence from Archaeology," *Proceedings of the British Academy* 117 (2002): 28.

91. Gansu sheng wenwu kaogu yanjiusuo, "Tianshui Fangmatan muzang fajue baogao," 116.

92. There were only fifteen items, including a brush case, all found in the coffin, in tomb 14. Gansu sheng wenwu kaogu yanjiusuo, "Tianshui Fangmatan muzang fajue baogao," 116.

93. Gansu sheng wenwu kaogu yanjiusuo, "Tianshui Fangmatan muzang fajue baogao," 129.

94. It is unclear from the archaeological reports which side was facing outward. The drawings were only described as having the tiger on the "front," but which side constituted the front is unclear from the archaeology report. Gansu sheng wenwu kaogu yanjiusuo, "Tianshui Fangmatan muzang fajue baogao," 119.

95. Li Ling, "'Shi' yu Zhongguo gudai de yuzhou moshi," *Zhongguo wenhua* 1 (1991): 1–30.

96. John S. Major, *Heaven and Earth in Early Han Thought: Chapters Three, Four, and Five of the* Huainanzi (Albany: State University of New York Press, 1993), 84.

97. Peng Jinhua and Liu Guosheng, "Shashi Zhoujiatai Qin mu chutu xiantu chutan," *Jianbo yanjiu* (2001): 241–50.

98. Marc Kalinowski, "The Notion of *Shi* and Some Related Terms in Qin-Han Calendrical Astrology," *Early China* 35/36 (2012/2013): 351.

99. Donald Harper, "Communication by Design: Two Silk Manuscripts of Diagrams (*Tu*) from Mawangdui Tomb Three," in *Graphics and Text in the Production of Technical Knowledge in China: The Warp and the Weft*, ed. Francesca Bray, Vera Dorofeeva-Lichtmann, and Georges Métailié (Leiden: Brill, 2007), 176.

100. Lillian Lan-Ying Tseng, "Representation and Appropriation: Rethinking the TLV Mirror in han China," *Early China* 29 (2004): 199–201.

101. Jiang Shoucheng, "Fangmatan M14 Qin mu banhua zhong de zongjiao xinyang," *Laozi xuekan* (2014): 85.

102. Jiang Shoucheng, 81.

103. *Hou Hanshu*, comp. Fan Ye and Sima Biao (Beijing: Zhonghua shuju, 2012), 86.2842.

104. Translation from Barbieri-Low and Yates, *Law, State, and Society*, 2:755.

105. For more on the administrative procedure of recording, reporting, and granting *fuchu*, see Zhuang Xiaoxia "Liye Qin jian suo jian Qin 'de hu fuchu' zhidu kaoshi," *Wuhan jianbo yanjiu zhongxin jianbo wang*, August 30, 2019, http://m.bsm.org.cn/view/19399.html.

106. *Qin jiandu he ji*, 2:35–36.

107. *Qin jiandu he ji*, 2:36–37; Barbieri-Low and Yates, *Law, State, and Society*, 2:754–55n7.

108. A. F. P. Hulsewé, *Remnants of Qin Law: An Annotated Translation of the Ch'in Legal and Administrative Rules of the 3rd Century BC Discovered in Yun-meng Prefecture, Hu-pei Province in 1975* (Leiden: Brill, 1985), 112–13.

109. Mark Edward Lewis, *The Construction of Space in Early China* (Albany: State University of New York Press, 2006), 277.

110. Guolong Lai, "Death and Otherworldly Journey in Early China as Seen through Tomb Texts, Travel Paraphernalia, and Road Rituals," *Asia Major* 18, no. 1 (2005): 30. See also Lai, *Excavating the Afterlife*, 173.

111. For a study on the two versions of Fangmatan daybooks, see Liu Lexian, "Daybooks," 57–90.

112. Mu-chou Poo, "Ritual and Ritual Texts in Early China," in *Early Chinese Religion*, pt. 1, *Shang through Han (1250 BC–220 AD)*, ed. John Lagerwey and Marc Kalinowski (Leiden: Brill, 2008), 301.

Chapter 3

1. *Shiji*, composed by Sima Qian, with Sima Tan (Beijing: Zhonghua shuju, 2010), 113.2969.

2. *Shiji*, 113.2967.

3. Fu Jüyou, "Guanyu 'zhujun tu' huizhi de niandai wenti," *Kaogu* 2 (1981): 173. Using GIS technology, Hsin-Mei Agnes Hsu and Anne Martin-Montgomery's study supports this position as well. Hsin-Mei Agnes Hsu and Anne Martin-Montgomery, "An Emic Perspective on the Mapmaker's Art in Western Han China," *Journal of the Royal Asiatic Society* 17, no. 4 (October 2007): 443–57.

4. Some scholars have suggested that the *Topography Diagram* served as a template for the *Garrison Diagram*. In this hypothesis, *ditu* makers had the opportunity to correct any "mistakes" that might have appeared in the *Topography Diagram* when it came time to make the *Garrison Diagram*. The argument for the *Topography Diagram* being made before the *Garrison Diagram* lies in the naming of places. On the *Topography Diagram*, there are places labeled *jun* that become *li* in the *Garrison Diagram*. The change from *jun* to *li* maps onto a chronological sequence for the two drawings. With this evidence in mind, Cao Xuequn dates the *Topography Diagram* to between 202 BCE, when the Han established control over the Hunan area, and the brief reign of Empress Lü in 181. Cao Xuequn, "Lun Mawangdui ditu de huizhi niandai," in *Mawangdui Han mu yanjiu wenji: 1992 nian Mawangdui Han mu guoji xueshu taolun hui lunwen xuan*, ed. Hunan sheng bowuguan (Changsha: Hunan chubanshe, 1994), 178–81.

5. While Fu Jüyou and Chen Songchang believe that Li Cang's oldest son, Li Xi, is the one buried, other scholars such as Li Shisheng and the archaeological report on tomb 3 identify the deceased as Li Xi's brother. For arguments supporting Li Xi, see Fu Jüyou, "Guanyu Changsha Mawangdui san hao Han mu de muzhu wenti," *Wenwu* 2 (1983): 165–72, and Chen Songchang, "Mawangdui san hao muzhu de zai renshi," *Wenwu* 8 (2003): 56–66. For arguments supporting the identification as Li Xi's unnamed brother, see Hunan sheng bowuguan and Zhongguo kexueyuan kaogu yanjiusuo, "Changsha Mawangdui er, san hao Han mu fajue jianbao," *Wenwu* 7 (1974): 46, and Li Shisheng, "Changsha Mawangdui sanhao muzhu zai yi," *Gugong bowuyuan yuankan* 3 (2005): 150–62.

6. Hsing I-tien, "Lun Mawangdui Han mu 'zhujun tu' ying zhengming wei 'jiandao fengyu tu," *Hunan daxue xuebao* 21, no. 5 (September 2007): 19.

7. Hsing I-tien, 19.

8. Cordell Yee, "Chinese Cartography among the Arts: Objectivity, Subjectivity, Representation," in *History of Cartography*, vol. 2, bk. 2, *Cartography in the Traditional East and Southeast Asian Societies*, ed. J. B. Harley and David Woodward (Chicago: University of Chicago Press, 1994), 151.

9. The major river on the *Topography Diagram*, for example, is the Xiao River, which is rendered with a line that measures 0.1 cm on one end and 0.8 cm at the other near the bottom edge of the map. Yu Bingxia, "Mawangdui Han mu 'dixing tu' yanjiu zongshu," *Hunan sheng bowuguan guankan* 9 (2013): 66.

10. Cheng Yinong provides another way of considering the problems of conflating uniformity with accuracy when he argues that use does not necessarily equate to

accuracy. That is, accuracy may lead to certain kinds of use, but that does not mean that accuracy is the only way in which *ditu* are made functional. Yinong Cheng, *"Fei kexue" de Zhongguo chuantong yutu: Zhongguo chuantong yutu huizhi yanjiu* (Beijing: Zhongguo shehui kexue chubanshe, 2016), 27.

11. Michael Nylan, "Calligraphy, the Sacred Text and Test of Culture," in *Character and Context in Chinese Calligraphy*, ed. Cary Liu, Dora Ching (Princeton, NJ: Art Museum, Princeton University Press, 1999): 20. Throughout early China, the term *wen* takes on different meanings, as outlined in Nylan's chapter. For more on the evolution of the term, see Martin Kern, "Ritual, Text, and the Formation of the Canon: Historical Transitions of 'Wen' in Early China," *T'oung Pao*, 2nd ser., 87, no. 1/3 (2001): 44.

12. Ananda K. Coomaraswamy, "Ornament," *Art Bulletin* 21, no. 4 (December 1939): 376.

13. In the initial report compiled by the Mawangdui tomb 3 excavation team, the scale of the drawing was determined by using five locations on the *Topography Diagram* that correspond with their modern equivalents in the area and are recorded in textual sources. Mawangdui Han mu boshu zhenli xiaozu, "Changsha Mawangdui san hao Han mu chutu ditu de zhenli," *Wenwu* 2 (1975): 37. Once the distance between these known locations was calculated and a ratio was produced based on their distances on modern maps, this ratio was then treated as the scale for the entire drawing despite the fact that this scale only applies to a portion of the *Topography Diagram*.

14. Tan Qixiang, "Erqian yibai duonian qian de yi fu ditu," *Wenwu* 2 (1975): 45. Mei-Ling Hsu, "The Han Maps and Early Chinese Cartography," *Annals of the Association of American Geographers* 68, no. 1 (March 1978): 47.

15. Tan Qixiang, "Erqian yibai duonian qian de yi fu ditu," 46.

16. Zhang Xiugui, "Mawangdui 'zhujun tu' cehui jingdu ji huizhi tedian yanjiu," *Dili kexue* 4 (1986): 366.

17. The main area of the *Garrison Diagram* arguably contains a map scale of 1:45,000 to 1:50,000. Zhang, "Mawangdui 'zhujun tu' cehui jingdu ji huizhi tedian yanjiu," 362. There are no textual records of places named *jiandao*, but scholars generally agree that the triangular structure is an administrative unit stationed in the Changsha region. The characters *jiandao* are written inside the triangular structure, while to its south are the characters *fudao*, which is the name given to an elevated walkway that connects the triangular fortress with a nearby watchtower. Fu Jüyou, "Youguan Mawangdui ditu de jige wenti," *Wenwu* 2 (1982): 76. Scholars derived the name *Garrison Diagram* from the presence of six named garrisons. Hsing I-tien argues that the *Garrison Diagram* should in fact be renamed the "Administrative Map of Jiandao." According to Hsing, the emphasis on the garrisons is misplaced and instead should be put on the *jiandao* administrative center. The "Administrative Map of Jiandao," in turn, is an ordinary administrative map rather than a unique map of the military strategy against the Nanyue kingdom. Hsing I-tien, "Lun Mawangdui Han mu 'zhujun tu' ying zhengming wei 'jiandao fengyu tu," 12–19.

18. Zhang Xiugui, "Mawangdui 'zhujun tu' cehui jingdu ji huizhi tedian yanjiu," 362–63. As Zhang argues, both the *Garrison Diagram* and *Topography Diagram* have a center from which the other regions emanate. In the *Topography Diagram*, the center is considered the region immediately surrounding Shenping, whereas the *Garrison Diagram* is anchored by the triangular structure labeled as *jiandao*. Interestingly, Zhang claims that because the *jiandao* symbol is enlarged to emphasize its centrality in the map, its graphic amplification distorts the scale of the region (363–64).

19. Zhang Xiugui, 364.

20. Hsing I-tien, "Lun Mawangdui Han mu 'zhujun tu' ying zhengming wei 'jiandao fengyu tu," 15.

21. *Hanshu*, composed by Ban Gu et al. (Beijing: Zhonghua shuju, 2009), 54.2451–52.

22. For a study on the meaning of *zhang*, see Zhou Shirong, "Youguan Mawangdui gu ditu de yixie ziliao he jifang Han yin," *Wenwu* 1 (1976): 28.

23. The only prefecture without a road is Guiyang. Zhang Xiugui, "Mawangdui Han mu chutu dixing tu pingjie fuyuan zhong de ruogan wenti," *Ziran kexue shi yanjiu* 3, no. 3 (1984): 274.

24. The river names appear at the point where tributaries flow into main rivers, which is different from modern maps but consistent with the labeling practice on the *Garrison Diagram*. Mawangdui Han mu boshu zhenli xiaozu, "Changsha Mawangdui san hao Han mu chutu ditu de zhenli," *Wenwu* 2 (1975): 38.

25. The Mawangdui silk manuscript team suggests that *fengzhong* may refer to the location *fengyang* in Nanyue. Mawangdui Han mu boshu zhenli xiaozu, 39. Fu Jüyou, however, disagrees, and argues that *fengzhong* means "border," like all other instances of *feng* that appear in the map. Fu Jüyou, "You guan Mawangdui ditu de jige wenti," 70–71. Huang Shengsong posits a third possibility for the meaning of *feng* as a drainage basin. Huang Shengsong, "Mawangdui 'zhujun tu' 'feng' zi shiyi," in *Jinian Mawangdui Han mu fajue sizhi zhounian guoji xueshu yantaohui lunwen ji*, ed. Hunan sheng bowuguan (Changsha: Yuelu chubanshe, 2016), 419.

26. Tan Qixiang suggests that this is because mountain ranges were not yet named at this point. Tan Qixiang, "Erqian yibai duonian qian de yi fu ditu," 45.

27. Tan Qixiang, 44. Also, Ge Jianxiong, *Zhongguo gudai de ditu huice* (Beijing: Shangwu yinshu guan, 1998), 3.

28. Cheng Yinong, *"Fei kexue" de Zhongguo chuantong yutu*, 19.

29. Merriam-Webster, s.v. "form line," https://www.merriam-webster.com/dictionary/form%20line.

30. While the *Huainanzi* was presented to Emperor Wu in 139 BCE, it does not necessarily mean that the text was written for him specifically. See Sarah A. Queen and Michael Puett, introduction to *The Huainanzi and Textual Production in Early China*, ed. Sarah A. Queen and Michael Puett (Leiden: Brill, 2014), 15–16. For a detailed introduction to the chapter, including its sources and an overview of its philosophical context, see John S. Major, *Heaven and Earth in Early Han Thought: Chapters Three, Four, and Five of the Huainanzi* (Albany: State University of New York Press, 1993), 141–42.

31. Liu An, "Four: Terrestrial Forms," in *The Essential Huainanzi: Liu An, King of Huainan*, trans. and ed. John Major et al. (New York: Columbia University Press, 2010), 159.

32. For an explanation of these terms, see the introduction.

33. Scholars have pointed out that there are a number of evocative images that are mobilized throughout the *Huainanzi* to describe the structural relations between heaven, earth, and humans. The "fundamental dynamic principle" of roots and branches is one that relates directly to descriptions of the relationship between mountains and rivers in the text. Andrew Meyer, "Root-Branches Structuralism in the *Huainanzi*," in *The Huainanzi and Textual Production in Early China*, ed. Sarah A. Queen and Michael Puett (Leiden: Brill, 2014), 25. See also Griet Vankeerberghen, *The* Huainanzi *and Liu An's Claim to Moral Authority* (Albany: State University of New York Press, 2001): 95–96.

34. Liu An, "Four: Terrestrial Forms," in *The Essential Huainanzi*, 168.

35. Liu An, "Four: Terrestrial Forms," 156.

36. Hajime Nakatani, "The Empire of Fame: Writing and the Voice in Early Medieval China," *positions* 14, no. 3 (2006): 555.

37. Nakatani, 555–56.

38. David Freedberg, *The Eye of the Lynx: Galileo, His Friends, and the Beginnings of Modern Natural History* (Chicago: University of Chicago Press, 2002), 366.

39. Martin Powers, *Pattern and Person: Ornament, Society, and Self in Classical China*, Harvard East Asian Monographs (Cambridge, MA: Harvard University Asia Center, 2006), 268.

40. Caroline Arscott, *William Morris and Edward Burne-Jones: Interlacings* (New Haven, CT: Yale University Press, 2008), 187.

41. Mawangdui Han mu boshu zhenli xiaozu, "Changsha Mawangdui san hao Han mu chutu ditu de zhenli," 37. Zhongguo kexueyuan kaogu yanjiu suo, Hunan sheng bowuguan xiezuo xiaozu, "Mawangdui er, san hao Han mu fajue de zhuyao shouhuo," *Kaogu* 1 (1975): 49.

42. Zhang, "Mawangdui Han mu chutu dixing tu pingjie fuyuan zhong de ruogan wenti," 269.

43. Dieter Kuhn suggests that "silk embroidery and painting during the Warring States period and at the beginning of the Han era show that the artistic wishes, aims and ideas of the time far exceeded the technical possibilities of woven textile patterning." Dieter Kuhn, "Silk Weaving in Ancient China: From Geometric Figures to Patterns of Pictorial Likeness," *Chinese Science* 12 (1995): 83.

44. David Rosand, *Drawing Acts: Studies in Graphic Expression and Representation* (Cambridge: Cambridge University Press, 2016), 2.

45. Hunan sheng bowuguan and Hunan sheng wenwu kaogu yanjiu suo, eds., *Changsha Mawangdui er, san hao Han mu: Tianye kaogu fajue baogao* (Beijing: Wenwu chubanshe, 2004), 210. Hunan sheng bowuguan and Zhongguo kexue kaogu yanjiusuo, eds., *Changsha Mawangdui yi hao Han mu* (Beijing: Wenwu chubanshe, 1973), 1:30.

46. Hunan sheng bowuguan and Zhongguo kexue kaogu yanjiusuo, 41.

47. Shanghai shi fangzhi kexue yanjiu yuan and Shanghai shi sichou gongye gongsi wenwu yanjiu zu, *Changsha Mawangdui yihao Han mu chutu fangzhipin de yanjiu* (Beijing: Wenwu chubanshe, 1980), 55.

48. Zhao Feng, *Zhongguo sichou yishu shi* (Beijing: Wenwu chubanshe, 2005), 99.

49. Yuan Jianping, "Mawangdui yihao Han mu yu Mashan yihao Chu mu chutu sizhipin de bijiao yanjiu," in *Mawangdui Hanmu yanjiu wenji—1992 nian Mawangdui Han mu guoji xueshu taolun hui lunwen xuan*, ed. Hunan sheng bowuguan (Changsha: Hunan chubanshe, 1994), 233.

50. A braid stitch is similar to what is later known as a Chinese knot stitch. It involves knotting a single thread in a variety of ways each time the thread is pulled up from the ground weave. Zhao Feng, *Zhongguo sichou yishu shi*, 104.

51. Dieter Kuhn and Zhao Feng, eds., *Chinese Silks* (New Haven, CT: Yale University Press, 2012), 136.

52. Shanghai shi fangzhi kexue yanjiu yuan and Shanghai shi sichou gongye gongsi wenwu yanjiu zu, *Changsha Mawangdui yihao Han mu chutu fangzhipin de yanjiu*, 55.

53. Zhao Feng, *Zhongguo sichou yishu shi*, 103.

54. Hanmo Zhang, however, argues that the triangular peaks (as well as the three mounds and the winding lines) are not the center stroke of the character *shan* (mountain) but are instead part of cloud symbols that were a part of the Western Han visual lexicon. Hanmo Zhang, "Mapped Territory Floating in the Clouds: A Reinterpretation of the Mawangdui Maps in Their Art and Religious Contexts," *Artibus Asiae* 2 (2016): 152–53.

55. Patrick Maynard, *Drawing Distinctions: The Varieties of Graphic Expression* (Ithaca, NY: Cornell University Press, 2005), 66.

56. I would like to thank the participants of my book manuscript workshop for bringing this process to my attention.

57. Hunan sheng bowuguan and Hunan sheng wenwu kaogu yanjiu suo, *Changsha Mawangdui er, san hao Han mu*, 43.

58. Hunan sheng bowuguan and Hunan sheng wenwu kaogu yanjiu suo, 117. Anthony Barbieri-Low, *Artisans in Early Imperial China* (Seattle: University of Washington Press, 2007), 77.

59. Hunan sheng bowuguan and Hunan sheng wenwu kaogu yanjiu suo, *Changsha Mawangdui er, san hao Han mu*, 88. See also Marc Kalinowski, "La production des manuscrits dans la Chine ancienne: Une approche codicologique de la bibliothèque funéraire de Mawangdui," *Études Asiatiques: Revue de la Société Suisse-Asie* 59 (2005): 138–40.

60. For a codicological analysis of the texts included in the lacquer box, see Kalinowski, "La production des manuscrits," 131–68.

61. Susan Stewart, *On Longing: Narratives of the Miniature, the Gigantic, the Souvenir, the Collection* (Durham, NC: Duke University Press, 1992), 156–57.

62. Other lacquer containers found in tomb 3 include two elaborately painted lacquer toilet boxes. For a detailed inventory of their contents, see Hunan sheng bowuguan and Hunan sheng wenwu kaogu yanjiu suo, *Changsha Mawangdui er, san hao Han mu*, 140–55. For an analysis of the tradition of burying toiletries in the Western Han, including an analysis of the Mawangdui toiletry boxes in tombs 1 and 3, see Sherri Lullo, "Making Up Status and Authority: Practices of Beautification in Warring States through Han Dynasty China (Fourth Century BCE–Third Century CE)," *Fashion Theory* 20 (2016): 415–40.

63. Hunan sheng bowuguan and Hunan sheng wenwu kaogu yanjiu suo, *Changsha Mawangdui er, san hao Han mu*, 28.

64. For an alternative analysis of the development from vertical pit-style tombs to horizontal chamber-style tombs, see Lai, *Excavating the Afterlife*, 97. It is the malleability of space as exemplified in Mawangdui tomb 3 that makes it topological in ways that are unlike later horizontal graves of the Western Han dynasty. The two rock-cut tombs belonging to Prince Liu Sheng and his wife Dou Wan at Mancheng (ca. 113 BCE), for instance, present a visual array of artifacts arranged in locations that reference the actual placement of ritual artifacts and the arrangement of rooms in a palace for the living. Space is carefully delineated between objects so as to maintain the possibility of movement between things. The Mancheng tombs can also be combed for meaning by examining their space topologically, as Jie Shi suggests. Jie Shi, *Modeling Peace: Royal Tombs and Political Ideology in Early China*, Tang Center Series in Early China (New York: Columbia University Press, 2020), 19.

Chapter 4

1. Gao Zhishan, "Bingqi he zhujuntu," in *Mawangdui Hanmu yanjiu*, ed. Hunan sheng bowuguan (Changsha: Hunan renmin chubanshe, 1979), 305.

2. For a discussion of *mingqi* and *shengqi* as they pertain to the book, please see the introduction.

3. Hunan sheng bowuguan and Hunan sheng wenwu kaogu yanjiu suo, eds., *Changsha Mawangdui er, san hao Han mu: Tianye kaogu fajue baogao* (Beijing: Wenwu chubanshe, 2004), 109. On the eastern wall of the *guan*, another smaller painting, measuring 68.7 cm long and 34.9 cm wide, was hung. Because of its fragmentary condition, it is difficult to piece together the painting in order to arrive at coherent interpretations of its content.

4. As Jin Weinuo notes, most of the painting is rendered from an aerial perspective, breaking free of the earlier tradition of lining up the figures on a single plane from eye level. Jin Weinuo, "Tan Changsha Mawangdui sanhao Han mu bohua," *Wenwu* 11 (1974): 41.

5. Hunan sheng bowuguan and Hunan sheng wenwu kaogu yanjiu suo, *Changsha Mawangdui er, san hao Han mu*, 110.

6. Chen Songchang, "Mawangdui san hao Han mu 'chema yizhang tu' bohua shishuo," in *Hunan bowuguan wenji* 4 (1991), 82–87.

7. Jin Weinuo, "Tan Changsha Mawangdui sanhao Han mu bohua," 41.

8. Chen Jianming, *Hunan chutu bohua yanjiu* (Changsha: Yuelu shu chubanshe, 2013), 193–201. Liu Xiaolu departs from these iconographic interpretations and presents an argument that focuses on the function of the depicted figures as *yong*, or burial surrogates. Liu's main evidence is the inventory list in tomb 3, which contains the number of figurines that are supposed to have been buried. While there were actual wooden figurines buried in the tomb, their numbers do not add up to the number included in the inventory list. Only when the number of figures painted on the silk paintings is included do the numbers match. Liu Xiaolu, "Lun bohua yong: Mawangdui san hao mu dong xi bi bohua de xingzhi he zhuti," *Kaogu* 10 (1995): 938.

9. Hsing I-tien, "Lun Mawangdui Han mu 'zhujun tu' ying zhengming wei 'jiandao fengyu tu,'" *Hunan daxue xuebao* 21, no. 5 (September 2007): 14.

10. Alva Noë, *Strange Tools: Art and Human Nature* (New York: Hill and Wang, 2015), 30.

11. Noë, 30.

12. For instance, in *Sanguo zhi*, composed by Chen Shou, commentary by Pei Songzhi (Beijing: Zhonghua shuju, 1959), 56.1315.

13. *Shuowen jiezi zhu*, comp. Xu Shen, and ed. Duan Yucai (Taipei: Hanjing wenhua shiye youxian gongsi, 1985), 15.94.

14. *Shuowen jiezi zhu*, 15.113.

15. As Qiu explains, *she* in these instances means to place (*zhi*) or to establish (*li*). Qiu Xigui, "Gu wenxian zhong du wei 'she' de 'yi' ji qi yu 'zhi' hu'e zhi li," *Dongfang wenhua* 36, no. 1 (1998): 40.

16. Qiu Xigui, "Zai tan gu wenxian yi 'yi' biao 'she,'" *Fudan daxue chutu wenxian yu guwenzi yanjiu zhongxin*, March 14, 2011, http://www.gwz.fudan.edu.cn/Web/Show/1429.

17. *The Art of War: Sunzi's Military Methods*, trans. Victor H. Mair (New York: Columbia University Press, 2007), 30.

18. Yinqueshan tomb 1 had a total of 4,942 bamboo slips. Of these, 222 slips belonged to the *Sun Bin bingfa*, and another 105 slips belonged to the *Sunzi bingfa*. Wu Jiulong and Bi Baoqi, "Shandong Linyi Xi Han mu faxian 'Sunzi bingfa' he 'Sun Bin bingfa' deng zhujian de jianbao," *Wenwu* 2 (1974): 16–17.

19. Yang Hong, "Yi bu guanche fajia luxian de gudai junshi zhuzuo—du zhujian ben 'Sun Bin bingfa,'" *Kaogu* 6 (1974): 347; Yang Bojun, "Sun Bin he 'Sun Bin bingfa' zakao," *Wenwu* 3 (1975): 10.

20. *The Art of War: A New Translation*, trans. Michael Nylan (New York: W. W. Norton, 2020), 21.

21. Translation from *Art of War*, trans. Nylan, 43. Victor Mair similarly translates *shi* as "(strategic/positional) advantage," with additional possible translations such as "configuration, circumstances, efficacy, inertia." Sun Tzu et al., *The Art of War*, trans. Mair, xlv. The term *shi* also features prominently in the chapter "Military Overview" ("Binglue") of the *Huainanzi*, which Andrew Meyer stresses is dependent on both "intrinsic and extrinsic factors affecting the military formation in question at any given time"—not only the sheer size of a troop (extrinsic), but also the quality of its training (intrinsic) and the advantages and disadvantages of the terrain (extrinsic). Liu An, *The Huainanzi: A Guide to the Theory and Practice of Government in Early Han China*, trans. and ed. John S. Major, Sarah A. Queen, Andrew Seth Meyer, and Harold D. Roth (New York: Columbia University Press, 2010), 575.

22. *Yinqueshan han mu zhu jian* (*yi*), vol. 1, ed. Yinqueshan Han mu zhujian zhenli xiaozu (Beijing: Wenwu chubanshe, 1985), 21.

23. Yinqueshan Han mu zhujian zhenli xiaozu, "Linyi Yinqueshan Han mu chutu 'Sunzi bingfa' canjian shiwen," *Wenwu* 12 (1974): 12. This orientation is also included in

the "Gai Lu" text excavated from Zhangjiashan tomb 247: "East is on the left, west is on the right, south is at the top, north is at the bottom. This is what is called according with the Way of Heaven." Olivia Milburn, "'Gai Lu': A Translation and Commentary on a Yin-Yang Military Text Excavated from Tomb M247, Zhangjiashan," *Early China* 33/34 (2010/2011): 120.

24. Translation from *Art of War*, trans. Nylan, 104.

25. *Art of War*, trans. Nylan, 104.

26. *Art of War*, trans. Nylan, 93.

27. For the Yinqueshan transcription of the chapter, see *Yinqueshan han mu zhu jian* (*yi*), 1:21–25.

28. *Art of War*, trans. Nylan, 111.

29. *Art of War*, trans. Nylan, 111.

30. *Art of War*, trans. Nylan, 120. This passage is unfortunately missing from the Yinqueshan bamboo slips, but similar phrases appear in the chapter "Contending Armies," (*Junzheng*), parts of which are present in the Yinqueshan finds. *Yinqueshan han mu zhu jian* (*yi*), 1:15.

31. *Art of War*, trans. Nylan, 104. *Sunzi shijia zhu, Zhuzi jicheng* ed., vol. 6, ed. Guoxue Zhenglishe (Beijing: Zhonghua shuju, 2010), 62–64. This phrase was also partially found in the *Yinqueshan han mu zhu jian* (*yi*), 1:8.

32. *Art of War*, trans. Nylan, 61–62.

33. Yinqueshan Han mu zhujian zhenli xiaozu, "Linyi Yinqueshan Han mu chutu 'Wang Bin' pian shiwen," *Wenwu* 12 (1976): 40–41. While there are similar passages in the "Wang Bing" and *Guanzi*, the Yinqueshan editorial team argues that this does not necessarily mean that "Wang Bing" was a part of the *Guanzi* (36). Instead, according to the portions translated above, the addition of certain phrases in the *Guanzi* suggests that the "Wang Bing" was probably a more complete text at the time of its copying than the *Guanzi*, which was more likely compiled from various sources (41).

34. Regarding the relationship between military texts and drawings, the Yinqueshan *Sun Bin bingfa* begins with a chapter titled "Qing Pang Juan," or "The Capture of Pang Juan," which details one of the infamous stories of Sun Bin's prowess as a strategist. In this Yinqueshan account, scholars note the rare specificity that is given to the physical routes that Sun Bin planned for the Qi general Tian Ji to defend the kingdom of Wey from the attacks launched by the kingdom of Wei. For more on the identification of specific places in the story, see Huang Shengzhang, "'Sun Bin bingfa, qing Pang Juan' pian shi di," *Wenwu* 2 (1977): 69; Zhao Zhenkai, "'Sun Bin bingfa, qing Pang Juan,' Zhong jige chengyi wenti de tantao," *Wenwu* 10 (1976): 51–56. For a transcription of *Sun Bin bingfa*, see Yinqueshan Han mu zhujian zhenli xiaozu, "Linyi Yinqueshan Han mu chutu 'Sun Bin binfa' shiwen," *Wenwu* 1 (1975): 36–43.

35. *Art of War*, trans. Nylan, 106–7.

36. Hsin-Mei Agnes Hsu and Anne Martin-Montgomery, "An Emic Perspective on the Mapmaker's Art in Western Han China," *Journal of the Royal Asiatic Society* 17, no. 4 (October 2007): 456.

37. For an analysis of the field commanders, see Cao Xuequn, "Guanyu Mawangdui gu ditu ji qi xiangguan de jige wenti," *Kaogu* 4 (1994): 355–57.

38. Wu Chengyuan, "Mawangdui ditu kao," *Ditu* 1 (1990): 46.

39. Hsing I-tien, "Lun Mawangdui Han mu 'zhujun tu' ying zhengming wei 'jiandao fengyu tu,'" 15–16.

40. Zhan Libo, "Mawangdui Han mu chutu de shoubei tu tantao," *Wenwu* 1 (1976): 26.

41. Hsu and Martin-Montgomery, "Emic Perspective," 452.

42. *Sunzi shijia zhu*, 6:70–71; *Yinqueshan han mu zhu jian* (*yi*), 1:11.

43. *Sunzi shijia zhu*, 6:68–69; *Yinqueshan han mu zhu jian* (*yi*), 1:10.

44. *Sunzi shijia zhu*, 6:131–36; translation modified from *Art of War*, trans. Nylan, 87; *Yinqueshan han mu zhu jian* (*yi*), 1:17.

45. *Sunzi shijia zhu*, 6:136–37; translation modified from *Art of War*, trans. Nylan, 87; *Yinqueshan han mu zhu jian* (*yi*) 1:17.

46. *Sunzi shijia zhu*, 6:213–14; translation modified from *Art of War*, trans. Nylan, 121, in order to account for the excavated text from Yinqueshan; *Yinqueshan han mu zhu jian* (*yi*), 1:22.

47. Mark Edward Lewis, *Sanctioned Violence in Early China* (Albany: State University of New York Press, 1989), 23.

48. Lewis, 13.

49. Lewis, 161.

50. Translation from Robin D. S. Yates, "The History of Military Divination in China," *East Asian Science, Technology, and Medicine* 24 (2005): 16.

51. Yates, 18.

52. Agnes Hsu-Tang suggests that the presence of Mount Jiuyi "illustrates a tertiary dimension [to the map] that is best described as ritual." Agnes Hsu-Tang, "Structured Perceptions of Real and Imagined Landscapes in Early China," in *Geography and Ethnography: Perceptions of the World in Pre-Modern Societies*, ed. Kurt A. Raaflaub and Richard J. A. Talbert (Oxford: Blackwell, 2009) 47.

53. Mawangdui Han mu boshu zhenli xiaozu, "Changsha Mawangdui san hao Han mu chutu ditu de zhenli," 38.

54. Jiang Sheng, "Lun Mawangdui chutu '*dixing tu*' zhi Jiuyishan tu jiqi jishu chuancheng," *Zhongguo lishi dili luncong* 24, no. 3 (2009): 109.

55. You Shen, "Mawangdui ditu Zhong de shundi ling miao," *Hunan keji xueyuan xuebao* 26, no. 10 (October 2005): 14–15.

56. Hanmo Zhang, "Mapped Territory Floating in the Clouds: A Reinterpretation of the Mawangdui Maps in Their Art and Religious Contexts," *Artibus Asiae* 2 (2016): 158.

57. Zhang, 162. In addition to paleographic analysis, Zhang suggests that the placement of the two characters is ambiguous; thus, it is unclear whether the two characters actually refer to the enclosed mountain form (156–57).

58. While Zhang argues that "information, realistic or imaginary, of the waterways, villages, population, and troops was added to fill the represented piece of land to make this transition of power and authority look 'real' and substantial," much in the way of burial texts that took on the look of administrative documents for the living, I would suggest that the likeness between the shapes on the *ditu* and shapes in real space is not a relationship based on formal imitation but instead on function. Zhang, "Mapped Territory," 161.

59. While Hanmo Zhang has also noted that there are two different sets of symbols used on the *Topography Diagram* and the *Garrison Diagram*, he argues that these two symbols represent clouds and not mountains. Zhang, "Mapped Territory," 152–53. Furthermore, Zhang also sees the thickened apexes of the mountain-range lines in the *Topography Diagram* as a "simplified version" of the elongated peaks in the mountain-range lines on the *Garrison Diagram* (155).

60. As Wu Chengyuan notes, the placement of the garrisons suggests that Changsha understood its southern and eastern borders as requiring the most protection, perhaps because of the greater number of occupied towns in this region and its proximity to Nanyue. Wu, "Mawangdui ditu kao," 27.

61. Mei-Ling Hsu, "The Han Maps and Early Chinese Cartography," *Annals of the Association of American Geographers* 68, no. 1 (March 1978): 54.

62. Zhu Guichang, "Guanyu boshu 'Zhujun tu' de jige wenti," *Kaogu* 6 (1979): 523.

63. See, for instance, Wu Hung's discussion of the Sanpan Shan chariot fittings inlaid with *xiangrui* or auspicious omens composed of cloud patterns. Wu Hung, "A Sanpan Shan Chariot Ornament and the Xiangrui Design in Western Han Art," *Archives of Asian Art* 37 (1984): 38–59.

64. A. F. P. Hulsewé, "Watching the Vapours: An Ancient Chinese Technique of Prognostication," *Nachrichten der Gesellschaft für Natur- und Völkerkunde Ostasiens/Hamburg* 125 (1979): 40.

65. *Shiji*, composed by Sima Qian, with Sima Tan (Beijing: Zhonghua shuju, 2010), 28.1387–88. Translation from Jessica Rawson, "The Eternal Palaces of the Western Han: A New View of the Universe," *Artibus Asiae* 59, no. 1/2 (1999): 17.

66. Most scholarly attention has been paid to the comets section of the manuscript. For detailed studies on the comets, see Wang Shujin, "Mawangdui boshu 'huixing tu' mingcheng shikao," *Hunan sheng bowuguan guankan* 6 (2009): 21–28; Xi Zezong, "Mawangdui Han mu boshu zhong de huixing tu," in *Zhongguo gudai tianwen wenwu lunji*, ed. Zhongguo shehui kexue yuan kaogu yanjiusuo (Beijing: Wenwu chubanshe, 1989), 29–34; Gu Tiefu, "Mawangdui boshu 'yunqi huixing tu' yanjiu," in *Zhongguo gudai tianwen wenwu lunji*, ed. Zhongguo shehui kexue yuan kaogu yanjiu suo (Beijing: Wenwu chubanshe, 1989), 35–45.

67. Chen Songchang, "Boshu 'Tianwen qixiang za zhan' yanjiu santi," *Wuhan jianbo yanjiu zhongxin jianbo wang*, February 13, 2006, http://47.75.114.199/show_article.php?id=186.

68. *Changsha Mawangdui Han mu jianbo jicheng*, comp. and ed. Fudan daxue chutu wenxian yu guwenzi yanjiu zhongxin and Hunan sheng bowuguan (Beijing: Zhonghua shuju, 2014), 4:247.

69. *Changsha Mawangdui Han mu jianbo jicheng*, 4:247.

70. *Changsha Mawangdui Han mu jianbo jicheng*, 4:247.

71. *Changsha Mawangdui Han mu jianbo jicheng*, 4:247.

72. *Changsha Mawangdui Han mu jianbo jicheng*, 4:252.

73. *Changsha Mawangdui Han mu jianbo jicheng*, 4:252.

74. *Changsha Mawangdui Han mu jianbo jicheng*, 4:252.

75. *Changsha Mawangdui Han mu jianbo jicheng*, 4:252.

76. For more on Western Han diviners and mantic experts, see Marc Kalinowski, "Divination and Astrology: Received Texts and Excavated Manuscripts," in *China's Early Empires: A Re-appraisal*, ed. Michael Nylan and Michael Loewe (Cambridge: Cambridge University Press, 2010), 340–42.

77. It should be noted that some drawings are missing labels. Chen Songchang suggests that this is evidence of the process in compiling the "Miscellaneous Prognostications" manuscript, wherein two groups of people were in charge of the drawings and the texts. The drawings were compiled and copied first from a source that might have had drawings but no texts. Then, when the scribes later put in the relevant textual labels, there were no texts in their sources that matched, and therefore the drawings were left without labels. Chen Songchang, "Boshu 'Tianwen qixiang za zhan' yanjiu santi."

78. Donald Harper, "Communication by Design: Two Silk Manuscripts of Diagrams (*Tu*) from Mawangdui Tomb Three," in *Graphics and Text in the Production of Technical Knowledge in China: The Warp and the Weft*, ed. Francesca Bray, Vera Dorofeeva-Lichtmann, and Georges Métailié (Leiden: Brill, 2007), 176.

79. For a translation of the inscriptions, see Harper, "Communication by Design," 173. See also *Changsha Mawangdui Han mu jianbo jicheng*, 4:287.

80. Translation based on Hulsewé, "Watching the Vapours," 44.

81. Translation from Hulsewé, 45.

82. As Pauline Yu argues, *xiang* requires that there be a "seamless connection, if not virtual identity, between an object, its perception, and its representation." Pauline Yu, *The Reading of Imagery in the Chinese Poetic Tradition* (Princeton, NJ: Princeton University Press, 1986), 40. For Jessica Rawson, within the Western Han universe, *xiang* is the visible manifestation of invisible patterns or *wen* that underlie invisible phenomena. Importantly, as she writes, *xiang* is the "equivalent and equal to the clouds, Heavens, and the Great Unity themselves." Rawson, "Eternal Palaces," 17.

83. Arthur Waley, "The Book of Changes," *Bulletin of the Museum of the Far Eastern Antiquities* 5 (1933): 136.

84. Translation from Guolong Lai, *Excavating the Afterlife: The Archaeology of Early Chinese Religion* (Seattle: University of Washington Press, 2015), 150.

85. Guolong Lai, 150.

86. Hunan sheng bowuguan and Hunan sheng wenwu kaogu yanjiusuo, *Changsha Mawangdui er, san hao Han mu*, 41.

Coda

1. Peter Lloyd and Mark Ovenden, *Vignelli Transit Maps* (Rochester, NY: Rochester Institute of Technology Press, 2012), 46.

2. Antonio de Luca and Sasha Portis, "New York's Subway Map Like You've Never Seen It Before," *New York Times*, December 2, 2019, https://www.nytimes.com/interactive/2019/12/02/nyregion/nyc-subway-map.html.

3. Lloyd and Ovendon, *Vignelli's Transit Maps*, 78.

4. Harry Beck made a similar comment on the unimportance of geography since one is usually traveling underground on the metro. Martin Nöllenburg, "Automated Drawing of Metro Maps" (master's thesis, Institut für Theoretische Informatik, Universität Karlsruhe, 2005), 1.

5. Lloyd and Ovendon, *Vignelli's Transit Maps*, 76.

6. Lloyd and Ovendon, 71.

7. Dong Shan, "Mawangdui san hao Han mu chutu de jüzang tu," in *Jinian Mawangdui Han mu fajue sishi zhounian guoji xueshu yantaohui lunwen ji*, ed. Hunan Provincial Museum (Changsha: Yuelu shushe, 2016), 408.

8. Cao Lüning, "Han chu 'zang lu' yu Mawangdui sanhao muzhu Li Xi," in *Jinian Mawangdui Han mu fajue sishi zhounian guoji xueshu yantaohui lunwen ji*, ed. Hunan Provincial Museum (Changsha: Yuelu shushe, 2016), 53.

9. Cao Lüning, 53.

10. J. B. Harley, "Maps, Knowledge, and Power," in *Iconography of Landscape: Essays on the Symbolic Representation, Design, and Use of Past Environments*, ed. Denis Cosgrove and Stephen Daniels (Cambridge: Cambridge University Press, 1989), 278.

11. Dong Shan, "Mawangdui san hao Han mu chutu de jüzang tu," 408.

12. Dong Shan, 405.

Bibliography

Alpers, Svetlana. *The Art of Describing: Dutch Art in the Seventeenth Century*. Chicago: University of Chicago Press, 1984.

Anhui sheng wenwu gongzuo dui, Fuyang diqu bowuguan, and Fuyang xian wenhua jü. "Fuyang Shuanggudui Xi Han Ruyang hou mu fajue jianbao." *Wenwu* 8 (1978): 12–31.

Arnheim, Rudolf. *Art and Its Objects*. Cambridge: Cambridge University Press, 1980.

Arscott, Caroline. *William Morris and Edward Burne-Jones: Interlacings*. New Haven, CT: Yale University Press, 2008.

The Art of War: A New Translation. Introduced and translated by Michael Nylan. New York: W. W. Norton, 2020.

The Art of War: Sunzi's Military Methods. Introduction and translation by Victor H. Mair. New York: Columbia University Press, 2007.

Bagley, Robert. "Anyang Mold-Making and the Decorated Model." *Artibus Asiae* 69, no. 1 (2009): 39–90.

———. "Meaning and Explanation." *Archives of Asian Art* 46 (1993): 6–26.

Barbieri-Low, Anthony J. *Ancient Egypt and Early China: State, Society, and Culture*. Seattle: University of Washington Press, 2021.

———. *Artisans in Early Imperial China*. Seattle: University of Washington Press, 2007.

———. "Model Legal and Administrative Forms from the Qin, Han, and Tang and their Role in the Facilitation of Bureaucracy and Literacy." *Oriens Extremus* 50 (2011): 125–56.

Barbieri-Low, Anthony, and Robin D. S. Yates. *Law, State, and Society in Early Imperial China: A Study with Critical Edition and Translation of the Legal Texts from Zhangjiashan Tomb No. 247*. 2 vols. Leiden: Brill, 2015.

Barr, Stephen. *Experiments in Topology*. Mineola, NY: Dover, 1989.

Behr, Wolfgang. "Placed into the Right Positions." In *Graphics and Text in the Production of Technical Knowledge in China: The Warp and the Weft*, edited by Francesca Bray, Vera Dorofeeva-Lichtmann, and Georges Métailié, 109–34. Leiden: Brill, 2007.

Bender, John, and Michael Marrinan. *The Culture of Diagram*. Stanford, CA: Stanford University Press, 2010.

Bodde, Derk. "Basic Concepts of Chinese Law: The Genesis and Evolution of Legal Thought in Traditional China." *Proceedings in the American Philosophical Society* 107, no. 5 (October 15, 1963): 375–98.

———. "Chinese 'Laws of Nature': A Reconsideration." *Harvard Journal of Asiatic Studies* 39, no. 1 (June 1979): 139–55.

Bol, Peter. "Exploring the Propositions in Maps: The Case of the 'Yuji tu' of 1136." *Journal of Song-Yuan Studies* 46 (2016): 209–24.

Bray, Francesca. "Introduction: The Powers of *Tu*." In *Graphics and Text in the Production of Technical Knowledge in China: The Warp and the Weft*, edited by Francesca Bray, Vera Dorofeeva-Lichtmann, and Georges Métailié, 1–79. Sinica Leidensia 79. Leiden: Brill, 2007.

Brown, Miranda, and Charles Sanft. "Categories and Legal Reasoning in Early Imperial China: The Meaning of *Fa* in Recovered Texts." *Oriens Extremus* 50 (2011): 283–306.

Bulling, A. G. "Ancient Chinese Maps." *Expedition Magazine* 20, no. 2 (1978): 16–23.

Campany, Robert. *Strange Writing: Anomaly Accounts in Early Medieval China*. Albany: State University of New York Press, 1996.

Campbell, Aurelia. "The Form and Function of Western Han Dynasty 'Ticou' Tombs." *Artibus Asiae* 70, no. 2 (2010): 227–58.

Cao Lüning. "Han chu 'zang lü' yu Mawangdui sanhao muzhu Li Xi." In *Jinian Mawangdui Han mu fajue sishi zhounian guoji xueshu yantaohui lunwen ji*, edited by Hunan Provincial Museum, 52–55. Changsha: Yuelu shushe, 2016.

———. *Zhangjiashan Han lü yanjiu*. Beijing: Zhonghua shuju, 2005.

Cao Wanru. "Ancient Maps Unearthed from Qin Tomb of Fangmatan and Han Tomb of Mawangdui: A Comparative Research." *Journal of Chinese Geography* 3, no 2 (1992): 39–50.

———. "Jin sishi nian lai Zhongguo ditu xue shi yanjiu de huigu." *Ziran kexueshi yanjiu* 9, no 3 (1990): 283–89.

———. "Youguan Tianshui Fangmatan Qin mu chutu ditu de jige wenti." *Wenwu* 12 (1989): 78–85.

———. "Zhongguo gudai dili xue shi de jige wenti." *Ziran kexueshi yanjiu* 1, no. 3 (1982): 242–50.

———. "Zhongguo gudai ditu huizhi de lilun he fangfa chutan." *Ziran kexue shi yanjiu* 2, no. 3 (1983): 246–57.

Cao Wanru, Zheng Xihuang, Huang Shengzhang, et al. *Zhongguo gudai ditu ji—Zhanguo Yuan*. Beijing: Wenwu chubanshe, 1990.

Cao Xuequn. "Guanyu Mawangdui gu ditu ji qi xiangguan de jige wenti." *Kaogu* 4 (1994): 355–57.

———. "Lun Mawangdui ditu de huizhi niandai." In *Mawangdui Han mu yanjiu wenji: 1992 nian Mawangdui Han mu guoji xueshu taolun hui lunwen xuan*, edited by Hunan sheng bowuguan, 178–81. Changsha: Hunan chubanshe, 1994.

Carter, Howard, and Alan H. Gardiner. "The Tomb of Ramesses IV and the Turin Plan of a Royal Tomb." *Journal of Egyptian Archaeology* 4, no. 2/3 (April–July 1917): 130–58.

Casti, Emanuela. *Reality as Representation: The Semiotics of Cartography and the Generation of Meaning*. Bergamo: Bergamo University Press, 2000.

Chang, Kuei-sheng. "The Han Maps: New Light on Cartography in Classical China." *Imago mundi* 31 (1979): 9–17.

Changsha Mawangdui Han mu jianbo jicheng. 7 vols. Compiled and edited by Fudan daxue chutu wenxian yu guwenzi yanjiu zhongxin and Hunan sheng bowuguan. Beijing: Zhonghua shuju, 2014.

Chemla, Karine. "Changes and Continuities in the Use of Diagrams *Tu* in Chinese Mathematical Writings (Third Century to Fourteenth Century) [1]." *East Asian Science, Technology, and Society* 4 (2010): 303–26.

———. "Mathematics, Nature and Cosmological Inquiry in Traditional China." In *Concepts of Nature in Traditional China: A Chinese-European Cross-Cultural Perspective*, edited by Hans Ulrich Vogel and Günter Dux, 255–84. Leiden: Brill, 2010.

———. "On Mathematical Problems as Historically Determined Artifacts: Reflections Inspired by Sources from Ancient China." *Historia mathematica* 36 (2009): 213–46.

Chemla, Karine, and Daniel Morgan. "Writing in Turns: An Analysis of Scribal Hands in the Bamboo Manuscript *Suan shu shu* (*Writings on Mathematical Procedures*) from Zhangjiashan." *Jianbo* 12 (2016): 235–52.

Chen Jianming. *Hunan chutu bohua yanjiu*. Changsha: Yuelu shu chubanshe, 2013.

———. *Mawangdui Han mu yanjiu*. Changsha: Yuelu shu chubanshe, 2013.

Chen Kaili. "Fangmatan Qin jian 'Dan' pian zhaji." *Wuhan jianbo yanjiu zhongxin jianbo wang*, September 25, 2012. http://www.bsm.org.cn/?qinjian/5925.html.

Chen Songchang. "Boshu 'Tianwen qixiang za zhan' yanjiu santi." *Wuhan jianbo yanjiu zhongxin jianbo wang*, February 13, 2006. http://m.bsm.org.cn/?boshu/4407.html.

———. "Mawangdui san hao Han mu 'chema yizhang tu' bohua shishuo." In *Hunan bowuguan wenji* 4 (1991): 82–87.

———. "Mawangdui san hao muzhu de zai renshi." *Wenwu* 8 (2003): 56–66.

Chen Wei. "Beida zang Qin jian 'Taiyuan you sizhe' shi xiao." *Wuhan jianbo yanjiu zhongxin jianbo wang*, July 14, 2012. http://m.bsm.org.cn/?qinjian/5904.html.

———. "'E Jun Qi jie' yu Chu guo de mianshui wenti." *Jianghan Kaogu* 3 (1989): 52–58.

———. "Qin yu Han chu de wenshu chuandi xitong." In *Liye gucheng: Qin jian yu Qin wenhua yanjiu: Zhongguo Liye gucheng*, edited by Bai Yunxiang, Bu Xianqun, Yuan Jiarong, et al., 150–57. Beijing: Kexue chubanshe, 2009.

———, ed. *Qin jiandu he ji*. 4 vols. Wuhan: Wuhan daxue chuban she, 2014.

Chen Zhi. "Qin taojuan yu Qin ling wenwu." *Xibei daxue xuebao* 1 (1957): 68–70.

Cheng Yinong. *"Fei kexue" de Zhongguo chuantong yutu: Zhongguo chuantong yutu huizhi yanjiu*. Beijing: Zhongguo shehui kexue chubanshe, 2016.

The Classic of Changes: A New Translation of the I Ching as Interpreted by Wang Bi. Translated and introduced by Richard John Lynn. New York: Columbia University Press, 2004.

Confucius Analects with Selections from Traditional Commentaries. Translated by Edward Slingerland. Indianapolis, IN: Hackett, 2003.

Cook, Constance A., and Paul R. Goldin, eds. *A Source Book of Ancient Chinese Bronze Inscriptions*. Berkeley, CA: Society for the Study of Early China, 2016.

Coomaraswamy, Ananda K. "Ornament." *Art Bulletin* 21, no. 4 (December 1939): 375–82.

Cosgrove, Denis. *Social Formation and Symbolic Landscape*. Madison: University of Wisconsin Press, 1998.

Crampton, Jeremy W., and John Krygier. "An Introduction to Critical Cartography." *ACME: An International E-Journal for Critical Geographies* 4, no. 1 (2006): 11–33.

Csikszentmihalyi, Mark. "Severity and Lenience: Divination and Law in Early Imperial China." *Extrême-Orient Extrême-Occident* 21 (1999): 111–30.

Cullen, Christopher. *Astronomy and Mathematics in Ancient China: The* Zhou bi suan jing. Cambridge: Cambridge University Press, 1996.

———. *The Foundations of Celestial Reckoning: Three Ancient Chinese Astronomical Systems*. New York: Routledge, 2017.

———. "Some Further Points on the 'Shih.'" *Early China* 6 (1980/1981): 31–46.

———. *The* Suàn shù shū*: "Writings on Reckoning"; A Translation of a Chinese Mathematical Collection of the Second Century BCE, with Explanatory Commentary*. Needham Research Institute Working Papers 1. Cambridge: Needham Research Institute, 2004.

Daston, Lorraine, and Peter Galison. *Objectivity*. Brooklyn, NY: Zone Books, 2007.

Dauben, J. W. "*Suan Shu Shu* (A Book on Numbers and Computations): English Translation with Commentary." *Archive for Exact Sciences* 62, no. 2 (March 2008): 91–178.

Davis, Whitney. *A General Theory of Visual Culture*. Princeton, NJ: Princeton University Press, 2017.

———. "How to Make Analogies in a Digital Age." *October* 117 (Summer 2006): 71–98.

———. *Visuality and Virtuality: Images and Pictures from Prehistoric to Perspective*. Princeton, NJ: Princeton University Press, 2017.

Dean, Carolyn. "The Problem with the Term 'Art.'" *Art Journal* 65, no. 2 (Summer 2006): 24–32.

De Certeau, Michel. *The Practice of Everyday Life*. Translated by Steven Rendall. Berkeley: University of California Press, 1984.

De Crespigny, R. R. C. "Two Maps from Mawangdui." *Cartography* 11, no. 4 (1980): 211–22.

Delano-Smith, Catherine. "Art or Cartography? The Wrong Question." *History of the Human Sciences* 2, no. 1 (1989): 89–93.

———. "The Grip of the Enlightenment: The Separation of Past and Present." In *Approaches and Challenges to a Worldwide History of Cartography*, edited by David Woodward, Catherine Delano-Smith, and Cordell D. K. Yee, 284–85. Barcelona: Institut Cartogràfic de Catalunya, 2000.

———. "Maps and Map Literacy I: Different Users, Different Maps." In *Approaches and Challenges in a Worldwide History of Cartography*, 223–40. Barcelona: Institut Cartogràfic de Catalunya, 2000.

———. "Why Theory in the History of Cartography?" *Imago mundi* 48 (1996): 198–203.

Deleuze, Gilles and Félix Guattari. *A Thousand Plateaus: Capitalism and Schizophrenia*. Translated by Brian Massumi. Minneapolis, MN: University of Minnesota Press, 1987.

De Luca, Antonio, and Sasha Portis. "New York's Subway Map Like You've Never Seen It Before." *New York Times*, December 2, 2019. https://www.nytimes.com/interactive/2019/12/02/nyregion/nyc-subway-map.html.

De Weerdt, Hilde. *Information, Territory, and Networks: The Crisis and Maintenance of Empire in Song China*. Cambridge, MA: Harvard University Asia Center, 2015.

———. "Maps and Memory: Readings of Cartography in Twelfth- and Thirteenth-Century Song China." *Imago mundi* 61, no. 2 (2009): 145–67.

Dodge, Martin, Rob Kitchin, and Chris Perkins. "Thinking about Maps." In *Rethinking Maps: New Frontiers in Cartographic Theory*, edited by Martin Dodge, Rob Kitchin, and Chris Perkins, Routledge Studies in Human Geography, 1–25. New York: Routledge, 2009.

Dong Shan. "Mawangdui san hao Han mu chutu de jüzang tu." In *Jinian Mawangdui Han mu fajue sishi zhounian guoji xueshu yantaohui lunwen ji*, edited by Hunan Provincial Museum, 404–9. Changsha: Yuelu shushe, 2016.

Dorofeeva-Lichtmann, Vera V. "Conception of Terrestrial Organization in the *Shan hai jing*." *Bulletin de l'École française d'Extrême-Orient* 82 (1995): 57–110.

———. "Political Concept behind an Interplay of Spatial 'Positions.'" *Extrême-Orient, Extrême-Occident* 18 (1996): 9–33.

Ebine Ryosuke. "Fangmatan Qin jian chaoxie niandai lice." *Jianbo* 7 (2012): 159–70.

Edney, Matthew H. *Cartography: The Ideal and Its History*. Chicago: University of Chicago Press, 2019.

Elgin, Catherine. *With Reference to Reference*. Indianapolis, IN: Hackett, 1983.

Fang Yong. "Ye tan Beida Qin du 'Taiyuan you sizhe' zhong de 'huang quan' yici." *Wuhan jianbo yanjiu zhongxin jianbo wang*, September 28, 2013. http://m.bsm.org.cn/?qin-jian/6099.html.

Feagin, Susan. "Pictorial Representation and the Act of Drawing." *American Philosophical Quarterly* 24, no. 2 (April 1987): 161–70.

Felt, D. Jonathan. *Structures of the Earth: Metageographies of Early Medieval China*. Cambridge, MA: Harvard University Asia Center, 2021.

Feng, Linda Rui. "Can Lost Maps Speak? Toward a Cultural History of Map Reading in Medieval China." *Imago mundi* 70, no. 2 (2018): 169–82.

———. "Merging into the Map: Sources of Imagined Cartographic Efficacy in Medieval China." *Word and Image* 34, no. 4 (2018): 322–31.

Freedberg, David. *The Eye of the Lynx: Galileo, His Friends, and the Beginnings of Modern Natural History*. Chicago: University of Chicago Press, 2002.

Fu Jüyou. "Guanyu Changsha Mawangdui san hao Han mu de muzhu wenti." *Wenwu* 2 (1983): 165–72.

———. "Guanyu 'zhujun tu' huizhi de niandai wenti." *Kaogu* 2 (1981): 171–73.

———. "Mawangdui Han mu chutu de zhujun tu." In *Zhongguo gudai ditu ji—Zhanguo Yuan*, edited by Cao Wanru, Zheng Xihuang, Huang Shengzhang, et al., 9–11. Beijing: Wenwu chubanshe, 1990.

———. "Youguan Mawangdui ditu de jige wenti." *Wenwu* 2 (1982): 76–77.

Fu Xinian. "Ji Gu Tiefu xiansheng fuyuan de Mawangdui san hao mu boshu zhong de xiaocheng tu." *Wenwu* 6 (1996): 49–55.

———. "Zhanguo tongqi shang de jianzhu tuxiang yanjiu." In *Fu Xinian jianzhu shi lun wenji*, 82–102. Beijing: Wenwu chubanshe, 1998.

———. "Zhanguo Zhongshan wang Cuo mu chutu de 'Zhaoyu tu' jiqi lingyuan guizhi de yanjiu." *Kaogu xuebao* 1 (1980): 97–119.

———. "Zhongguo gudai de jianzhu hua." *Wenwu* 3 (1998): 75–94.

———. "Zhongguo gudai jianzhu waiguan sheji shoufa chutan." *Wenwu* 1 (2001): 74–89.

Fujita Katsuhisa. "Liye Qin jian de jiaotong ziliao yu xian shehui." *Jianbo* 10 (2015): 155–75.

———. "Liye Qin jian suo jian Qin dai jun xin de wenshu chuandi." *Jianbo* 8 (2013): 179–94.

———. "Liye Qin jian yu Qin diguo de qingbao chuanda." In *Liye gucheng, Qin jian yu Qin wenhua yanjiu: Zhongguo Liye gucheng, Qin jian yu Qin wenhua guoji xueshu yantaohui lunwenji*, edited by Bai Yunxiang, Bu Xianqun, Yuan Jiarong, et al., 158–71. Beijing: Kexue chubanshe, 2009.

———. "Zhanguo shi Qin de lingyu xingcheng he jiaotong luxian." Translated by Li Shuping. *Qin wenhua luncong* 6 (1998): 358–404.

Gao Zhishan. "Bingqi he zhujun tu." In *Mawangdui Hanmu yanjiu*, edited by Hunan sheng bowuguan, 305–6. Changsha: Hunan renmin chubanshe, 1979.

Ge Jianxiong, *Zhongguo gudai de ditu cehui*. Beijing: Shangwu yinshu guan, 1998.

Gell, Alfred. "How to Read a Map: Remarks on the Practical Logic of Navigation." *Man* 20, no. 2 (June 1985): 271–86.

Ghazarian, Armen, and Robert Ousterhout. "A Muqarnas Drawing from Thirteenth-Century Armenia and the Use of Architectural Drawings during the Middle Ages." *Muqarnas* 18 (2001): 141–54.

Giele, Enno. "Excavated Manuscripts: Context and Methodology." In *China's Early Empires: A Re-appraisal*, edited by Michael Nylan and Michael Loewe, 114–34. Cambridge: Cambridge University Press, 2010.

———. "Using Early Chinese Manuscripts as Historical Source Materials." *Monumenta serica* 51 (2003): 409–38.

Goldin, Paul R. "Han Law and the Regulation of Interpersonal Relations: 'The Confucianization of the Law' Revisited." *Asia Major*, 3rd ser., 25, no. 1 (2012): 1–31.

———. "*Heng Xian* and the Problem of Studying Looted Artifacts." *Dao* 12 (2013): 153–60.

Goodman, Nelson. *Languages of Art*. Indianapolis, IN: Hackett, 1976.

———. "On Capturing Cities." *Journal of Aesthetic Education* 25, no. 1 (Spring 1999): 5–9.

———. *Ways of Worldmaking*. Indianapolis, IN: Hackett, 1978.

Graves, Margaret. *Arts of Allusion: Object, Ornament, and Architecture in Medieval Islam*. New York: Oxford University Press, 2018.

Gu Tiefu. "Mawangdui boshu 'yunqi huixing tu' yanjiu." In *Zhongguo gudai tianwen wenwu lunji*, edited by Zhongguo shehui kexue yuan kaogu yanjiu suo, 35–45. Beijing: Wenwu chubanshe, 1989.

Guanzi jiaozhu. Xinbian zhuzi jicheng edition. Selected by Li Xiangfeng and edited by Liang Yunhua. 3 vols. Beijing: Zhonghua shuju, 2004.

Guo Jue. "Western Han Funerary Relocation Documents and the Making of the Dead in Early Imperial China." *Bamboo and Silk* 2, no. 1 (2019): 141–273.

Guo Zizhi. "Zhanguo Qin feng zongyi washu mingwen xinyi." *Guwenzi yanjiu* 14 (June 1986): 177–96.

Habberstad, Luke. *Forming the Early Chinese Court: Rituals, Spaces, and Roles*. Seattle: University of Washington Press, 2018.

Hamburger, Jeffrey F. *Diagramming Devotion: Berthold of Nuremberg's Transformation of Hrabanus Maurus's Poems in Praise of the Cross*. Chicago: University of Chicago Press, 2020.

Han Zhongmin. "Guanyu Mawangdui boshu gu ditu de zhenli yu yanjiu." In *Zhongguo gudai ditu ji—Zhanguo Yuan*, edited by Cao Wanru, Zheng Xihuang, Huang Shengzhang, et al., 12–17. Beijing: Wenwu chubanshe, 1990.

Han Feizi jijie. Xinbian zhuzi jicheng edition. Beijing: Zhonghua shuju, 1998.

Hanshu. Composed by Ban Gu (32–90 CE) et al. Beijing: Zhonghua shuju, 2009.

Harley, J. B. "Maps, Knowledge, and Power." In *Iconography of Landscape: Essays on the Symbolic Representation, Design, and Use of Past Environments*, edited by Denis Cosgrove and Stephen Daniels, 277–312. Cambridge: Cambridge University Press, 1989.

———. *The New Nature of Maps: Essays in the History of Cartography*. Baltimore: Johns Hopkins University Press, 2001.

Harley, J. B., and David Woodward. Preface to *History of Cartography*, vol. 1, *Cartography in Prehistoric, Ancient, and Medieval Europe and the Mediterranean*, edited by J. B. Harley and David Woodward, xv–xxi. Chicago: University of Chicago Press, 1987.

Harper, Donald. "Communication by Design: Two Silk Manuscripts of Diagrams (*Tu*) from Mawangdui Tomb Three." In *Graphics and Text in the Production of Technical Knowledge in China: The Warp and the Weft*, edited by Francesca Bray, Vera Dorofeeva-Lichtmann, and Georges Métailié, 169–89. Sinica Leidensia 79. Leiden: Brill, 2007.

———. "Daybooks in the Context of Manuscript Culture and Popular Culture Studies." In *Books of Fate and Popular Culture in Early China*, edited by Donald Harper and Marc Kalinowski, 91–137. Leiden: Brill, 2017.

———. "The Han Cosmic Board (*Shih*)." *Early China* 4 (1978–79): 1–10.

———. "Resurrection in Warring States Popular Religion." *Taoist Resources* 5, no. 2 (1994): 13–28.

———. "Warring States Natural Philosophy and Occult Thought." In *The Cambridge History of Ancient China: From the Origins of Civilization to 221 BC*, edited by Michael Loewe and Edward L. Shaughnessy, 813–84. Cambridge: Cambridge University Press, 1999.

Hay, Jonathan. "The Passage of the Other: Elements for a Redefinition of Ornament." In *Histories of Ornament: From Global to Local*, edited by Gülru Necipoglu, Alina Payne, et al., 62–69. Princeton, NJ: Princeton University Press, 2016.

He Shuangquan. "Tianshui Fangmatan Qin jian zongshu zong shu." *Wenwu* 2 (1989): 23–31.

———. "Tianshui Fangmatan Qin mu chutu ditu chutan." *Wenwu* 2 (1989): 12–22.

Hebei sheng wenwu yanjiu suo. *Cuo mu: Zhongshanguo guowang zhi mu*. 2 vols. Beijing: Wenwu chubanshe, 1996.

Henderson, John B. "Chinese Cosmographical Thought: The High Intellectual Tradition." In *History of Cartography*, vol. 2, bk. 2, *Cartography in the Traditional East and Southeast Asian Societies*, edited by J. B. Harley and David Woodward, 203–27. Chicago: University of Chicago Press, 1994.

———. "Cosmology and Concepts of Nature in Traditional China." In *Concepts of Nature in Traditional China: A Chinese-European Cross-Cultural Perspective*, edited by Hans Ulrich Vogel and Günter Dux, 181–97. Leiden: Brill, 2010.

Ho Peng Yoke. "Chinese Science: The Traditional Chinese View." *Bulletin of the School of Oriental and African Studies, University of London* 54, no. 3 (1991): 506–19.

Hou Hanshu. Compiled by Fan Ye and Sima Biao. Beijing: Zhonghua shuju, 2012.

Hsing I-tien. "Qin-Han Census, Tax, and Corvée Administration: Notes on Newly Discovered Materials." In *Birth of an Empire: The State of Qin Revisited*, translated by Hsieh Mei-yu and William G. Crowell and edited by Yuri Pines, Gideon Shelach, Lothar von Falkenhausen, and Robin D. S. Yates, 155–86. Berkeley: University of California Press, 2014.

———. "Lun Mawangdui Han mu 'zhujun tu' ying zhengming wei 'jiandao fengyu tu." *Hunan daxue xuebao* 21, no. 5 (September 2007): 12–19.

———. *Zhiguo anbang: fazhi, xingzheng yu junshi*. Beijing: Zhonghua shuju, 2011.

———. "Zhongguo gudai de ditu—cong Jiangsu Yinwan de 'hua tu', 'xie tu' shuo qi." *Yishu shi yanjiu* 6 (2005): 105–24.

Hsu, Hsin-Mei Agnes and Anne Martin-Montgomery. "An Emic Perspective on the Mapmaker's Art in Western Han China." *Journal of the Royal Asiatic Society* 17, no. 4 (October 2007): 443–57.

Hsu, Mei-Ling. "The Han Maps and Early Chinese Cartography." *Annals of the Association of American Geographers* 68, no 1 (March 1978): 45–60.

———. "The Qin Maps: A Clue to Later Chinese Cartographic Development." *Imago mundi* 45 (1993): 90–100.

Hsu-Tang, Agnes. "Structured Perceptions of Real and Imagined Landscapes in Early China." In *Geography and Ethnography: Perceptions of the World in Pre-Modern Societies*, edited by Kurt A. Raaflaub and Richard J. A. Talbert, 43–63. Oxford: Blackwell, 2009.

Hu Pingsheng and Li Tianhong. *Changjiang liuyu chutu jiandu yu yanjiu*. Wuhan: Hubei jiaoyu chubanshe, 2004.

Huang Jie. "Fangmatan Qin jian 'Dan' pain yu Beida Qin du 'Taiyuan you sizhe' yanjiu." *Renwen luncong* (2013): 433–58.

Huang Kejia. "Qian xi Liye Qin jian zhong youguan ditu huizhi xijie de can jian." *Zhongguo wenwu bao*, January 17, 2014. http://www.kaogu.cn/cn/xueshuyanjiu/yanjiuxinlun/qita/2014/0123/45106.html.

Huang Peixian. "Mawangdui 'che ma yi zhang tu' bohua de zai sikao." In *Jinian Mawangdui Han mu fajue sizhi zhounian guoji xueshu yantaohui lunwen ji*, edited by Hunan sheng bowuguan, 461–65. Changsha: Yuelu chubanshe, 2016.

Huang Shengsong. "Mawangdui 'zhujun tu' 'feng' zi shiyi." In *Jinian Mawangdui Han mu*

fajue sizhi zhounian guoji xueshu yantaohui lunwen ji, edited by Hunan sheng bowu-guan, 416–26. Changsha: Yuelu chubanshe, 2016.

Huang Shengzhang. "'Sun Bin bingfa, qing Pang Juan' pian shi di." *Wenwu* 2 (1977): 72–79.

Huang Shengzhang and Niu Zhongxun. "Youguan Changsha Mawangdui Han mu de lishi dili wenti." *Wenwu* 9 (1972): 22–29.

Hubei sheng wenwu kaogu yanjiu suo, Xiaogan diqu bowuguan, and Yunmeng xian bowuguan. "Yunmeng Longgang Qin Han mu de di yi ci fajue baogao." *Jianghan kaogu* 3 (1990): 16–27.

Hubei Xiaogan diqu di er qi yi gong yi nong wenwu kaogu xunlian ban. "Hubei Yunmeng Shuihudi shiyi zuo Qin mu fajue jianbao." *Wenwu* 9 (1976): 51–61.

Hulsewé, A. F. P. *Remnants of Qin Law: An Annotated Translation of the Ch'in Legal and Administrative Rules of the 3rd Century BC Discovered in Yun-meng Prefecture, Hu-pei Province in 1975*. Sinica Leidensia 17. Leiden: Brill, 1985.

———. "Watching the Vapours: An Ancient Chinese Technique of Prognostication." *Nachrichten der Gesellschaft für Natur- und Völkerkunde Ostasiens/Hamburg* 125 (1979): 40–49.

Hunan sheng bowuguan and Hunan sheng wenwu kaogu yanjiu suo, eds. *Changsha Mawangdui er, san hao Han mu: Tianye kaogu fajue baogao*. Beijing: Wenwu chu-banshe, 2004.

Hunan sheng bowuguan and Zhongguo kexue kaogu yanjiusuo, eds. *Changsha Mawang-dui yi hao Han mu*. 2 vols. Beijing: Wenwu chubanshe, 1973.

Hunan sheng bowuguan and Zhongguo kexueyuan kaogu yanjiusuo. "Changsha Mawangdui er, san hao Han mu fajue jianbao." *Wenwu* 7 (1974): 39–48, 63.

Hunan sheng wenwu kaogu yanjiusuo. *Liye fajue baogao*. Changsha: Yuelu shushe, 2007.

Ingold, Timothy. *The Perception of the Environment: Essays on Livelihood, Dwelling, and Skill*. New York: Routledge, 2011.

Jacob, Christian. *The Sovereign Map: Theoretical Approaches in Cartography throughout History*. Chicago: University of Chicago Press, 2006.

Jacobsen, Esther. "Mountains and Nomads: A Reconsideration of the Origins of Chinese Landscape Representation." *Bulletin of the Museum of Far Eastern Antiquities* 57 (1985): 133–80.

Jiang Sheng. "Lun Mawangdui chutu '*dixing tu*' zhi Jiuyishan tu jiqi jishu chuancheng." *Zhongguo lishi dili luncong* 24, no. 3 (2009): 108–14.

Jiang Shoucheng. "Beida Qin du 'Taiyuan you sizhe' kaoshi." *Zhonghua wenshi luncong* 115, no. 3 (March 2014): 143–78.

———. "Fangmatan M14 Qin mu banhua zhong de zongjiao Xinyang." *Laozi xuekan* 1 (2014): 77–95.

———. "Fangmatan Qin jian 'zhiguai gushi' zhong de zongjiao xinyang." *Shijie zongjiao yanjiu* 5 (2013): 160–75.

Jiang Wen. "To Turn Soybeans into Gold: A Case Study of Mortuary Documents from Ancient China." *Bamboo and Silk* 2, no. 1 (September 2019): 32–51.

Jin Weinuo. "Tan Changsha Mawangdui sanhao Han mu bohua." *Wenwu* 11 (1974): 40–44.

Jinshu. Compiled by Fang Xuanling. 10 vols. Beijing: Zhonghua shuju, 1974.

Kalinowski, Marc. "Divination and Astrology: Received Texts and Excavated Man-uscripts." In *China's Early Empires: A Re-appraisal*, edited by Michael Nylan and Michael Loewe, 339–66. Cambridge: Cambridge University Press, 2010.

———. "La production des manuscrits dans la Chine ancienne: Une approche codi-cologique de la bibliothèque funéraire de Mawangdui." *Études Asiatique: Revue de la Société Suisse-Asie* 59 (2005): 131–68.

———. "The Notion of *Shi* and Some Related Terms in Qin-Han Calendrical Astrology." *Early China* 35/36 (2012/2013): 331–60.

Kalinowski, Marc, and Phyllis Brooks. "The Xingde Texts from Mawangdui." *Early China* 23/24 (1998/1999): 125–202.

Kern, Martin. "Ritual, Text, and the Formation of the Canon: Historical Transitions of 'Wen' in Early China." *T'oung Pao*, 2nd ser., 87, no 1/3 (2001): 43–91.

Korolkov, Maxim. "Empire-Building and Market-Making at the Qin Frontier: Imperial Expansion and Economic Change, 221–207 BCE." PhD diss., Columbia University, 2020.

Kuhn, Dieter. "Silk Weaving in Ancient China: From Geometric Figures to Patterns of Pictorial Likeness." *Chinese Science* 12 (1995): 77–114.

Kuhn, Dieter, and Zhao Feng, eds. *Chinese Silks*. New Haven, CT: Yale University Press, 2012.

Lai, Guolong. "Death and Otherworldly Journey in Early China as Seen through Tomb Texts, Travel Paraphernalia, and Road Rituals." *Asia Major* 18, no. 1 (2005): 1–44.

———. "The Diagram of the Mourning System from Mawangdui." *Early China* 28 (2003): 43–99.

———. *Excavating the Afterlife: The Archaeology of Early Chinese Religion*. Seattle: University of Washington Press, 2015.

Lam Lay Yong. "Jiu Zhang Suanshu (Nine Chapters on the Mathematical Art): An Overview." *Archive for History of Exact Sciences* 47, no. 1 (June 1994): 1–51.

Lander, Brian. *The King's Harvest: A Political Ecology of China from the First Farmers to the First Empire*. New Haven, CT: Yale University Press, 2021.

Lao Gan. "Lun Han dai zhi lu yun yu shui yun." *Zhongyang yanjiu yuan* 16 (1947): 69–91.

Lee Chi-Hsiang. "The *Hanshu* Geographic Treatise on the Eastern Capital." Translated by Michael Nylan. In *Technical Arts in the Han Histories*, edited by Mark Csikzentmihalyi and Michael Nylan, 135–80. Albany: State University of New York Press, 2021.

Lewis, Mark Edward. *The Construction of Space in Early China*. Albany: State University of New York Press, 2006.

———. "Ritual Origins of the Warring States." *Bulletin de l'École française d'Extrême-Orient* 84 (1997): 73–98.

———. *Sanctioned Violence in Early China*. Albany: State University of New York Press, 1990.

Li Ling. "Beida Qin du 'Taiyuan you sizhe' jianjie." *Wenwu* 6 (2012): 81–84.

———. "Jianbo de maizang yu faxian." *Zhongguo dianji yu wenhua* 2 (2003): 4–11.

———. *Rushan yu chusai*. Beijing: Wenwu chubanshe, 2004.

———. "'Shi' yu Zhongguo gudai de yuzhou moshi." *Zhongguo wenhua* 1 (1991): 1–30.

———. *Zhongguo fangshu xukao*. Beijing: Dongfang chubanshe, 2001.

Li Shisheng. "Changsha Mawangdui sanhao muzhu zai yi." *Gugong bowuyuan yuankan* 3 (2005): 150–62.

Li Xianzhong. "Liye Qin jian daolu licheng jian suo jian 'Yan Qi dao lu.'" *Zhongguo lishi dili luncong* 32, no. 1 (January 2017): 57–61.

Li Xiaocen. "Gansu Tianshui Fangmatan Xi Han mu chutu zhi de zai yanjiu." *Kaogu* 10 (2016): 110–14.

Li Xueqin. "Fangmatan jian zhong de zhiguai gushi." *Wenwu* 4 (1990): 43–47.

———. "Yi Hou Ce gui yu Wu guo." *Wenwu* 7 (1985): 13–16, 25.

———. "Yunmeng Longgang mudu shi shi." *Jiandu xue yanjiu* (1997): 53–55.

Li Yong. "Dui Zhongguo gudai hengxing fenye he fenye shipan yanjiu." *Ziran kexue shi yanjiu* 11, no. 1 (1992): 22–31.

Li Yunming. "Guanyu 'zhujun tu' junshi yaosu de bijiao yanjiu." In *Chuxue lu*, 406–13. Taibei: Latai chubanshe, 1999.

Lianyungang shi bowuguan. "Jiangsu Donghai xian Yinwan Han mu qun fajue jianbao." *Wenwu* 8 (1996): 4–24.

Liji jin zhu jin yi. Edited by Wang Yunwu and annotated by Wang Meng'ou. 2 vols. Taipei: Taiwan shangwu yinshu guan gufen youxian gongsi, 1992.

Lin, Fan. "Cartographic Empire: Production and Circulation of Maps and Mapmaking Knowledge in the Song Dynasty (960–1279)." PhD diss., McGill University, 2014.

Lin Gang. "Cong gu ditu kan Zhongguo jiangyu jiqi guannian." *Beijing daxue xue bao* 47, no 3 (2010): 47–56.

Liu An. *The Essential Huainanzi: Liu An, King of Huainan,* translated and edited by John Major et al. New York: Columbia University Press, 2010.

———. *Huainanzi.* In *Huainan honglie jijie,* edited by Liu Wendian. 2 vols. Beijing: Zhonghua shuju, 1989.

———. *The Huainanzi: A Guide to the Theory and Practice of Government in Early Han China.* Translated and edited by John S. Major, Sarah A. Queen, Andrew Seth Meyer, and Harold D. Roth, with additional contributions by Michael Puett and Judson Murray. New York: Columbia University Press, 2010.

Liu Laicheng. "Zhanguo shiqi Zhongshan wang Cuo zhaoyu tu tongban shixi." *Wenwu* 1 (1992): 25–34.

Liu Lexian. "Daybooks: A Type of Popular Hemerological Manual of the Warring States, Qin, and Han." In *Books of Fate and Popular Culture in Early China,* edited by Donald Harper and Marc Kalinowski, 57–90. Leiden: Brill, 2017.

Liu Xiaolu. "Lun bohua yong: Mawangdui san hao mu dong xi bi bohua de xingzhi he zhuti." *Kaogu* 10 (1995): 937–41.

Liu Xinfang and Liang Zhu. *Yunmeng Longgang Qin Jian.* Beijing: Kexue chubanshe, 1997.

Liye Qin jian (yi). Edited by Hunan sheng wenwu kaogu yanjiusuo. Beijing: Wenwu chubanshe, 2012.

Liye Qin jiandu jiaoshi (diyi juan). Edited by Chen Wei. 2 vols. Wuhan: Wuhan University Press, 2012.

Lloyd, Peter, and Mark Ovenden. *Vignelli Transit Maps.* Rochester, NY: Rochester Institute of Technology Press, 2012.

Loewe, Michael. *A Biographical Dictionary of the Qin, Former Han and Xin Periods, 221 BC-AD 24.* Leiden: Brill, 2000.

———. *Divination, Mythology, and Monarchy in Han China.* Cambridge: Cambridge University Press, 1994.

———. *The Men Who Governed Han China: Companion to a Biographical Dictionary of Qin, Former Han and Xin Periods.* Leiden: Brill, 2004.

———. "The Royal Tombs of Zhongshan (c. 310 BC)." *Arts Asiatique* 40 (1985): 130–34.

———. "The Western Han Army: Organization, Leadership, and Operation." In *Military Culture in Imperial China,* edited by Nicola Di Cosmo, 45–64. Cambridge, MA: Harvard University Press, 2009.

Longgang Qin jian. Edited by Zhongguo wenwu yanjiusuo and Hubei sheng wenwu kaogu yanjiusuo. Beijing: Zhonghua shuju, 2001.

Lullo, Sherri. "Making Up Status and Authority: Practices of Beautification in Warring States through Han Dynasty China (Fourth Century BCE–Third Century CE)." *Fashion Theory* 20 (2016): 415–40.

Lunyu jishi. Xinbian zhuzi jicheng edition. Selected by Cheng Shude. Beijing: Zhonghua shuju, 1992.

Lüshi chunqiu jiaoshi. Collation and commentary by Chen Qiyou. 4 vols. Shanghai: Xuelin chubanshe, 1984.

Ma, Tsang Wing. "Between the State and Their Superiors: The Anxiety of Low-Ranked Scribes in Qin and Han Bureaucracies." *Asia Major* 33, no. 2 (2020): 25–59.

———. "Scribes, Assistants, and the Materiality of Administrative Documents in Qin-Early Han China: Excavated Evidence from Liye, Shuihudi, and Zhangjiashan," *T'oung Pao* 103, no. 4/5 (2017): 297–333.

Ma Yinan. "Fangmatan Qin jian 'Dan' pian wenben xingzhi de zai sikao." *Guoxue xuekan* 2 (2019): 13–20.

Major, John S. *Heaven and Earth in Early Han Thought: Chapters Three, Four, and Five of the* Huainanzi. Albany: State University of New York Press, 1993.

Mawangdui Han mu boshu zhenli xiaozu. "Changsha Mawangdui san hao Han mu chutu ditu de zhenli." *Wenwu* 2 (1975): 35–42.

Maynard, Patrick. *Drawing Distinctions: The Varieties of Graphic Expression*. Ithaca, NY: Cornell University Press, 2005.

McDowell, A. G. *Village Life in Ancient Egypt: Laundry Lists and Love Songs*. New York: Oxford University Press, 1999.

Meyer, Andrew. "Root-Branches Structuralism in the *Huainanzi*." In *The Huainanzi and Textual Production in Early China*, edited by Sarah A. Queen and Michael Puett, 21–39. Leiden: Brill, 2014.

Miao Xia. "Zhongguo gudai pushou xianhuan qianxi." *Yindu xuekan* 3 (2006): 29–39.

Milburn, Olivia. "'Gai Lu': A Translation and Commentary on a Yin-Yang Military Text Excavated from Tomb M247, Zhangjiashan." *Early China* 33/34 (2010/2011): 101–40.

Mo Yang. "You xing zhi shou: Cong wu le gongming dao Zhongshan gongjiang." *Gudai muzang meishu yanjiu* 4 (2017): 53–77.

———. "Zhongshan wang de lixiang: Zhaoyu tu tongban yanjiu." *Gudai meishu shi* 1 (2016): 45–52.

Monmonier, Mark S. *Maps, Distortion, and Meaning*. Washington, DC: Association of American Geographers, 1977.

Morgan, Daniel Patrick. *Astral Science in Early Imperial China: Observation, Sagehood, and the Individual*. Cambridge: Cambridge University Press, 2017.

Nakatani, Hajime. "The Empire of Fame: Writing and the Voice in Early Medieval China." *positions* 14, no. 3 (2006): 535–66.

Needham, Joseph. "Human Laws and the Laws of Nature in China and the West (III): Chinese Civilization and the Laws of Nature." *Journal of the History of Ideas* 12, no. 2 (April 1951): 194–230.

Needham, Joseph, and Wang Ling. *Science and Civilisation in China*. Vol. 3, *Mathematics and the Sciences of the Heavens and the Earth*. Cambridge: Cambridge University Press, 1959.

Noë, Alva. *Strange Tools: Art and Human Nature*. New York: Hill and Wang, 2015.

Nöllenburg, Martin. "Automated Drawing of Metro Maps." Master's thesis, Institut für Theoretische Informatik, Universität Karlsruhe, 2005.

Nylan, Michael. "Calligraphy, the Sacred Text and Test of Culture." In *Character and Context in Chinese Calligraphy*, edited by Cary Liu and Dora Ching, 1–42. Princeton, NJ: Art Museum, Princeton University, 1999.

———. *The Five "Confucian" Classics*. New Haven, CT: Yale University Press, 2014.

———. "Mapping Time in the *Shiji* and *Hanshu* Tables *Biao*." *East Asian Science, Technology, and Medicine* 43 (2016): 61–122.

———. "The Power of Highway Networks during China's Classical Era (323 BCE–316 CE): Regulations, Metaphors, Rituals, and Deities." In *Highways, Byways, and Road Systems in the Pre-Modern World*, edited by Susan E. Alcock, John Bodel, and Richard J. A. Talbert, 33–65. Hoboken, NJ: John Wiley and Sons, 2012.

———. "Toward an Archaeology of Writing: Text, Ritual, and the Culture of Public Display in the Classical Period." In *Text and Ritual in Early China*, edited by Martin Kern, 3–49. Seattle: University of Washington Press, 2007.

Nylan, Michael, and Michael Loewe, eds. *China's Early Empires: A Re-appraisal*. Cambridge: Cambridge University Press, 2010.

Ōba, Osamu. "The Ordinances on Fords and Passes Excavated from Han Tomb Number 247, Zhangjiashan." Translated and edited by David Spafford, Robin D. S. Yates, and Enno Giele, with Michael Nylan. *Asia Major*, 3rd ser., 14, no 2 (2001): 119–41.

Olberding, Garrett. *Designing Boundaries in Early China: The Composition of Sovereign Space*. Cambridge: Cambridge University Press, 2022.

———. "Movement and Strategic Mapping in Early Imperial China." *Monumenta serica* 64, no. 1 (2016): 23–46.

Pankenier, David W. *Astrology and Cosmology in Early China: Conforming Earth to Heaven*. Cambridge: Cambridge University Press, 2015.

Peirce, Charles Sanders. *The Collected Papers of Charles Sanders Peirce*. 6 vols. Edited by Charles Hartshorne and Paul Weiss. Cambridge, MA: Harvard University Press, 1960.

Peng Jinhua and Liu Guosheng. "Shashi Zhoujiatai Qin mu chutu xiantu chutan." *Jianbo yanjiu* (2001): 241–50.

Pines, Yuri. "The Question of Interpretation: Qin History in Light of New Epigraphic Sources." *Early China* 29 (2004): 1–44.

———. Review of *Material Culture, Power, and Identity in Ancient China*, by Xiaolong Wu. *Journal of Asian Studies* 77, no. 3 (August 2018): 791–92.

Pirazzoli-T'Serstevens, Michèle. "Death and the Dead: Practices and Images in the Qin and Han." In *Early Chinese Religion*, pt. 1, *Shang through Han (1250 BC–220 AD)*, edited by John Lagerwey and Marc Kalinowski, 949–1025. Handbook of Oriental Studies, sec. 4, China, vol. 21/1. Leiden: Brill, 2008.

Poo, Mu-chou. "Preparation for the Afterlife in Ancient China." In *Mortality in Traditional China*, edited by Amy Olberding and P. J. Ivanhoe, 13–36. Honolulu: University of Hawai'i Press, 2011.

———. "Ritual and Ritual Texts in Early China." In *Early Chinese Religion*, pt. 1, *Shang through Han (1250 BC–220 AD)*, edited by John Lagerwey and Marc Kalinowski, 281–313. Handbook of Oriental Studies, sec. 4 China, vol. 21/1. Leiden: Brill, 2008.

Powers, Martin. *Pattern and Person: Ornament, Society, and Self in Classical China*. Harvard East Asian Monographs. Cambridge, MA: Harvard University Asia Center, 2006.

Puett, Michael. "Combining the Ghosts and Spirits, Centering the Realm: Mortuary Ritual and Political Organization in the Ritual Compendia of Early China." In *Early Chinese Religion Part One: Shang through Han (1250 BC–220 AD)*, edited by John Lagerwey and Marc Kalinowski, 1:695–720. Leiden: Brill, 2009.

———. "Following the Commands of Heaven: The Notion of *Ming* in Early China." In *The Magnitude of Ming: Command, Allotment, and Fate in Chinese Culture*, edited by Christopher Lupke, 49–69. Honolulu: University of Hawai'i, 2005.

Qiu Guangming, Qiu Long, and Yang Ping. *Zhongguo kexue jishu shi: Du liang heng juan*. Edited by Lu Jiaxi. Beijing: Kexue chubanshe, 2001.

Qiu Xigui, *Chinese Writing*. Translated by Gilbert L. Mattos and Jerry Norman. Berkeley, CA: Society for the Study of Early China and the Institute of East Asian Studies, 2000.

———. "Gu wenxian zhong du wei 'she' de 'yi' ji qi yu ''zhi' hu'e zhi li." *Dongfang wenhua* 36, no. 1 (1998): 39–45.

———. "Zai tan gu wenxian yi 'yi' biao 'she.'" *Fudan daxue chutu wenxian yu guwenzi yanjiu zhongxin*, March 14, 2011. http://www.fdgwz.org.cn/Web/Show/1429.

Qu Kale. "Tianshui Fangmatan muban ditu xinyi." *Ziran kexue shi yanjiu* 32, no. 4 (2013): 491–503.

Queen, Sarah A., and Michael Puett, eds. *The Huainanzi and Textual Production in Early China*. Leiden: Brill, 2014.

Rawson, Jessica. "The Eternal Palaces of the Western Han: A New View of the Universe." *Artibus Asiae* 59, no. 1/2 (1999): 5–58.

———. "The Origins of Chinese Mountain Painting: Evidence from Archaeology." *Proceedings of the British Academy* 117 (2002): 1–48.

Rees, Ronald. "Historical Links between Cartography and Art." *Geographical Review* 70, no. 1 (January 1980): 60–78.

Reeves, Nicholas. "Two Architectural Drawings from the Valley of the Kings." *Chronique d'Egypt bulletin périodique de la Fondation égyptologique reine Élisabeth* 61 (1986): 43–49.

Reiter, Florian C. "Some Remarks on the Chinese Word *T'u* 'Chart, Plan, Design.'" *Oriens* 32 (1990): 308–27.

Richey, Jeffrey L. "Lost and Found Theories of Law in Early China." *Journal of the Economic and Social History of the Orient* 49, no. 3 (2006): 329–43.

Rickett, W. Allyn, ed. and trans. *Guanzi: Political, Economic, and Philosophical Essays from Early China*. Vol. 2. Princeton, NJ: Princeton University Press, 1998.

Ricoeur, Paul. "Ways of Worldmaking" (review). *Philosophy and Literature* 4, no 1 (Spring 1980): 107–20.

Riegel, Jeffrey. "Do Not Serve the Dead as You Serve the Living: The 'Lüshi chunqiu' Treatises on Moderation in Burial." *Early China* 20 (1995): 301–30.

Roetz, Heiner. "On Nature and Culture in Zhou China." In *Concepts of Nature in Traditional China: A Chinese-European Cross-Cultural Perspective*, edited by Hans Ulrich Vogel and Günter Dux, 198–219. Leiden: Brill, 2010.

Rosand, David. *Drawing Acts: Studies in Graphic Expression and Representation*. Cambridge: Cambridge University Press, 2016.

Rossi, Corinna. *Architecture and Mathematics in Ancient Egypt*. Cambridge: Cambridge University Press, 2007.

Sanft, Charles. *Communication and Cooperation in Early Imperial China: Publicizing the Qin Dynasty*. Albany: State University of New York Press, 2014.

———. "Notes on Penal Ritual and Subjective Truth under the Qin." *Asia Major*, 3rd ser., 21, no 2 (2008): 35–57.

Sanguo zhi. Composed by Chen Shou (233–297). Commentary by Pei Songzhi (372–451). Beijing: Zhonghua shuju, 1959.

Schmidt-Glintzer, Helwig. "Diagram (*Tu*) and Text (*Wen*): Mapping the Chinese World." In *Conceiving the Empire: China and Rome Compared*, edited by Fritz-Heiner Mutschler and Achim Mittag, 169–94. Oxford: Oxford University Press, 2008.

Seidel, Anna. "Traces of Han Religion in Funeral Texts Found in Tombs." In *Taoism and Religious Culture*, edited by Akizuki Kan'ei, 21–57. Tokyo: Hirakawa Shuppan, 1987.

Selbitschka, Armin. "Sacrifice vs. Sustenance: Food as a Burial Good in late Pre-Imperial and Early Imperial Chinese Tombs and Its Relation [to] Funerary Rites." *Early China* 41 (2018): 179–243.

Shang Zhiru. "Qin feng zongyi washu de jige wenti." *Wenbo* 6 (1986): 43–49.

Shanghai shi fangzhi kexue yanjiu yuan and Shanghai shi sichou gongye gongsi wenwu yanjiu zu. *Changsha Mawangdui yihao Han mu chutu fangzhipin de yanjiu*. Beijing: Wenwu chubanshe, 1980.

Shaughnessy, Edward L. "Historical Geography and the Extent of the Earliest Chinese Kingdoms." *Asia Major*, 3rd ser., 2, no. 2 (1989): 1–22.

———. *Sources of Western Zhou History: Inscribed Bronze Vessels*. Berkeley: University of California Press, 1992.

Shi, Jie. "The Hidden Level in Space and Time: The Vertical Shaft in the Royal Tombs of the Zhongshan Kingdom in Late Eastern Zhou (475–221 BCE) China." *Material Religion: The Journal of Objects, Art, and Belief* 11 (2015): 76–103.

———. *Modeling Peace: Royal Tombs and Political Ideology in Early China*. Tang Center Series in Early China. New York: Columbia University Press, 2020.

Shiji. Composed by Sima Qian (ca. 145–86 BCE), with Sima Tan (d. 112 BCE). Beijing: Zhonghua shuju, 2010.

Shuihudi Qin mu zhujian. Edited by Shuihudi Qin mu zhujian zhengli xiaozu. Beijing: Wenwu chubanshe, 1990.

Shuowen jiezi zhu. Compiled by Xu Shen. Edited and annotated by Duan Yucai. Taipei: Hanjing wenhua shiye youxian gongsi, 1985.

Sichuan sheng wenwu kaogu yanjiuyuan and Qingchuan xian wenwu guanlisuo. "Sichuan Qingchuan Haojiaping Zhanguo muqun M50 fajue jianbao." *Sichuan wenwu* 3 (2014): 13–19.

Sima Qian. *Records of the Grand Historian*. Vol. 1, *Early Years of the Han Dynasty, 201–141 B.C.* Translated by Burton Watson. New York: Columbia University Press, 1961.

Sivin, Nathan, and Gari Ledyard Scope. "Introduction to East Asian Cartography." In *History of Cartography*, vol. 2, bk. 2, *Cartography in the Traditional East and Southeast Asian Societies*, edited by J. B. Harley and David Woodward, 23–31. Chicago: University of Chicago Press, 1994.

Song Huaqiang. "Fangmatan qin jian 'zhiguai gushi' zhaji." *Wuhan jianbo yanjiu zhongxin jianbo wang*, October 1, 2017. http://www.bsm.org.cn/?qinjian/5427.html.

Soper, Alexander. "Early Chinese Landscape Painting." *Art Bulletin* 23, no. 2 (June 1941): 141–164.

Staack, Thies. "'Drafting,' 'Copying,' and 'Adding Notes': On the Semantic Field of 'Writing' as Reflected by Qin and Early Han Legal and Administrative Documents." *Bamboo and Silk* 2 (2019): 290–318.

Steinhardt, Nancy. *Chinese Architecture: A History*. Princeton, NJ: Princeton University Press, 2019.

———. *Chinese Traditional Architecture*. New York: China Institute in America, 1984.

Sterckx, Roel. *Food, Sacrifice, and Sagehood in Early China*. Cambridge: Cambridge University Press, 2011.

———. "Religious Practices in the Qin and Han." In *China's Early Empires: A Reappraisal*, edited by Michael Nylan and Michael Loewe, 415–30. Cambridge: Cambridge University Press, 2010.

Stewart, Susan. *On Longing: Narratives of the Miniature, the Gigantic, the Souvenir, the Collection*. Durham, NC: Duke University Press, 1992.

Sun Yanzhe. "The Interpretation of Hetu and Luoshu." *Linguistics and Literature Studies* 8. no. 4 (2020): 190–94.

Sun Zhanyu. "Fangmatan Qin jian yi 360–366 hao 'muzhu ji' shuo shangque." *Xibei shi da xue bao* 47, no. 5 (2010): 46–49.

———. *Gansu Qin Han jiandu jishi: Tianshui Fangmatan Qin jian jishi*. Lanzhou: Gansu wenhua chubanshe, 2013.

Sun Zhongming. "Zhanguo Zhongshan wang mu 'zhaoyu tu' de chubu tantao." *Dili yanjiu* 1 (March 1982): 86–93.

———. "Zhanguo Zhongwang wang mu zhaoyu tu ji qi biaoshi fangfa de yanjiu." In *Zhongguo gudai ditu ji—Zhanguo Yuan*, edited by Cao Wanru, Zheng Xihuang, Huang Shengzhang, et al., 1–3. Beijing: Wenwu chubanshe, 1990.

Sunzi shijia zhu. Zhuzi jicheng edition. Vol. 6, edited by Guoxue Zhenglishe. Beijing: Zhonghua shuju, 2010.

Tan Qixiang. "Erqian yibai duonian qian de yi fu ditu." *Wenwu* 2 (1975): 43–48.

———. "Mawangdui Han mu chutu ditu suo shuoming de jige lishi dili wenti." *Wenwu* 6 (1975): 20–28.

———. "'Zhongguo gudai ditu ji' xu." *Wenwu* 7 (1987): 68–71.

Teng Zhaozong. "Yinwan Han mu jiandu gaishu." *Wenwu* 8 (1996): 32–36.

Thorp, Robert L. "Architectural Principles in Early Imperial China: Structural Problems and Their Solution." *Art Bulletin* 68, no. 3 (September 1986): 360–78.

Thote, Alain. "Daybooks in Archaeological Context." In *Books of Fate and Popular Culture in Early China: The Daybook Manuscripts of the Warring States, Qin, and Han*, edited by Donald Harper and Marc Kalinowski, 11–56. Leiden: Brill, 2017.

Tian Jian and He Shuangquan. "Gansu Tianshui Fangmatan zhanguo Qin Han muqun de fajue." *Wenwu* 2 (1989): 1–31.

Tianshui Fangmatan Qin jian. Edited by Gansu sheng wenwu kaogu yanjiusuo. Beijing: Zhonghua shuju, 2009.

Tseng, Lillian Lan-Ying. "Funerary Spatiality: Wang Hui's Sarcophagus in Han China." *RES: Anthropology and Aesthetics* 61/62 (Spring–Autumn 2012): 116–31.

———. *Picturing Heaven in Early China.* Harvard East Asian Monographs. Cambridge, MA: Harvard University Press, 2011.

———. "Representation and Appropriation: Rethinking the TLV Mirror in Han China." *Early China* 29 (2004): 163–215.

Tufte, Edward. *Envisioning Information.* Cheshire, CT: Graphics Press, 1990.

Turnbull, David. *Maps Are Territories: Science Is an Atlas.* Chicago: University of Chicago Press, 1994.

Vankeerberghen, Griet. *The* Huainanzi *and Liu An's Claim to Moral Authority.* Albany: State University New York Press, 2001.

Vellodi, Kamini. "Diagrammatic Thought: Two Forms of Constructivism in C. S. Peirce and Gilles Deleuze." *Parrhesia* 19 (2014): 79–95.

———. *Tintoretto's Difference: Deleuze, Diagrammatics, and Art History.* London: Bloomsbury Press, 2019.

Von Falkenhausen, Lothar. *Chinese Society during the Age of Confucius (1000–250 BC): The Archaeological Evidence.* Los Angeles: Cotsen Institute of Archaeology Press, 2006.

———. "The E Jun Qi Metal Tallies: Inscribed Texts and Ritual Contexts." In *Text and Ritual in Early China*, edited by Martin Kern, 79–123. Seattle: University of Washington Press, 2007.

———. "Mortuary Behavior in Pre-Imperial Qin: A Religious Interpretation." In *Religion and Chinese Society*, vol. 1, *Ancient and Medieval China*, edited by John Lagerwey, 109–72. Hong Kong: Chinese University of Hong Kong, 2004.

———. "Social Ranking in Chu Tombs: The Mortuary Background of the Warring States Manuscript Finds." *Monumenta serica* 51 (2003): 439–526.

Waley, Arthur. "The Book of Changes." *Bulletin of the Museum of the Far Eastern Antiquities* 5 (1933): 121–42.

Wang, Eugene. *Shaping the Lotus Sutra: Buddhist Visual Culture in Medieval China.* Seattle: University of Washington Press, 2007.

Wang, Haicheng. "Inscriptions from Zhongshan: Chinese Texts and the Archaeology of Agency." In *Agency in Ancient Writing*, edited by Joshua Englehardt, 209–30. Boulder: University Press of Colorado, 2013.

Wang Keling. "Yi hou Ce gui mingwen ji 'Wu wang, Cheng wang fa Shang tu,' 'Dong guo tu' ji Xi Zhou ditu zongxi." *Ditu* 1 (1990): 49–52.

Wang Shujin. "Mawangdui boshu 'huixing tu' mingcheng shikao." *Hunan sheng bowu-guan guankan* 6 (2009): 21–28.

Wang Yong. *Zhongguo dili xue shi*. Shanghai: Shanghai san lian shudian, 2014.

———. *Zhongguo ditu shigang*. Beijing: Shangwu yinshu guan, 1959.

Wang Zijin. "Liye Qin jian 'youlizu' kao." *Shoudu shifan daxue xuebao (shehui kexue ban)* 2 (2018): 41–48.

———. "Mawangdui Han mu gu ditu jiaotong shiliao yanjiu." *Jianghan kaogu* 4 (1992): 65–70, 49.

———. "Qin guo jiaotong de fazhan yu Qin de tongyi." *Shilin* 4 (1989): 6–9, 21.

———. "'Qin qiao' kaoyi: zai lun Qin jiaotong youshi." *Shixue yuekan* 5 (2020): 5–15.

———. "Qin tongyi yuanyin de jishu chengmian kaocha." *Shehui kexue zhanxian* 9 (2009): 222–31.

———. *Zhongguo gudai jiaotong wenhua luncong*. Beijing: Zhongguo shehui kexue chubanshe, 2015.

Wang Zijin and Li Si. "Fangmatan Qin ditu linye jiaotong shiliao yanjiu." *Zhongguo lishi dili luncong* 28, no. 2 (April 2013): 5–10.

Waring, Luke. "Writing and Materiality in the Three Han Dynasty Tombs at Mawang-dui." PhD diss., Princeton University, 2019.

Whittington, Karl. *Body-Worlds: Opicinus de Canistris and the Medieval Cartographic Imagination*. Toronto: Pontifical Institute of Mediaeval Studies, 2014.

Winther, Rasmus Grønfeldt. *When Maps Become the World*. Chicago: University of Chicago Press, 2020.

Wood, Denis. *Rethinking the Power of Maps*. New York: Guildford Press, 2010.

Woodward, David. "The 'Two Cultures' of Map History—Scientific and Humanistic Traditions: A Plea for Reintegration." In *Approaches and Challenges in a Worldwide History of Cartography*, 49–68. Barcelona: Institut Cartogràfic de Catalunya, 2000.

Wu Chengyuan. "Mawangdui ditu kao." *Ditu* 1 (1990): 45–48.

Wu Hung. *Art of the Yellow Springs*. London: Reaktion Books, 2010.

———. "From Temple to Tomb: Ancient Chinese Art and Religion in Transition." *Early China* 13 (1988): 78–115.

———. "'Mingqi' de lilun he shijian." *Wenwu* 6 (2006): 72–81.

———. *Monumentality in Early Chinese Art and Architecture*. Stanford, CA: Stanford University Press, 1995.

———. "Picturing or Diagramming the Universe." In *Graphics and Text in the Production of Technical Knowledge in China: The Warp and the Weft*, edited by Francesca Bray, Vera Dorofeeva-Lichtmann, and Georges Métailié, 191–214. Sinica Leidensia 79. Leiden: Brill, 2007.

———. "A Sanpan Shan Chariot Ornament and the Xiangrui Design in Western Han Art." *Archives of Asian Art* 37 (1984): 38–59.

———. "'Shengqi' de gainian yu shijian." *Wenwu* 1 (2010): 87–96.

Wu Jiulong. "Yinqueshan Han jian bingshu de yiyi ji yingxiang." *Binzhou xueyuan xuebao* 21, no. 5 (October 2005): 80–83.

———. "Yinqueshan Han jian ji jinnian lai chutu bingshu gaishu." *Junshi lishi* 1 (2002): 8–11.

Wu Jiulong and Bi Baoqi. "Shandong Linyi Xi Han mu faxian 'Sunzi bingfa' he 'Sun Bin bingfa' deng zhujian de jianbao." *Wenwu* 2 (1974): 15–26.

Wu Shundong. "Mawangdui guditu youguan fangwei wenti qianxi." In *Mawangdui Han mu yanjiu wenji—1992 nian Mawangdui Han mu guoji xueshu taolun hui lunwen xuan*, edited by Hunan sheng bowuguan, 183–92. Changsha: Hunan chubanshe, 1994.

Wu, Xiaolong. *Material Culture, Power, and Identity in Ancient China*. Cambridge: Cambridge University Press, 2017.

Xi Zezong. "Mawangdui Han mu boshu zhong de huixing tu." In *Zhongguo gudai tianwen wenwu lunji*, edited by Zhongguo shehui kexue yuan kaogu yanjiusuo, 29–34. Beijing: Wenwu chubanshe, 1989.

Xiaogan diqu di er qi yi gong yi nong wenwu kaogu xunlian ban. "Hubei Yunmeng Shuihudi shiyi hao Qin mu fajue jianbao." *Wenwu* 6 (1976): 1–10.

Xiong Chuanxin. "Guanyu 'zhujun tu' zhong de youguan wenti ji qi huizhi niandai." In *Mawangdui Han mu yanjiu wenji—1992 nian Mawangdui Han mu guoji xueshu taolun hui lunwen xuan*, edited by Hunan sheng bowuguan, 154–60. Changsha: Hunan chubanshe, 1994.

Xunzi: Basic Writings. Translated by Burton Watson. New York: Columbia University Press, 2003.

Xunzi jijie. Compiled by Wang Xianqian (1842–1918). *Xinbian zhuzi jicheng* edition. Beijing: Zhonghua shuju, 2013.

Yan Changgui. "Chutu wenxian yu gudai zhengqu dili yanjiu." *Huazhong shifan daxue xuebao* 54, no 2 (March 2015): 109–23.

———. "Fangmatan jian 'di cheng ye yushi' zhong de shijian yu didian." *Chutu wenxian* 4 (2013): 297–303.

———. "Tianshui Fangmatan muban ditu xintan." *Kaogu xuebao* 3 (2016): 365–84.

Yan Dunjie. "Guanyu Xihan chuqi de shipan he zhanpan." *Kaogu* 5 (1978): 334–37.

Yang Bojun. "Sun Bin he 'Sun Bin bingfa' zakao." *Wenwu* 3 (1975): 9–13, 8.

Yang Hong. "Yi bu guanche fajia luxian de gudai junshi zhuzuo—du zhujian ben 'Sun Bin bingfa.'" *Kaogu* 6 (1974): 345–55.

———. "Zhanguo huihua chutan." *Wenwu* 10 (1989): 53–59, 36.

Yang Hong and Li Li. *Zhongguo gu bing ershi jiang*. Beijing: Sanlian shudian, 2013.

Yang Hongxun. "Zhanguo Zhongshan wang ling ji zhaoyu tu yanjiu." *Kaogu xuebao* 1 (1980): 119–138.

Yates, Robin D. S. "The History of Military Divination in China." *East Asian Science, Technology, and Medicine* 24 (2005): 15–43.

———. "Introduction: The Empire of the Scribes." In *Birth of an Empire: The State of Qin Revisited*, edited by Yuri Pines, Gideon Shelach, Lothar von Falkenhausen, and Robin D. S. Yates, 141–54. Berkeley: University of California Press, 2014.

———. "Law and the Military in Early China." In *Military Culture in Imperial China*, edited by Nicola Di Cosmo, 23–44. Cambridge, MA: Harvard University Press, 2009.

———. "New Light on Ancient Chinese Military Texts: Notes on Their Nature and Evolution, and the Development of Military Specialization in Warring States China." *T'oung Pao*, 2nd ser., 74, no. 4/5 (1988): 211–48.

———. "The Qin Slips and Boards from Well No. 1, Liye, Hunan: A Brief Introduction to the Qin Qianling County Archives." *Early China* 35/36 (2012/2013): 291–329.

———. "State Control of Bureaucrats under the Qin: Techniques and Procedures." *Early China* 20 (1995): 331–65.

———. "The Yin-Yang Texts from Yinqueshan: An Introduction and Partial Reconstruction, with Notes on Their Significance in Relation to Huang-Lao Daoism." *Early China* 19 (1994): 75–144.

Yee, Cordell. "Breaking the Grid: Maps and the Chinese Art of Writing." In *Approaches and Challenges in a Worldwide History of Cartography*, 153–78. Barcelona: Institut Cartogràfic de Catalunya, 2000.

———. "Chinese Cartography among the Arts: Objectivity, Subjectivity, Representation." In *History of Cartography*, vol. 2, bk. 2, *Cartography in the Traditional East and Southeast Asian Societies*, edited by J. B. Harley and David Woodward, 128–68. Chicago: University of Chicago Press, 1994.

———. "Reinterpreting Traditional Chinese Geographical Maps." In *History of Cartography*, vol. 2, bk. 2, *Cartography in the Traditional East and Southeast Asian Societies*, edited by J. B. Harley and David Woodward, 35–70. Chicago: University of Chicago Press, 1994.

———. "Taking the World's Measure: Chinese Maps between Observation and Text." In *History of Cartography*, vol. 2, bk. 2, *Cartography in the Traditional East and Southeast Asian Societies*, edited by J. B. Harley and David Woodward, 96–127. Chicago: University of Chicago Press, 1994.

Yin Difei. "Xi Han Ruyin hou mu chutu de zhanpan he tianwen yiqi." *Kaogu* 5 (1978): 338–43.

Yinqueshan Han jian shiwen. Compiled by Wu Jiulong. Beijing: Wenwu chubanshe, 1985.

Yinqueshan Han mu zhu jian (yi). Vol. 1, edited by Yinqueshan Han mu zhujian zhenli xiaozu. Beijing: Wenwu chubanshe, 1985.

Yinqueshan Han mu zhujian zhenli xiaozu. "Linyi Yinqueshan Han mu chutu 'Sun Bin binfa' shiwen." *Wenwu* 1 (1975): 1–43.

———. "Linyi Yinqueshan Han mu chutu 'Sunzi bingfa' canjian shiwen." *Wenwu* 12 (1974): 11–12.

———. "Linyi Yinqueshan Han mu chutu 'Wang Bin' pian shiwen." *Wenwu* 12 (1976): 36–43.

Yinwan Han mu jiandu. Edited by Lianyungang shi bowuguan, Zhongguo shehui kexueyuan jianbo yanjiu zhongxin, Donghai xian bowuguan, and Zhongguo wenwu yanjiusuo. Beijing: Zhonghua shuju, 1997.

Yong Jichun. "Jinnian lai guanyu Tianshui Fangmatan muban ditu yanjiu de huigu yu zhanwang." *Zhongguo shi yanjiu tongtai* 5 (1997): 10–17.

———. *Qin zaoqi lishi yanjiu*. Beijing: Zhongguo shehui kexue chubanshe, 2017.

———. "Tianshui Fangmatan ditu zhuji ji qi neirong chutan." *Zhongguo lishi dili luncong* 1 (1998): 211–24.

———. *Tianshui Fangmatan muban ditu yanjiu*. Lanzhou: Gansu renmin chubanshe, 2002.

Yong Jichun and Bo Pengxu. "Jin ershi nian lai Tianshui Fangmatan muban ditu yanjiu zongshu." *Tianshui shifan xueyuan xuebao* 36, no. 4 (July 2016): 21–25.

Yong Jichun and Dang Anrong. "Tianshui Fangmatan muban ditu banshi zuhe yu ditu fuyuan xintan." *Zhongguo lishi dili luncong* 4 (2000): 179–92.

You Shen. "Mawangdui ditu Zhong de shundi ling miao." *Hunan keji xueyuan xuebao* 26, no. 10 (October 2005): 12–16.

Yu Bingxia. "Mawangdui Han mu 'dixing tu' yanjiu zongshu." *Hunan sheng bowuguan guankan* 9 (2013): 64–75.

Yu, Pauline. *The Reading of Imagery in the Chinese Poetic Tradition*. Princeton, NJ: Princeton University Press, 1986.

Yuan Jianping. "Mawangdui yihao Han mu yu Mashan yihao Chu mu chutu sizhipin de bijiao yanjiu." In *Mawangdui Hanmu yanjiu wenji—1992 nian Mawangdui Han mu guoji xueshu taolun hui lunwen xuan*, edited by Hunan sheng bowuguan, 225–36. Changsha: Hunan chubanshe, 1994.

Yunmeng Qin jian zhenli xiaozu. "Yunmeng Qin jian shiwen (er)." Edited by Yunmeng Qin jian zhengli xiaozu. *Wenwu* 7, no. 1 (1976): 11–14.

———. "Yunmeng Qin jian shiwen (san)." Edited by Yunmeng Qin jian zhengli xiaozu. *Wenwu* 7, no. 1 (1976): 27–37.

———. "Yunmeng Qin jian shiwen (yi)." Edited by Yunmeng Qin jian zhengli xiaozu. *Wenwu* 7, no. 1 (1976): 1–11.

Yunmeng Shuihudi Qin mu bianxie zu. *Yunmeng Shuihudi Qin mu*. Beijing: Wenwu chubanshe, 1981.

Zhan Libo. "Mawangdui Han mu chutu de shoubei tu tantao." *Wenwu* 1 (1976): 24–27.

Zhang, Hanmo. "Mapped Territory Floating in the Clouds: A Reinterpretation of the Mawangdui Maps in Their Art and Religious Contexts." *Artibus Asiae* 2 (2016): 147–63.

Zhang Xinbin. "Hui xian Guweicun Zhanguo mu guo bie wenti taolun." *Zhongyuan wenwu* 2 (1994): 90–96.

Zhang Xiugui. "Mawangdui dixing tu cehui tedian yanjiu." In *Zhongguo gudai ditu ji—Zhanguo Yuan*, edited by Cao Wanru, Zheng Xihuang, Huang Shengzhang, et al., 4–8. Beijing: Wenwu chubanshe, 1990.

———. "Mawangdui Han mu chutu dixing tu pingjie fuyuan zhong de ruogan wenti." *Ziran kexue shi yanjiu* 3, no. 3 (1984): 266–74.

———. "Mawangdui 'zhujun tu' cehui jingdu ji huizhi tedian yanjiu." *Dili kexue* 4 (1986): 357–67.

———. "Tianshui 'Fangmatan ditu' de huizhi niandai." *Fudan xuebao* 1 (1991): 44–48.

———. "Xi Han chuqi Changsha guo nan jie tantao—Mawangdui Han mu chutu gu ditu de lunzheng." *Zhongguo lishi dili luncong* 2 (1985): 323–43.

———. *Zhongguo lishi dimao yu gu ditu yanjiu*. Beijing: Shehui kexue wenxian chubanshe, 2006.

Zhangjiashan Han mu zhujian [ersiqi hao mu]. Edited by Zhangjiashan ersiqi hao Han mu zhujian zhengli xiaozu. Beijing: Wenwu chubanshe, 2001.

Zhangjiashan Han mu zhujian [ersiqi hao mu] (shiwen xiuding ben). Edited by Zhangjiashan ersiqi hao Han mu zhujian zhengli xiaozu. Beijing: Wenwu chubanshe, 2006.

Zhanguo ce. Annotated by Gao You, in *Sibu beiyao*. Taiwan: Zhonghua shuju, 1990.

Zhao Feng. *Zhongguo sichou yishu shi*. Beijing: Wenwu chubanshe, 2005.

Zhao Zhenkai. "'Sun Bin bingfa, qing Pang Juan,' Zhong jige chengyi wenti de tantao." *Wenwu* 10 (1976): 51–56.

Zheng Shubin. "Shi xi Mawangdui Han mu shengqi bian zangqi de zhuanhuan xingshi." *Hunan sheng bowuguan guankan* (2015): 26–35.

Zhongguo kexueyuan kaogu yanjiu suo and Hunan sheng bowuguan xiezuo xiaozu. "Mawangdui er, san hao Han mu fajue de zhuyao shouhuo." *Kaogu* 1 (1975): 47–61.

Zhongguo lidai duliang hengkao. Edited by Qiu Guangming. Beijing: Kexue chubanshe, 1992.

Zhou Shirong. "Mawangdui gu ditu bushi Qin dai jiang tu." *Ditu* 3 (1993): 45–48.

———. "Youguan Mawangdui gu ditu de yixie ziliao he jifang Han yin." *Wenwu* 1 (1976): 28–31.

Zhouli jin zhu jin yi. Edited by Wang Yunwu and annotated by Lin Yin. Taipei: Taiwan shangwu yinshu guan gufen youxian gongsi, 1997.

Zhu Dexi and Qiu Xigui. "Pingshan Zhongshan wang mu tongqi mingwen de chubu yanjiu." *Wenwu* 1 (1979): 42–52.

Zhu Guichang. "Guanyu boshu 'Zhujun tu' de jige wenti." *Kaogu* 6 (1979): 522–524, 570.

Zhu Lingling. "Fangmatan Zhanguo Qin tu yu xian Qin shiqi de ditu xue." *Zhengzhou daxue xuebao* 1 (1992): 61–67.

Zhuang Xiaoxia. "Liye Qin jian suo jian Qin 'de hu fuchu' zhidu kaoshi." *Wuhan jianbo yanjiu zhongxin jianbo wang*, August 30, 2019. http://m.bsm.org.cn/?qinjian/8125.html.

Zun Xin. "'Sunzi bingfa' de zuozhe ji qi shidai—tantan Linyi Yinqueshan yi hao Han mu 'Sunzi bingfa' zhujian de chutu." *Wenwu* 12 (1974): 20–24.

Zuo Tradition–Zuozhuan: Commentary on the Spring and Autumn Annals. Translated and introduced by Stephen Durrant, Wai-yee Li, and David Schaberg. 3 vols. Seattle: University of Washington Press, 2016.

Index

Page locators in *italic* refer to figures.

Dan's story: authorship of, 74, 76–77, 192n23; bamboo slips of, from Fangmatan tomb 1, *75*; bureaucratic form of, 77–79, 82, 99; correlation between text, occupant, and tomb, 74, 76, 193n30; dating of, 74, 76–77; as *shengqi*, 194n56; as a "story of the strange" (*zhiguai gushi*), 78, 194n41; text from Longgang tomb 6 compared with, 78–79; text of, 74; three parts of, 80, 194n41

daybooks (*rishu*). *See* Fangmatan tomb 1, daybooks

Deleuze, Gilles, 22

Diagram of the Residence and Burial Ground (*jüzang tu*), from Mawangdui tomb 3, *3*; *Diagram of the Auspicious Domain* (*zhaoyu tu*) as alternative title, 2, 170; iconological examination of, 171; measurements compared with dimensions of Mawangdui tomb 2, 170

Dodge, Martin, 183n70

Dongke River: in area covered by Fangmatan diagrams, *71*; "hydrostructure" of Fangmatan indicated in drawings 1A, 1B, and 4B, 70, *71*, 83, 84, *85*, *86*, 91, 92, 97

Dong Shan, 170, 171

Dorofeeva-Lichtmann, Vera V., 21, 186n8

Eastern Han dynasty: Fangmatan mentioned in the *Hanshu* (*History of the Han*), 72; stone-carved door knockers on a sarcophagus dating to, 53

Ebine Ryosuke, 76

Edney, Matthew H., 5–6

Egypt: complexities of building royal necropolises, 46; tomb plan of Ramesses IV, 35, *36*, 37, 187n26; tradition of hybridizing plan and elevation views, 35, 37, 188n35

E Jun Qi bronze tallies: described, 190n76; legal authority and magical power of, 59–60

Elgin, Catherine, 19–20

embroidery on silk: artistry of, during Warring States period, 201n43; in inventory list from Mawangdui tomb 3, 126; notational logic of, compared with patterns on terrestrial diagrams,

116, 134–35, 137. *See also* Mawangdui tomb 1, embroideries

Fangmatan: fourteen tombs excavated at, 63; as a historical site, 72–73

Fangmatan drawings: area covered by, *71*; classed as maps for living use, 195n67; discovery of in tomb 1, 63; enumeration of, 191n5; map scale of, 96, 196n80; orientation of the boards, 83–84, 91–93, 96, 196n73, 196n75; as resource maps, 73, 192n15; as travel paraphernalia for a postmortem ritual journey, 195n65

Fangmatan drawings, drawing 1A: grouped with drawings 1B and 4B, 70, 83–84, 91; infrared photograph of, *62*, *85*; the Wei River's western trajectory noted on, 91

Fangmatan drawings, drawing 1B: grouped with drawings 1A and 4B, 70, 83–84, 91; infrared photograph of, *64*, *86*; "north" (*beifang*) indicating orientation of, 84, 96; photograph of, *93*; water transportation indicated on, 73, 91; the Wei River's western trajectory noted on, 91

Fangmatan drawings, drawing 2: distances measured in *li* on, 96; infrared photograph of, *65*, *87*; inscriptions for timber in the area, 73; as master map for the region, 70, *87*; orientation of, 196n75; Qin Mountains on, 83, *87*, 91, 98

Fangmatan drawings, drawing 3A: clustered with drawing 4A, 70, 83, 84, 91, 92; distances measured in *li* on, 96; infrared photograph of, *66*, *88*; mountain-range line as framing device on, *88*, 98; orientation of, 84; photograph of, *94*; timber resources notated on, 73; water transportation indicated on, 73

Fangmatan drawings, drawing 3B: hemp paper fragment compared with, 100; infrared photograph of, *67*; as possible map of Yongchuan River valley, 196n87; uniqueness of, 99–100

Fangmatan drawings, drawing 4A: clustered with drawing 3A, 70, 83, 84, 91,

92; infrared photograph of, *68*, *89*; orientation of, 84; photograph of, *95*; water transportation indicated on, 73, 91

Fangmatan drawings, drawing 4B: direction of river flows recorded by the *ditu*-maker, 91; grouped with drawings 1A and 1B, 70, 83–84, 91; infrared photograph of, *69*, *90*; mountain-range line as framing device on, *90*, 98; relationship to the Dongke and Yongchuan Rivers, 84, 91; timber resources notated on, 73

Fangmatan tomb 1: blank wooden board laid over the deceased, 102; dating and excavation of, 63; drawing 4B, *69*, 70, 73; wooden boards with terrestrial drawings found in, 102; scribal status of the tomb occupant attested by artifacts found in, 70; terrestrial diagrams compared with cosmic motifs in tomb 14, 106–7. *See also* Dan's story

Fangmatan tomb 1, daybooks: Pace of Yu road ritual included in, 107; the resurrection story as part of version B, 193n39

Fangmatan tomb 5, drawing on a fragment of hemp paper, 4, *101*; interpretation of lines on, 100–101; placement of, 196n86; size of, 100

Fangmatan tomb 14: captive tiger on wooden board, 102, *103*, 104, 105, 107, 197n94; "cord-hook" design on wooden board, 102, *103*, 104–5; items found in, 197n92; wooden board laid over the deceased, 102

Feagin, Susan, 15

Felt, D. Jonathan, 21

fenye (methods of field allocation), 12, 182n52

Fujita Katsuhisa, 83, 91, 196n71

Fu Jüyou, 198n5, 200n25

Fu Xinian, 38, 40, 187n21, 187n27, 187n29

Gardiner, Alan H., 187n26

Garrison Diagram (*zhujun tu*), *110*, *111*; arsenals on, 158, *159*; cloud patterns on, 155, 157–58, 164; elongated peaks on, 100; formal elements on, 145, 149, *150*, 151, *152*, 158; garrisons in Changsha

as focus of, 109, 114, 149, 151, *152*, *153*, 198n5, 199n17; *jiandao*, 116, 199n17; ornamental pattern on, 116, 125, 134–37; relationship to the *Topography Diagram*, 198n4

Giele, Enno, 23

Goodman, Nelson, 19, 20, 26–27, 184n82, 184n84

Graves, Margaret, 40

Guanzi jiaozhu, "Terrestrial Diagram" ("Ditu") chapter: terrestrial diagrams discussed in, 8; "Wang Bing" ("King's Army") text compared with, 148, 204n33

Guattari, Félix, 22

Guo Jue, 79–80

Habberstad, Luke, 21

Hamburger, Jeffrey F., 12

Han Feizi jijie, *tu* (diagram) mentioned in, 9

Hanshu (*History of the Han*): "Biography of Wang Mang" ("Wang Mang zhuan") chapter of, 10; *Sun Bin bingfa* mentioned in the "Bibliographic Treatise" of, 146; "Treatise on Celestial Patterns" ("Tianwen zhi") chapter of, 158, 163, 206n64; "Treatise on Geography" ("Dili zhi") chapter of, 9, 73; "Treatise on the Five Phases" ("Wuing zhi") chapter of, 14; *tu* used with certain texts in the "Bibliographic Treatise" of, 11

Haojiaping tomb 50, 70; "Statutes on Agriculture" ("Tianlü") from, 58–59, 70

Harley, J. B., 6, 180n14, 183n70

Harper, Donald, 72, 104, 183n57, 184n78, 194n41

hemp paper fragment. *See* Fangmatan tomb 5, drawing on a fragment of hemp paper

He Shuangquan, 195n67

hetu (river diagrams) and *luoshu* (Luo river writing), 13–15

Hou Hanshu (*History of the Later Han*), 105

Hsing I-tien, 10, 114, 144, 199n17

Hsu, Hsin-Mei Agnes, 149, 198n3

Hsu, Mei-Ling, 180n9

Hsu-Tang, Agnes, 195n69, 205n52

Huainanzi. *See* Liu An, *Huainanzi*